KEELE
UNIVERSITY LIBRARY

AR'

IN THE

MANCHESTER
UNIVERSITY PRESS

THE BARBER INSTITUTE'S
CRITICAL PERSPECTIVES
IN ART HISTORY SERIES

SERIES EDITORS
Tim Barringer, Nicola Bown
and Shearer West

EDITORIAL CONSULTANTS
John House, John Onians,
Marcia Pointon and Alan Wallach

Art and the academy
in the nineteenth century

EDITED BY
RAFAEL CARDOSO DENIS
AND COLIN TRODD

Manchester University Press

Published by Manchester University Press
Oxford Road, Manchester M13 9NR, UK
http://www.man.ac.uk/mup

British Library Cataloguing-in-Publication Data
A catalogue record for this book is available from the British Library

ISBN 0 7190 5495 8 *hardback*
 0 7190 5496 6 *paperback*

First published 2000

06 05 04 03 02 01 00 10 9 8 7 6 5 4 3 2 1

Typeset by
D R Bungay Associates, Burghfield, Berks

Printed in Great Britain
by Bell & Bain Ltd, Glasgow

Contents

List of illustrations

List of contributors

Caroline Arscott is Lecturer in the History of Art at the Courtauld Institute. Her publications include essays on Leighton, Frith and sentimental discourses in Victorian art and art criticism.

Paul Barlow is Lecturer in Art History at the University of Northumbria at Newcastle. The author of many articles on Victorian art and art theory, he co-edited *Victorian Culture and the Idea of the Grotesque* and is currently preparing manuscripts on Carlyle and mid-nineteenth-century art criticism, and art institutions in Victorian London.

Rafael Cardoso Denis is Visiting Professor at the Escola Superior de Desenho Industrial in Rio de Janeiro. His publications include essays on the institutionalisation of art and design education in Victorian London.

Gen Doy is Professor of History and Theory of Visual Culture at De Montfort University. Her books include *Seeing and Consciousness, Women and Visual Culture in France, 1800–1852* and *Materialising Art History*.

Paul Duro is Senior Lecturer in Art History at the Australian National University, Canberra. His edited books include *Essential Art History* and *The Rhetoric of the Frame;* he is the author of *The Academy and the Limits of Painting in Seventeenth-Century France.*

Duncan Forbes teaches Art History at the University of Aberdeen. In addition to preparing his Ph.D. for publication, he is currently researching art unions in mid-Victorian London.

Gordon Fyfe is Lecturer in Sociology at Keele University. The author of many articles on the sociology of cultural institutions, he is the co-editor of *Theorising Museums.*

Michaela Giebelhausen lectures in Art History at the University of Essex. She is currently editing a collection of essays on museum culture.

Elizabeth Prettejohn teaches Art History at the University of Plymouth and has published on many aspects of Victorian painting, aesthetics and art criticism. Her most recent publication is *Frederic Leighton: Antiquity, Renaissance and Modernity*, which she co-edited. A volume of essays on Victorian art and taste is in preparation.

Colin Trodd teaches Art History at the University of Sunderland. He has written many essays on Victorian art, culture and cultural institutions. The co-editor of *Victorian Culture and the Idea of the Grotesque*, he is currently co-editing *Governing Cultures: Art Institutions in Victorian London*.

William Vaughan is Professor of the History of Art at Birkbeck College, University of London. His books include *German Romanticism and English Art, Art and the Natural World in Nineteenth-Century Britain, German Romantic Painting* and *Art in Bourgeois Society*, which he co-edited. The essay in this volume forms part of a larger project entitled *Artistic Brotherhoods in the Nineteenth Century*.

Introduction: academic narratives

Colin Trodd and Rafael Cardoso Denis

Thinking the academic

Until the late 1970s the dominant forms of Anglo-American art history were the highly codified iconographical practices of the Warburgian tradition, with its engagement with pictorial motifs, and Gombrichian visual aesthetics, which conflated J. J. Gibson's work on the psychology of perception with a critical methodology derived from the writings of Karl Popper. Elsewhere the discipline was serviced by a convivial alliance between the patrician values of connoisseurship and the academic customs of liberal humanism. Since the early 1980s, however, Art History has experienced, along with other disciplines, the spread of theoretical ideas associated with Cultural Studies. The 'new art history' of the 1980s was articulated as critical, oppositional and radical: contesting the conventions and assumptions of the 'old' disciplinary formation; and generating new readings about representation, cultural authority and visual meaning. And yet, both 'old' and new' versions of the subject shared many assumptions about the nature of academic art, particularly that of the nineteenth century. If the traditional view of academic art tended to find in it the formulaic repetition of 'mechanical' art theory, 'new art history' figured such art as sterile and inert, something determined by the ideological materials from which it was formed. In both cases academicism was articulated by narrative systems that identified it as synthetic, unable to escape from its self-enclosing environment, unwilling to express an organic, historical aesthetic and thus doomed to evolutionary failure. Academicism was written away by two manoeuvres: it was either unable to bear the weight of proper critical evaluation and judgement, or it disappeared beneath a superior theoretical power that overwhelmed it. It was either vulgar and tasteless or complicit with 'bourgeois hegemony'.

Is it possible to generate other readings of academicism and academic institutions since the end of the eighteenth century? Might it be the case that such art was more complex than the two dominant positions have acknowledged? A useful starting point might be the writings of Reynolds, which are, in many ways, paradigmatic of the dominant values which transmitted themselves to nineteenth-century

academic culture. In his ninth *Discourse* of 1780, Reynolds claimed: 'the art we pro-
fess has beauty for its object; this it is our business to discover and express, but the
beauty of which we are in quest is general and intellectual; it is an idea that subsists
only in the mind; the sight never beheld it, nor has the hand expressed it: it is an
idea residing in the breast of the artist, which he is always labouring to impart, and
which he dies at last without imparting ...'.[1] This position is intriguing, revealing
and somewhat surprising. Beauty (art) is at once too somatic to enter discourse and
too numinous to be represented as a body. Where Clement Greenberg, T. J. Clark,
Norman Bryson and Pierre Bourdieu find in academicism an epic landscape of
inertia, Reynolds, in defining the goal of art, conjures a paradoxical vision that
acknowledges the central import of a concept that is always in the process of cancel-
lation in the moment of its articulation. Affirmation and alienation, as well as con-
sciousness and its negation, are locked together in an ineluctable embrace. Like
David, Ingres, Leighton and Watts, Reynolds wanted to perfect representation and
establish pictorial coherence through a theory of invention whereby imitation is
figured as originality. If imitation is defined as the preservation of the original
plastic forms and critical structures by which the fine arts distinguish themselves
from other systems of visualisation, then Reynolds, the archetypal academic 'syn-
thesiser', goes beyond the traditional image of art as the obsessional search for
Aristotelian unities and structures, to a visuality of corporeal intensity. Such views
became part of the institutional behaviour of the nineteenth-century academy,
shaping its pedagogic systems and processes, suggesting a richness and fluidity of
ideas and practices that the essays in this volume demonstrate, address and explore.

Academic histories

The nineteenth century is, in many senses, the crucial moment in the history of the
academy. Indeed, it could be argued that academies became more powerful as social
and cultural institutions at the moment in which academicism was confronted
with, and weakened by, different methods of calibrating aesthetic value as well as
other ways of dealing with the status of nature or the nature of representation. To
assess the veracity of this apparent paradox, it is necessary to consider the material,
discursive and political cultures of the academy. Such an approach can begin by
examining the institutional systems within which academic processes and values
were generated, distributed and contested. This vital task of situating the historical
contexts of academic development and unravelling specific institutional histories is
undertaken by various essays in the present volume, particularly by Gordon Fyfe
and Colin Trodd in the case of London's Royal Academy of Arts; Paul Duro in the
case of the *Académie de France* in Rome; Duncan Forbes in the case of the Royal
Scottish Academy; and Rafael Cardoso Denis in the case of Brazil's Imperial
Academy of Fine Arts.

 The authority of academic culture became increasingly attenuated as its treat-
ment of the nature of form, value and beauty were subjected to re-evaluation

throughout the nineteenth century. Once dismissed as that in which the truth of beauty was deformed and traduced, the quotidian emerges during this period as the vivid source of the life of art itself, particularly in the increasingly 'realist' and 'naturalist' strategies of representation deployed as the century progressed. Dynamic, rather than inert, common nature is credited with projecting value, bringing to birth art in a ceaseless tide of experimentations, adaptations and modifications. Instead of associating beauty with the formulation of abstract systems, aesthetic value thus comes to be located in vital processes and in the interplay between the experiential and the practical. Or, rather, it is perceived as occurring within the domain of the counter-cultural formation we have come to call the avant-garde. This opposition between art as system and art as process was at the heart of the avant-gardist critique of academicism as the epitome of bourgeois taste and commercialism. Revealingly, though, the dealer-critic system that succeeded the decline of academic power was to commodify artistic production as never before, negating professed pretensions towards aesthetic purity. The manner by which academic art was accommodated by the sinuosity of such Modernist discourses is examined in detail in this volume by Paul Barlow, while Elizabeth Prettejohn similarly confronts articulations of academic identity in the histories and genealogies surrounding Aestheticism. Before examining these issues, however, we can begin to get some form of purchase on such matters by looking closely at the way in which the institutional life of the academy has been inscribed into readings of the development of the post-Renaissance art world.

The history of academies, a subject of increasing interest to scholars, has tended to create three types of critical commentary: first, the accounts proffered by Boschloo and Goldstein, which seek to survey the generation and transformation of the material practices and conceptual systems of academic art; second, the work of Boime, which attempts to revise attitudes to academic culture by locking its technical and practical procedures into the development of certain forms of early Modernism; finally, the writings of Fried and Bryson, which explore the pictorial systems, traditions and processes of academic culture in the context of the new networks and structures of representation that emerge in the eighteenth and nineteenth centuries.[2] In each case the rituals and regimes of academic culture are tested and probed in relation to a panoply of formal, visual and discursive programmes. Although we should observe the important contribution made by a long line of critical historians to the understanding of the philosophical framework in which eighteenth-and nineteenth-century academic art was produced, it must be recalled that the most famous engagement with the idea of the academy and the practice of academic art was not made by a speculative thinker in the tradition of Kant, Hegel, Riegl and Wölfflin.[3] Rather, it is Pevsner, whose *Academies of Art* remains the looming presence in most accounts of the institutionalisation of academic authority. Pevsner wrote the history of academies on an epic scale: his totalising historicism traced in the development of academic institutions the identity of political cultures and social systems; and his devotion to examining academies as

managerial and bureaucratic structures disavowed any engagement with the 'local' level of style, visual representation and art production. Because systematisation operated at the level of institutional life rather than aesthetic discourse, Pevsner's history was entangled with ideas about national culture and its historical legitimation, but in a way that stressed the importance of organisations rather than pictorial forms.

Although Pevsner's reading of the history of academic life detaches itself from explaining, examining or engaging with specific examples of academic art, more recent publications have returned to the space of pictorial evaluation, judgement and analysis. It is undoubtedly true that some very important and challenging work has been conducted into the historicity of academic cultures since the 1970s. Indeed, it is possible to identify two 'moments' within this process of scholarly recuperation. A first moment involves the re-evaluation of the academic in the name of a pluralistic liberalism which generates a more relativising image of the development of modern culture than that countenanced by Modernism. In some cases, this revival of interest in work by Bouguereau, Couture, Cabanel, Gérôme, Gleyre and other so-called *artistes pompiers* has taken the form of an attempt to recapture the stability associated with a long vanquished shared symbolic order or even an identification of this art as a resolute defence of specific aesthetic qualities threatened by the remorselessly self-questioning logic of the avant-gardes.[4] The problem of such revisionism is that it can easily collapse into a demand for the restoration of some lost authenticity of art or into a form of rhetoric that multiplies the opportunities for aesthetic tourism just as it bemoans the anti-aestheticism of contemporary culture. In recent years a more complex and rigorous amalgam of readings has come to the fore, culminating in books by Fried and Stephen Bann, both of which seek to suture aspects of academic culture to the pictorial and epistemological procedures of Modernism itself. Delaroche, for instance, has been identified as participating in an 'exegetical' art that inscribes itself into the new visual systems of the mid-nineteenth century. Elsewhere Marc Gotlieb has attempted to analyse the work of Meissonier by locking his art into a discourse of 'emulation', which he identifies as the master-tradition of post-Davidian painting in nineteenth-century France.[5] Fried, Bann and Gotlieb are united by a desire to examine how powerful visual morphologies are generated, negated or overcome by the specific pictorial procedures of particular artists.

Even when such discourses have claimed to refigure the relations between traditional and avant-garde art, they have done so from the perspective of Paris as the unique centre of artistic norms and values. This desire to legitimate the academic in and through its tension with the material and conceptual locus of Modernism is in itself a subject worthy of separate critical analysis. The present volume, however, containing a mixture of empirical case studies, theoretical engagements and critical reviews, surveys a range of material that goes far beyond the allure of Parisian culture. By exploring British, French, German and Brazilian academic painting in detail, these essays offer a more complete image of how the authority of such art

was mobilised, exercised or blocked during the period between 1815 and 1900. All the contributions to this project map out different histories of academies and academic art, testing and probing the forces and practices that sustained them, examining the technologies of power and techniques of representation that fashioned their cultures. These critical ruminations provide detailed engagements with developments within academic culture. Consequently, the essays in this volume address a series of related topics: the transmission of academic protocols across national, cultural and historical spaces; the organisation and management of training within academic systems; the location of the academy within the material fabric of modern state formation; the positioning of the academy within the symbolic economies and cultural geographies of the city; the relationship between academic identity and the commercialisation of the art world; the association of the academy with the formation, mobilisation or continuation of 'brotherhood' or 'group' narratives; the organisation of and challenge to 'national-school' discourses generated by academic culture; the connections and tensions between models of value outlined by the academy and cultural journals; the articulation of academic knowledge and practice within the master discourse of Classicism; the entangling of academic culture with the kenosis of kitsch in Modernist criticism. In each case, what we see is the animated debate that informs and gives force to academic discussion at a specific historical moment. This commitment to identifying academic discourse as a process of renewal and challenge is a marked feature of a volume that examines the productive clashes and dramatic conflicts between aesthetic formation and institutional normalisation.

What emerges most clearly from this non-Paris-based reading of nineteenth-century art is the impossibility of defining a single history of the academic. If academicism at its height represented anything in the way of a unified system, the essence of this system was a fairly broad set of shared beliefs, assumptions and practices which varied widely in the intensity and rigour of their application. It is impossible to speak of a specific ideology of academicism anywhere near as explicit or intrusive in its direct impact on the minutiae of teaching, producing, exhibiting and reviewing art as the writings of Alfred J. Barr or Greenberg often became in the mid-twentieth century. The essays in this volume demonstrate unequivocally the enormous range of practices encompassed by the label 'academic' in contexts as far removed from Paris, and from each other, as nineteenth-century Düsseldorf, Edinburgh, London, Rio de Janeiro or Rome. In fact, the network of emulation that directed attention from all points in the system towards Paris was fundamentally premised on the belief that, in any final analysis, Paris derived its authority from links to an older tradition stretching back from the not so distant Italian past to ancient Greece. Assimilation and absorption seem to be more accurate characterisations of such academic processes than copying or repetition. That landscape and genre painting were able to achieve such eminence within the English academy that their status came to require substantial revision of traditional hierarchies; that private or semi-private atelier tuition under a single master was allowed

to complement or even supplant classroom training in Paris and some parts of Germany; that industrial and applied art could be taught within the confines of the academy in Brazil: these and other exceptions to the presumed norms of academic practice lend credence to the idea of academicism as more of a loose network of similar institutions and procedures all drawing upon a common tradition than a unified system based upon a single model or answering to a central authority.

Academic values

If there is little hope of constructing a comprehensive and homogeneous account of academic history without completely obliterating the subtle differences of context that often constitute the most historically salient aspects of each individual case, then we must look elsewhere for a definition of the term academicism. An obvious place to begin is with the perception by academies themselves of the purpose and relevance of these institutions. Were there any values and ideals shared by most or all academies in the nineteenth century, and, if so, what were these? The answer to the first part of the question is, evidently, yes; otherwise, there would have been no basis for positing the academic, even oppositionally. The answer to the second part is more elusive; but it can be argued that academic values revolved, to a greater or lesser extent, around the upholding of the interrelated notions of taste, skill and professional status. Nineteenth-century academies tended to provide a forum for debating and refining the shifting borders of these concepts, gradually adjusting their meanings through continual consensus-building and the constant reaffirmation of institutional authority.[6] In practical terms, this meant retaining some measure of control over the means of teaching, exhibiting and rewarding artistic practice, though the extent of this control has often been exaggerated in hindsight. As White and White argued in their analysis of the subject, the decay of the academic establishment in nineteenth-century France can be traced to its inadequacy in retaining any sort of monopoly over the means of artistic communications and rewards.[7] From a theoretical standpoint, the legitimacy to enforce effectively any set of values with regard to taste, skill and status depended upon the academy's ability to invoke and give credence to some appropriate aspect of the notion of tradition in which its authority was ultimately grounded.

 Much of the debate within nineteenth-century academic education is about tradition, but this is not to say that academic practice was strictly circumscribed by the past. As Fyfe reaffirms in this volume, the notion of tradition is ultimately reflexive in character and its very authority lies in its ability to reinvent itself. Thus, he suggests, traditionalism functioned as the cultural correlate of modernisation in nineteenth-century Britain, and the institutional identity of the Royal Academy represents an evolving amalgam of these two terms. A similar sense that academies provided not a monolithic locus of institutional authority and control but, rather, sites of contest and struggle is present in many of the essays in this book. William Vaughan reveals that the Düsseldorf Academy was able to accommodate internal

dissension while serving, at the same time, as an instrument for countering politi-
cally subversive tendencies. In fact, the academic reforms which have been hailed
by the likes of Pevsner as Germany's great contribution to liberalising the academic
system of teaching may very well have served to intensify the pedagogic power of
the master. On the other hand, contrary to established assumptions about cen-
tralised authority, academies could act as venues for affirming regional identities or
for ensuring the economic survival of artists on the fringe of the modern art world
in contexts as far apart as Edinburgh and Rio de Janeiro, as demonstrated by
Duncan Forbes and Rafael Cardoso Denis. Even gender roles, as Gen Doy points
out, were not so clear-cut in academic practice as has been previously assumed.
Generally speaking, it is fair to say that academies functioned not as irrevocably
fixed conduits of established power but as fields of shifting interdependencies, in
which universalising principles and localising conventions were always subject to
negotiation. This is perhaps most clearly borne out by the discreet entangling of
Romantic nationalism with academicism that prevailed in England and Germany
as well as in Scotland and Brazil, in contradistinction to the emphasis placed upon
the clash between Classicism and Romanticism in standard accounts of French art.
 In the end, the verbal and visual discourses emanating from the academic milieu
in the nineteenth century are far from clear or unequivocal. The lack of trans-
parency of official discourse, as noted by Gordon Fyfe and Forbes, is evenly
matched, if not surpassed, by the complex usages of critical and theoretical dis-
courses at the time, as amply demonstrated by Caroline Arscott, Michaela
Giebelhausen, Elizabeth Prettejohn and Colin Trodd. The very significance of the
term 'academic' varied greatly in its application throughout the nineteenth cen-
tury, as Arscott and Prettejohn make clear, and it has continued to acquire new
meanings in the aftermath of the avant-gardist evaluations elucidated by Barlow. It
would be impossible, furthermore, to restrict academic values to a mere set of
artistic practices, disengaging their ramifications from a range of powerful moral,
social, religious and political forces which operated through them. Drawing atten-
tion to the conflation of academic power with the idea of national schools of
painting, Trodd unravels the politically useful opposition thus established between
English liberality and Continental tyranny as expressed in less contentiously
phrased contrasts of artistic temperament and tradition. Similarly, as
Giebelhausen reveals, the language of art criticism in mid-Victorian Britain was
infused with dramatic overtones of religious intolerance which stimulated an
almost fanatical defence of orthodoxy and ended up by branding deviations from
accepted artistic practice as heresy. The readings of images presented here by
Arscott, Denis, Giebelhausen and Duro, all of which reaffirm the fluidity of acad-
emic practices working within and against historical systems and visual conven-
tions, seek to question the view that academicism is locked into a culture of
programmatic pictorialisations. The image of academicism that emerges is one in
which the cultivation of cultural habits, practices and techniques is just as impor-
tant as the consolidation and reproduction of a pictorial canon.

It remains the case, however, that a characteristic feature of academic theory and practice from Reynolds and David to Leighton and Bouguereau is its ardent engagement with past pictorial traditions and its unsqueamish appropriation of canonical motifs and compositions, both visual and textual, putting them to new uses in often eclectic combinations. This approach, rejecting the thraldom of the image to the word, seems to go against the grain of both traditional and 'new' art history, thus locking academic artists like Reynolds, Leighton and Watts into encounters with a classical formalism that Modernism has forgotten, although Fry was favourably disposed to this cultural tradition.[8] The essays in this volume seek to challenge the often misleading image of academic culture found in many Modernist, Post-Structuralist and 'new art history' readings. For example, Bryson's articulation of the relationship between academic and post-academic painting, based as it is on the division between 'discursive' and 'figural' modes of representation, is no more than a more theoretically dense recapitulation of the standard accounts of academic culture being subject to endless subordination by literary language. Furthermore, at no stage does Bryson acknowledge the way in which Lessing's anti-pictorialism was incorporated into many forms of late eighteenth- and nineteenth-century academic discourse. In contrast, the contributors to this volume examine the complex web of relations at work in the institutions, histories and pictorial registrations of academic culture, revealing the essential flaws of any binary model that opposes word and image as eternal antagonists in a teleological account of emergent figuration liberating itself from what Bryson calls 'the hegemonising word'.[9]

Despite the impossibility of pinning down a unified academic experience, it is nonetheless possible to identify a common set of values and practices that cut across national and regional boundaries. For instance, even if the British tradition of academic discourse tends to be more 'psychological' or 'practical' than 'technical' or 'metaphysical', we should not ignore the common interests that shape both British and other European forms of academic culture.[10] These shared practices include: the Albertian articulation of the laws of composition and action, principles of design and the appropriate deployment of bodies in space, derived as they were from Aristotle's writings about unities; the identification of art as a liberal profession through its association with the mastery of perspective, geometry and colour relations; the regular use of the nude model in teaching, composing and copying, as well as *écorché* anatomical statues, based on a conception of the human body as the summit of natural unity and variety; the assumption that art both embodies and completes nature, or that it attempts the incarnation of the idea of the beautiful; the influence of the tradition of *ut pictura poesis* in academic meditations about the nature and limits of representation; the reproduction of Vasarian methods of historical periodisation and canonisation and the corollary belief in the historical achievement of ideal forms; the use of generic classification for the identification and evaluation of subjects and types; the emphasis on the value of selection, modification and incorporation in the relationship between nature and representation, and the concomitant interest in mimesis. Finally, we might note

that academic authorities, associating art with pleasure, tend to make use of the Aristotelian tradition which claims that the beauty of art and its objects is not reducible to the horizon of experience which frames and represents nature and its objects.

The essence of academic values such as these have tended to strike most twentieth-century observers as doubly equivocal and almost wholly alien. For instance, academic deference to canons and tradition derives from a historically-situated debate in which it is plausible – indeed, often necessary – to regard the past as superior to the present, thus contradicting the tradition of auto-critique associated with Modernist criticism. At the same time, the universalising claims of aesthetic transcendence and ideal beauty that underlie virtually all academic theory stand in stark opposition to a scientifically derived relativism that denies any absolute values to which such notions could be referred.[11] In the final analysis, it is perhaps the assimilatory nature of academic values and practices that most grates upon the modern sensibility, generally incapable of admitting any inconsistency, particularly of an intellectual sort. If so, this would explain why Modernist critics were at once so eager to pigeon-hole academicism as a homogeneous nullity while silently glossing over the detailed reality of academic histories. It would be fairly easy now, in the context of Postmodernity, to recover this culture as some sort of radically pluralist exercise in accommodating difference and coexisting with the seemingly irreconcilable limits of paradox and truth. Tempting as such a course of action might be, assimilation is clearly not the same as pluralism. Therefore instead of declaring that an academic aesthetic can be recuperated as an ironic cornucopia of formal coherence, the following essays suggest that academicism has been estranged from us by the discourses that have spoken of it. Modernism, obssessed with the idea of the unique and self-sufficient object, has castigated academic art for its systematising rationality: in the desire to establish a universe of pictorial forms in relation to each other it has cast academicism as a void that isolates itself from the real diversity of 'organic' culture. But does this view really address the nature of academic art? Modifying Reynolds, we might suggest that the most interesting manifestations of academicism are figured by a language that no one knows how to speak or to pictorialise, that this language is condemned to repeat what it says to an audience that is obliged to memorialise it as value, as practice.

Notes

1 J. Reynolds, *Discourses on Art*, ed. R. Wark (New Haven and London, 1959), p. 171.

2 A. W. A. Boschloo ed., *Academies of Art Between Renaissance and Romanticism* (The Hague, 1989); C. Goldstein, *Teaching Art: Academies and Schools from Vasari to Albers* (Cambridge, 1996); A. Boime, *The Academy and French Painting in the Nineteenth Century* (London, 1971); idem *Thomas Couture and the Eclectic Vision* (New Haven and London, 1980). Boime's central claim is this: that by encouraging both formal and expressive modes of pictorial realisation in its treatment of the sketch, the Academy sanctions a

culture of originality that has been identified as an attribute of Modernist practice: see also M. Fried, *Absorption and Theatricality: Painting and the Beholder in the Age of Diderot* (Berkeley, 1980); N. Bryson, *Tradition and Desire, from David to Delacroix* (Cambridge, 1984). There is something rather ironic about the current dominance of the Friedian paradigm; for by drawing, as it most certainly does, on the Hegelian position that works of art call for our engagement to complete themselves in meaning, it tends to seek the threshold of this process of reflexivity and self-awareness in those types of art that worked against the classical-academic tradition Hegel concerned himself with.

3 For two excellent accounts of this tradition, see M. Podro, *The Critical Historians of Art* (New Haven and London, 1982); and A. Bowie, *Aesthetics and Subjectivity: From Kant to Nietzsche* (Manchester, 1993).

4 See K. Varnedo, 'Revision, re-vision, re:vision', *Arts Magazine*, 49, 1974, pp. 68–71. G. Weisberg, 'Jules Breton, Jules Bastien-Lepage and Camille Pissarro in the context of nineteenth-century peasant painting and the Salon', *Arts Magazine*, 56, 1982, pp. 115–20; G. A. Ackerman, *The Life and Work of Jean-Leon Gérôme, with a Catalogue Raisonné* (London and New York, 1986); G. A. Ackerman, 'The Neo-Grècs: a chink in the wall of Neoclassicism', in J. Hargrove, ed., *The French Academy: Classicism and its Antagonists* (London and Toronto, 1990), pp.170–91; and the materials produced by the Dahesh Museum, New York, which is dediciated to collecting and exhibiting academic art.

5 S. Bann, *Paul Delaroche, History Painted* (London, 1997); M. Fried, *Manet's Modernism* (Chicago, 1995) and M. Gotlieb, *The Plight of Emulation* (Princeton, 1996).

6 For a glimpse of the precise mechanisms through which institutional politics shaped academic practices, see R. C. Denis, 'From Burlington House to the Peckham Road: Leighton and the polarities of Victorian art and design education', in T. Barringer and E. Prettejohn, eds, *Frederic Leighton: Antiquity, Renaissance, Modernity* (New Haven and London, 1999), pp. 248–56, and P. Mainardi, *The End of the Salon: Art and the State in the Early Third Republic* (Cambridge, 1993).

7 H. C. White and C. White, *Canvases and Careers: Institutional Change in the French Painting World* (New York, 1965), pp. 100–1.

8 Fry's interest in Watts's 'formalism' is referred to in C. Trodd, 'Turning back the Grotesque: the matter of painting and the oblivion of art', in C. Trodd, P. Barlow and D. Amigoni, eds, *Victorian Culture and the Idea of the Grotesque* (Aldershot, 1999). Barrell's very perceptive characterisation of Reynoldsian art theory as a 'philosophical rather than a rhetorical aesthetic', and its assertion that painting 'teaches … a form of knowledge' before it demonstrates a 'form of action', establishes the critico-pictorial framework in which Fry celebrates classical-formalism: see J. Barrell, 'Sir Joshua Reynolds and the Englishness of English art', in H. K. Bhabha, ed., *Nation and Narration* (London and New York, 1990), p.161; and J. Barrell, *The Political Theory of Painting from Reynolds to Hazlitt* (New Haven and London, 1986), pp. 82–90.

9 See N. Bryson, *Word and Image, French Painting and the Ancien Régime* (Cambridge, 1981), pp. 6, 56, cf. 28, 31, 43, 238. Interestingly, Bourdieu's comments about nineteenth-century French academic art bear more than a passing resemblance to Bryson's image of academic culture as the machinery of the state, and of such painters as the products of a system that determines their being. As Salon art is, Bourdieu claims, determined by the conditions of its production, it is the discharge of 'a sclerotic academic institution', but one which produces 'incredible docility' and 'infantile dependency' in its recruits. Although such rhetoric seems to suggest some type of structural homology between the

anonymous 'impersonality' and mechanical regularity of the academic tradition and the industrial production of commodities, there is no attempt to explain how modern academic art is devoid of the qualities or values associated with art created in similar institutions in earlier periods. As is so often the case with Bourdieu, aesthetic sterility is assumed rather than explained by an 'objective' sociological methodology that repeats the banalities produced in the most simplistic accounts of the subject. His narrative repeats all the clichés about the 'massified' nature of academic culture we find in J. Bland's 'The Academy and the avant-garde', in L. Dawtrey and T. Jackson, eds, *Investigating Modern Art* (New Haven and London, 1996), pp. 35–47. Furthermore, Bourdieu's conflation of the academic with the degenerative perpetuates the ethico-moral pieties of conservative Modernist patricians like Rewald and Eitner, both of whom are content to compare the 'luminous' and life-enhancing qualites of modern art to the 'still-born concepts' and 'antiquated ideals' of the deadly academicists: see P. Bourdieu, *The Field of Cultural Production* (Cambridge, 1993), pp. 240–5; J. Rewald, 'Foreword', *Pissarro, 1830–1903* (London, 1980), pp. 9–10; L. Eitner, *An Outline of European Painting from David through Cézanne* (London, 1987), p. 275.

10 Lessing's influence on writers in the British academic tradition is certainly evident by the mid-nineteenth century in the work of Howard, Eastlake and Leslie. Howard, borrowing Lessing's anti-pictorialist terminology, augments his Reynoldsian defence of high art with a resolute rejection of the idea that images are translated texts. Likewise Eastlake, in opposing the theory of *ut pictura poesis*, uses Reynolds and Lessing to claim that as visual and literary pictorialisations do not always coincide, painting should not be expected to emulate poetical discourse. Leslie, whose use of Reynolds and Lessing was part of a process of reconsidering the division between historical and ordinary subjects, wrote that poetry and painting were, indeed, 'Sister Arts … but it is the business of each to do what the other cannot; and words can no more become substitutes for pictures than line and colours can supply the place of poetry.' See H. Howard, *A Course of Lectures on Painting Delivered at the Royal Academy of Fine Art* (London, 1848), pp. 11–25; C. Eastlake, *Contributions to the Literature of the Fine Arts* (London, 1848), pp. 51–5; and C. R. Leslie, *A Hand-Book for Young Painters* (London, 1855), p. v.

11 For a parallel discussion of the ambiguous place of transcendence in art historical discussion of the nineteenth century, see Barringer and Prettejohn, *Leighton*, pp. xxviii–xxx.

PART I

REWRITING THE ACADEMIC

Fear and loathing of the academic, or just what is it that makes the avant-garde so different, so appealing?

Paul Barlow

Academicism as anti-art

It has become a cliché to identify 'academicism' in art as a negative force, associated with the mechanisation of culture and the repressive authority of social institutions. The term appears constantly in commentaries on art in the nineteenth-century, when an heroic 'avant-garde' is said to have struggled against academic agents of conformity and banality. But what exactly is this 'academicism'? Numerous, very different, artists have been saddled with the label. Clement Greenberg in his essay 'Towards a newer Laocoon' (1940) produces a list of 'kitsch' nineteenth-century academics, naming some of the culprits: 'Vernet, Gérôme, Leighton, Watts, Moreau, Böcklin, the Pre-Raphaelites etc.'.[1] The list is odd, as we shall see, but one thing is clear. Academic art is bad art. 'Academic' is not simply a label which describes a particular type of painting. It is an act of evaluation. As Greenberg himself says in his most influential essay, 'Avant-garde and kitsch' (1939), 'self-evidently, all kitsch is academic; and conversely, all that's academic is kitsch'.[2]

What does this mean? Of course, the word 'academic' is widely, if loosely, used to refer to whatever may be deemed stuffy, irrelevant or uninspired. But here something more is being claimed. Greenberg and other commentators do not use the word simply to suggest such attributes, though they *are* usually implied. Greenberg is claiming to place the artists he lists within a critical and historical category. But how are we to define this category? The list contains Neoclassicists, Symbolists and Naturalists. All are apparently 'academic' in the sense in which Greenberg is using the term.

Greenberg's own attempt to explain this will be considered later, but it is important to note that his usage was thoroughly established by the time he attempted to theorise it. Indeed, it has been central to the consensus that has emerged in twentieth-century critical commentary on nineteenth-century art. It is expressed,

for example, by the critic André Salmon, who describes an encounter with the 'naive' artist Henri Rousseau at the Salon des Artistes Français, the annual exhibition organised by the French Academy. Salmon is at pains to point out that he was only visiting the Salon 'professionally' as a journalist. Rousseau, however, had chosen to go and was 'transfixed before a mediocre portrait signed by Courtois, an academical artist today quite forgotten'. Rousseau, it seems, admired Courtois for his 'finish'. Salmon goes on to defend Rousseau's apparent lapse of taste:

> What is best about this story is that the answer perfectly describes Courtois' work. His was the honesty of a bad academic painter stuffed with 'general culture' and his naivety was not as worthy as Rousseau's. It is reported that Courtois, having been invited to lunch on 'any Thursday', replied: 'Impossible, I am doing a portrait and I always put in the expression on Thursdays.'[3]

Salmon identifies Courtois's 'academic' identity against his own avant-garde values, and against Rousseau's naivety, both of which are identified with authentic art. Salmon's encounter with Rousseau is difficult because Rousseau chooses to visit the Salon, an institution self-evidently, for Salmon, identified with bad taste. Furthermore, it is Courtois's 'finish' – his technical skill – which fascinates the untrained Rousseau. Salmon seeks to turn this very skill against Courtois, presenting him as a petit-bourgeois pedant, a man who restricts 'expression' to Thursdays.

For Salmon, Courtois's skill is the centre of the problem; it is something which obscures proper judgements of taste. The technically incompetent, but artistically worthy, Rousseau is enthralled by the deceptive skills of the aesthetic non-entity Courtois. 'Academic' culture – normally avoided by Salmon – works to generate a systematic misrecognition of art: alluring but false values from which Salmon, the cultural sophisticate, must rescue the naive Rousseau. Courtois is associated with both compartmentalised conventional respectability (expression on Thursdays, religion on Sundays, etc.) and with production-line manufacturing.

This is the central 'myth' of academicism on which Greenberg draws. It works to describe an institutionally powerful but aesthetically impoverished art at its most pervasive during the nineteenth-century. This academic art is sustained by the teaching and exhibiting practices of the various European academies, most importantly the French Academy. It is the 'official' art of the nineteenth-century. Despite its status, and its contemporary popularity, it is in fact – as Greenberg and Salmon know – merely the degraded remnant of post-Renaissance naturalism, destined to be supplanted by the 'avant-garde', the oppositional and innovatory art it seeks to denigrate.

What is surprising is that, despite its pervasiveness, this usage has remained, for the most part unexplored. Certainly, the concept of the avant-garde itself has been examined at length and, in addition, there have been important studies of the major European academies of art, their histories and values. Some biographical and critical literature also exists on the work of better known artists who have been labelled

'academic', or 'pompier' – a pejorative term applied to French nineteenth-century Neoclassicists.[4] But in such texts the central myth is generally either ignored or uncritically repeated. It is clear that Salmon's words are suffused with complex and interrelated assumptions (concerning culture, truth, class identity, institutions), all of which bear upon his use of the term 'academic'. These assumptions need to be unpacked. This will involve exploration of the legitimating and theorising function of the term 'academic' within avant-garde discourse, its relation to the positions of so-called academic artists themselves, their institutional roles, and the ways in which the aesthetic nullity ascribed to academic art by Salmon has been – and continues to be – asserted and sustained.

This project is complex. This essay merely seeks to look at some of the issues to be addressed, and to bring into the open some paradoxes and preconceptions which are persistently occluded in art historical writing on the nineteenth and early twentieth centuries. We are familiar with Salmon's judgements: that the 'bad' painter Rousseau is, in reality, good, while the seemingly 'good' artist, Courtois, is in truth bad. His intervention at the Salon, seeking to break the spell that traps Rousseau, is connected to his implicit equation of academicism with the pomp of public authority: a spectacle which generates a faith in the legitimacy of social institutions. It is no coincidence that the modern concept of academicism develops alongside the Marxist theory of 'false consciousness'. It can be plausibly argued that this attitude emerges with the avant-garde itself in the late 1840s. Courbet's claims for Realism were famously connected with his anarchist politics. Likewise, in Britain, Pre-Raphaelite criticism of the Royal Academy (RA) arose from their belief that academic ('Raphaelite') practice was a form of mechanisation – the aesthetic equivalent to the rationalising and disciplining functions of early industrial manufacturing. If Courbet was considered the 'Proudhon of painting', and the Pre-Raphaelites associated with Carlyle's critique of the capitalist 'cash nexus', then it is unsurprising that many critics continue this association between the Academy and the cultural imperatives of state institutions in urban-capitalist society.

This oppositional identity is what characterises the 'avant-garde'. It is certainly new in cultural history and is tied to the emergence of social criticism, which itself seeks to articulate radical socio-economic transformation. Carlyle himself was among the first explicitly to connect free-market industrialism with academicism. In 1829 he wrote that, like modern manufacturing, contemporary 'Philosophy, Science, Art, Literature, all depend on machinery ... In defect of Raphaels and Angelos, and Mozarts, we have Royal Academies of Painting, Sculpture, Music'.[5] When Greenberg equated academicism with commercially produced commodities (kitsch), he repeated this connection, but also sought to claim a space for the avant-garde apart from mechanised market-led culture. However, an obvious difficulty arises from the identification of this lineage. The Pre-Raphaelites appear prominently on Greenberg's list of 'academics'. As we shall see, this problem persistently recurs as soon as the avant-garde/academic split is examined, but at this stage it is enough to note that it arises from the double role of the concept as Salmon and

Greenberg use it – its conflation of aesthetic evaluation and critical-historical description.

In fact, what Greenberg attempts to do is to claim *both* an equation of 'academicism' with industrial capitalism, and of good taste with the ethics of political radicalism. In other words, Greenberg implies that the pleasure to be had from the avant-garde is the affective form of a libertarian social conscience. Likewise, the enjoyment of academic art is both an aspect of false consciousness and a subjection to cultural forms in which alienating or oppressive structures and processes are implicit. This claim that there is something both truer and freer in avant-garde practice has been very widely repeated, and continues to be found in the work of T. J. Clark and Charles Harrison, among others.[6]

Of course, not all supporters of the avant-garde adopt a quasi-Marxist, or even leftist political position. Indeed Greenberg himself abandoned this argument in later essays. Nevertheless, critics consistently use 'academic' as a value judgement, and commonly claim that its failings are connected to 'bourgeois' taste. In their writings on the subject Clive Bell and Roger Fry explain the shortcomings of Victorian artists such as W. P. Frith and Luke Fildes when pointing out the distinction between these superficially successful figures and the work of true masters such as Cézanne. Many other art critics and historians have taken the equations 'academic = reactionary = bad' and 'avant-garde = radical = good' for granted in discussion of nineteenth-century art.

Even writers who have sought to take so-called academic art seriously have often interpreted it in the terms bequeathed by its critics. Albert Boime argued in 1971 that it was no longer useful to 'view the development of French art as a sequence of dramatic conflicts between innovatory "heroes" and academic "villains".'[7] Nevertheless his own book on Thomas Couture consistently associates the artist with Louis Philippe's regime, connecting the judgement of taste by which Couture has been designated a 'pompier' painter with the compromised politics ascribed to the July Monarchy. Much the same mythic communion between aesthetic and political failure is sought in his comments on Ford Madox Brown's *Work*.[8] Equally, Michael Marrinan's recent article on Horace Vernet, repeats Greenberg's criticism that Vernet's paintings are 'illustrative' propaganda, invoking semiotics to argue that this is their very aspiration.[9] Many commentaries on Victorian art, including those of Lynda Nead and Griselda Pollock, construe Victorian exhibits at the RA as illustrated ideology, taking 'ideology' in its neo-Marxist sense as systematic and narcissistic misconstruction of social relations, one which claims 'common sense' transparency and totality for itself. Nead opines that 'the Royal Academy painting works to negotiate and displace contradictions around class and social respectability, it offers the viewer a complete and seamless affirmation of middle-class moral values'.[10] Here academicism is unambiguously identified with the Ideological State Apparatus.

There are some obvious difficulties with this particular judgement. How do we identify 'the Royal Academy painting'? Does this imply every painting exhibited at

the RA, those which seem to endorse 'bourgeois' social values, or those which are not avant-garde in style? Here open claims regarding taste are repressed in a critical text which, following Althusser, professes an affectless condition of 'theory'. Of course, despite the obvious political and ideological functions of many critically admired pre-nineteenth-century paintings – such as the Sistine Chapel ceiling – theories of false consciousness are rarely, if ever, applied to them. This implies that taste operates in the unconscious of cultural theory. When Nead attacks 'the Royal Academy painting' she is creating a chimera. The aesthetic nullity to which she in fact refers, she cannot acknowledge as a problem. Here academicism is a concept which works to *conceal* the conditions for judgements, even as its claims expose ideological mystification. The questions, then, are these: how, or why, did academic art become 'bad' art? Was is necessary that it should do so? What is the logic – both aesthetic and historical – of this judgement?

Academicisms: high art and kitsch art

At this point it is useful, I think, to note some further problems with the critical Manichaeism of the avant-garde/academic split. The first concerns the scope of the concept itself, which, as we have seen, is worryingly amorphous. If we look back beyond the nineteenth-century, we can find references to an 'academicism' which appears to have a more distinct identity. One of the earliest unambiguous attacks on the academic in art came in 1745, when William Hogarth organised an auction of his paintings. The ticket for the auction, labelled *The Battle of the Pictures* (figure 1), was an engraving depicting a 'battle' between Hogarth's own modern-moral paintings and a series of mechanically produced works on classical and religious subjects. In the print, these forces are lined up in ranks, led by several stereotypical examples of high art. A painting of *The Rape of Europa* is followed by a rigid line of identical images, each marked 'ditto'. Nearby is a line of *Flayings of Marsyas*. All are arranged like troops on a battlefield. Beyond, individual paintings fight it out in aerial combat, slashing at one another's canvases with their frames. Thus, a penitent Magdalene slices into one of the scenes from Hogarth's *Harlot's Progress*, while Hogarth's own amoral anti-heroine attempts to resist submission to the Magdalene's insistent rhetoric of repentance.

Here, then, Hogarth proclaims his modernity against ruthlessly organised and disciplined lines of 'official art', which are implicitly associated with the powers of Absolutism and Catholicism, from which economically dynamic Britain has successfully freed itself. Hogarth's pictorial combatants have been liberated by the energies of the market place to roam free and occupy new realms of social and aesthetic experience. His opponents are associated with the values of the French Academy, implying an art based on rigorous training in approved subjects and style. This rigour is metaphorically linked to military drilling and to its vicious consequences; the relentlessly repeated subjects of flaying and rape suggest both war's atrocities and the arbitrary violence of despotism.[11]

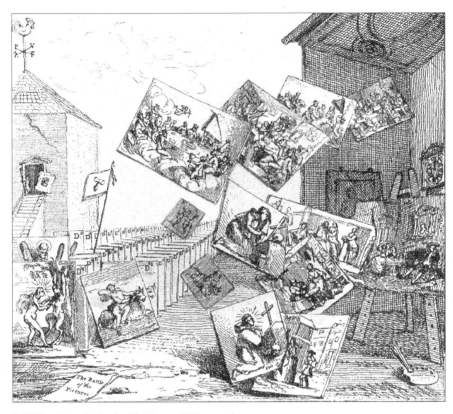

1 William Hogarth, *Battle of the Pictures*, 1745, engraving.

Hogarth's claim on modernity initiates a line of assault on such academic values which continues with Hazlitt, whose attacks on Reynolds were allied to a defence of Hogarth's naturalism, and a fascination with the spectacular diversity of the modern city. The argument finds its most famous expression in Baudelaire's essay *The Painter of Modern Life* (1863), generally interpreted as a prophecy of the avant-garde practices of Manet and the Impressionists. However, Hogarth's status as progenitor of this anti-academic position is rarely acknowledged. As recently as 1996, Andrew Graham-Dixon proclaimed him a vulgar painter, whose 'vicious, dark, world-hating art' is merely 'literary'. Hogarth's vulgarity is evident in his 'disastrous' experiments with 'the higher reaches of art', by which Graham-Dixon means history painting.[12] Much the same criticism was, of course, made of Manet by his contemporary detractors, such as P. G. Hamerton, who dismissed his 'vulgar' and 'indecent' realism as evidence of his nihilism.[13] Hamerton went on to argue that Goya, the hero of Manet and the French avant-garde, was a morally degenerate low-life figure, 'full of scorn and incontinent of hatred ... a born hater and despiser' whose paintings display 'foulness of colour and brutality of style'.[14] In other words, his is a 'vicious, dark, world-hating art'.

However, such views are only repeated today as purely historical perceptions of Manet's and Goya's work, and are associated with the defence of an obsolete academic tradition against the avant-garde.

What is notable here is that Hogarth is excluded from 'avant-garde' identity. He is judged with reference to the very academicism he rejected, but Goya and Manet are customarily lauded as heroic opponents of the academic. Graham-Dixon invokes 'high art', a concept closely associated with academic claims to represent values which transcend the crude, commercial, vulgar realm with which he associates Hogarth. However, Hamerton's very similar arguments against Goya, whose graphic satirical grotesque is obviously comparable to Hogarth's, are now only intelligible as moralistic and reactionary. By the nineteenth-century, it is academicism itself which is understood to have become 'vulgar'. The relentless ranks of aesthetic Absolutism resisted by Hogarth's heroic individualists have been transformed into the kitsch products of the production line, their opponents have been lifted out of the 'foul' gutter into which Hamerton wished to place them, and now occupy the territory of high art. While Hogarth identifies the market as a liberating force, critics of nineteenth-century 'academicism' seek to ally it with the very mercantile values Hogarth invoked against the Academy.

This is surely the key to the inconsistencies noted above, and to the exclusion of Hogarth from 'avant-garde' identity. But it also draws attention to the central contradiction in twentieth-century accounts of academic art. The 'authoritarian' version of the academic which Hogarth attacks continues to overlap with the 'kitsch' account. Hogarth had referred to the French Academy, which was strongly associated with Classical values and prescriptions derived from its founder, Charles Le Brun. Le Brun's codification of gestures and facial expressions epitomised the incorporation of visual art into the rationalising, rule-based French intellectual culture devoted to Aristotelian formal 'unities'. In art the justification of such an approach is to be found in the Roman High Renaissance, to which the founders of this particular 'academicism' consistently deferred. This is, of course, Graham-Dixon's 'high art'. The Victorian paintings discussed by Nead are largely inconsistent with this usage, as are many of the names on Greenberg's list. This academicism codifies artistic practice in a hierarchy in which 'history painting' is considered the highest genre of art and in which Greco-Roman (Classical) models are recommended. This definition identifies a continuum from the conceptual to the material, according to which visual documentation (epitomised by still life) is accorded a low status. It is construed as the apotheosis of inarticulate materiality, betraying an absorption in localised detail and exercise of manual skill. In contrast, the Classical tradition is claimed to provide models of physical and formal perfection in which the act of representation is intellectually articulated.

This Classical high art does not, by any means, imply bad taste. Its exponents include Poussin, Reynolds and David. It sets the Ideal against the Real, and is organised through the concept of Rhetoric. It depends upon the assumption that

the components of artistic practice – both formal and representational – are subject
to analysis, and that such analysis uncovers structuring principles which should
guide the artist. These principles are directed towards the articulation of ideal
forms: those most appropriate to their intended function. These are abstracted
from material conditions, which are seen as incarnations, or instances, of such gen-
eral forms. Such high art seeks analogy with philosophy, an analogy often claimed
by academic theorists. It is no coincidence that Raphael's *School of Athens*,
depicting philosophical debate, is widely presented as the fount of such
Academicism. Raphael is proffered as the artist who most clearly and fully inte-
grates his understanding of pictorial form (relations of colour, interval, space) with
the requirements of representation, guided by the principle of beauty. In this
respect, pictorially formal 'grace' is synthesised with that embodied in represented
forms and figures (pose, expression, gesture) and with their analysis into classifi-
able and legible types. In the words of Ingres, Raphael's paintings represent an
ideal, because they 'say what they propose to say'.[15]

It is important to note this usage, because the Modernist discourse discussed
above closely connects the terms 'academic' and 'illustrative', as evidenced in
Salmon's distaste for Courtois's high finish and in the writings of many critics who
identify the academic with what are often termed 'literary' tendencies, by which is
meant a painting's reference to dramatic action suggestive of psychologically
engaging events. The painting which 'conjures up' a scene rather than explores its
own internal visual structures and effects is deemed literary or illustrative. This
judgement is explicit in Greenberg, and it provides the justification for his list of
names. Such 'formalist' criticism emerges with aestheticism, being most dogmati-
cally articulated by Whistler in the 1870s. It is repeated by Bell and Greenberg.
The conservative artist and critic C. E. Hallé, writing in 1909, lamented this same
connection, when attacking the Impressionists for mere 'juggling with pigment'.
This was, he thought, typical of 'latter-day art, and we are told, the only painting
nowadays permissible; any other is called academical and photographic'.[16] This
equation of the academic with visual documentation is evidenced in both the for-
malist critical tradition and the quasi-Marxist invocation of ideology (Nead's refer-
ence to 'seamless' images).

Here, then, is a problem. These two uses of the term academic are inconsistent,
but both are to be found in critical discourse, leading to the strange inversions evi-
denced in the differing commentaries on Hogarth and Manet. However, in discus-
sion of the nineteenth-century these two usages overlap. As the concept of an
avant-garde is invoked, both 'Raphaelite' and 'illustrative' forms of academicism
are set against it. The former refers to an intellectual and formal rigour which
rejects 'unacademic' methods of painting, those which are characterised as lacking
a theoretical understanding of the formal ordering of representation. Such paint-
ings are criticised for indiscriminate documentation, confusing or redundant visual
information, presented naively. This academicism is art as an educated practice, its
professors possessed of what Salmon calls 'general culture'. Courbet's Realism,

emphasising 'irrelevant' details, placing motifs in an apparently clumsy manner across the canvas, epitomises the assault on this position, proffering a self-consciously uneducated, mythically naive, act of depiction. Other responses to this academicism are comparable. The Pre-Raphaelites also courted naivety, but did so through both Realism and Medievalism, invoking the apparently unrestrained visual abundance and eccentricity of fifteenth-century painting against the High Renaissance. Baudelaire in *The Painter of Modern Life* proclaims an art of the fugitive, marginal and unresolved against the academic claim to abstract, codify and universalise. A particularly complex and ambivalent response is found in Manet's early works, which deploy Reynolds-like pastiche quotations from High Renaissance models, but also involve acts of pictorial abstraction and abbreviation which work against the academic principle of beauty, referring to the traditions of caricature and sketch. Manet turns academic methods against academic values.

How can this be resolved with the accusation that academicism is illustrative and literary? If it is Manet's very intellectual self-consciousness which leads Greenberg to claim that he is the first truly avant-garde artist, then he might reasonably be considered the heir of Reynolds and Le Brun. However, for Greenberg academicism is identified with kitsch because – he asserts – both are systems for producing pre-designated effects. Both function through the institutional imperatives of business, generating the most efficient responses to a defined and controllable set of requirements. Academic art is the bureaucratic form taken by the commodity within a cultural hierarchy. By concentrating on the formal procedures of painting Manet engages in an act of criticism. In this he follows Kant, the first philosopher to identify his task as the analysis of philosophy itself.

So here we have art allied to philosophy once more, its aesthetic and intellectual legitimacy defined by its ability to examine its own procedures. Kant rather than Aristotle or Plato is now the preferred model, but the logic of the reference to philosophy is unaltered. To illustrate his distinction between this 'literary' academicism and authentic art Greenberg takes the example of the Russian social-realist painter Ilya Repin, 'a leading exponent of academic kitsch'. He imagines the responses of a Russian peasant encountering a Repin painting at a village exhibition.[17] It is clear that, for Greenberg, such an encounter stands for the eruption into a pre-industrial culture of the quasi-magical capacities of industrial production, with its attendant complex techniques of manufacturing. The peasant, like Rousseau contemplating Courtois, encounters Repin's art as something 'impossibly' sophisticated and seductive. In this respect it is the equivalent to Marx's account of the commodity as an *alien* object, that which presents itself to the consumer as a spectacle. This argument is tied up with Greenberg's claim that, following Manet, it is the duty of modern art to investigate its own practices, to reveal its own internal workings as a means to demystify the experiences generated by commodity culture.

What is notable here is that Repin is no Classicist. The Itinerants, the group to which he belonged, sought to organise village exhibitions to bypass the social role

of the Academy. His art might be described as illustrative, but it is so in a fashion which functions in opposition to academic institutions and to the concept of high art. Here, then, is the problem. Greenberg's academicism is that which submits to the logic of the commodity, invading and deracinating pre-industrial cultures, translating inherited techniques into marketable effects, mirroring the liquidation of social relations forced by capitalism. How is this to be reconciled with the Renaissance Classical tradition and with the analytical techniques developed by Le Brun or Reynolds?

The two academicisms produce parallel Modernisms, which might be called the 'Baudelaireian' and the 'Greenbergian'. Baudelaire describes an avant-garde immersed in the processes and energies of modernisation. He writes of an art of the city, alert to new patterns of social interaction, to the arbitrary, multiple, dynamic condition of modernity. The myth of 'academicism' which is set against this is static, alienated, formal, institutionalised. It comes to be associated with a hide-bound, class-ridden, hierarchical conservatism which resists social change. Indeed Baudelaire implied a conflict between the aspiration to construct coherent forms and the need to mark the traces of the always-reforming objects of visual study. For Baudelaire, modernity was defined by the failure adequately to realise form, by entrapment in the trace. The bohemian myth of the authentic artist rejecting polite social convention to plunge into the maelstrom of life emerges from this image. Baudelaire quotes a story by Poe about a man who 'hurls himself into the throng' in pursuit of a glimpsed vision of beauty.[18] In the twentieth century a variant of this argument is evidenced in Walter Benjamin's famous essay *The Work of Art in the Age of Mechanical Reproduction* (1936), which celebrates technologies of reproduction, claiming that they liquidate the image, hurling into the throng a chaos of motifs to be appropriated and redeployed, thus breaking the enchantment of high art's mystical 'aura' of elevated nobility.

Against this may be set Greenberg's conception of an avant-garde which seeks to maintain a position of philosophical distance from the tide of commercial kitsch generated by modernisation and commodification, constantly threatening to over-whelm authentic culture and the critical consciousness it represents. Here modern art seeks by forms of abstraction a state of 'purity', contriving its own alienation from a corrupted wider culture. The myth of the academic which corresponds to this is of a bourgeois social system in which class hierarchy is allied to the logic of commerce. Academic art is organised for legibility; it conceals its own formal systems, and is thus ideological in both its methods and its content. Its superficial glamour resembles that of the manufactured commodity itself. Those who are enthralled by academic-kitsch culture are, it is implied, deceived in the same way as conservative workers and intellectuals who accept the legitimacy of bourgeois society.

To sum up, we have two sets of equations: academic = idealised rigidity (death), avant-garde = engaged dynamism (life). Or, alternatively: academic = illustrative/literary (ideology), avant-garde = formal/visual (authenticity). This double

usage would be relatively unimportant were it not for the fact that both of these inconsistent mythic equations are used interchangeably in critical discourse on nineteenth-century artists. Thus Peter and Linda Murray denounce Delaroche for painting 'melodramatic subjects' which indicate the 'decline of history painting into illustration which occurred during the nineteenth-century in England and Germany as well as France'. At the same time G. F. Watts is condemned as an exponent of 'High Art: a type of picture based on high-minded generalities or abstractions, expressed in idealised forms, and a striving for sublime feeling that results in a numbing divorce from reality, physical and intellectual'.[19]

What matters here is that the discursive *ritual* of cultural evaluation through which 'academic' functions as a negative concept remains unchanged. Both Watts and Delaroche epitomise the negation of art. This leads us to the fundamental problem with the use of the concept 'academic'. Why should the conservatism of the academies be associated with aesthetic failure, and why should artists deemed aesthetic failures (e.g. the Pre-Raphaelites and Repin) be identified as academic? It is important to note this because there is neither a logical nor an historical connection between conservatism and bad taste. Indeed the equivalent to the idea of the academic simply does not exist in the discussion of creative activity within other fields during this period. There is no such thing as 'academic' music or literature – both conservative and aesthetically impoverished – against which the work of a genuinely creative avant-garde is defined. This is not, of course, to deny that avant-garde tendencies have been identified at work in music and literature during the nineteenth-century, nor that some – mostly literary – figures (e.g. Hemans, Whittier, Longfellow) have been attacked as 'sentimental' or even 'kitsch' in a way comparable to criticism of some of the names on Greenberg's list. But such complaints have been relatively muted and they have not been consistently directed towards the whole body of non-avant-garde writers and musicians. While critical commentary on music during the nineteenth-century identifies Brahms as a conservative figure and Wagner as a radical, Brahms's conservatism has not consigned him to the status 'Academic composer', conferring critical contempt on him and his work.[20] Equally, writers such as Tennyson – conservative, publicly acclaimed and officially recognised in their lifetime – though suffering to some extent from attacks by Modernists like Pound and Eliot, have retained for the most part the high reputations they enjoyed in their own day.

Rethinking academicism

This oddity may lead us to question the ritual reference to the 'academic' described above. If we compare the reputation of Tennyson with that of Frederic Leighton – one of the names on Greenberg's list – we can see in more detail the ways in which the concept of academicism blocks understanding of nineteenth-century art. The status of these two figures was, during their lifetime, almost equivalent. Both received peerages for their work. Leighton became President of the Royal Academy, Tennyson

Poet Laureate. Both were noted for the consistently elevated tone of their productions and for supreme technical mastery and facility. By the mid-twentieth century, however, Leighton's reputation had all but disappeared. By 1970, the entry on Leighton in the *Encyclopaedia Britannica* is very short. It mentions only one painting, his early exhibit *Cimabue's Madonna* (1855), saying that it is characterised by a 'a cosmopolitan academic manner in which grandeur of scale and forms of Phidian and high Renaissance extraction are used to embody subject matter of an anecdotic and superficial nature'.[21] The same encyclopaedia's account of Tennyson is extensive. Its assessment of his achievement acknowledges twentieth-century doubts, echoing some of the language used to censure Leighton. The author condemns Tennyson's 'mellifluous versifying of shallow and confused thoughts'.[22] But he is certainly not dismissive. Tennyson's 'sometimes exquisite' but limited technique is, the author states, not to modern taste, but he balances words like 'sentimental' and 'mawkish' against others such as 'sensitive' and 'poignant'. He concludes that Tennyson's achievement is 'imperishable'. The wording of both articles changes during the 1970s and 1980s. As the intensity of the Modernist desire to pull down Victorian cultural monuments subsides, the assessment of Tennyson becomes more positive, but that of Leighton remains dismissive. The attack on *Cimabue's Madonna* is repeated unchanged in the 1986 and 1997 editions of the *Britannica*.[23]

What is notable here is that though Tennyson is attacked for much the same reasons as Leighton, his importance remains undisputed. Even more significantly he is criticised as a particular individual, not as a representative of an impersonal 'cosmopolitan academic manner'. Leighton disappears behind the label 'academic'. Tennyson remains a distinctive voice whose weaknesses, though historically located, are his own, and are part of a complex creative identity. Where the judgement of Leighton is absolute, that of Tennyson is equivocal. But the most important point to be made about these 'authoritative' encyclopaedia articles is that the criticism of Leighton is, unsurprisingly, fundamentally mythical in character. It presents an image of a Great Tradition brought low, of grandiose forms containing puny content. It implies that the substance of a once-legitimate academic culture has shrivelled away. But the argument makes little sense. It is difficult to see why the subject of *Cimabue's Madonna* is any more 'superficial' than that of many other works of art. The painting depicts Cimabue leading a procession transporting his newly completed *Madonna and Child* through the streets of Florence. Similar subjects from the lives of artists had been painted by Turner and Ingres among others. The theme can be traced back to the Renaissance, when Netherlandish artists painted many 'anecdotal' scenes of *St Luke Painting the Virgin*, in which St Luke appears as the first Christian painter. Scholars of the Renaissance have sometimes attributed profound significance to this subject, connecting it to theological debate during Iconoclastic controversies, for example.[24] Even when no specific theological meaning is attached to such paintings, the legitimacy of its domestic and anecdotal treatment is accepted. There is no reason why Leighton's theme – the relation of

pictorial convention to nature and tradition, and of the artist to the community – should not be taken seriously. Leighton, in fact, adapts and develops the original meaning of the *St Luke* subject: a modern artist's reference back to a 'purer' moment of devotional painting.[25]

Of course, a formalist such as Bell or Greenberg might object that the subject matter of the painting, to whatever intellectual complexities it refers, is irrelevant to its merit as art. However, it is precisely the fact that Leighton is criticised for the superficiality of his subject rather than the formal failings of his work that is interesting. Formalist criticism has never had the effect that the iconographical subtleties of a Michelangelo or a Vermeer have been ignored in the evaluation of their work. As in the case of the Netherlandish *St Luke* paintings, reference to cultural debates and iconographical complexity entrenches such images within the realm of the culturally serious. It is part of the ritual of art historical affirmation.

Leighton's supposed failures of content are the key here. Leighton himself, in fact, adopted a distinctly formalist position, in line with academic Classicism. He expressed a 'deep desire to leave behind me something in art … in which Form and Style, the highest attributes of Form, should be chiefly sought'.[26] He was, he claimed, relatively uninterested in the transient content of modern life, proclaimed as 'heroic' by Baudelaire. He argued that the Impressionists, trying to avoid 'conventionalism' by tracing fugitive moments, 'forget that it is the deep-sinking and not the fugitive impressions which are the best'.[27] Leighton believed his paintings to be structured according to formal principles which constituted their significance as art. Yet his work is not engaged on these grounds, despite the fact that the analysis of planes, light and boundary is central to it. Equally, Watts, another of Greenberg's 'literary' academics, is preoccupied by the tension between material excess, embodied in pigment, and the trans-material bodily ideal manifest in 'forms of Phidian and high Renaissance extraction'.[28] Of course this claim leads us back to our two academicisms.

Leighton and Watts are both academic in the older sense satirised by Hogarth, and yet both appear on Greenberg's list on the grounds that they are literary, using motifs for their cultural connotations rather than for their pictorial function (this is also his reason for including Symbolist painters). However, as we have seen, this judgement is founded on very little. Nevertheless, even if we accept Greenberg's argument as an *aesthetic* theory, like Bell's concept of 'significant form', it is difficult to see why this should coincidentally happen to include all later nineteenth-century art which is associated with conservative values, whether in its socio-political content or pictorial method.

This is not to deny that the phenomenon of the avant-garde is real and important, or that its emergence and persistence leads to serious questions about the cultural transformations witnessed in the nineteenth-century. But the attempt to equate stylistic and political radicalism is deeply problematic, as is the constant invocation of the endlessly adaptable concept of 'bourgeois' identity, values or taste. The valorisation of the avant-garde in visual art has entangled notions around

'anti-bourgeois' attitudes, stylistic innovation and the vindication of posterity (affirmation of authenticity). This leads to profoundly confused discussion of the complex cultural and social processes at work in nineteenth-century art. Most crucially, for us, the concept 'academic' refers to an identity which is, ultimately, *absent* and unknowable. It is always already false: alienated from its own aesthetic claims, nullified by the language which constitutes it. Hence the persistence of mythic and inconsistent commentaries.

One final quotation – from Paul Duro, writing in 1996 on the history of art academies. Duro attempts to reconcile the two forms of academicism I have described, arguing that before the nineteenth-century academies could claim aesthetic and institutional authority because of the prestige of history painting. With the expansion of the art market and the increasing importance of 'public opinion', the intellectual authority of high art collapsed:

> Artists no longer felt the need to demonstrate intimacy with the more recondite aspects of the Classical past, but attempted to meet the needs of a broader and less discriminating public by maintaining the outward appearance of history painting while quietly abandoning its intellectual endeavour. The result was the rise of narrative painting epitomised in the work of Paul Delaroche, Lean-Leon Gérôme and Sir David Wilkie in Britain.[29]

Duro draws on the familiar argument that academicism was corrupted by an undefined 'undiscriminating' public. It is not clear what these worthy 'recondite aspects of the classical past' may be, but it is difficult, however, to understand why such knowledge guarantees aesthetic worth, or why Gérôme's *Phryne* (1861), or Leighton's very 'recondite' *The Daphnephoria* (1876) possess less of it than earlier portrayals of classical themes. As for the argument about the tastelessness of the public, this was used by Michelangelo in the Renaissance to condemn the chaotic naturalism of Netherlandish art, just as John Evelyn later denigrated the 'clownish' vulgarity of Dutch painting. Even Hogarth satirised history painting in the 'ridiculous manner of Rembrandt'. In each case such attacks connected these shortcomings with bourgeois-mercantile cultures. Also, in each case, these aberrant modes of painting have since been granted aesthetic legitimacy.

What is necessary now is a dissolution of the academic/avant-garde split as it is currently used and understood: as a means to equate avant-garde identity with aesthetic legitimacy. This pattern has entrenched a new high/low hierarchy. Salmon's comments imply a claim to a 'real' cultural insight which is absent in both the academy and from Rousseau's own conscious judgements. Likewise, Greenberg's list of kitsch artists sets up a distinction between the culturally authentic and the inauthentic which simply replaces the old high/low distinction of the conceptual and the material. Such a distinction is, of course, allied to the theory of false consciousness invoked above, just as Salmon's and Greenberg's claims imply their positions as representatives of the intellectual vanguard (possessed of an 'authentic consciousness').

However, while the logic of the old hierarchy was intelligible – and indeed was constructed around the very idea of intelligibility – the new distinction is profoundly opaque. It depends on an elaborate series of specific judgements. Thus, for example, when Delacroix attacks the so-called academic artist Meissonier because his 'faithfulness in representation' is 'horrible', this view can be equated with the argument about 'illustration'. However, when he attacks Courbet in very similar language, lamenting the 'commonness and uselessness' of his figures, he can be criticised for accepting the idealising values of academic high art.[30] Likewise when Ruskin condemns Whistler for exhibiting sloppy, unfinished work, he is, like Rousseau, mistakenly assuming that 'photographic' finish is to be admired. However, when he denigrates Millais's later paintings in near-identical language, he is apparently right to attack such rapid-manufacture work which belongs to the realm of kitsch.

The problem is that there is an investment in the academic/avant-garde distinction from exponents of both connoisseurial traditions in art history and those associated with the social history of art. The former seek to sustain claims to cultural sophistication distinct from a 'low culture' realm, the latter to find a way in which the performance of social ideology, alienation and resistance can be figured in pictorial gestures. The problem here is not the distinction itself. Both concepts are probably necessary and certainly useful – though inevitably limiting, like most other commonly used historico-stylistic terms. The real difficulty is the insistence that the distinction marks an experience of taste. We need to look in detail at the full range of non-avant-garde practice, to consider its own pictorial strategies, its preoccupations with surface, structure, form. We need, at this time, a 'Greenbergian' account of academic art, one which resists the easy assimilation of academicism to the reading of ideology, or the airy, inconsistent, accusations of vulgarity and pomposity. There are many paintings dismissed as 'anecdotal and superficial' in which complex pictorial structures can be identified, in which the debate with forms of avant-garde identity does not simply take the form of rejection, but of attempts to renew pictorial practice. Thus, the anti-Pre-Raphaelite artist Henry O'Neil seeks, in his *The Last Moments of Raphael* (1866), to reconstruct a renewed pictorial logic for a 'Raphaelite' position; Leighton's denigrated *Cimabue's Madonna* articulates a naive visuality from the self-conscious position of 'academic' alienation from visual pleasure; Millais's ridiculed late paintings mark an often profoundly complex engagement with the relation between form and the liberation of painterly gesture. There are many such works waiting to be rescued from the enormous complacency and condescension of posterity.

Notes

1 C. Greenberg, *Collected Essays and Criticism, vol. 1: Peceptions and Judgements 1939–1944*, ed. J. O'Brian (London and Chicago, 1986), p. 27.

2 *Ibid.*, p. 12.

3 A. Salmon, *Henri Rousseau*, trans. Paul Colacicchi, 'Art and Colour' series (London, 1963), pp. 15–16.

4 The word 'pompier', meaning 'fireman', plays on the supposed banality of their portrayal of Classical subjects. The helmets of Greco-Roman heroes in such paintings were said to resemble those of Parisian firemen.

5 T. Carlyle, 'Signs of the times', *The Works of Thomas Carlyle*, ed. H. D. Trail (London, 1896–1901), vol. 27, p. 60. Carlyle's arguments are comparable to Blake's equation of Reynolds's work with the evils of rationalism.

6 These claims appear early in 'Avant-garde and kitsch', when Greenberg says that an anti-bourgeois, bohemian avant-garde was 'unconsciously' influenced by Marx. The argument seems to shift later when he asserts that the avant-garde is the art of the bourgeois elite, while kitsch/academicism is mass culture. This confusing pattern of class-identification is mirrored in many theorists. Clark attempts to resolve the problem in his essay 'Clement Greenberg's theory of art', in F. Frascina, ed., *Pollock and After: The Critical Debate* (London, 1985), pp. 47–64. Clark is, however, keen to retain Greenberg's belief that the 'bourgeois' art of the later nineteenth-century is 'ersatz' or 'pseudoart'. Harrison's commentaries written with Paul Wood form a classic collection of stereotypical judgements on the various figures covered: C. Harrison and P. Wood, eds, *Art in Theory, 1815–1900: An Anthology of Changing Ideas* (Oxford, 1998).

7 A. Boime, *The Academy and French Painting in the Nineteenth century* (London, 1971), p. vii.

8 A. Boime, *Thomas Couture and the Eclectic Vision* (New Haven and London, 1980); idem, 'Ford Madox Brown, Thomas Carlyle and Karl Marx: meaning and mystification of work in the nineteenth-century', *Arts Magazine* (August 1980), pp. 116–23. Boime considers Couture to be the model for 'modern official art': p. 29. Harrison and Wood refer to Boime's account of this 'juste milieu' art, repeating predictable sneering phrases about 'bourgeois eclecticism' 'got up in togas': Harrison and Wood, *Art in Theory*, p. 147.

9 M. Marrinan, 'Historical vision and the writing of history at Louis-Philippe's Versailles', in P. D. Chu and G. P. Weisberg, eds, *The Popularization of Images: Visual Culture Under the July Monarchy* (Princeton, 1994), pp. 113–43. Marrinan claims that there is no reason to assume that 'illustrative' should automatically function as a condemnation. Of course, he rightly implies a comparison with contemporary attacks on Manet as sketchy or incomplete. This has no more or less *a priori* validity as a criticism, as both positions assume that the mere naming of a feature is an act of evaluation.

10 L. Nead, 'The Magdalen in modern times: the mythology of the fallen woman in Pre-Raphaelite painting', *The Oxford Art Journal*, 7 (1985), p. 34. The passage appears at a crucial transition-point in the essay. Nead has discussed several implicitly 'standard' RA exhibits (i.e. those not identifiable as Pre-Raphaelite). She sums up with this assertion about 'the Royal Academy painting', then goes on to discuss two Pre-Raphaelite pictures. This structure implies a repressed distinction between conventional/academic painting and unconventional, potentially 'legitimate', art. It is never clear whether the Pre-Raphaelite works are or are not instances of 'Royal Academy painting'.

11 The engraving draws, of course, on the conventions of battle scenes, in which the rows of troops are depicted in stylised blocks and lines. The references to individual combat between isolated pictures is particularly characteristic of accounts of naval engagements, which were closely associated with imperial trade wars. The imagery of naval

trade appears in a number of Hogarth's prints and paintings. Carlyle may have had in mind *The Battle of the Pictures*, with its despotic/academic flayings and rapes, when he attacked the high art on display at the Dresden gallery, where 'you find Flayings of Bartholomew, Flayings of Marsyas, Rapes of the Sabines': *The Works of Carlyle*, vol. 5, p. 407.

12 A. Graham-Dixon, *A History of British Art* (London, 1996), p. 126. Graham-Dixon can always be relied upon to repeat conventional art-school connoisseurship, in this and many other judgements. His animus towards Hogarth is, however, extreme. For Graham-Dixon, Hogarth is a 'fundamentalist, tub thumping preacher', insisting on codification and 'judgement', given to endless 'repetitiveness' and hatred of pleasure. As elsewhere in the book, these views are asserted rather than argued: pp. 88–9. Hogarth's Victorian follower F. M. Brown is insulted in similar language. An interesting discussion of Brown's own fascination with the anarchic energies of the marketplace is found in Julie F. Codell's 'Ford Madox Brown, Carlyle, Macaulay, Bakhtin: the pratfalls and penultimates of history', *Art History*, 21, 3 (1998), pp. 324–66.

13 For this and other views see Harrison and Wood, *Art in Theory*, pp. 510–13. See also C. E. Hallé, for whom Manet was associated with crude, low culture. To prefer 'Manet to Mantegna' was like admiring 'a music hall ditty' more than Mozart: Hallé, *Notes from a Painter's Life* (London, 1909), p. 209.

14 P. H. Hamerton, 'Goya', in his *Portfolio Papers* (London, 1889), pp. 140 and 123.

15 D. Thompson, *Raphael, the Life and Legacy* (London, 1983), p. 136.

16 Hallé, *Notes from a Painter's Life*, p. 187.

17 Greenberg, *Collected Essays*, vol. 1, p. 14.

18 Harrison and Wood, *Art in Theory*, p. 495.

19 P. Murray and L. Murray, *Dictionary of Art and Artists* (Harmondsworth, 1976), pp. 107 and 441.

20 In fact Wagner has been more commonly the recipient of such attacks. Wagner's *Die Meistersinger* (1864) is seen as a hymn to bourgeois culture. His practice of 'infinite melody', enharmonic shifts and his use of the leitmotif has been subject to the Greenberg-like criticism that it is literary. For a detailed formalist-Marxist critique of Wagner see T. Adorno, *In Search of Wagner*, trans. R. Livingstone (London, 1981).

21 *Encyclopaedia Britannica*, 1970 edition, vol. 13, p. 993. *Collier's Encyclopaedia* is even more virulent. 'Leighton's subjects were chiefly drawn from ancient literature and life, usually involving chaste female nudes, and plentifully interspersed with trivial, senti-mental, even maudlin representations': vol. 14, p. 480. 'Female nudes' are actually very rare in Leighton's works. The *New English Encyclopaedia* is more measured, but also seems fixated on Leighton's few nudes, claiming that these 'tastefully undraped young ladies' painted with 'superb craftsmanship, no humour, and very little feeling' were mainly responsible for Leighton's success. Why a nude should possess 'humour' remains unclear: p. 3608.

22 *Encyclopaedia Britannica*, 1970 edition, vol. 21, p. 854.

23 There are stylistic changes. The word 'anecdotic' is changed to 'anecdotal' in 1986. Likewise, 'Phidian' is changed to 'Classical Greek': *Encyclopaedia Britannica*, 1986 edi-tion, p. 253. The 1997 CD-ROM and Internet edition repeats this version of the sen-tence. In 1977 the sentence, together with most of the text, had been dropped and only a very small entry remained. Leighton's tiny entry appears in the 'Micropaedia', while Tennyson remains in the 'Macropaedia'. In 1970 the article on Tennyson concludes

with a prediction that his reputation will continue to decline, and that he will finally be recognised as a relatively minor poet. By 1986 this prediction has disappeared.

24 See C. Olds, 'Jan Gossaert's *St. Luke Painting the Virgin*: a Renaissance artist's cultural literacy', *Journal of Aesthetic Education*, 24 (Spring 1990) p. 89–96. Rogier van der Weyden, whose *St Luke Painting the Virgin* is listed by the *Britannica* among his religious works, is praised for his 'crystalline vision' and 'profound religious emotion': vol. 23, p. 450.

25 I have discussed this point in more detail in my essay on Leighton in T. Barringer and E. Prettejohn, eds, *Frederic Leighton: Antiquity, Renaissance, Modernity* (New Haven and London, 1999).

26 J. Comyns Carr, *Some Eminent Victorians* (London, 1908), p. 97. The sentence is admittedly confusing, as it is unclear how form can be an attribute of form, or what exactly is meant by 'style'. The 's' after 'attribute' may be a mistake or mistranscription.

27 A. Gruetzner Robins, 'Leighton and British Impressionism: the academician and the avant-garde', *Apollo*, 2 (1996).

28 See C. Trodd, 'Turning back the grotesque: G. F. Watts, the matter of painting and the oblivion of art', in C. Trodd, P. Barlow and D. Amigoni, eds, *Victorian Culture and the Idea of the Grotesque* (Aldershot, 1999). Trodd describes Watts' need to 'register the primal in the body' while deferring to 'the Phidian tradition'.

29 P. Duro, 'Art institutions: academies, exhibitions, art training and museums', in S. West, ed., *Guide to Art* (London, 1996), p. 89.

30 Harrison and Wood, *Art in Theory*, p. 360.

Leighton: the aesthete as academic

Elizabeth Prettejohn

Sir Frederic Leighton, later Lord Leighton, President of the Royal Academy from 1878 until his death in 1896, can seem the quintessential academic artist, the seamless polish of his picture surfaces mirroring, and mirrored in, the flawless performance of his official duties. Leighton's institutional role and his painting style seem to confirm each other in an impenetrable closed circle, leaving no breach or gap open to critical enquiry. Victorian art critics frequently accused Leighton's paintings of seeming 'too perfect', of denying the 'inequalities' of human experience. The implication would seem to be that 'perfectness' (carefully distinguished, in criticism, from 'perfection') excluded the critic or viewer from engagement with the work.[1] The twentieth-century response to Leighton has followed suit, occasionally acknowledging his historical importance, but rarely finding his work relevant to wider issues in nineteenth-century art, culture or society.[2]

The most obvious method of rescuing Leighton from this interpretative stalemate is to stress his involvement with Aestheticism, well attested in Victorian art criticism. Yet this defence would leave intact the standard polarity between academic and avant-garde.[3] By playing down Leighton's academic allegiances in favour of his links to Aestheticism, ordinarily treated as Britain's closest approximation to a late nineteenth-century avant-garde, such a reinterpretation would merely shift Leighton's position closer to the virtuous avant-garde pole. The academic would remain in its conventional position as the negative standard against which we customarily pit largely unexamined aesthetic values such as originality, spontaneity, imaginative power and technical innovation.

Yet there is a certain congruity between the closed circle of academic 'perfectness' and Aestheticism's hermetic world of pure beauty. Moreover, negative characterisations of late nineteenth-century academicism, as observance of forms drained of whatever meaning they may once have held, correspond uncannily to positive characterisations of Aestheticism as privileging form over meaning.[4] In this essay I want to ask whether these affinities can offer a new starting point for exploring academic art, one that is not predetermined by notional opposition to an avant-garde or 'Modernist' aesthetic whose high cultural status has remained remarkably secure despite calls for 'revision'. I shall begin by surveying

contemporary responses to Leighton's academicism; this will show that the now-familiar connotations of the academic are not eternal, but emerged in particular historical circumstances. However, it is not enough to demonstrate the contingency of our notions of the academic. We must still ask whether the category of the academic can provide useful or interesting interpretations of nineteenth-century art. I shall argue that the academic, figured as a theoretical category whose contingencies are fully acknowledged, can open fresh perspectives on the aesthetic debates of the nineteenth century – particularly debates involving formalism and intentionality, central to Western aesthetics well before they were polarised into academic and avant-garde positions, and still contentious. We need not, then, 'rescue' Leighton from his own academic eminence. On the contrary: Leighton's academic position can help to rescue current art history from its recidivist bias toward Modernist aesthetics.

Leighton as 'academic': a brief history of usage

The 'French character' of Leighton's work attracted comment from the beginning of his English exhibiting career in 1855.[5] It was not, however, until 1864 that critics began to use the word 'academic' to describe this; perhaps it was the vast display of French painting at the International Exhibition, held in London in 1862, that equipped critics to associate Leighton's style specifically with that of 'academic' French art. The word could be applied, on occasion, to other English painters known to have studied in France, such as Edward Armitage and Edward John Poynter. Nonetheless, it was overwhelmingly associated with Leighton from its first appearances in the 1860s to D. S. MacColl's article of 1897, 'Academicism and Lord Leighton', perhaps the most thorough discussion in English art criticism of the notion of the 'academic'.[6]

Throughout this history, the word 'academic' represented the 'form' side of some kind of polarity between form and content, but the connotations of both sides of the polarity changed during the period. In the earliest usages, academic form was equated with the artist's scholarly learning, understood either as technical knowledge or as familiarity with the art of the past. It was opposed to 'nature', understood in a loosely Ruskinian sense as the faithful representation of objects or scenes in the 'real' world. For example, here is Joseph Beavington Atkinson, writing of Leighton in 1864: 'The knowledge he brings, the academic training he displays, no one can question. His learning, in fact, is almost in excess; his artistic tact and contrivance, indeed, usurp the place which unsophisticated nature might with advantage occupy.'[7] The connotations of the academic were inseparable from its foreignness, relative to a perceived English norm based on direct observation of nature without the intervention of scholarly learning. If Leighton demonstrated the technical adeptness and formal eclecticism of the French academic artist, John Everett Millais was often pitted against him as the quintessential English 'realist'.[8]

Within a month or two of the first references to Leighton's 'academic' manner, a more positive image of the academic appeared in the *Cornhill Magazine*: Matthew Arnold's essay 'The literary influence of academies'.[9] Although Arnold was concerned with academies of literature, his account of the academic was to prove influential beyond its immediate context, and helps to fill out the connotations of the more casual usages in art criticism. Like Leighton's critics, Arnold considered the notion as peculiarly French. However, he presented this as a potential corrective to the 'note of provinciality' he thought regrettable in English literature. Arnold subtly deflected the stock English objection, that the academic was authoritarian, by associating it instead with 'openness of mind and flexibility of intelligence', in Arnold's view the special virtues of the French. Setting standards in accordance with these qualities, the French Academy served as 'a sort of centre and rallying-point' for literary excellence, an 'intellectual metropolis' rhetorically opposed to English 'provinciality'.[10]

Arguably, Leighton's later policies as President of the Royal Academy were devoted to ridding it of its 'note of provinciality'.[11] As many scholars have noted, he strove to widen Academic membership to include artists he considered excellent even if their styles were quite opposed to his own (and therefore 'non-academic' in contemporary terms).[12] His ambition would seem to have been to make the Royal Academy a 'centre and rallying-point' for British art in the broadest sense, in line with Arnold's francophile model of the Academy. Leighton's presidential policies and his painting style were, then, congruent in the basic sense that both were broadly French in orientation.

But by the same token both were oppositional in England where, as MacColl later put it, 'Our Academy has been as little academic as such an institution could well be'.[13] Towards the end of Leighton's lifetime, art critics occasionally used the word 'academic' with reference to his role in the Royal Academy, but that usage never became dominant.[14] Indeed, his 'French' academic style seemed positively at odds with Royal Academy norms. It is not difficult to see Leighton's early work as refreshingly cosmopolitan, and indeed some contemporary critics did so. The stylistic qualities that some critics rebuked as 'academic' in Leighton's early work could be praised by others in the emerging terms of Aestheticism; what was regrettably 'un-English' in pejorative accounts could appear laudably cosmopolitan in favourable ones.[15] A picture such as *Odalisque* of 1862 (figure 2) participates in Aestheticism's revolt, ordinarily seen as progressive in the modern art-historical literature, against the narrative and moralising conventions of Victorian genre painting. The reciprocal curves of woman and swan are not only artfully disposed; they are 'academic' in the more precise sense of referring to a significant art-historical precedent, Leonardo's celebrated lost painting of *Leda and the Swan*.[16] Moreover, this 'scholarly' formal reference calls attention to the fact that the picture lacks an elevated classical subject like Leonardo's. The formal play of white on white, a demonstration of technical skill overtly in the French academic tradition, is not dissimilar to James McNeill Whistler's painting of the same date, *The White*

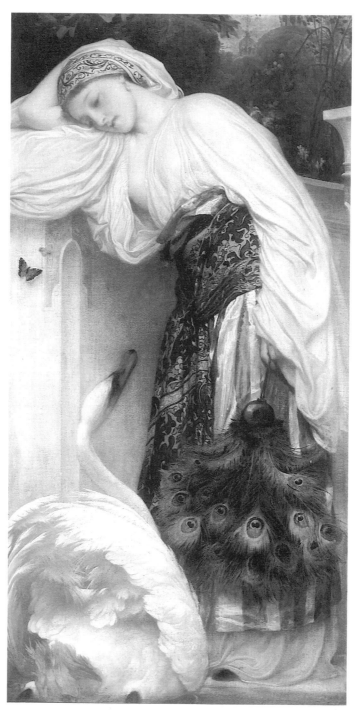

2 Frederic Leighton, *Odalisque*, 1862, oil on canvas, 90.8 × 45.7 cm.

Girl (National Gallery of Art, Washington, DC), ordinarily taken as a key work in the early history of Aestheticism.[17] Whistler's celebrated 'formalist' statement of 1862 about *The White Girl* – 'My painting simply represents a girl dressed in white standing in front of a white curtain'[18] – finds a parallel in W. M. Rossetti's account of Leighton's work, the next year: 'the art of luxurious exquisiteness; beauty, for beauty's sake; colour, light, form, choice details, for their own sake, or for beauty's'.[19] Leighton was the first artist to be identified, in English criticism, with the slogan 'art for art's sake'.[20]

In the criticism of Leighton's early work the terminology of academicism was virtually interchangeable with that of Aestheticism; the formal features seen as 'scholarly' or 'artificial' in negative accounts became the 'purely artistic' in more favourable ones. But a shift in critical criteria became evident towards the end of the 1870s.[21] Where earlier critics had opposed academic form to 'nature', later accounts stressed a deficiency of 'expressive' content. The new criterion is conspicuous in the reviews of Leighton's *Elijah in the Wilderness* (figure 3), exhibited at the Paris Exposition Universelle in 1878 and at the Royal Academy the next year; the work was seen as a major statement by the painter at the very moment when he was elected President of the Royal Academy. Several critics singled out the picture as representing either Leighton's most academic manner, or the most academic product of the English school.[22] But this repelled many English critics; with remarkable unanimity they saw its academic excellence as entailing a loss of expressiveness. Such works, wrote F. G. Stephens (a personal friend and ordinarily a supporter of Leighton's), 'are the work of a consummate master; they compel our admiration, but they do not sway our hearts'.[23] Harry Quilter of the *Spectator* used remarkably similar language: '[*Elijah*] is a picture of an artist whose hand is trained; whose mind is cultivated; and whose heart is dead or dormant. All that an Academy can teach is exemplified in this work. Everything which is beyond the reach of Academic precept is sought for here in vain.'[24] This pejorative usage of the word 'academic' is still so familiar that its late emergence, in English criticism, must be stressed. It might be called a 'decadent turn' in the connotations of the academic, exaggerating the traditional emphasis on form to claim that this was necessarily at the expense of deeper emotional or spiritual meaning – that 'academic' form had become vacuous, playing out a decadent afterlife after its expressive *raison d'être* had departed from it.

By this date English critics had a new point of reference, again a French one, for the notion of the academic; from this point onward, the stock comparison was between Leighton and Bouguereau, who seems to have come to the attention of English critics at the Exposition Universelle of 1878.[25] The next year, Quilter reviewed the French Salon and the English Royal Academy together in the *Cornhill*. In response to Bouguereau's *Birth of Venus* at the Salon (figure 4), he wrote:

> The whole is painted with a smooth perfection of finish that no English painter can rival, unless it be Sir F. Leighton in his best moments ... The composition throughout is of an intensely academical character, carried out with a skill to which

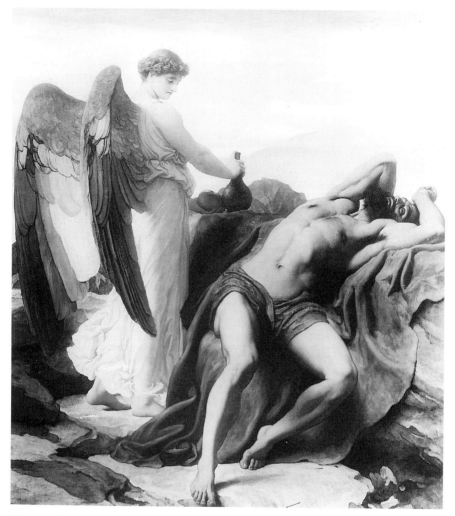

3 Frederic Leighton, *Elijah in the Wilderness*, 1878, oil on canvas, 235 × 210.2 cm.

we have, as far as I know, no parallel in England; but the effect of this arrangement
is rather to draw the attention of the spectator to itself than to heighten the interest
of the picture … The feeling of the scene has not been grasped, and the best proof of
this is that it is with extreme difficulty that we can turn our eyes from the beauty
of the painting to the consideration of the subject. We keep returning, in spite
of ourselves, to the artist's ability, to the beautiful balance of parts, to the
exquisite arrangements of line, to the manner in which every detail leads the eye to
the principal figure.

Predictably, Quilter goes on to compare Bouguereau's 'academical' picture to
Leighton's *Elijah in the Wilderness*, repeating his points more waspishly for the
English artist's work:

Whatever praise is due to this picture ... is due to the solution of the problems of drawing the naked figure in such a very difficult attitude, and arranging it so as to give a fine combination of lines. There is no success, probably no desire of success, in depicting the spirit of the scene, or inspiring the beholder with any emotion in regard to it. The prophet is not a famished Hebrew, but an athlete rather out of condition ... In so far as sentiment and feeling go, the picture is a *tabula rasa*; in so far as skilful drawing and composition are sought for, it is a work of great merit.[26]

It is notable that, at this point, Quilter has no doubt about the excellence or 'beauty' of academic form in itself; his reservations are solely about its obtrusiveness relative to the picture's content. However, the rising prestige of 'Impressionist' styles and spontaneous brushwork, in the 1880s, began to affect the 'form' side of the form-content dichotomy; now academic form seemed not merely unmotivated by its expressive content but visually unappealing because it was excessively calculated. Critics had long been aware of Leighton's 'academic' working procedure, elaborating the work through a methodical and painstaking sequence of steps. As early as 1872 a critic referred to Leighton's 'scholastic and academic manner', observing that 'The clue to his success, and perhaps also the secret of his shortcomings, is that he paints up to an idea, and that, the conception once settled, the sequence is carried out with relentless logic.'[27]

Emily Pattison, the author of a monograph on Leighton published in 1882, was the first to describe Leighton's working procedure in detail; she presented Leighton's methods as more sophisticated and cosmopolitan than ordinary English practices.[28] But by the later 1880s some writers began to use Leighton's working procedure as a conservative sign of his integrity, in specific opposition to the 'slap-dash' of 'Impressionist' execution. From 1889 the *Magazine of Art*, under the editorship of Marion Henry Spielmann, took the lead in this campaign, publishing lengthy accounts of Leighton's working procedure and reproducing his careful preliminary drawings.[29] From then on a detailed account of working procedure was a conspicuous feature of articles and monographs on Leighton, published in increasing numbers at the end of his life. Favourable critics took care not to use the word 'academic', tainted by its pejorative connotations, but in their accounts the working procedure is identical to that of French academic artists; in 1895 F. G. Stephens explicitly compared Leighton's working procedure to those of Gérôme and Bouguereau.[30]

Accordingly, Leighton's press image shifted with the new critical alignments of the late 1880s and beyond; earlier critics favourable to Aestheticism could present his attention to form as progressive, but later responses recast his style as conservative and increasingly equated this with the word 'academic'. The most detailed exploration of Leighton's academicism is the article by D. S. MacColl, published in response to Leighton's memorial exhibition of 1897. MacColl's approach is sophisticated but utterly damning; in the first sentence he introduces the word 'academic' as synonymous with 'uninspired'. He takes for granted the empty formalism of the academic: 'it is small wonder if the academic lesson is neglected save

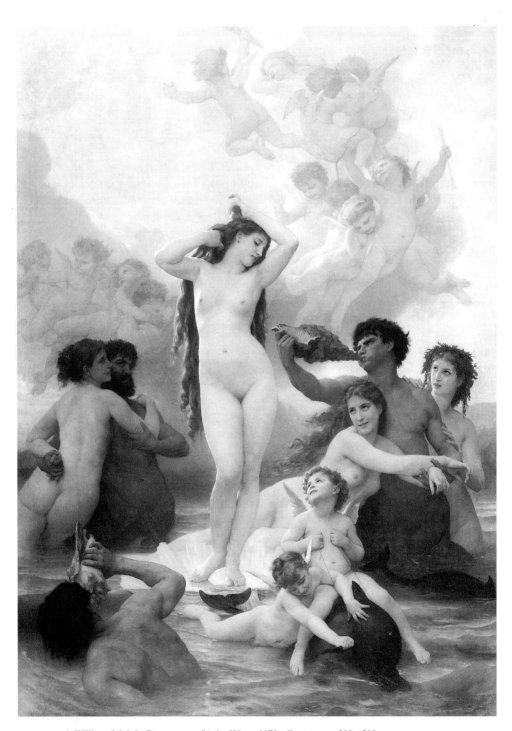

4 William-Adolphe Bouguereau, *Birth of Venus*, 1879, oil on canvas, 300×218 cm.

by the schoolmaster minds, minds alive to the formal side of an art, but devoid of the impulse of feeling'. At the same time he castigates the academic painter's calculated approach to his work: 'the taste which leads a man before another's picture to say, That is what I should like to paint, and that persuades him to plot out his picture with a kindred intention', instead of the inspiration 'that intrudes itself unbidden with the execution'. In MacColl's article we can see the distinctive Modernist division between avant-garde heroes and academic villains beginning to emerge. He praises Degas, Puvis de Chavannes, Alphonse Legros and Millet for transcending their French academic training, but classes Leighton with Bouguereau and Cabanel as vulgarisers of the tradition of Ingres: 'the idea of these men was to seize on any pretext to be found within the "classic" canon for prettiness, to sugar the academic study so that it might become a popular middle-class recreation'.[31] Here the decadent turn reaches an extreme, where the academic is degraded not only relative to kinds of contemporary painting presented as more vital, but relative to its own past history.

MacColl's opinions about the academic are so close to the evaluations that have prevailed during the twentieth century that his judgement on Leighton has a deceptive ring of authority. The responses to Leighton's art, in criticism of the retrospective exhibition of his work held at the Royal Academy in 1996, use vocabulary startlingly similar to MacColl's or, indeed, Quilter's. The charge of empty formalism is insistent: 'because [Leighton's] ambition was backed up by so little in the way of emotional or intellectual compulsion, the result was an art large in scale but minute in feeling and conception'; phrases like 'resplendent moral and emotional vacuity' or 'empty pomp' occur in most of the reviews.[32] Moreover, the critics of 1996 also stress Leighton's excessive intentionality: 'His paintings are predetermined to death.'[33] The most damning criticisms take the 'decadent turn' relative to both content and form: 'Most of Leighton's pictures are the negation of art: devoid of emotion, pompous in subject, and physically repulsive.'[34]

Leighton's reputation in more serious art history has scarcely fared better. Yet the foregoing history of usage suggests that the decadent connotations of his academicism were constructed by criticism rather than 'documented' in it. What is singular about this history is not the shifting meanings of the academic during Leighton's lifetime, but their ossification at the end of the nineteenth century. We might even argue that it is our usage of the category 'academic' that is irredeemably conservative, rather than the works it purports to describe. Yet that observation raises more questions than it answers. If the category's interpretative potential reached a state of virtual inertia more than a century ago, why has it remained a crucial point of reference for most of the twentieth century? It is all too easy to see how the academic myths of empty formalism and excessive intentionality can act as negative counterimages to the Modernist myths of 'significant form' and spontaneity. The persistent denigration of the academic might be explained as a desperate attempt to bolster the 'virtuous' versions of the myths by degrading their 'vicious' doubles.[35] Yet to define the characteristics of the academic as negative versions of

those of Modernism is historically irrational; worse still, it is conceptually reductive. Both academicism and what would come to be called Modernism participated in wider debates central to Western aesthetics, such as the relation between form and content and the nature of artistic intentionality. It is important to recover the academic positions in these debates, not simply to 'correct' the historical record, but to widen the possibilities available to our own thinking.

Formalism

As we have seen, the earliest usages of the word 'academic', in the criticism of Leighton's work, already presuppose the conceptual division between form and content basic to Western aesthetics at least since its notional definition as a distinct discipline in the eighteenth century; indeed, the academic would seem to have been a crucial category for theorising the 'form' side of the division. The qualities Matthew Arnold associates with the academic in 1864 are all biased towards form. Having established 'openness of mind and flexibility of intelligence' as primary characteristics of the French spirit, he elaborates their effects on literature: 'The form, the method of evolution, the precision, the proportions, the relations of the parts to the whole, in an intellectual work, depend mainly upon them.'[36] Arnold opposes these qualities to the 'chief spiritual characteristics' of the English, 'energy and honesty', closely associated in turn with 'genius'. Arnold's antithesis draws at least informally on a key point in Kantian aesthetics: the academic relates to the process by which the raw inspiration of genius is formally organised so that it becomes a work of art. In Kant's formulation, 'Genius can only furnish rich *material* for products of beautiful art; its execution and its *form* require talent cultivated in the schools'.[37]

The habit of polarising form and content has come under attack, notably in Heidegger's *The Origin of the Work of Art* (1935–36):

> The distinction of matter and form is *the conceptual scheme which is used, in the greatest variety of ways, quite generally for all art theory and aesthetics … Moreover, the range of application of this pair of concepts has long extended far beyond the field of aesthetics …* Form and content are the most hackneyed concepts under which anything and everything may be subsumed. And if form is correlated with the rational and matter with the irrational; if the rational is taken to be the logical and the irrational the alogical; if in addition the subject-object relation is coupled with the conceptual pair form-matter; then representation has at its command a conceptual machinery that nothing is capable of withstanding.[38]

This hints at the range of ramifications, which easily extend to the ideological and political realms, that the form-content division might authorise. As a corollary we might observe that the division has ordinarily been used, in art history and criticism as well as aesthetic theory, to propose some sort of reconciliation between form and content as normative. The late nineteenth-century condemnation of the

academic presented it as a deviation from the normative equilibrium, where form becomes excessive relative to content. The kinds of ideological entailments hinted in Heidegger's comments readily followed, as 'empty' form came to seem both politically conservative, through its subservience to the authority of past teaching, and morally reprehensible, as it ceased to express significant meaning. By contrast the Modernist notion of 'significant form' can imply that meaning has been absorbed into form, somewhat along the lines proposed in Schiller's letters, *On the Aesthetic Education of Man*:

> In a truly successful work of art the contents should effect nothing, the form every-thing; for only through the form is the whole man affected, through the subject-matter, by contrast, only one or other of his functions … Herein, then, resides the real secret of the master in any art: *that he can make his form consume his material* …[39]

The moral rectitude of an art that unites form and content is obvious in the evoca-tion of the well-balanced personality, and Schiller also stresses its political progres-siveness, as a free aesthetic that is the germ of political emancipation. This is a glorious vision where the union of form and content in art entails both personal fulfilment and the good of society; little wonder that some such union seemed so compelling at the beginning of the twentieth century.

Yet the Modernist dream is only one way of resolving a form-content division that can encompass 'anything and everything'; Heidegger's criticism might be turned on its head. We must be careful not to reify the terms that might indeed be totalising if they categorised a fixed 'reality', but prove exceptionally flexible, if not unstable, in critical usage. Even in the foregoing history of just thirty years of English criticism, the connotations of both sides of the division were constantly shifting: 'form' could refer to technique or craftsmanship, to eclectic borrowings from the art of the past, to compositional evidence of the artist's intellect, or to traces in the brushwork of the artist's inspiration; 'content' could refer to subject-matter, to the faithful imitation of 'nature', to emotional expressiveness, or to some notion of spiritual depth. The distinction between 'empty form' as drained of con-tent and 'significant form' as somehow resonant with content is mere mystification, except within a debate where the terms of the opposition, form *versus* content, are at issue.

One important aspect of the distinction must be the notion of 'originality', the most redoubtable of Modernist myths.[40] Academic form is defined as empty because its 'original' meaning has gradually lapsed, as the forms have been passed from teacher to pupil through the academic succession of generations. As MacColl put it:

> the schoolmaster would be mistaken who dreamed that any short of the mightiest blasts of the spirit could animate or revivify the public form of a Phidias, a Donatello, or a Michael Angelo, or that in untoward times and in pettier hands emulation of such art could produce anything but hollow and stupid formality.[41]

However, the second of Leighton's Presidential Addresses to the Royal Academy, delivered in 1881, presents the opposite case; for Leighton forms accumulate associative meaning as they are passed through history. 'Form, Colour, and the contrasts of Light and Shade' are the basic elements of the painter's art, 'which can be communicated only through the sense of sight'. However, 'they are inseparably connected by association of ideas, with a range of perceptions and feelings of infinite variety and scope. They come fraught with dim complex memories of all the ever-shifting spectacle of inanimate Creation, and of the more deeply stirring phenomena of Life'.[42] This is reminiscent of Schiller's notion of a form in which content is consumed, but in Leighton's explanation it is not the individual 'master' that imbues the form with its content. Instead it is the past history of the form:

> You will find, for instance, that, through this operation of Association, lines and forms and combinations of lines and forms, colours and combinations of colours have acquired a distinct expressional significance, and, so to speak, an *ethos* of their own, and will convey, in the one province, notions of strength, of repose, of solidity, of flowing motion and of life, in the other sensations of joy or of sadness, of heat or of cold, of languor or of health.[43]

In the wider context of Leighton's *Addresses*, the source of the 'associations' is partly a notion of the universal history of the human race, but more precisely the history of art. The formal eclecticism for which critics had so often taken Leighton to task might, on this interpretation, amount to a method of realising a unity of form and content akin to Schiller's. Perhaps there is also an echo of Walter Pater's notion of tradition, elaborated in his essay of 1867 on 'Winckelmann':

> The supreme artistic products of succeeding generations thus form a series of elevated points, taking each from each the reflection of a strange light, the source of which is not in the atmosphere around and above them, but in a stage of society remote from ours.[44]

Odalisque might be interpreted as an early experiment in such a unity of form and content. Its forms combine the associations of the Leonardesque prototype with those of modern Orientalism to convey the erotic in formal terms, without relying on the kind of romantic narrative usual in Victorian genre painting. As seen above, the purgation of narrative and moralising subject-matter, in early works of this kind, can seem a 'progressive' assertion of form over what has often been stigmatised as excessive content in Victorian narrative painting. But the procedure is extended rather than curtailed in later works such as *Elijah in the Wilderness*, where the formal references are more complex. Where Quilter saw merely a 'difficult attitude', an arrogant flaunting of technical prowess, some recent scholars have found a deeply felt reinterpretation of the Michelangelesque male body. Stephen Jones has compared the disposition of Elijah's legs to the legs of Christ in the *Entombment*, attributed to Michelangelo, that entered the National Gallery in 1868.[45] This near-quotation is certainly 'academic' in the terms of Victorian criticism, but the

drawing of the legs is far from a dry exercise in anatomical idealisation. The calf muscle of Elijah's right leg, pronounced to the point of exaggeration, suggests extreme tension; the thigh is hollowed to indicate the saint's emaciation. The upper body has often been related to a different prototype, the celebrated ancient statue known as the Barberini Faun, a notoriously sensualised depiction of the male nude.[46] At first thought this might seem an obvious example of academic formalism, borrowing a pose whose 'original' connotations are positively inappropriate in the new context. However, Leighton manages to transform the meaning of the pose, narrowing the powerful chest and increasing the tension in the musculature to express the prophet's exhaustion after spiritual anguish, in place of the faun's drunken stupor. Perhaps Quilter's discomfort with the figure has a homophobic edge. The critic permits himself to enjoy the female nude in Bouguereau's *Birth of Venus*, 'on a rosy shell, in an attitude of languorous exhaustion, both arms raised to the rich masses of her chestnut hair'.[47] Elijah too has raised arms in what we may interpret as an eroticised pose; but this kind of investment in the nude male figure was evidently repellent to Quilter.

Perhaps this helps to make sense of Quilter's preference for Bouguereau's formalism over Leighton's. The critic argues that the academic style of the Bouguereau is acceptable in a romantic subject such as the birth of Venus, but inadmissible in the Scripture subject, 'where the human element is, or rather should be, distinctly the great thing in the composition', but is reduced 'to a nullity by the style'.[48] As in *Odalisque*, Leighton rejects the standard techniques of Victorian narrative painting for dramatising the 'human element'. The emotional content ordinarily indicated in facial expression and narrative interaction with other figures is transferred to the rugged musculature, complex pose and rich chiaroscuro of the prophet's body. The angel, radiant, pale and expressionless, serves as a formal and emotional foil to the figure of the prophet rather than an actor in a drama; what might have been a narrative scene is simplified to an emblematic contrast between the human and the heavenly. In fact Leighton omits the narrative interaction between Elijah and the angel in the Biblical source, I Kings 19:5: 'And as he lay and slept under a juniper tree, behold, then an angel touched him, and said unto him, Arise and eat.' The scene, however, corresponds to a crucial moment in Mendelssohn's oratorio, *Elijah*, first performed at the Birmingham Festival in 1846 and subsequently among the most revered of musical works in Victorian England; in the oratorio music of breathtaking calm succeeds Elijah's powerful expression of despair in the aria, 'It is enough'. In his earlier, more overtly aestheticist days, Leighton had certainly been interested in synaesthesia, and particularly the possibility of correspondence between musical and pictorial form. Here he was perhaps translating the impact of Mendelssohn's music into his own formal terms, centred on the depiction of the human body.

Both the form and the content of *Elijah in the Wilderness*, then, are the reverse of 'original'; they draw self-consciously on associations meaningful only because they are shared with other works of art. In Leighton's method, it is not the unique

creative individual who achieves the magic fusion of form and content, but an artistic collaboration that may cross boundaries of time, space and medium. The apparent anonymity of academic finish, dispensing for the most part with the conspicuous brushstroke that marks the individual's creative performance, is congruent with this collaborative approach; indeed Leighton never signed his pictures, apart from a few early essays.

We may criticise this 'academic' method of unifying content and form as elitist or Eurocentric; it depends on the spectator's familiarity with the traditions of Western art. But it is more concrete and traceable than the Modernist notion of an inspiration that, in MacColl's phrase, 'intrudes itself unbidden with the execution'. Moreover, it is unequivocally theorised as modern. Leighton's *Addresses* drew heavily on the Hegelian notion that the 'unconscious' production of earlier ages had become impossible for the modern artist: 'the questioning spirit is now abroad'.[49] Where an earlier artist might achieve an intuitive fusion of form and content, once the problem had been raised in aesthetic theory it could only be approached self-consciously. The modern artist, though, had at least the advantages that awareness of art's historicity could give. Academic eclecticism might be called the formal expression of that awareness, modern precisely because it takes historical forms and contents as its material. This was, of course, only one possible approach to the form-content division; but that of Modernism was only another.

Intentionality

In Matthew Arnold's account, the link between 'academic' style and the French Academy as an institution is no historical accident. The qualities of 'form, method, precision, proportions, arrangement' are precisely those, in a work of art, 'which are really most communicable from it, which can most be learned and adopted from it, which have, therefore, the greatest effect upon the intellectual performance of others'.[50] The teachability of the academic is clearly at odds with Modernist notions of originality. Moreover, it contradicts the most basic premise of Kantian and post-Kantian theory, that the purely aesthetic is not directed towards an end but exists in perfect freedom from determination; the potential political ramifications of this notion are obvious. Both Kant and Arnold used the term 'genius' to denote the kind of artistic talent that cannot be taught or learned. As Arnold put it:

> what that energy, which is the life of genius, above everything demands and insists upon, is freedom; entire independence of all authority, prescription, and routine, the fullest room to expand as it will. Therefore, a nation whose chief spiritual characteristic is energy, will not be very apt to set up, in intellectual matters, a fixed standard, an authority, like an academy.[51]

Kant's formulation is more complicated, but also more rigorous. If the purely aesthetic or 'free beauty' is to be exempt from means-end rationality, it cannot work

under the guidance of a rule or concept: 'Hence *originality* must be its first property.' Genius cannot, then, imitate the works of others: 'Now since learning is nothing but imitation, it follows that the greatest ability and teachableness (capacity) regarded *quâ* teachableness, cannot avail for genius.'[52] The academic, by virtue of its teachability, is thus inalterably opposed to the purely aesthetic.

As we have seen, Leighton's working procedure was 'academic' in the sense that it corresponded quite closely to the methods taught in French teaching studios, and employed by French academic artists. But it was also 'academic' in the sense that it organised work to lead to a predetermined end; it achieved its results in a systematic and potentially imitable way. As it was described in contemporary accounts, each of the many painstaking steps was devoted to achieving a finished project that would realise, in every detail, the first conception of the work in the 'mind's eye' of the artist.[53] Through it the initial inspiration was realised in the finished work without remainder; every jot and tittle of the first conception was carried through to the final work, and in principle nothing adventitious was added.

Even Leighton's apologists admitted that the working procedure lacked 'spontaneity'[54] – or we could return to Arnold's and Kant's term, 'genius'. In theory the element of 'genius' was embodied in the original conception in the 'mind's eye', but the intentionality of the rest of the procedure was, nonetheless, fundamentally at odds with the notion of the aesthetic as 'free beauty'. In a strict sense, then, academic working procedure was incompatible with the purely aesthetic. This, though, created a dilemma, reflected informally in Arnold's assertion that English 'genius' might not be sufficient to achieve excellence with the consistency and reliability that 'academic' methods might provide. In Kant a similar problem marks an intriguing gap in the theory:

> Although mechanical and beautiful art are very different, the first being a mere art of industry and learning and the second of genius, yet there is no beautiful art in which there is not a mechanical element that can be comprehended by rules and followed accordingly, and in which therefore there must be something *scholastic* [*Schulgerechtes*][55] as an essential condition. For ... some purpose must be conceived; otherwise we could not ascribe the product to art at all, and it would be a mere product of chance.[56]

Arguably, certain later art forms such as aleatory music or automatic writing responded to the implicit challenge to make a kind of art that dispensed with the academic element altogether. But in Kant's formulation the truly aesthetic work of art is unmakeable, since some kind of intentionality (hence something 'academic') is always involved, in the form either of a plan to make a work or simply of the technical competence, acquired scholastically, needed to carry it out.

According to the Hegelian scheme of Leighton's *Addresses*, artists in premodern periods might have been able to work 'unconsciously' or 'spontaneously'; indeed, Leighton repeats the word 'spontaneous' no less than three times on the

second page of his first *Address* (1879). But for the modern artist 'the critical intelligence stands by the imagination at her work, and Fancy no longer walks alone'.[57] There were (at least) two solutions to the dilemma of intentionality. One was to flaunt 'spontaneity' while suppressing the 'academic' as resolutely as possible, in broad terms the approach that would become associated with Modernism. This entailed a kind of deception, although it was one sanctioned by Kant himself:

> the purposiveness in the product of beautiful art, although it is designed, must not seem to be designed; *i.e.* beautiful art must *look* like nature, although we are conscious of it as art. But a product of art appears like nature when, although its agreement with the rules, according to which alone the product can become what it ought to be, is *punctiliously* observed, yet this is not *painfully* apparent; the form of the schools does not obtrude itself[58] – it shows no trace of the rule having been before the eyes of the artist and having fettered his mental powers.[59]

However, this strategy has the character of an expedient; the work of art can only masquerade more or less successfully as nature, since at some level it is always planned. An alternative approach might be to bring the academic element to the fore, to parade its intentionality. This would avoid deception, but it would also relinquish the work's claim to represent a 'free beauty' analogous to that of nature. Perhaps the enthusiasm for artifice in Victorian Aestheticism takes such a course, admitting and even avowing its fundamental difference from the 'free beauty' of nature in direct opposition to the 'realist' pretensions of either Pre-Raphaelitism or mid-Victorian genre painting. In that case the increasing emphasis on Leighton's working procedure, in the final two decades of the century, might be an extension of the aestheticist project, now in opposition to the 'spontaneity' of Impressionist styles. Both Aestheticism and late nineteenth-century academicism have been seen as escapist in their attempts to construct artistic beauty independently of real-world concerns. But those attempts represented engagement, on another level, with the problematic status of art in the post-Kantian world. It may be that our preference for 'spontaneity' is itself escapist, permitting us to evade the questions that aesthetic artificiality and academic predetermination raise about art's radical unreality.

Notes

I owe thanks to John House for introducing me to academic art and showing the way towards fresh interpretations; and to Charles Martindale for reading this paper more often and more intelligently than was reasonable.

1 See for example 'The Royal Academy exhibition', *Pall Mall Gazette* (21 May 1868), 10: 'the very perfectness of his style, which is not quite the same thing as perfection, seems to show a shrinking from the inevitable inequalities of nature itself ... we feel that we are being introduced not to the best aspects of this world, but into some strangely perfect region which only reminds us of this.' Cf. W. E. Henley, 'Current art', *Magazine of Art*, 8 (1885), p. 347.

2 Leighton plays a minor role in general works on nineteenth-century and Victorian art; the study of his work has been confined to monographs: L. and R. Ormond, *Lord Leighton* (New Haven and London, 1975); C. Newall, *The Art of Lord Leighton* (Oxford, 1990); Royal Academy of Arts, *Frederic Leighton 1830–1896*, exhibition catalogue (London, 1996); T. Barringer and E. Prettejohn, eds, *Frederic Leighton: Antiquity, Renaissance, Modernity* (New Haven and London, 1999).

3 Recent 'revisionist' attempts to rehabilitate the reputations of French academic artists have been criticised for similar reasons: see N. McWilliam, 'Limited revisions: academic art history confronts academic art', *Oxford Art Journal*, 12:2 (1989), pp. 71–86.

4 In historical terms such affinities are not surprising; it is only a loose equation of Aestheticism with the avant-garde that makes it appear opposed to academicism. Peter Bürger's theory of the avant-garde might suggest that Aestheticism and academicism should be characterised simply as alternative variants of a mature bourgeois art practice in which content evaporates as 'art becomes the content of art'. The literal institutionalisation of the academic is irrelevant in Bürger's theory, since it is art itself that constitutes the bourgeois institution regardless of its siting within or outside a formal Academy. The positive formalism of Aestheticism and the negative formalism of academicism are equally overt in their disengagement from the life praxis that the avant-garde of the twentieth century would later seek to reassert: see P. Bürger, *Theory of the Avant-Garde*, trans. M. Shaw (Manchester, 1984), p. 49.

5 F. G. Stephens, 'Royal Academy', *Athenaeum* (4 May 1861), p. 600; cf. W. M. Rossetti, 'The Royal Academy', *Spectator* (12 May 1855), p. 495. Leighton's continental training was highly unusual for an English artist at this period; he studied in Frankfurt (1846-52), then lived and worked in Rome (1852-55) and Paris (1855-58): see Royal Academy of Arts, *Frederic Leighton*, pp. 93–4.

6 'Academicism and Lord Leighton', *Saturday Review* (6 March 1897), p. 241 (signed D. S. M.).

7 'The London art-season', *Blackwood's Edinburgh Magazine*, 96 (July 1864), p. 87; cf. F. T. Palgrave, 'The Royal Academy of 1864', *Saturday Review* (14 May 1864), p. 593: 'academical, rather than natural, arrangement of the drapery'.

8 See for example 'The Royal Academy', *Art-Journal*, n.s. 13 (June 1874), pp. 165–6.

9 M. Arnold, 'The literary influence of academies', *Cornhill Magazine*, 10 (August 1864), pp. 154–72; reprinted in Arnold's *Essays in Criticism*, 1865 and later editions.

10 Arnold 'The literary influence of academies', pp. 157, 161, 163.

11 Leighton's detractors saw his Presidency as initiating a 'denationalisation' in British art; see G. D. Leslie, *The Inner Life of the Royal Academy* (London, 1914), pp. 53, 129, 136.

12 See A. Gruetzner Robins, 'Leighton: a promoter of the new painting', in Barringer and Prettejohn, *Frederic Leighton*, ch. 14, for Leighton's efforts to elect the 'Impressionist' George Clausen and the 'outsiders' Edward Burne-Jones and Albert Moore (unsuccessful in the case of Moore).

13 MacColl, 'Academicism and Lord Leighton', p. 241. George Moore's attack of 1892 on the Royal Academy borrowed Arnold's terms to criticise it for its difference from the French model: 'The hatred of artistic England for the Academy proceeds from the knowledge that the Academy is no true centre of art, but a mere commercial enterprise protected and subventioned by Government:' 'Our Academicians', reprinted in G. Moore, *Modern Painting* (London, 1898), p. 99.

14 See for example 'The Leighton exhibition', *Daily News* (2 January 1897), p. 6: 'It is the fashion to speak of Leighton as an ideal President; but ... one feels he would have been a greater master if the Academy had not taught him to be academic.' George Moore demurred, presenting Leighton's institutional role as irrelevant to his dedication to art: 'He loved the Academy as a lady loves her milliner; her milliner is essential to her worldly life, as the Academy was essential to Leighton's. He took much from the Academy, and gave very little; his heart, like the lady's, was elsewhere': G. Moore, 'Lord Leighton', *Cosmopolis*, 1:3 (March 1896), p. 715.

15 See E. Prettejohn, 'Morality versus aesthetics in critical interpretations of Frederic Leighton, 1855–75', *Burlington Magazine*, 138 (February 1996), pp. 79–86. For a general account of critical practices in the period see E. Prettejohn, 'Aesthetic value and the professionalisation of Victorian art criticism', *Journal of Victorian Culture*, 2:1 (1997), pp. 71–94.

16 Leonardo's *Leda and the Swan* was known through Renaissance copies, including one by Cesare da Sesto in the collection of the Earl of Pembroke at Wilton House. For its reputation see K. Clark, *The Nude: A Study of Ideal Art* (Harmondsworth, 1985; 1st pub. 1956), pp. 113–15.

17 See R. Spencer, 'Whistler's "The White Girl": painting, poetry and meaning', *Burlington Magazine*, 140 (May 1998), pp. 300–11 (the academic tradition of painting white on white is discussed on p. 308).

18 *Ibid.*, 1998, p. 300.

19 W. M. Rossetti, 'The Royal Academy exhibition', *Fraser's Magazine*, 67 (June 1863), p. 790.

20 T. Taylor, 'Among the pictures', *Gentleman's Magazine*, n.s. 1 (July 1868), p. 151.

21 For this shift see E. Prettejohn, 'Art and "materialism": English critical responses to Alma-Tadema 1865–1913', in Van Gogh Museum, Amsterdam, and Walker Art Gallery, Liverpool, *Sir Lawrence Alma-Tadema*, exhibition catalogue (Zwolle, 1996), pp. 104–7.

22 See for example P. G. Hamerton, 'Sir Frederick Leighton, P.R.A.', *Portfolio*, 10 (1879), p. 3.

23 'The International Exhibition', *Athenaeum* (11 May 1878), p. 609.

24 'The Royal Academy', *Spectator* (17 May 1879), p. 627.

25 The comparison was usually to Leighton's disadvantage; see for example E. W. Gosse, 'The Royal Academy in 1881', *Fortnightly Review*, n.s. 29 (June 1881), p. 691. Comparisons to Cabanel became common somewhat later; see for example MacColl, 'Academicism and Lord Leighton', p. 241; and George Moore's canon of academic artists: Ingres, Cabanel, Leighton, Bouguereau, Lefèbvre, in descending order of merit (note all the artists except Leighton are French); Moore, 'Lord Leighton', p. 716.

26 'French and English pictures', *Cornhill Magazine*, 40 (July 1879), pp. 98–9.

27 'The Royal Academy', *Saturday Review* (18 May 1872), p. 633 (probably by J. B. Atkinson).

28 E. F. S. Pattison, 'Sir Frederick Leighton, P. R. A.', in F. G. Dumas, ed., *Illustrated Biographies of Modern Artists* (London and Paris, 1882), pp. 18–24.

29 'Current art. The Royal Academy', *Magazine of Art*, 12 (1889), pp. 226–7. Cf. 'The building up of a picture by the late Lord Leighton, P. R. A.', *Magazine of Art*, 22 (1897), pp. 1–2.

30 F. G. Stephens, 'Introductory essay', in E. Rhys, *Sir Frederic Leighton Bart., P. R. A.: An Illustrated Chronicle* (London, 1895), p. xxvii. Stephens also attributes the working

procedure to E. J. Poynter and (quite erroneously) Lawrence Alma-Tadema: 'These are the artists of the artists, learned in painting and devoted to it in all things.'

31 MacColl, 'Academicism and Lord Leighton', p. 241.

32 Andrew Graham-Dixon, 'Victorian vices', *The Independent Section Two* (20 February 1996), p. 8; Brian Sewell, 'Flame, flesh and Victorian values', *Evening Standard* (22 February 1996), p. 28.

33 Adrian Searle, 'All the president's women', *Guardian* (20 February 1996), p. 8.

34 John McEwen, 'Short on emotion and physically repulsive', *The Sunday Telegraph Sunday Review* (18 February 1996), p. 13.

35 The use of the academic as negative context for the avant-garde is still evident in the most recent accounts: see for example C. Harrison, *Modernism* (London, 1997), p. 18 and *passim*.

36 Arnold, 'The literary influence of academies', p. 158.

37 *Kant's Critique of Judgement*, trans. J. H. Bernard, 2nd. ed. revised (London, 1914), p. 193. Bernard's translation of 1892 was the first complete English version. In the translation of 1911 by James Creed Meredith, still the standard English text, Kant's phrase 'die Schule gebildes Talent', translated by Bernard as 'talent cultivated in the schools', becomes 'a talent academically trained': Immanuel Kant, *The Critique of Judgement*, trans. J. C. Meredith (Oxford, 1952; 1st pub. 1911), pp. 171–2.

38 M. Heidegger, *Basic Writings*, ed. D. F. Krell, rev. ed. (London, 1993), p. 153.

39 F. Schiller, *On the Aesthetic Education of Man: In a Series of Letters*, trans. E. M. Wilkinson and L. A. Willoughby (Oxford, 1967), XXII.5, pp. 155–7.

40 See R. Krauss, *The Originality of the Avant-Garde and Other Modernist Myths* (Cambridge, Mass., 1985).

41 MacColl, 'Academicism and Lord Leighton', p. 241.

42 F. Leighton, *Addresses Delivered to the Students of the Royal Academy* (London, 1896), p. 56.

43 *Ibid.*, pp. 56–7.

44 W. Pater, *The Renaissance: Studies in Art and Poetry*, ed. Donald L. Hill (Berkeley, 1980), p. 159.

45 S. Jones, 'Leighton's debt to Michelangelo: the evidence of the drawings', *Apollo*, 143 (February 1996), p. 37.

46 See for example the entry on the picture by C. Newall, in Royal Academy of Arts *Frederic Leighton*, p. 185.

47 Quilter, 'French and English pictures', p. 98.

48 *Ibid.*, p. 99. For discussions of Leighton's use of traditional History Painting subjects, *versus* his more 'aestheticist' or 'subjectless' pictures, see Prettejohn, 'Morality versus aesthetics'; and E. Prettejohn, 'Aestheticising History Painting', in Barringer and Prettejohn, *Frederic Leighton*, ch. 5.

49 Leighton, *Addresses*, p. 5.

50 Arnold, 'The literary influence of academies', pp. 160, 158.

51 *Ibid.*, p. 158.

52 Kant, *Critique of Judgement*, trans. Bernard, pp. 189–90.

53 For a more detailed account of the working procedure see E. Prettejohn, 'Painting indoors: Leighton and his studio', *Apollo*, 143 (February 1996), pp. 17–21.

54 See for example A. Corkran, *Frederic Leighton* (London, 1904), pp. 22–3, 39, 44, 92; Mrs R. Barrington, *The Life, Letters and Work of Frederic Leighton* (London, 1906),

vol. 2, pp. 20–3; G. Costa, 'Notes on Lord Leighton', *Cornhill Magazine*, n.s. 2 (March 1897), p. 376.

55 Translated as 'academic' in 1911: Kant, *Critique of Judgement*, trans. Meredith, p. 171.

56 Kant, *Critique of Judgement*, trans. Bernard, p. 192.

57 Leighton, *Addresses*, p. 5.

58 'ohne dass die Schulform durchblickt'; 'without academic form betraying itself' in the 1911 translation: Kant, *Critique of Judgement*, trans. Meredith, p. 167.

59 Kant, *Critique of Judgement*, trans. Bernard, p. 188.

3

Academicism, imperialism and national identity: the case of Brazil's *Academia Imperial de Belas Artes*

Rafael Cardoso Denis

Recent discussions of colonial discourse and the power of imagery to define cultural stereotypes have largely been premised on the often extreme dualism which characterised the relationship between Europe, on the one hand, and Asia and Africa, on the other, at the height of European imperialism. This is certainly the case with Edward W. Said's masterful study of *Culture and Imperialism* (1993) as well as with Homi K. Bhabha's less satisfying *The Location of Culture* (1994). The colonial experience of the Americas – and, particularly, of Latin America – tends to figure only marginally, if at all, in debates on the notion of the colonial 'other'. It is not surprising, therefore, to find that the paradigms of 'otherness' established by such studies fit only very loosely on to the actual historical contours of the American experience. Much in the same way that the mantle of European civilisation, worn proudly by Latin American elites of the past, appeared ludicrously ill-placed to careful observers, the ragged trappings of 'otherness', sometimes embraced by today's elites as a reverse badge of courage, must ultimately prove to be equally inadequate as an explanation for the persistent perverseness of cultural discourses 'south of the Rio Grande'.

There is good reason for the usual omission of Latin America from debates on 'otherness'. According to Bhabha (who quotes Said), colonial discourse operates by positing the colonised subject as an entirely knowable and visible 'other': an object of difference, certainly, but one that can be fetishised and made familiar through the use of the stereotype.[1] Such a view of colonial discourse holds up nicely in situations where the lines are clearly drawn between coloniser and colonised but utterly collapses in a historical context in which it is never quite clear exactly who qualifies as what. Nineteenth-century Brazil is, perhaps, the ultimate case in point: politically independent after 1822 but still economically dependent on a colonising power; desirous of European approval but wary of anything akin to outside meddling in domestic affairs; ruled by an elite which veered continually between

intense feelings of nationalism and a profound loathing of all things native; comprising a population both rigidly stratified and thoroughly fused by centuries of slavery, racial mixture and cultural interchange. This is a historical context, of no small significance, in which it was virtually impossible to posit absolute difference and, therefore, extremely difficult to fetishise a knowable 'other'. Stereotypes can serve only a very limited political purpose when the grounds for asserting difference are constantly shifting as a function of relative position; and, therefore, any solid theoretical basis for understanding such a context cannot be premised upon the comparatively schematic notion of colonial discourse as a one- or even a two-way traffic. The true relationship of 'colony' to 'culture' is, as the Brazilian literary historian Alfredo Bosi has argued, multiple and layered: a historically textured stream of meanings which flows, etymologically, from the Latin *colere* to *cultus* to *culturus*.[2] The 'dialectics of colonisation', as Bosi has labelled this process, suggests a rich interplay of presentations and representations, none of which should ever be assumed to be knowable except within the necessarily restricted terms of the culture that generated them.

The place of 'academicism' in such a context – particularly with reference to the imposition of 'universal' artistic ideals and values – is much more complex than has usually been made out. Should academic practice in nineteenth-century Brazil be understood primarily as an instance of European cultural imperialism, as an example of the affirmation of national identity or as both? And what is to be made of the role of the *Academia Imperial de Belas Artes* (henceforth, Imperial Academy) as an element in the process of internal cultural imperialism which sought to 'civilise' those peoples and practices seen to lie outside the aspirations of the Brazilian imperial state? These are not questions easily answered; and the present essay hopes to demonstrate that they should not simply be dismissed with facile answers. Before proceeding to any further direct examination of such issues, however, there is the small matter of evoking something of the historical context to be discussed. Although Brazilian art has always fixed its gaze obsessively on Europe, its sad fate has been that Europe has rarely taken the trouble even to glance back. For that reason, it is safe to assume that few readers of this book possess any knowledge of the subject or, for that matter, of the broader history of Brazil.[3] It will, therefore, be necessary to preface the present discussion with an account of the origins and development of Brazil's academy.

Origins of the Imperial Academy

Unlike the United States, which won its independence from Britain in the late eighteenth century by means of a revolutionary war, eighteenth-century Brazil was a country more than ever subjected to the colonial yoke. Under the Marquês de Pombal, Portugal's *de facto* ruler during the middle decades of that century, metropolitan control was extended and further centralised. Measures repressive to the development of Brazilian intellectual and cultural autonomy during the period

included the systematic suppression of printing presses, most notoriously in 1747, and the expulsion of the educationally active Jesuit order from the entire colony in 1759. On the economic and political fronts, all manufacturing activities were declared illegal in 1785, and a succession of pro-independence and broadly republican uprisings between 1789 and 1801 were brutally put down. At the turn of the nineteenth century, Brazil remained little more than an extremely lucrative cash cow exporting sugar and minerals to Portugal, which maintained control through an extensive network of rural oligarchies loyal to the crown, as well as through direct military occupation. The art of the period, much of it religious, reflected Brazil's isolation from the major changes taking place in much of Europe and remained decidedly parochial in outlook and scope. This isolation has led some subsequent commentators – particularly Modernist ones – to look back upon colonial art as paradigmatic of a supposedly purer national identity, untinged by the 'corrupting' influences of the nineteenth century.

This sleepy scenario changed drastically when Napoleon's forces invaded Portugal in 1807, as part of his strategy to close the Continent off to British trade. Lisbon's traditional ally, Britain, provided the logistical support to transfer the Portuguese crown to Brazil; and, in exchange, its empire was transformed into a virtual British protectorate. In January 1808, the ageing Portuguese queen, the prince regent, D. João VI, and their court of 15,000 persons arrived in Rio de Janeiro – then a city of approximately 50,000 inhabitants – permanently transforming its social and cultural life. One of the prince's first actions – announced six days after his arrival – was to issue a decree opening Brazilian ports to trade with all friendly nations, by which, in essence, was meant Britain. Portuguese economic influence quickly waned; and, for the next hundred years or so, Brazil would remain more or less a British dependency, if not in terms of political sovereignty, at least in commercial and financial terms.[4] It is at least somewhat curious, then, that the new court in Rio should turn directly to France in matters of culture and art.

In 1815, Brazil was elevated to co-equal status with Portugal as part of a new United Kingdom of Portugal, Brazil and the Algarve, with the court remaining in Rio, much to the chagrin of its metropolitan subjects. The city was ill-equipped to function as the centre of what was still one of Europe's largest empires; and the prince regent set about making improvements. Among these initiatives, a proposal was made to hire artists and craftsmen in Europe in order to found a Royal School of Sciences, Arts and Crafts. The idea came from the francophile wing of the crown's ministry, represented in the person of the Conde da Barca, who instructed his representative in Paris to make the appropriate commissions. Contacts were initiated with Joachim Lebreton, then perpetual secretary of the *beaux-arts* section of the *Institut de France*, who had risen to power under Napoleon and now found himself distinctly out of political favour under the Bourbon restoration. He proceeded to organise a group of artists and craftsmen – many disgraced Bonapartists – who would be willing to emigrate to Brazil for an initial period of six years, to set up a colony of artists and a school. The group of sixteen that eventually left for Brazil in

January 1816 included an expert in naval architecture, a mechanical engineer, a master blacksmith, carpenters, carriage makers and other craftsmen, as well as the architects and fine artists who were to provide the nucleus of Brazil's future academy of art. The most celebrated of these are the painters Jean-Baptiste Debret, a disciple of Louis David, and Nicolas-Antoine Taunay, a former pensioner at the French Academy in Rome, as well as the architect Auguste-Henri-Victor Grandjean de Montigny, a pupil of Percier and Fontaine and *Prix de Rome* winner. They were joined in Brazil by other French artists forming a colony which has since come to be called the 'French Mission of 1816' in the historical literature.[5]

The future academy did not get off to an easy start. The most serious blow was the death of the Conde da Barca, the originator of the whole scheme, only three months after the arrival of the French artists, depriving the group of its most enthusiastic and powerful supporter in government. Lacking the necessary political support to get the school up and running, the French artists busied themselves with other things. Their first few years in Rio were largely devoted to fulfilling the function of court artists, especially when the death of the ailing queen in 1816 occasioned the coronation of the prince regent. Lebreton's own death further complicated the life of the group, opening the way for a Portuguese artist named Henrique José da Silva to get himself appointed director of the non-existent school through skilful manipulation of good contacts in government. In 1820, the official title of the school was altered to Royal Academy of Drawing, Painting, Sculpture and Architecture; but the next few years were largely wasted in petty infighting between Silva and his French colleagues.[6]

When D. João VI departed Rio in 1821, he left behind his son D. Pedro I as regent. Post-Napoleonic Portugal was a political shambles, and nationalistic pressures in Brazil led D. Pedro to declare independence from Portugal in 1822, a measure enacted peacefully thanks to British mediation, in exchange for which the new Empire of Brazil became even more directly a British client state. However fragile the new Emperor's authority might be, it was at least sufficient, according to Debret's account of events, to decree the opening of a painting class in 1824. Two years later, on 5 November 1826, the long-awaited academy was finally inaugurated, under its definitive name, establishing it as one of the first such institutions in the New World, preceded only by colonial Mexico's Academy of San Carlos and more or less contemporaneous with New York's National Academy of Design. Having just barely managed to survive the ten long years of waiting, the Academy got under way with thirty-eight students divided into six classes: drawing, painting, sculpture, architecture, engraving and mechanics, although the latter subject was never actually taught, bringing to an inglorious conclusion the original plan to teach sciences and crafts as well as fine art. It was not a particularly good time for opening an academy of art: Brazil was at war with Argentina, and the government was busy with other more pressing matters.

The Imperial Academy entered a second, less precarious, phase of its existence in the 1830s which was to last until the early 1850s. Its statutes were reformed in

1831, dividing students into four specialities: history painting, landscape painting, sculpture and architecture. Silva's death in 1834 led to the appointment as director of Félix-Emile Taunay, son of Nicolas-Antoine, under whose direction the Academy managed to establish something of a working routine. The first General Exhibition, or Salon, was held in 1840, superseding a series of smaller exhibitions. These Salons continued to take place more or less annually until 1852, and after a seven-year hiatus, were reduced to an irregular, almost biennial basis after 1859.[7] As in France, the Brazilian Salons came to function as the centre of the system of display and sale of art in the nineteenth century, acquiring particular importance in terms of acquisitions by the Emperor and, to a lesser extent, by government. Under Taunay's direction, the Academy also set up its picture galleries in 1843, bringing together a collection of paintings brought over by Lebreton as well as those which had belonged to the Conde da Barca. A three-year travelling studentship was first instituted in 1845, eventually developing into a semi-annual travel prize similar to the *Prix de Rome*. At first, students were given a choice of going to either Rome or Paris but, after 1855, were sent directly to Paris for three years with an option to extend their sojourn elsewhere. One of the conditions of the pensioner's stay in Paris was the successful prosecution of studies at the *École des Beaux-Arts*, a fact which generated a level of intense proximity between the Imperial Academy's practices and tastes and those of its French counterpart.

The Imperial Academy's continued survival and even growth during the troubled 1830s is something of a remarkable achievement. The first emperor, D. Pedro I, abdicated and returned to Portugal in 1831 to take part in the struggle with his brother over the succession to the Portuguese crown. He left his five-year-old son on the throne, with actual control surrendered to a series of regents who ruled for nine years marked by administrative turmoil and separatist rebellions in various regions of Brazil. The young Emperor Pedro II would not be constitutionally entitled to rule until the age of eighteen, but generalised political chaos led to his being enthroned prematurely in 1840, at the age of fourteen. The following decade marked a change in Brazil's economic fortunes. Coffee surpassed sugar as an export, signalling the start of a period of economic prosperity; and tariffs were more than doubled, paving the way for the first hesitant steps towards import substitution and, as a consequence, incipient industrialisation. It is no coincidence, therefore, that the Academy finally began to achieve some measure of stability at that time.

The existence of the Academy tended to draw habitual criticism from various quarters, dating even from before the actual opening of the institution and mostly casting aspersions on the suitability of an academy of art as an item of government expenditure. Complaints against public spending on art are certainly not unique to Brazil nor to the nineteenth century, for that matter; but it is interesting to note that critics of the Academy often made use of nationalistic rhetoric, singling out the government's employment of foreign artists as a soft target. The years around independence had naturally been a high point for Brazilian nationalism, and they foreshadowed an extended period of Romanticism in the arts, especially literature,

which peaked during the 1830s and 1840s.[8] Brazilian Romanticism was, broadly speaking, nationalistic, intensely nativist, vaguely populist and more or less of a modernising tendency. In the visual arts, it implicitly opposed itself to the Neoclassical heritage to which the Academy still officially subscribed. One of the movement's major exponents was the poet and painter Manuel de Araújo Porto-Alegre, who had been among the first students of the Imperial Academy, working under Debret. He accompanied his teacher to Paris in 1831 and went on to study both in the studio of Gros and at the *École des Beaux-Arts*. Already a moderately successful painter and writer by 1850, Porto-Alegre cast himself in the role of leading critic of the Academy, denouncing its 'monstrous' method of instruction, the 'decadence' of its drawing school and, most controversially, the believed favouritism of Taunay in awarding the travel prize for 1850 to an artist who, though born in Brazil, had been raised and educated in France. The ensuing debate in the press cast into relief the contrast between what Porto-Alegre characterised as his own 'Brazilian enthusiasm' as opposed to Taunay's 'French frigidity'. The director chose the rather questionable course of defending himself on the grounds that Porto-Alegre had bad grammar and wrote turgid poetry, which gave his opponent ample opportunity to make him look pompous and foolish. A memorable letter printed in one of Rio's most important newspapers demanded:

> I want an artist, *senhor* Taunay, and not a grammarian, a direct and honest man, and not a cunning logician. Answer the facts with the same frankness that I have answered you, and do not dodge the question; for such a course is neither honourable nor reasonable for a man who thinks so highly of himself, and who imagines he can annihilate the poor savage with his dogmatic tone, devoid of truth.[9]

In light of Porto-Alegre's very strong links to France and French culture, the fact that he was able to deploy his own 'Brazilian-ness' successfully in his favour – and even cast himself as the downtrodden savage – indicates not only the inherent flexibility of the concept of national identity in Brazil but, equally, the extent to which the topic remained restricted to a small elite whose vision of art and culture was essentially premised on European values.

Porto-Alegre was full of innovative ideas for the Academy, and he made these widely known in the early 1850s. He was particularly taken with the idea of art education as a stimulus to industrial development and, therefore, firmly advocated a return to the original proposal of using the Academy not only for training fine artists but also craftsmen and designers. He was emboldened in his reformist zeal by the fact that he was well connected in courtly circles, initially through a close friendship with the chamberlain of the Imperial household and later via direct access to the Emperor himself. The Emperor seems to have liked Porto-Alegre and, in 1853, charged him with devising plans for a 'radical reform' of the Academy. Porto-Alegre was made director the following year and, in 1855, the government decreed a major overhaul of the teaching system: the number of theoretical disciplines was increased; studies in ornamental art and industrial

design were introduced; students were subdivided into two classes, one studying fine art and the other applied art; the regulations for prizes were substantially altered; and the conservatory of music was subordinated to the Academy.[10] However successful he may have been at making changes within the institution, no amount of reformist zeal was powerful enough to tackle the structures that lay beyond it. In 1857, the new director was not consulted with regard to the appointment of a new professor of history painting and the post was awarded to an artist protected by the extremely powerful Minister of Empire. Porto-Alegre promptly resigned in protest, and even the Emperor could not or would not help him.

Much had changed in the Imperial Academy during Porto-Alegre's turbulent three-year directorship, but much remained the same. After his resignation, the post was turned over to a safe pair of hands, the professor of medicine and Royal Physician Tomaz Gomes dos Santos, who would remain director until his death in 1874. By 1860, the Academy had largely surpassed its formative period and had reached a level of relative administrative stability which would last at least until the end of the Empire and the Republican coup of 1889. At this point, therefore, it is probably worth changing track from what has so far been a standard account of its institutional development and to focus, instead, on the type of work being produced within its confines.

Brazilian art in the mid-nineteenth century

It would be wrong to imagine that the Imperial Academy exercised a monopoly over the production and sale of fine art. Since the early years of the nineteenth century, the country had been a fertile ground for travelling artists from Europe, some of whom went accompanying naturalists or documenting scientific expeditions, and others of whom went simply to take advantage of the lucrative business of portrait painting for the local rich.[11] Charles Landseer is an example of the former type of artist, going to Brazil in 1825 with the British ambassador Sir Charles Stuart and remaining for two years. France's Claude-Joseph Barandier and Germany's Ferdinand Krummholz are particularly successful examples of the latter type. Many of these artists displayed their works in the Salons, and quite a few chose to stay on in Brazil, sometimes becoming teachers at the Imperial Academy itself. Interestingly, some of the most successful landscape painters of the mid-nineteenth century were European immigrants, including the German Georg Grimm and the Italian Nicolau Facchinetti. The tension between depictions of Brazil's landscape as an exotic and sometimes threatening tropical wilderness and its evocation as the site of more domestic sentiments of place and belonging is one of the great underlying themes in the work of such painters.

Like academies elsewhere, the Imperial Academy's stated priority was history painting. Unlike some other academies, though, the particular requirements of state building in nineteenth-century Brazil actually allowed a fair amount of history painting to get done. Victor Meirelles, who was to become one of the

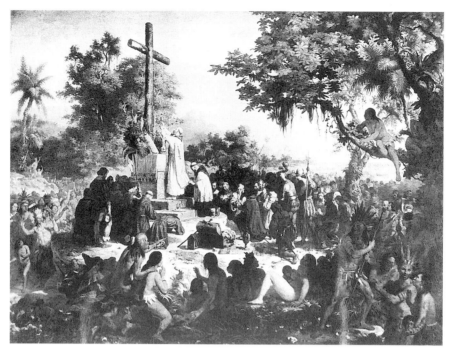

5 Victor Meirelles de Lima, *First Mass in Brazil,* 1861, oil on canvas, 356 × 268 cm.

leading painters of the imperial period, exhibited his *First Mass in Brazil* (figure 5) at the Paris Salon of 1861 and, subsequently, at the 1862 Salon in Rio, earning him the honour of chevalier of the Imperial Order of the Rose, as well as paving the way for his appointment as full professor of history painting at the Academy. This is a paradigmatic example of the type of history painting favoured at the time: generating an iconography of nationhood which transformed troubling aspects of the past – in this case, the reception of Catholicism by indigenous peoples – into easily grasped and unproblematic images of national self-affirmation. Meirelles's canvas, stressing an abiding continuity between Brazil's first inhabitants and its subsequent colonisers, was widely believed at the time to be a historically accurate depiction of the primal scene. The very recent past also allowed ample scope for history painting. The Paraguayan War of 1865–70 – easily the only other con-tender, alongside the American Civil War, for the title of biggest and bloodiest war ever fought in the Americas – provided the pretext for an orgy of national self-glorification. A steady stream of battle paintings of all shapes and sizes began to appear as early as the 1865 Salon, steadily increasing in number until a high point at the 1872 Salon. Several artists made a career out of painting the war, including the Italian Edoardo de Martino who was able to obtain lucrative commissions from the Imperial Navy. Thereafter, throughout the 1870s and even later, the Paraguayan War continued to be an enduring theme for history painting,

especially of a more Realist tendency. Pedro Américo – considered to be the greatest Brazilian painter of his time, alongside Meirelles – completed a monumental version of the *Battle of Avaí* commissioned by the Minister of Empire in 1872 and exhibited to a deliriously admiring public at the 1879 Salon.[12]

Although history painting was the official priority, occasionally bringing in juicy government commissions, the mainstay of nineteenth-century Brazilian art was portraits of the nobility and other powerful individuals. Portraiture was the bread and butter of both painters and, to a lesser extent, sculptors. At least one very important type of portrait functioned as a sort of borderline with history painting: namely, the hundreds of portraits of the Emperor which circulated throughout the country. These were often commissioned by the imperial government or provincial governments for display in public buildings, and every Salon contained an assortment of such portraits. They functioned as an important reminder of imperial power and, coincidentally, as a nice earner for artists. Religious orders and other private associations were also an important source of commissions for portraits of prominent benefactors, as well as for paintings and sculpture of religious subjects. One interesting portrait that has long been singled out for its unusual engagement with issues of ethnic identity is José Correia de Lima's *Portrait of the Intrepid Sailor Simão, Coal-Heaver on the Steamship Pernambucana* (figure 6), exhibited at the 1859 Salon. This heroic depiction of an African-born sailor who single-handedly saved thirteen people from a shipwreck, was widely circulated in the form of engravings made to order for the painting's patron, the typographer, liberal journalist and publisher Francisco de Paula Brito, who was himself of mixed race.[13] Both the theme and the intentional heroising of a black subject are reminiscent of the circumstances surrounding John Singleton Copley's painting of *Watson and the Shark* (1778); and it can be argued, convincingly, that Correia Lima's painting is likewise imbued with strong abolitionist sentiments.[14]

If portraits provided a middle ground between public and private art, the virtual opposite of official art in almost every sense came to be embodied in landscape and genre paintings, much as in Europe. As a rule, these tended to be smaller in scale, freer in style and composition and, therefore, to appeal to the private collector, particularly those collectors who were members of what might rather uncertainly be termed an urban bourgeoisie. During the first half of the nineteenth century, these types of paintings were comparatively scarce in Brazil, as were the urban elites who might have consumed them. Many early landscapes served a mainly topographical or descriptive purpose and were often the preserve of travelling, reporter artists from Europe. Although the European presence in Brazilian landscape painting remained strong throughout the imperial period, landscape painters came to view their work in a more self-consciously aestheticised manner after the 1860s. Various schools of landscape came into being, and a strong market for this kind of painting was definitely in existence by the 1870s, led by no less prominent a collector than the Duke of Saxe-Coburg-Gotha, consort of the Emperor's younger daughter. As imperial society grew in wealth and complexity during the 1870s and 1880s, a

similar expansion took place in the market for genre paintings. Some of the most remarkable paintings of the period date from these two decades, largely produced by a second generation of Brazilian graduates of the Imperial Academy. Many of these artists – such as Almeida Júnior, Belmiro de Almeida or Rodolpho Amoedo – had been trained initially at the Academy and subsequently in Paris, often studying with the recognised masters of their day, such as Delaroche, Flandrin, Horace Vernet, Cabanel and Puvis de Chavannes.

An example of this more mature stage of the Imperial Academy's output is Almeida Júnior's *The Brazilian Wood-cutter* (figure 7), executed in 1879 and exhibited as part of a one-man show upon the painter's return to Brazil in 1882, after six years of study in France. The painting displays an unorthodox deployment of landscape, portrait and genre conventions in the service of an intriguing exploration of issues of national, ethnic and class identity. The far from idealised figure of the wood-cutter lounges idly with a cigarette in one hand amidst the remains of the forest he has helped destroy. Both stylistically and ideologically, it betrays the enduring influence of French Realism, in general, and Courbet, in particular. It was originally exhibited under the largely forgotten but revealing title *Caboclo at Rest*, the term *caboclo* being an ethnic category used to describe the typical inhabitant of

6 José Correia de Lima, *Portrait of the Intrepid Sailor Simão, Coal-Heaver on the Steamship Pernambucana*, c. 1855, oil on canvas, 93 × 72 cm.

7 José Ferraz de Almeida Júnior, *The Brazilian Wood-cutter*, 1879, oil on canvas, 227 × 182 cm.

rural Brazil and, more specifically at that time, the racial mixture of European and indigenous stock. For that very reason, it drew fire from the critic Félix Ferreira, a great admirer of the painter's other work and perhaps the first to publicise his merit. Ferreira objected to the fact that the model was obviously European, and not a 'pure Indian' or even a 'half-breed', a conclusion he surmised from the 'false colouring' of the subject's skin.[15] Interestingly, in light of the key role of racial miscegenation as a banner for Brazilian identity in the twentieth century, Almeida Júnior was later taken up by many Modernist critics as a precursor of modern art and, erroneously, as an artist at odds with the academic milieu which nurtured him. The Modernist canon transformed him into a sort of Brazilian version of Impressionism: a lone beacon of 'acceptable' aesthetic values to be held up as a shining example in the face of otherwise 'deplorable' academic taste.

The nature of the market for art in nineteenth-century Brazil is a distinctly under-researched subject; but indications do exist to suggest that the 1870s and 1880s were a period of marked growth. The apparently increased prominence of landscape and genre is one such indication, though it can be demonstrated that these types of subjects were never absent from even the earliest Salons. Another indication is the opening of what may have been Rio's first full-time art gallery in 1875, though this venture was short-lived.[16] More commonly, paintings continued to be sold in print shops in the *rua do Ouvidor*, nineteenth-century Rio's most fashionable street and intellectual hub. Perhaps the most significant indication of a growing market for art was the contemporaneous expansion and sophistication of the field of art criticism. Porto-Alegre is generally cited as Brazil's first art critic, at least in so far as he systematically wrote about art, past and present, from the late 1840s. Journalistic interest in the state of the nation's art remained lukewarm throughout the following decades, being more or less restricted to a usually timid coverage of the Salons. However, the astounding popular success of the Paraguayan War paintings of the 1870s provided a spur to art criticism, generating a flurry of press coverage and sparking passionate debates between admirers of Victor Meirelles and of Pedro Américo, as to which was the greater artist.[17] A new mediating element between art and the press also came on the scene in the form of the illustrated magazines and reviews which gained prominence throughout the 1860s and 1870s. During this period, political caricature blossomed into one of the great strengths of the Brazilian press, and the Imperial Academy proved to be a fitting target, especially for the growing tide of anti-monarchical sentiment which sometimes deployed it as a bastion of old-guard conservatism.

With the death of the Academy's long-reigning director in 1874, one or two artists who wished to succeed him also saw fit to dabble in public discussions of art, aesthetics and the purposes of art education. Criticism of the Academy's well-publicised deficiencies mounted in the face of unfavourable comparisons with the *Liceu de Artes e Ofícios*, a high-profile and surprisingly successful school of industrial art founded privately by the Academy's own professor of architecture.[18] These largely institutional critiques of the 1870s and 1880s helped open the way for the

rise of a series of prominent art critics – notably, Gonzaga-Duque, who was to rede-fine the prevailing view of Brazilian art at the close of the imperial period, advo-cating what may be very loosely described as a progressive stance of opposing perceived official doctrines and embracing more self-consciously modernising ten-dencies in European art – particularly Symbolism, which had a strong impact on Brazilian literary and artistic circles in the late 1880s. The parallel within the Academy was the rise to power of a new generation of artists, led by the sculptor Rodolpho Bernardelli and the painter Amoedo, which would bridge the transition from Imperial Academy to a new but largely unchanged National School of Fine Arts under the Republic of 1889.

The margins of otherness

The Imperial Academy cannot be regarded simply as a prolongation of European academic practice and ideals, inasmuch as it represents a much more complex his-torical reality than a straightforward 'cultural colonisation' model would imply. That conclusion may seem so obvious, after what has been said so far, that it requires an exposition of what is being argued against in order to come across as anything other than utterly banal. First, and most obviously, the evidence from Brazil's Academy adds weight to ongoing revisions of the Modernist conception which posited academicism as a monolithic backdrop against which to gauge the originality of the avant-garde. Whether in Europe or elsewhere, academies of art can by no means be viewed as representing a consistently conservative social and cultural position: even in a society as politically unsubtle – in relative terms – as imperial Brazil, the functions and nature of the Academy clearly fluctuated over time. Moreover, conflicts and dissent within the Academy meant that, at different moments, different factions held sway. This must hopefully seem painfully evident from the preceding thumbnail sketch, but it is still far from being generally recog-nised in historical discussions of nineteenth-century Brazilian culture. The Imperial Academy's close links to the Emperor are usually taken as grounds for assuming a priori that all the art produced by its artists was part and parcel of the process of building up the monarchical state and, therefore, politically conservative and anti-progressive. This, in turn, is based on an extremely biased reading of the role of the Emperor in Brazilian society and politics – dating from as early as the republican propaganda of the 1870s – which reduces his ambivalent position as a unifying figure in a deeply stratified, divided and even centrifugal nation-state to a mere emblem of the power of its slave-holding elites.

The works of art themselves have traditionally been disavowed as merely deriva-tive copies of artistic styles in Europe and often ridiculed for their tendency to lag many years behind the prevailing European fashion. Thus, the self-professed avant-gardes were able to heap merciless sarcasm on those 'academic' artists who were still painting in an Impressionist style in the 1920s, while priding themselves on the fact that they, in contrast, were able to import Cubism or Abstract

Expressionism with a much shorter delay of only a few years. Such a critique is, of course, based on the kind of teleological reading of the evolution of art towards Modernism which is, hopefully, completely discredited by now. The multiple and complex ways in which artists outside Europe have responded to European initiatives, adapted European artistic models and translated their formal values into something meaningful to their own cultures is surely what really matters to anyone interested in the development of a unified network of Western art over the past few centuries. To despise past attempts to come to terms with the all-encompassing process known as modernisation is indeed a short-sighted, if not a blatantly foolish, cultural strategy.

The relationship between Europe and the rest of the nineteenth-century world touches upon the second, and more difficult, argument which needs to be contested here: namely, any straightforward reading of the colonial 'other' as a homogeneous or universally applicable concept. Most discussions of the colonial 'other', though eminently worthy, would seem to be premised on a view of the world as divided between included and excluded, a crude division which masks vital distinctions within both groups. When talking about a colonial 'other', just what makes for 'otherness' is often poorly defined; and, accordingly, most of the work on the subject necessarily fails to take into account those countries or cultures which fall into what I would describe as *the margins of otherness*. The existence of such a middle ground between coloniser and colonised is precisely what makes the Americas – and particularly Latin America – so interesting as a case study in the cultural values of the nineteenth century. The Americas provide not one, but several different examples of attempts to negotiate the fundamental cultural difference between being European and being Western, which do not fit the traditional 'colonial other' mould and which ought, perhaps, to redefine our very understanding of Western culture – moving it away from a simple dualism with the East and towards some notion of desire for an ever-shifting frontier of the new and unfamiliar. Some of these attempts were so successful, as in the cases of the United States and Canada, that these cultures have virtually ceased to be depicted as colonial 'others' and have almost imperceptibly come to be viewed as a seamless portion of the colonising self. The fact that similar attempts in Latin America were less successful in shifting colonial identities during the nineteenth century should serve as ground for intensive study and research, and not for the silence and indifference which has generally been reserved for the cultural history of the region's past.

The comparison between different parts of the Americas may yet engender useful insights regarding the post-colonial dialectic of imperialism versus national identity, as well as the ways in which academic cultures served to mediate this dialectic. In so far as academicism sought (among other things) to impose a range of normative artistic values and institutional practices, it can certainly be viewed as a key site for unravelling the shifting relationship between coloniser and colonised. I would argue that the experience of academicism in Brazil cannot be taken simply at face value: either negatively as importation/imposition/imperialism or positively

as assimilation/affirmation/autonomy. The transferral of cultural values over time and place is never merely a process of reproduction, nor should it be read necessarily as one of subversion (a tempting inversion of terms). Rather, the available historical evidence would seem to suggest that, during the process of shifting sites, meanings are wont to break loose from the forms that bear them and to recombine in highly unpredictable ways, like so many mutated strands of DNA. This skewing of values, I would argue, is one of the hallmarks of the transposition of culture in a colonial context and accounts for what I earlier labelled as its perverseness of discourse. The potential nuances of signification in any such context are subject to a process of continual hybridisation, in which readings are reflected and almost endlessly deflected in the distorting mirrors of colonial relationships. Thus, apparently simple visual statements such as the colouring of a wood-cutter's skin or the positive depiction of a slave can acquire surprising gradations of depth and reflexivity, serving as loci for a continuing reassessment of identities caught between competing fields of discourse. Without careful scrutiny, the real nature of colonial identities tends to remain hidden in the interstices between such fields. Impervious to full appropriation into either of the poles of 'otherness' which delimit their existence, they are otherwise condemned perpetually to turn in on themselves as nothing more than bad copies of a lost original.

Notes

The author wishes to acknowledge the support of the Research Council of the State of Rio de Janeiro (FAPERJ) in providing a travel grant to attend the conference at which an earlier version of this essay was presented.

1 Homi K. Bhabha, *The Location of Culture* (London, 1994), pp. 70–5.
2 Alfredo Bosi, *Dialética da Colonização* (São Paulo, 1992), esp. pp. 11–25.
3 A one-volume introduction to the history of Brazil can be found in E. Bradford Burns, *A History of Brazil* (New York, 1993). A wider range of perspectives is available in Leslie Bethell, ed., *Colonial Brazil* (Cambridge, 1987) and Leslie Bethell, ed., *Brazil: Empire and Republic, 1822–1930* (Cambridge, 1989). Virtually the only English-language source to touch upon Brazilian art before the twentieth century is Dawn Ades, *Art in Latin America: The Modern Era, 1820–1980* (New Haven and London, 1989).
4 On Brazil's relationship with Britain, see Richard Graham, *Britain and the Onset of Modernisation in Brazil, 1850–1914* (Cambridge, 1972); and D. C. M. Platt, *Latin America and British Trade, 1806–1914* (London, 1972).
5 Among the standard sources on the 'French Mission', see Afonso de Escragnolle Taunay, *A Missão Artística de 1816* (Brasilia, 1983; 1st pub. 1911); and Adolfo Morales de los Rios Filho, 'O ensino artístico: subsídio para a sua história', in Instituto Histórico e Geográfico Brasileiro, *Anais do Terceiro Congresso de História Nacional* (1942), vol. 8, pp. 11–50.
6 Some of the flavour of the Academy's early days can be gleaned from J. B. Debret, *Voyage pittoresque et historique au Brésil, ou séjour d'un artiste français au Brésil, depuis 1816 jusqu'en 1831* (Paris, 1834–39), vol. 3, pp. 81–110.

7 The major reference on the Salons is Donato Mello Júnior, 'As exposições gerais na Academia Imperial das Belas Artes no 2° Reinado', in Instituto Histórico e Geográfico Brasileiro, *Anais do Congresso de História do Segundo Reinado; Comissão de História Artística* (1984), vol. 1, pp. 203–352.

8 An essential reference on Romanticism in Brazilian literature is Antônio Cândido [de Melo e Souza], *Formação da Literatura Brasileira* (*Momentos Decisivos*) (Belo Horizonte, 1981), vol. 2, chs 1–2.

9 Cited in Alfredo Galvão, 'Manuel de Araújo Porto-Alegre – sua influência na Academia Imperial das Belas Artes e no meio artístico do Rio de Janeiro', *Revista do Patrimônio Histórico e Artístico Nacional*, 14 (1959), pp. 22–7.

10 A detailed account of these measures can be found in Donato Mello Júnior, 'Manuel de Araújo Porto-Alegre e a reforma da Academia Imperial das Belas Artes em 1855: a reforma Pedreira', *Revista Crítica de Arte*, 4 (1981), pp. 27–30.

11 Interesting perspectives on artists travelling in Brazil can be found in Ana Maria de Moraes Belluzzo, *The Voyager's Brazil* (São Paulo, 1995); and Katherine Emma Manthorne, *Tropical Renaissance: North American Artists Exploring Latin America, 1839–1879* (Washington, DC, 1989).

12 A fuller treatment of the history paintings depicting the Paraguayan War is available in my article, 'Ressuscitando um velho cavalo de batalha: novas dimensões da pintura histórica do Segundo Reinado', *Concinnitas*, 1, 2 (1998).

13 Moreira de Azevedo, *O Rio de Janeiro: sua Historia, Monumentos, Homens Notaveis, Usos e Curiosidades* (Rio de Janeiro, 1877), vol. 2, p. 190.

14 On the significance of Copley's painting, see A. Boime, *The Art of Exclusion: Representing Blacks in the Nineteenth Century* (London, 1990), pp. 20–36.

15 Felix Ferreira, *Bellas Artes: Estudos e Apreciações* (Rio de Janeiro, 1885), pp. 125–6.

16 Mello Júnior, 'As exposições gerais', p. 305.

17 See Donato Mello Júnior, *Pedro Américo de Figueiredo e Melo, 1843–1905* (Rio de Janeiro, 1983), pp. 41–52.

18 See my article 'A Academia Imperial de Belas Artes e o ensino técnico', in Sônia Gomes Pereira, ed., *180 Anos da Escola de Belas Artes: Anais do Seminário EBA 180* (Rio de Janeiro, 1997), pp. 181–95.

PART II

ACADEMIES AND POLITICAL CULTURES

Hidden from histories: women history painters in early nineteenth-century France

Gen Doy

It has often been said that the French Revolution of 1789 was a defeat for women, decisively suppressing their demands for political and social equality. As a bourgeois revolution, it put in place the conditions for the growing ascendancy of bourgeois ideologies of femininity, where women are associated with the domestic sphere and men with public, political and professional activity. One of the clearest assertions of this is to be found in Griselda Pollock's discussion of Elizabeth Vigée-Lebrun. Having analysed some of the artist's self-portraits, Pollock concludes that 'a profound contradiction was established between the ideological identities of the artist and of woman'.[1]

Pollock is right in saying that the bourgeois revolution resulted in contradictions both for women as a group and as artists in particular. However, these contradictions are not the ones she identifies. As I have discussed at length elsewhere, the very economic, political and social upheavals that made the domination of bourgeois ideology possible also resulted in an increase in the number of artists, both male and female.[2] According to the figures of Harris and Nochlin, numbers of women Salon exhibitors rose in the early nineteenth century.[3]

Clearly, bourgeois ideology did not make it impossible for women to become artists. It was not easy for women to become successful professional artists, however, as they were not allowed to train at the national (or regional) *École des Beaux-Arts*. Pupils had to be male, unmarried and less than thirty years of age to compete in the annual *Prix de Rome* competitions in history and landscape painting.[4] In 1889, the determined campaigner for women artists' rights, Mme Léon Bertaux, pointed out that even then women could not compete for the prize, and stressed the disadvantages of their unjust exclusion:

> To be a Rome prize winner! Apart from the proof of one's skill in the grand manner, this means that henceforth one is sheltered from serious misfortunes, it means that one has in the École des Beaux-Arts a family that looks after one, gives one absolutely free the best teaching with the most famous professors, supports one first of all, then encourages one, and protects one at all times.[5]

In the years immediately after the Revolution, we find among the increasing number of women artists some who became history painters. This happened at a period when supposedly bourgeois ideology is so embedded in the mental and physical life of men and women of the upper classes that the very notion of the woman artist is an impossible contradiction. Furthermore, the dominant artistic style for high art in the late eighteenth and early nineteenth centuries in France was Neoclassicism. This style, as practised and taught by Jacques-Louis David, has often been described as virile, and in a recent book by Tom Crow, his teaching milieu has been described as homosocial.[6] How was it, then, that David had a number of women pupils whom he encouraged as history painters, and were they not important 'emulators' of their teacher? Crow describes how Gros took on the mantle of the Davidian tradition when he succeeded the exiled David at the Academy in 1816. However, as I want to show here, David's pupil Angélique Mongez played an important public role in keeping alive David's reputation and that of his school in the period of her master's exile in Brussels. Unfortunately her name does not receive a single mention in the pages of Crow's book. Thus, once again, women artists are elided from history, and in this case, history painting. Crow understands a study of gender and Davidian history painting to mean a concern with the homosocial and with male homosexuality, but not with women.[7]

The Revolution certainly had positive consequences for women artists who were able to show their work in larger numbers than ever before at the open Salon of 1791.[8] The Academy was increasingly attacked as a bastion of aristocratic privilege by David and other artists, and it was closed in 1793. Alternative associations of artists were set up before the state decided to set up its own national institution for the teaching and administration of the fine arts in 1795. At this point architecture, painting and sculpture were brought together as the Fine Arts section of the new Institute of France. The *Prix de Rome* was restarted in 1797, and after the Restoration the Institute was renamed the Academy in 1816.

It has often been argued that revolutionary painters were against women artists and would not allow them to take part in the new associations which briefly replaced the defunct Academy.[9] However, it appears there was a considerable amount of debate on this question. For example the *Société Républicaine des Arts* voted to ban women from membership in late 1793, but this decision was later reversed and women were allowed back on an equal basis.[10] Thus even in the midst of economic crisis and uncertainty for professional artists, the majority of male artists were not prepared to deny women their rights in the new artists' organisations. However, it is true that there were seventeen women Academicians at various times in the pre-revolutionary Academy, while in the early nineteenth century the new official artists' organisations funded by the state had no place for them.[11]

In theory, the newly established *École des Beaux-Arts* in the late eighteenth century was open to all and advancement was decided purely on merit, rather than accident of birth or the support of powerful patrons. Thuillier points proudly to

the competitions around which teaching in the *École* was organised as a democratic gain of the Revolution which enabled the sons of poor families to rise to the highest levels of art, funded by the state and municipal authorities: 'no allowance was made for patronage, class or economic privilege; talent was the sole arbiter'.[12] He makes no mention of the fact that women were excluded. Thus women artists were legally in a far less democratic situation, and in order to train extensively at the highest level some private income was required, because women would not receive state teaching or bursaries from their local authorities. They needed support from their families or husbands, and if money was a problem then the temptation to turn to portraits as a way of earning a living meant that few women artists were willing to invest time and effort speculatively in history paintings. No women would be able to travel to Rome to study the antique and other great works of Italian art unless they paid their own way. Vigée-Lebrun travelled across Europe at this period as a political émigrée, making a living for herself and her daughter by her portraiture, but not many female artists were in a similar position. Mme Haudebourt-Lescot was able to visit Italy for seven years in 1807 at the age of twenty-two, helped by the fact that she was a pupil and friend of the newly appointed director of the French Academy in Rome, Guillon-Lethière.[13] The market for history painting in the first years of the nineteenth century was weak, and from 1789 to 1808 subjects from ancient history made up less than 4 per cent of all works exhibited at the Salons.[14] In this situation, then, when the art market picked up accompanied by an increase in the number of artists and a proliferation of old and new genres of painting, it was only a highly motivated or a financially secure woman who would attempt a career in history painting without any help from the state. Thus women history painters at this period were working in the grand manner on the margins of the *École des Beaux-Arts*.

Most of the winners of the *Prix de Rome* during these years came from the studios of David, Regnault and Vincent.[15] It is interesting to note that the first two of these artists had a number of women pupils, and the third was the partner and later husband of Adélaïde Labille-Guiard, one of the pre-revolutionary members of the Academy, a campaigner for increased participation of women, and an important role model for women artists. David was reprimanded by the painter Pierre who used his senior position in the Academy to admonish David for allowing women pupils to attend classes in his studio in the Louvre in 1787. David replied defensively saying that the women were secluded and kept well away from the male pupils.[16] Regnault had thirty to forty women students in a studio supervised by his wife at the time of the Revolution, and by 1813 three studios in Paris are mentioned as having nude life-drawing facilities for women – those of David, Regnault and P. N. Guérin.[17] Oppenheimer has discovered a fascinating document written by a young Swiss woman, Romilly, studying art in Paris in 1813. She was accompanied by her mother, who would not allow her to copy from nude figures in the Louvre museum. She was frustrated by this but was herself constrained by the same kind of ideology. She felt she could not take up the offer of visiting an unmarried artist's

studio to share the model, nor visit the studios of David, Regnault or Guérin to draw from the nude model in mixed company. She pointed out that some women hired models to come to their homes in order to avoid any possible gossip about their morals if they drew and painted *académies* (nudes) alongside men.[18] Oppenheimer's research has developed earlier work by Vivien Cameron, who discovered drawings representing male and female nudes by Mme Auzou in a private collection in Paris. Cameron suggested that Regnault, her teacher, must have allowed female students access to nude models unofficially.[19] This probably happened in other studios where women worked.

Charles Gabet's *Dictionnaire des Artistes de l'École française au XIXe Siècle* (1831) mentions a number of women exhibiting history paintings in the early years of the nineteenth century and classes them as history painters – for example Mlle Béfort, a pupil of Sérangeli, Mlle Cochet de Saint-Omer (whom he mentions as doing large history paintings, some of which remain unfinished due to ill health which forced her to turn to genre), Mme Mongez, and Mlle Sophie Guillemard (a Regnault pupil who exhibited history paintings in 1802 and 1804 and then moved to portraiture and genre). It appears that the Revolution opened up spaces for women to become artists in greater numbers and to tackle history paintings with the help of their teachers, despite the fact that the majority of the male bourgeois revolutionaries denied women equal political and social rights. This period early in the nineteenth century, which comes to a close around 1830 with the demise of the influence of Davidian classicism, does show that some women managed to exhibit history painting publicly and employ the style and subject matter of the *École*. Given that they were at a disadvantage, their achievements are all the more impressive. However, the relationship between the private studios of individual teachers and their academic roles meant that women who could afford to devote themselves to history painting had some things in their favour. At the *École* students were taught by both painters and sculptors who rotated monthly. In contrast, students of David, say, were taught all year by the same master, borrowed his drawings and sometimes worked on his paintings and sketches. Boime believes that most private studios no longer carried on this collaborative tradition of earlier workshops by the Restoration.[20] Nevertheless we know that David got his pupils to collaborate with him – Mme Mongez is said to have done the *ébauche* (laying in the basic paintwork foundation) for his *Sapho and Phaon* – and continued with this practice in exile.[21] In some ways this helped pupils, but perhaps by this time the notion of workshop output was seen as restrictive to the marketing of a younger artist's artistic persona. David's pupil Sophie Frémiet and her husband Rude, the sculptor, fell out with David, perhaps because the master was signing some of her copies made after his own work.[22] David's teaching showed progressive aspects linked to his radical bourgeois criticisms of the Academy. His encouragement of women pupils as history painters is one aspect of this. Yet his teaching practice was situated in a transitional phase before the art market and development of independent art dealers could provide an alternative to state patronage for the history painter. It is arguable

that private patronage never did provide this alternative to any great extent. David tried a new financial initiative by exhibiting the *Intervention of the Sabine Women* for an entrance fee. In the 1820s he again privately exhibited work in Paris, this time helped by Mme Mongez, since he himself was in exile.

I want to look now in more detail at some works by two female pupils of David. How did they exist on the margins of academic history painting, and how did that existence become briefly less marginalised before women artists became associated once again with lesser genres of painting (e.g. small-scale literary subjects or anecdotal history) in the middle years of the nineteenth century?

The first painter I want to look at is Mme Angélique Mongez née Levol (1775–1855). Mme Mongez was taught by Regnault and then David. In 1793 she married the Director of the Mint, Antoine Mongez (1747–1835). Mongez was a former priest, and author of books on arithmetic and algebra for women. He became a revolutionary and left the church. Mongez was also a classicist who published a number of works on ancient culture, including four volumes of a *Recueil d'Antiquités* in 1804, which were illustrated by his wife. Angélique Levol, her brother and her husband were linked financially with David as well as personally and artistically. The couple lent David money and later visited him in exile. David's portrait of Angélique and her husband Antoine (1812) was in her possession at her death, and was bequeathed by her directly to the Louvre. Mongez is dressed in his official uniform as a member of the Institute to which he was appointed in 1796.[23] David dedicated the portrait to his two friends in Latin. The use of Latin and the appearance of Mongez in his dress uniform coat, holding one of his classical books and a coin, is obviously intended to unite sitters and artist in their love of the antique.

It is strange that David included no iconographical details to allude specifically to Angélique Mongez' contribution to French Neoclassical culture, given that by 1812 she was a well-known history painter. Her husband was director of the Mint during the First Empire and she still had a studio there on her death. She had two smaller studios, and the inventory of her possessions after her death testifies to her lifelong devotion to Davidian painting. As well as the double portrait (valued at 50 francs, compared to a cashmere shawl in a box valued at 75!), her apartments and studios contained engravings after David, a head of Romulus by David (valued at 100 francs), framed drawings by David, portraits of David and papers relating to David and his works. Also mentioned are paintings (presumably by Mongez herself), drawings of figures, plaster models, books on painting, five helmets, a plaster head of Jupiter, one hundred and fifty plaster models including warriors, horses and nudes.[24]

Mme Mongez' main works exhibited were her first major painting, *Astyanax arraché à sa Mère* (1802), *Alexandre pleurant la mort de la femme de Darius* (1804) for which she received the only first-prize gold medal at the Salon, *Thésée et Pirithoüs* (1806), *Orphée aux Enfers* (1808), *La Mort d'Adonis* (1810), *Perseus et Andromède* (1812), *Mars et Vénus* (1814), *Saint Martin partageant son manteau avec un pauvre*

(1819), and her impressive last Salon exhibit *Les Sept Chefs devant Thèbes* (1827). From the very first, Mme Mongez set out her stall as a history painter and nothing less. Her subjects clearly emulated the masters of French academic art, and were comparable to subjects set for the *Prix de Rome* competitions which she could not enter. Le Brun, Lagrenée the Elder and David had chosen subjects similar to her 1804 medal-winning painting. Many of the *Prix de Rome* subjects were rather static, with deathbed scenes, or judgements by worthy men on thrones, and the most lively moment selected during the first Empire was the 1812 *Ulysses and Telemachus slaying Penelope's Suitors*. Mongez had a number of compositions where action was important, and in her *Perseus and Andromeda* (figure 8) she went one better than most of the male *Prix de Rome* competitors and included a female nude . Female nudes rarely appear in *Prix de Rome* entries, as nude female models were prohibited.[25]Mme Mongez' full-scale nude figures made it clear that there were no areas of art which were out of bounds for her. She situated herself as a David pupil alongside others such as Girodet and Gérard, proudly signing her 1806 Salon entry 'Mme Mongez, Élève de M. David, 1806'.

 This painting *Thésée et Pirithoüs purgeant le terre des brigands délivrent deux femmes des mains des ravisseurs* (*Theseus and Pirithoüs*) (figure 9) is an ambitious composition full of dramatic action. The subject was seen as original, displaying the artist's creative familiarity with classical mythology. It was certainly an outstanding piece of work for any artist of the time. Yet there are some intimate and sensual touches. The Herculean figure wielding the club has a lion-skin draped over his shoulder and falling between the crease of his buttocks. The woman he has just saved from her captor has one breast pressed against his crotch. In this central group the woman's hair falls gently against the top of the man's leg as he looks down at her with concern, and the movement of her hair against his crotch is continued by the drapery which comes right through between his legs. Strong blues and reds are used in the central group, while the brigand on the ground to the right wears a mustard-coloured tunic and dull pinkish leggings, an interesting choice of colours reminiscent of David's work, for example in his *Sabine Women*. David's use of nude male figures in this work was thought controversial, and he defended their use as both truthful and skilful, maintaining that clothed figures were easier to paint.[26] Thus Mme Mongez' inclusion of nude figures in her history paintings signified several things: her emulation of David's work; a demonstration of her grasp of the most difficult technical aspects of painting; and confirmation of her understanding of the most modern developments in Neoclassical history painting. The radicalism of David as a left bourgeois politician and artist persisted during the early years of the nineteenth century, despite his now official status. Davidian Classicism under Napoleon signified the modernisation of Classicism and the cultural hegemony of France in Europe within a period of somewhat precarious bourgeois rule. The tensions within bourgeois culture and ideology at this time opened up a space for women to participate in the creation of modern classical painting, where, despite women's lack of political rights, they strove to show

8 Line engraving after Angélique
Mongez, *Perseus and Andromeda*,
C. P. Landon, *Salon de 1812.*

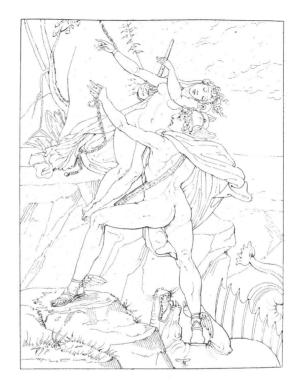

9 Angélique Mongez, *Thésée et
Pirithoüs purgeant le terre des brigands
délivrent deux femmes des mains des
ravisseurs* (*Theseus and Pirithoüs,*)
1806, oil on canvas, 3.40 × 4.49 m.

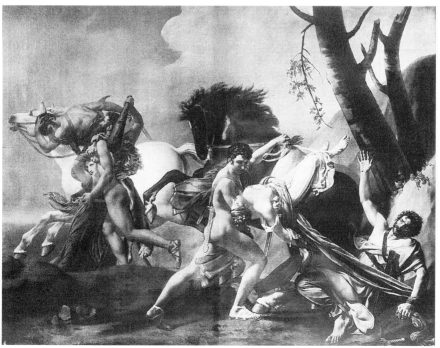

themselves as the equals of David's male pupils. Technically, of course, the Academy did not exist at this time and was only reinstigated after the fall of Napoleon, as a sign of the re-establishment of *ancien régime* culture and rule. The women history painters therefore inhabited a strange area somewhere on the margins of something that was not quite an academy, and excluded from the *École des Beaux-Arts*. These paintings from the Empire seem to me to signify that women choosing to exhibit publicly classical history paintings in a Davidian style were associating themselves with a continued commitment to equality and opportunity for women, even in the face of reactionary legislation on women and the family in the Code Napoleon of 1804.[27] Thus Davidian Classicism as modern Classicism practised by women painters does not equate with the Academy or the academic, but with opposition to the Academy perceived as a bastion of privilege and inequality of opportunity. They do not present Classicism as academic authority but as a site where women's erudition can be displayed and where their progress towards (at least cultural) equality can be represented.

As a woman, although married, Mme Mongez was bound to attract some comments relating to her representations of the male nude. The reviewer in the *Journal de l'Empire* (*Débats*) in 1806 (M. B.) wrote:

> But while artists admire the constantly improving merit of her drawing, and a vigour of brush without parallel among women, austere men are shocked by the kind of studies which all this knowledge suggests. It is however possible that Madame Mongez has studied and even executed her paintings more after the antique, and what are known as casts, than after life models.[28]

David's influence was detected in her work, and as noted above she publicly announced the master/pupil relationship on her canvas. This relationship had contradictory outcomes. On the one hand, David was thought to have had a hand in her work; on the other hand, it enabled Mongez' work to be seen as a defence and development of a modernised Classicism. Her work in taking forward Davidian history painting was troubling to notions of morality and conceptions of femininity among certain sections of the bourgeoisie, though she received state encouragement and more radical members of her class, as well as an important Russian aristocratic patron, supported her achievements. David acted as an intermediary to help Mongez to sell the work to Prince Youssoupov for 6,000 francs.[29]

A second David pupil, Sophie Frémiet, was also encouraged by him to take up a career in history painting. The subject chosen for the 1820 competition of the Ghent Academy was *La Belle Anthia* (*Beautiful Anthea*) (figure 10). Frémiet, aged 23, was runner-up in the competition, and David's influence is discernible in the tone of the work and use of colours which include mustard and a dull pink, reminiscent of the *Sabines* and later paintings. Anthea (posed by the artist's sister) is shown as a huntress. The figures are life-size as stipulated by the competition rules. An account by Frémiet herself speaks of David's support of her work when she entered it in the *Académie Royale de Dessin, Peinture, Sculpture et Architecture* competition. The

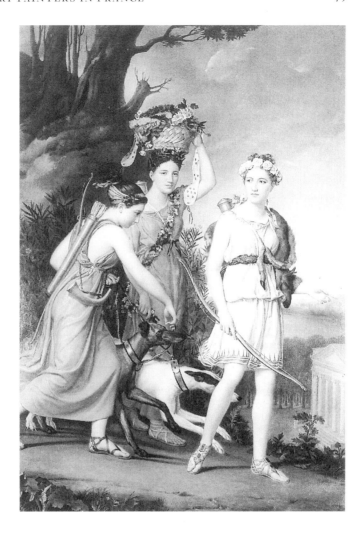

10 Sophie Frémiet, *La Belle Anthia*, 1820, oil on canvas, 2.57 × 1.80 m.

competition was for a *'prix de tableau d'histoire'*, and although she was runner-up to a much more experienced former pupil of David, her work was praised and purchased soon afterwards. Frémiet recounts that David, unable to travel to Ghent for the competition, wrote to Odevaere, the King's painter, to ask him to look at the competition entries and compare those of his young pupil and the older Pelinck, the eventual winner. Odevaere felt that Frémiet's was the better picture, the other being merely workmanlike. She has produced the superior work, he wrote. 'Your young pupil, who is a woman only in her dress but is a man by merit', deserves to win.[30] This praise may seem demeaning to the ears of women in the late twentieth century. However, if we place it in the context of its time it has certain progressive aspects. Such praise for Frémiet's work means that Odaevere, and probably David too, believed that women could be taught to paint history paintings, just as male students could. 'Masculinity',

signifying the conquest of artistic skill and public recognition, was not a natural endowment but could be learned. After 1826 Frémiet-Rude's work was mainly portraiture, and it does seem, in spite of some problems she had with David, that women were more likely to tackle history paintings sucessfully under his supervision. His encouragement of Frémiet and Mongez in terms of teaching, personal and professional aid, and help in selling their work and gaining other commissions testifies to his support of these women.

While David was in exile during the Restoration, his late work *Mars and Venus* was exhibited in Paris in 1824. Mme Mongez, along with another two of David's pupils, Naigeon and Stapleaux, had organised the display of the painting in rented rooms at 115 Rue de Richelieu. The painting was hung in a large square room with dark green drapery and was reflected in a mirror placed so as to exclude the reflection of the frame.[31] In a letter to David of 26 May 1824, Mongez describes the work's impact on her, referring in particular to the air of mistiness and the sensual flesh tones. 'You have never done better, my dear master, than to send us this painting to Paris, where the taste for true art and the style which you took such pains to develop was being lost. We needed this lesson, but it is a good one.' Mongez is thus speaking on behalf of David's pupils here, to their master. Mongez confesses she had rather different expectations of the painting before she saw it: '[i]t paralysed me and rendered me incapable of working for some days, so much did I realise my worthlessness, but at least I have the consolation of seeing that this staggering blow will strike many others.' Her husband finishes off the letter, congratulating David, but pointing out that he cannot discuss paintings as well as his wife as he is only an 'amateur' while she is the professional like David.[32] Mme Mongez had previously corresponded with David giving him her opinion of his work and its reception while he was in exile. In a letter to Mongez and Mme Mongez in 1817 David writes: '[y]our dear wife, my good friend, is the only person to have given me her opinion on my Psyche [*Cupid and Psyche*, 1817, now in Cleveland] the others, notably M. Gros, promised to tell me what they thought of it, but up till now nothing has come of this and I am still waiting.'[33]

Mme Mongez saw herself as part of what remained of the Davidian tradition in France and she clearly believed in the mid-1820s that David's work was still innovative and impressive as a model for French history painting. Like other pupils of David, she saw the master as a symbol of high principles in art and in political commitment.[34] She attempted to build on the impact of the Mars and Venus herself in her painting *The Seven Theban Chiefs* (1826) (figure 11) which was to be her last Salon painting.

This ambitious and complex work shows the oath of the seven Theban chiefs to support Polynices. The latter and Eteocles, sons of Oedipus and Jocasta, were to rule the city alternately each year. When Eteocles broke this agreement Polynices was helped by the seven chiefs against his brother in the War of the Seven Chiefs. Mongez refers back to David's *Horatii*, but goes one (or more) better, arranging a semi-circle of male figures around a foreshortened bull pledging themselves

to their historic mission. Some of them are clothed, but the two nearest to the spectator are heroic nudes in the Davidian manner reminiscent of the *Sabines* and the *Leonidas*. The figure on the extreme left is particularly well realised. The painting is very subdued in colouring with a blue-grey sky and castle in the background. The army in the lower right includes figures with blue and pink cloaks, the central figure wears white, and the figure second from the right wears a blue tunic and red cloak. The nude figure on the left has a red sword belt and red-strapped sandals, while the figure next to him has a white tunic and a pinky-grey cloak. The colour and tone of the work is fairly austere and possibly Mme Mongez never really managed to emulate the lush saturated colour of some of David's work. Perhaps this was one of her self-criticisms on viewing the *Mars and Venus*.

Whereas Prince Youssoupov had bought her 1806 Salon painting, the later painting was unfortunately not purchased and Mme Mongez donated it to the Museum at Angers through an intermediary in the year before her death. In spite

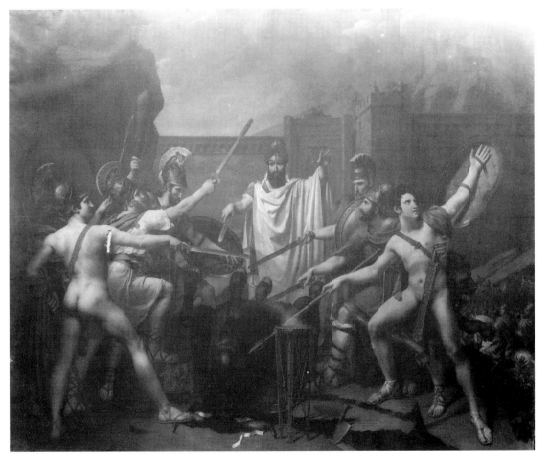

11 Angélique Mongez, *The Seven Theban Chiefs*, 1826, oil on canvas, 3.20 × 4.20 m.

of some critical support for her work, the future of the Davidian aesthetic without David was seen as bleak. The critic in *La Pandore* found the work a curious monument to a school nearing its end, composed of bits of David's paintings.[35] Jal pointed out that the work demonstrates that David did not do Mongez' work for her since he was dead by this date, yet nevertheless thinks that the work is unsatisfactory and 'bitty': 'I see in this painting arms, torsos, thighs, heads; but I am still looking for a man.' He adds: '[t]he Romantics looked at this lady's painting and laughed; I am sure she repaid their compliment.'[36] It is fair to say that the *Seven Chiefs* does not succeed in presenting a coherent compositional whole. This may partly be due to Mongez' being unable to study the male nude sufficiently and/or her desire to make clear references to David's previous works as the best examples for contemporary artists to emulate. Consequently, for whatever reasons, her work was bound to be seen as imitative and derivative of her teacher's.

Delécluze, himself a former pupil of David, defended Mme Mongez and, though recognising her work was not popular, claimed she had the right 'at least to the praises of those who practice the same art as she'. However, he believed that the image was more powerful than the written word and that his literary interventions on her behalf would therefore have little effect.[37] How much more true this would have seemed when the position of those he termed 'Homéristes' was weakened even further by the late arrivals of Delacroix's *Sardanapalus* and Sigalon's *Athalie* at the Salon.

It has been argued that there was an attempt to expel the feminine from 'official and élite visual culture' during the period from the Revolution to the late Restoration, precisely at the time when Mongez exhibited *The Seven Chiefs*.[38] It is certainly true that the increased commercialisation of visual imagery during the mid-nineteenth century was accompanied by a corresponding commodification of representations of the female body to a far larger extent than that of the male, given the subordinate position of women and a dominant culture of heterosexuality. Mongez' painting was not only seen as part of a dying Davidian school whose master's radical bourgeois politics were outmoded but was also ill-suited to a more modern art market involving smaller paintings handled by dealers and a greatly increased production and distribution of lithographic prints. History paintings like those produced by Mongez needed either the prestige of official recognition through the maker's membership of the Institute or the Academy, or the support of teachers linked to official art bodies. Significantly David was never a member of the new Academy since he was in exile in Belgium during the Restoration. Academicism in the Restoration could not easily recuperate Davidian Classicism. For rather different reasons than those earlier in the century, Mongez' work as an artist was still marginalised. With the death of David, Mongez' support and links with acknowledged masters disappeared, precisely at the time when she was able to exhibit work which could not possibly have been touched by her teacher. Thus for a number of reasons Mongez found herself in a weak position in the Parisian art world of the later 1820s, though she was a mature artist aged

fifty-one arguably producing her most ambitious work. By this time, the opportunities in the sphere of history painting which the Revolution had, in some ways, opened up for a few women artists, had almost disappeared. As the most radical phase of the French bourgeoisie became a memory, so did the early-nineteenth century contributions of women to French history painting.

Notes

1 G. Pollock, *Vision and Difference: Femininity, Feminism and Histories of Art* (London and New York,1988), pp. 48–9.

2 See chapter two of my *Seeing and Consciousness: Women, Class and Representation* (Oxford and Washington DC, 1995), and my more recent and extensive treatment of this topic in *Women and Visual Culture in France, 1800–1852* (London,1998).

3 A. S. Harris and L. Nochlin, *Women Artists 1550–1950* (Los Angeles, 1976), p. 46.

4 P. Grunchec, *The Grand Prix de Rome: Paintings from the École des Beaux-Arts 1797–1863* (Washington DC, 1984), p. 25. This useful catalogue uses material from Grunchec's more extensive book *Le Grand Prix de Peinture: Les Concours des Prix de Rome de 1797 à 1863* (Paris, 1983).

5 M. Sauer, *L'Entrée des demmes à l'École des Beaux-Arts 1880–1923* (Paris,1990), p. 36.

6 T. Crow, *Emulation: Making Artists for Revolutionary France* (New Haven and London, 1995).

7 Another recent work on gender and representation largely ignores women history painters, only mentioning Mongez in passing; see A. Solomon-Godeau, *Male Trouble: A Crisis in Representation*, (London, 1997), p. 47.

8 Twenty-two women artists exhibited their work, see M. A. Oppenheimer, 'Women artists in Paris, 1791–1814' (D.Phil., New York Institute of Fine Arts, 1996), p. 12. Oppenheimer points out that numbers of women artists were rising in the immediate pre-revolutionary period.

9 See for example Harris and Nochlin, *Women Artists*, p. 45.

10 See E. Harten and H. C. Harten, *Femmes, Culture et Révolution* (Paris,1989), p. 72.

11 G. Biedermann, 'Les femmes peintres de l'Académie royale de peinture', *L'Estampille*, 204 (1987), pp. 46–54.

12 J. Thuillier, 'The Beaux-Arts Institution', in Grunchec, *The Grand Prix de Rome*, p. 20.

13 Oppenheimer, 'Women artists in Paris', p. 55.

14 A. Schnapper, 'La peinture française sons la révolution', in *De David à Delacroix: La Peinture Française de 1774 à 1830*, exhibition catalogue (Paris, 1974), p. 109.

15 Grunchec, *The Grand Prix de Rome*, p. 30.

16 D. Wildenstein and G. Wildenstein, *Louis David. Recueil de Documents complémentaires au catalogue complet de l'oeuvre de l'artiste* (Paris,1973), pp. 23–4.

17 Oppenheimer, 'Women artists in Paris', pp. 41, 44.

18 *Ibid.*, pp. 34, 45–6, 48. The manuscript, written by Amélie Romilly, is in the Bibliothèque Publique et Universitaire, Geneva, Ms. Fr. 3210.

19 See chapter two of V. Cameron's D.Phil., 'Woman as image and image-maker in Paris during the French Revolution' (Ann Arbor, 1984).

20 A. Boime, *The Academy and French Painting in the Nineteenth Century* (London, 1971), p. 23.

21 Oppenheimer, 'Women artists in Paris, p. 240.

22 M. Geiger, 'Sophie Rude (1797–1867). Une élève de David et son évolution artistique (avec essai de catalogue de son oeuvre)', *Bulletin de la Société de l'Histoire de l'Art Français*, Année 1987, (1989), pp. 167–90, esp. p. 172.

23 Details from Oppenheimer's thesis, the *Nouvelle Biographie Générale*, edited by Dr Hoefer (Paris, 1968), and catalogue entry no. 208 in *Jacques-Louis David 1748–1825* (Musée du Louvre, Musée national du Château de Versailles, Paris, Réunion des Musées Nationaux), 1989.

24 Mme Mongez' inventories and wills are in the Archives Nationales, ET. LIV 1491, 21 Mars 1855. Mme Mongez' possessions are typically bourgeois apart from her art and art materials – furniture, clothes, some railway shares, debts which have to be collected, works by classical French authors such as Molière, Corneille, Labruyère and fifty-two volumes of the *Biographie Universelle*. However, her classical tastes did not prevent her from enjoying Walter Scott's novels along with many other members of the bourgeoisie.

25 This was expressly forbidden in a rule of 1846 cited in Grunchec, *The Grand Prix de Rome*, p. 26. Nude female models were not used for academy drawing classes but were available in private studios, according to C. Clements, 'The Academy and the other: *Les Grâces* and *Le Genre Galant*', *Eighteenth Century Studies*, 25 (1992), pp. 474–6. After 1863 female models posed for students at the *École des Beaux-Arts*, see *L'Art du Nu au XIXe siècle: le photographe et son modèle* (Paris, 1997), pp. 13, 20.

26 Wildenstein and Wildenstein, *Louis David*, p. 150. When the painting was first exhibited, the genitals of the male figure on the left were visible. David covered them with a sword scabbard later.

27 See P. McPhee, *A Social History of France 1780–1880* (London and New York, 1992), pp. 84–5 for a summary of the Code Napoleon.

28 'Salon de l'an 1806', *Journal de l'Empire* (*Débats*), 4 October 1806, pp. 3–4, for comments on Mongez' picture. The reviewer suggests that Mongez' probable use of casts excuses the rather sculptural look of the figures. Reviewers' comments on Mongez' works are discussed in the article by Margaret F. Denton, 'A woman's place: the gendering of genres in post-revolutionary French painting', *Art History*, 21:2 (1998), pp. 219–46, which appeared just as I finished writing this. I feel that Denton underestimates the importance of wider economic, political and social factors significant for the production of history paintings by Mongez and others in the period after the Revolution, and which resulted in a more fluid and contradictory situation than the one she discerns.

29 *Jacques-Louis David 1748–1825*, p. 612.

30 *Autour du Néo-classicisme en Belgique 1770–1830* (Brussels, Musée Communal des Beaux-Arts d'Ixelles, 1985), p. 253, catalogue no. 223. See also Geiger, 'Sophie Rude', p. 170, and L. de Fourcaud, *François Rude Sculpteur: ses oeuvres et son temps (1784–1855)* (Paris, 1904), pp. 104–7.

31 D. Johnson, *Jacques-Louis David: Art in Metamorphosis* (Princeton, 1993), p. 270.

32 École des Beaux-Arts, Paris, Ms.318 no. 65. Extracts in Johnson, *Jacques-Louis David*, pp. 261–2. The whole letter is reprinted in J. L. J. David, *Le Peintre Louis David* (Paris, 1880), vol. 1, pp. 590–1. Johnson says that most of David's students were baffled by the work, and Gros prevaricated in his letter to David, merely flattering his former teacher with empty phrases such as 'worthy of Homer' p. 262.

33 Wildenstein and Wildenstien, *Louis David*, p. 208.

34 For letters written by David pupils and their reactions to his death (Mongez is not men-
tioned) see G. Wildenstein, 'Les Davidiens à Paris sous la Restauration', *Gazette des
Beaux-Arts*, 53, (1959), pp. 237–46.

35 *La Pandore. Journal des Spectacles, des Lettres, des Arts, des Moeurs et des Modes*, 6
November 1827, p. 2.

36 A. Jal, *Esquisses, Croquis, Pochades ou Tout ce qu'on voudra sur le Salon de 1827* (Paris,
1828), pp. 270–1. I discuss critical responses to the work in more detail in my *Women and
Visual Culture in France 1800–1852*, (London, 1998), ch. two.

37 Delécluze in *Journal des Débats*, 23 December 1827, pp. 2–3.

38 A. Solomon-Godeau, 'Male trouble: a crisis in representation', *Art History*, 16:2 (1993),
pp. 286–312, and her 'The other side of Venus: the visual economy of feminine display',
in V. de Grazia with E. Furlough, eds, *The Sex of Things: Gender and Consumption in
Historical Perspective* (Berkeley, Los Angeles and London,1996,) pp. 113–50.

Private advantage and public feeling: the struggle for academic legitimacy in Edinburgh in the 1820s

Duncan Forbes

The refashioning of structures of artistic patronage in Britain during the early years of the nineteenth century fostered disputes in a number of cities between emergent groups of professional artists and established coteries of lay patronage.[1] Edinburgh was no exception, and this chapter examines the attempts of its artists to establish their economic independence in a burgeoning art market dense with the play of power. After the political censorship and repression of the Napoleonic period, Edinburgh witnessed, in Henry Cockburn's words, 'an elevation of the whole liberal surface', and the struggle for control of the fine arts became implicated in the broader political antagonisms that so marked Scotland's cities during the 1820s.[2] With opposition to the exclusive practices of a distant aristocratic oligarchy more acute in Scotland than in other parts of Britain, the artists' manoeuvring against amateur patronage was seized upon by agitators and heralded as exemplary. For the liberal press the ideal of professional autonomy formed a potent weapon with which to attack the nepotism and conspiracy of Tory oligarchy. As we shall see, the *Scotsman* in particular offered unprecedented propaganda support for Edinburgh's would-be academicians, and in an environment devoid of accessible political institutions, the new Scottish Academy became a leading venue for a bourgeois class fraction eager to acquire new forms of social and cultural legitimacy.

'It is altogether impossible that artists can arrive at any degree of perfection till the *popular* voice assumes a despotic sway over their productions ... It is in great towns, and in great towns only, that the arts ever have, or ever can flourish.' So argued one Whiggishly-inclined contributor in the *Edinburgh Magazine* in 1819, emphasising what a pressing political priority the creation of accessible urban venues for the fine arts had become.[3] Certainly, the time seemed ripe for patrician intervention: Edinburgh's status as a fashionable capital of leisure and learning during the war years exposed the need for carefully regulated sites for the display

and exchange of contemporary art, and the commercial expansion of the period required direction towards more properly public ends. Critics became increasingly aware of the belatedness of artistic developments in Scotland, blaming the lack of progress on a toxic mix of Calvinist fastidiousness, comparative deprivation and the rigours of industrial rationalisation.[4] For most, the solution lay in extending the practice of improvement, so potent in the economic sphere, to the production of high culture, assimilating the liberal arts – as in England – to the workings of an already aggressively commercial nation.[5] After 1815, an expanding art market, fuelled by the opening up of Continental trade routes, provided steady business growth for increasing numbers of artistic middlemen, and we see for the first time in Scotland the appearance of the specialised urban art dealer. New modes of art criticism emerged, beginning to assert the strength of the indigenous (Scottish) arts, and the post-Napoleonic period also marked the birth of the historiography of Scottish painting. Escalating urban segregation helped define the parameters of a specific community for the fine arts in Edinburgh particularly in the stark division between the Old and New Town. By the 1820s distinctions between high and low had begun to cohere, with popular culture more persistently degraded, and the aesthetic mode divorced readily from more functional cultural forms.[6]

But these transformations were not immediately of benefit to Edinburgh's artists. Even during the 1820s, a decade of unprecedented growth in the Edinburgh art market, business activity in the fine arts was overwhelmingly focused on the resale exchange of prints and old master paintings. Modern art – with the exception of portraiture – was neither popular, nor yet especially prestigious: those few who could afford to purchase pictures followed traditional tastes, investing in imported works from distinguished and, by now, accessible foreign marts. Inevitably, the pull of the more open London market proved an attractive alternative, and after 1805 the majority of Edinburgh's artists headed south at one time or another, either in search of training (there were still no properly established life schools in Scotland), or of the good fortune that had so startlingly transformed the career of David Wilkie. For those who stayed behind, or returned to Edinburgh empty-handed, the pathway to success was a tortuous one, with advancement largely dependent on often humiliating client networks of patronage and control. In a hostile market, burdened by debt and occasionally threatened with imprisonment, Edinburgh's artists looked increasingly towards the collective solidarity offered by forms of professional association.

The artists' opening institutional foray, initiated by those at the lower end of the evolving professional spectrum, failed to transform itself into a fully-fledged academy. Edinburgh's Society of Incorporated Artists (1808–13) was an exhibiting body founded essentially as a protective incorporation of tradesmen, but it soon fragmented under pressure from the more elevated aspirations of its most successful members. Its collapse illustrates the competing pressures placed on emergent artists' organisations: for some they were a means of survival in a hostile working environment; for others a vehicle for extending their social authority into

the elite artistic circles of the urban public sphere. In an art market that was small and highly stratified, the Society's loose constitution failed to contain this diversity of interests, revealing the difficulties of achieving communal solidarity in a competitive profession still dominated by the powerful pull of lay patronage.

The failure of the Incorporated Artists loomed large in subsequent developments, not least because it provided Edinburgh's connoisseurs and collectors with irrefutable evidence of the necessity of their mediating influence. Utilising a traditional defence of propertied disinterest, they looked, above all, to the model of London's British Institution – in particular to its combination of a pedagogic commitment to antique art supported by the social stability of elite patronage with carefully orchestrated exhibitions of contemporary painting. As one reviewer commented in 1815, elite governance would help 'to prevent the disputes which necessarily arise from jarring interests', thus securing 'a much more judicious and impartial system of management'.[7] For their part, the artists' supporters responded by lambasting the critical pretensions of interfering connoisseurs, and increasingly utilised a rhetoric derived from political economy's assault on Old Corruption, emphasising meritocratic values and the freedoms to be won from market forces. As 'Candidus' argued in the *Scots Magazine* in 1815, why should artists submit to the 'painful discipline of public instruction from those who are unqualified for the task'?[8]

This war of words, vigorously articulated in Edinburgh's press, gradually favoured the forces of reaction, and Scotland's version of the British Institution, the Institution for the Encouragement of the Fine Arts in Scotland (henceforth, the Institution), was founded shortly afterwards in Edinburgh in February 1819 under the patronage of the Prince Regent and a selection of Scotland's leading aristocracy and gentry.[9] Following Henry Cockburn's myth-making appraisal of its activities, the Institution has often been characterised as a feckless 'aristocratic' organisation, inevitably antagonistic to contemporary artists by virtue of the status of its founders.[10] However, conforming to accepted patterns of voluntary organisation, its operations were controlled by a management committee comprising members of the lesser gentry and upper bourgeoisie, most of whom were either representatives of agrarian capitalism or its willing urban agents. Founding activists included the advocates Alexander Oswald, Alexander Wood, and the former Lord Advocate, Lord Meadowbank; Scottish officials of the exchequer such as Baron Clerk Rattray and Sir Henry Jardine; the Professor of Clinical Surgery at Edinburgh University, James Russell; the auctioneer and picture dealer, Francis Cameron; and an assortment of retired military figures and minor landowners including the Secretary of the Institution, James Skene. Other influential peripheral contributors included Walter Scott and the banker Sir William Forbes. Often closely associated by familial or professional ties, many of these men were prominent members of Edinburgh's predominantly conservative social and civic circles, their patterns of sociability – buttressed by the nominal support of Scotland's aristocracy – giving the Institution the air of an elite private club. Of particular importance were the close links between the

Institution and the Board of Manufactures, Scotland's eighteenth-century improving quango, with a number of key personnel involved in the management of both organisations.[11] Indeed, in 1829, as the Institution faced financial embarrassment due to competition from the recently-founded Scottish Academy, the Treasury awarded an annual stipend of £500 to be paid to it from the coffers of the Board of Manufactures, an attempt to sustain the Institution's authority in the face of withering public support.

Drawing on the rhetoric of its southern predecessor as well as the practice of the Board of Manufactures, the Institution's programme expressed a commitment to high culture directed at the competitive advance of a capitalist economy. Antique models were considered a key source of contemporary economic progress, encouraging 'beauty of form and elegance of ornament' at a time when 'the great powers of Europe and America are making the most vigorous efforts to exclude our manufactures from their territories, and to raise up a spirit of enterprise amongst their subjects'.[12] But despite its pedagogic ambitions, the Institution's initial exhibition programme of Old Masters, culled from its members' collections, proved far from successful – the 1820 exhibition receiving somewhere between five and six thousand visits. With no permanent public collection of its own, and having already exhausted Scotland's reliable private collections of Old Masters, the Institution turned its attention to contemporary painting, and the first of a series of modern exhibitions was opened in March 1821.

The switch to exhibitions of contemporary art has often been interpreted by the Institution's opponents as evidence of the bankruptcy of its project and a sure sign of the rise of a new set of relations of artistic production in the capital. But as Edinburgh's Institution was consciously modelled on London's British Institution (which had held both modern and old master exhibitions since 1815) the accusation is unfounded, and there is good evidence to suggest that the support of living artists was part of the management's project all along.[13] Indeed, far from representing the unbridled ascendancy of a modern art market in Edinburgh, the displays of contemporary art proved only marginally more popular than their antique predecessors. Even in 1826, when the Institution moved into its spectacular Treasury-funded exhibition rooms on the Mound, the sale of paintings was unimpressive (figure 12). Despite visitor numbers of between 16,000 and 18,000, and unprecedented coverage in the local press, only forty-six paintings were sold, thirty-eight of which were bought by members of the Institution itself.[14] Certainly, there is no evidence of a vibrant modern-picture-buying public in Edinburgh during the 1820s. The purchase of contemporary painting remained the preserve of a small coterie of wealthy and well-connected lay patrons, affirming the distinction between private patronage and those who could not afford to buy.

With the Institution dominating both the exhibition and consumption of their work, Edinburgh's artists soon rekindled their campaign to establish an academy in the hope of gaining greater control over the techniques of innovation, specialisation and accumulation forced on them by competitive pressures. The exclusions

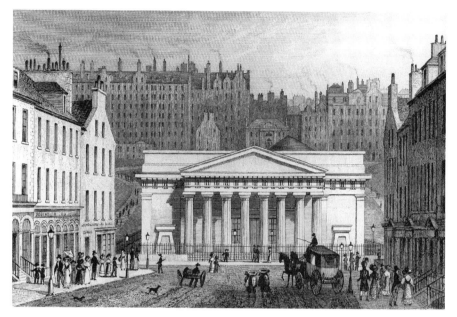

12 S. Lacy after T. H. Shepherd, *Royal Institution from Hanover Street,* engraving from Shepherd's *Modern Athens*, 1825.

embodied in the Institution's constitution (in particular the ban on artists' membership), as well as arguments over who should benefit from the profits of the modern exhibitions, generated disputes over the just regulation of institutional power; by 1822, in the wake of the Institution's two modern exhibitions, some of Edinburgh's 'oldest and best established Artists' were again organising to form their own association.[15] As their judiciously chosen intermediary, Sir Henry Raeburn, noted in a letter to James Skene, 'there was something degrading in the idea which had gone abroad, that they were unfit to conduct their own affairs', and he proposed a more tightly structured organisation than the earlier Incorporated Artists, 'admit[ting] only a limited number, and [making] it a *sine qua non* of admission, that the funds shall never be divided'. Furthermore, any attempt to work within the orbit of the Institution was completely ruled out: it 'necessarily implied a power of control on the one side, and a state of dependence on the other, to which, in so far at least, as concerns the use of their own property, arising from the fruit of their own labours, there was no necessity for subjecting themselves'.[16] It was this claim of right to direct their labour according to their own aspirations that formed the keystone of the artists' argument over the coming decade. Even Raeburn, who had no need now to become involved in anything that might ruffle his patrons' pride, admitted the legitimacy of their claims, noting that he found several of their arguments 'unanswerable'.

By 1824 the Institution was under attack both from artists claiming control of the management and profits of its modern exhibitions, and from growing

opposition in the press to its secret and exclusive practices. As we have seen, the Institution's failure to publicise its activities encouraged Whig opposition from the start, with critics arguing that the transfer of art to the urban public sphere would only be effective morally and commercially if the social relations governing its display were also transformed. The *Scotsman*, too, worked hard to rally a diverse liberal constituency – comprising members of the urban gentry as well as the variegated 'middle ranks' – in opposition to the self-elected juntas of placemen and pensioners that organised what passed for municipal and national government in Scotland. Inevitably, Edinburgh's Institution was included in the frame of its assault, criticised both for its failure to embrace the new regulatory principles coming to dominate the workings of public life, as well as blocking what was increasingly perceived to be the central regulating mechanism of artistic practice, the 'free' operation of the market. In a bourgeois culture saturated by discourses of political economy, Edinburgh's would-be academicians conceived of professional authority primarily in terms of commercial power, and at this stage there was little echo in their campaigning either of a residual civic humanism or the kind of anti-commercial arguments that so often appeared in the public apologetics of London's Royal Academicians.[17] Acutely troubled by their artisanal status, but as yet only dimly aware of their function as corporate representatives of a national culture, a strident commercial rhetoric proved the most potent weapon for those eager to escape the monopolistic authority of lay patronage.

Although the Academy's pedagogic potential as a national institution was rarely articulated, the general tenor of emergent art criticism in Scotland during the post-Napoleonic period worked subtly to undermine the Institution's project, its expression of a vibrant civic nationalism implicitly hostile to the dynamic of a private club founded on reverence for antique models and headed up by a select coterie of absentee landlords. The pleasures of peace brought with them a revived interest in the development of an indigenous artistic tradition, including early attempts to construct an autonomous history of 'Scottish' painting.[18] During the 1820s, an environmentalist art criticism – 'especially suited to the characters of our minds' – began to supplant that grounded in a British imperial framework, expressing less ambiguous support for the inferior academic departments of landscape and genre.[19] This attempt to construct a naturalised Scottish school of criticism conflicted with traditional estimations of value in the fine arts, inducing a growing uncertainty about the relevance of metropolitan academic criteria for Scottish painting and generating anxiety in those academicians faced with the commercial popularity of non-academic art.[20] However, the authority of 'Scottish school' discourse was quickly established, and by the early 1830s a national romantic explanatory paradigm had become the dominant critical mode, its meanings and identifications quickly becoming central to the business culture of the thriving bourgeois art markets that sprang up first in Edinburgh and then Glasgow during the 1830s and 1840s. Although riven by contradictions, the wider integration of high culture at the level of the (Scottish) nation proved remarkably resilient,

coexisting more or less harmoniously with the political and economic integration of the (British) state. Closely associated with the rise of the Scottish bourgeoisie, this network of hegemonic values and practices – termed in one recent study unionist-nationalism – was a product of the autonomy generated within the mechanisms of Scotland's expanding civil society during the nineteenth century, emphasising a simplistic Scottish distinctiveness whilst rarely posing any political challenge to the unity of the British state.[21] Combined with the growing commercial popularity of indigenous art, the mobilisation of Scottish school narratives proved vital for the structuring of academic authority, providing a tractile formulation of cultural distinctiveness and further undermining the relevance of the Institution's civic humanist and commercial discourses.

The agenda of the reform-minded press provided extensive propaganda support for Edinburgh's artists, its commitment to liberal politics and *laissez-faire* centrally constitutive of the artists' conception of their professional status. During the 1820s, the *Scotsman* called the Institution's directors to account for the secrecy of their financial activities; for their failure to hang exhibitions according to properly historicised principles of display; for the lack of information provided to visitors; as well as their indifferent spelling of the names of Old Masters.[22] Coupled with more general comments about the inadequacies of connoisseurs, these lapses called into question the Institution's commitment to public openness. As the *Scotsman* argued in 1825, 'too much mystery is thrown over the whole … it is not enough to mean well or to do well; the general public must be made to see *how*'.[23] Then again, in a lead article the following year:

> Little good can be done without *general* patronage; but that is what never will be afforded until the public be *interested*; and that interest is to be generated only by frank and full communications … [the directors of the Institution] *have been* more aristocratic, and less communicative than could have been wished.[24]

However, the most persistent target of attack was the Institution's series of exclusive 'Evening Dress Parties' offering select and scrupulously regulated access to the various exhibitions. These private promenades amounted to an elaborate seasonal display of authority on the part of Edinburgh's civic elite, providing a forum for the acquisition and display of corporate self-consciousness (figure 13). Non-transferable entrance tickets were available in limited numbers only from members of the Institution themselves, and the complex rules of ticket distribution were widely advertised in the Edinburgh press. Unlike the Scottish Academy's more accessible philanthropic promenades of the 1830s, the Evening Parties had no public function. For the *Scotsman* this was the rub: the promenades, organised 'exclusively for [the directors] and their friends', displayed a 'monopolizing, aggrandizing, or selfish spirit' and prevented the exhibition being seen '*in a light* to which all had access on equal terms'. Everything in Edinburgh, it concluded, was 'tainted by an exclusive or aristocratical spirit'; the Institution's directors should cease 'direct[ing] an intelligent public by their coterie principles'.[25]

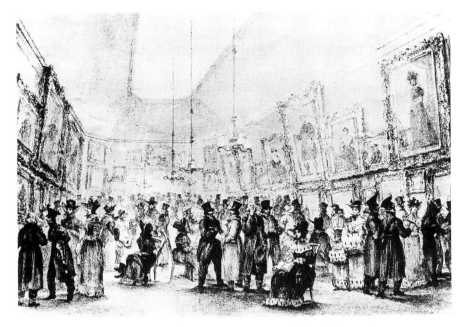

13 William Turner, *First Evening Dress Party in the New Galleries, Edinburgh*, lithograph.

Although this reframing of the artists' struggle into a clear opposition between 'aristocratic' and liberal forces worked to misrepresent the nature of the conflict, its rhetorical force was substantial in a society burdened by long-running disputes over ecclesiastical patronage. Aware that they were unlikely to win the propaganda battle, the Institution's directors acted swiftly to neutralise the opposition, and in 1824 they established a category of associate artist. The manoeuvre was designed to forestall further moves to autonomy by incorporating a leading selection of the city's painters within the body of the club; those who accepted the invitation were already closely connected with the city's patronal elite (they included William Allan, Samuel Joseph, Alexander Nasmyth, George Watson, Hugh W. Williams and Andrew Wilson). As in the case of the Incorporated Artists, the city's painters failed to unite in the pursuit of a clearly defined set of corporate interests, and the move had the important strategic implication of dividing Edinburgh's artists into two distinct camps (figure 14). For those without the ear of Edinburgh's patrons, economic independence – the founding of an academy – was an absolute. For others, usually those better established, the acquisition of professional autonomy involved a more complex process of negotiation with the city's cultural elites, working within, rather than against, existing institutional hierarchies. As one would-be academician put it, the 'old established artists' should cease 'meanly truckling to power' and instead 'begirt themselves for active combat'.[26]

There is no need here to reconstruct the exceedingly complex pattern of moves, counter-moves and strategic realignments that constitute the working out of this

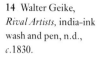

14 Walter Geike,
Rival Artists, india-ink
wash and pen, n.d.,
c.1830.

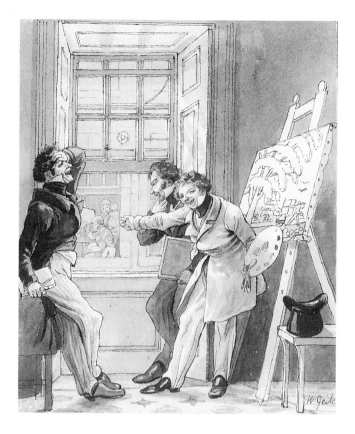

confrontation. Many of the Institution's sixteen associate artists benefited exten-
sively from its patronage, although the offering of generous premiums and fifty-
guinea commissions did little to resolve the artists' fundamental grievance, which
revolved around their lack of formal rights in relation to the exhibiting practices of
the club. The directors continued to assert that the Institution should be placed
under 'the sole direction of men of such rank and station in the country as to pre-
vent the possibility of any personal views ever being attributed to their manage-
ment'.[27] At a time when the fine arts, like the city's more developed literary
networks, were densely integrated into the upper echelons of an acutely hierarchic
social structure, most of the associate artists refused to join the Scottish Academy
when it was founded in May 1826, remaining instead with the Institution. Such
was the authority of rank, that in January 1827 six founding Academicians trans-
ferred to the Institution, with one of their number, Kenneth Macleay, noting that
his actions derived from the lack of 'unanimous approval of the Artists of Scotland
and particularly of the leading men of the profession in Edinburgh'.[28]

The struggle between the Institution and the Scottish Academy for control of
the urban fine arts was eventually resolved in 1829 with the signing of the Hope-
Cockburn Award, an act of professional mediation led by two of Scotland's leading

legal figures (one Tory, one Whig), bringing both groups of artists together in the form of the autonomous and reconstituted Scottish Academy. This gingerly worded legal document discreetly capped two years of bitter confrontation, which had involved a hard fought propaganda battle between the two sides, competing modern exhibitions and a protracted struggle with the state over respective Charters of Incorporation. (The Academy was eventually granted its Charter in 1838.) Throughout this period the Institution continued to refuse any rights to its associates, and the Hope-Cockburn Award represented the recognition by Edinburgh's artists that the Institution's model of management was irretrievably bankrupt. If a symbolic date is needed, then July 1829 marks the ascendancy of a new set of patronage relationships in Edinburgh.

Concerned to augment the social and economic value of what were essentially artisanal modes of manufacture, the Academicians drew on technologies first practised by the welter of professional and voluntary associations that emerged in Edinburgh during the early nineteenth century. Such activity expanded rapidly after 1810, a disciplinary and philanthropic response to the inequality and unrest fostered by rural migration to the city.[29] Voluntary forms were situated at the very heart of bourgeois ascendancy, carving out a space for social and political action within the boundaries of civil society, and thus defining the limits of bourgeois power. In an economy where the state was in many senses subordinate to the workings of civil society, the processes of specialisation embodied by an artists' academy were not only a reflex of increased competition, but also a concerted attempt by artists to arrogate the social authority of the fine arts to the bourgeois public sphere. As Geoff Eley has argued, voluntary association formed the 'primary context of expression for bourgeois aspirations to the general leadership of nineteenth-century society', and was thus deeply implicated, not only in the pursuit of a new liberality and rationality in public life, but also in issues of '*interest, prestige,* and *power*'.[30]

In 1828, Samuel Joseph, a wavering associate of the Institution, weighed up the relative merits of both organisations. Opting for the Academy, he outlined its advantages in the following way:

> Its constitution leads the artists to rely on their own talents, character and intelligence, for success, which has a natural tendency to elevate them in worth and attainments. It permits genius to feel its power, and morality its security in the approval of an enlightened public. It brings the artists into more immediate communication with society at large; cherishes a spirit of honorable emulation; favours independence, and cultivates reciprocity of respect on the part of the artists, and kindness on the part of their Patrons. It cherishes habits of providence by training the artists to look to their own exertions as the means of providing a fund for themselves and families. It tends to produce liberality, co-operation, and mutual respect among the artists themselves, because where power is equally possessed by all, superior character and talent will have the best chance of ascending, and less scope will be left for jealousy and envy, or the supposition of honors being conferred, or favours bestowed from considerations unconnected with merit.[31]

The invocation of these values, buttressed by hegemonic conceptions of political economy, dominated early Academy discourse, and were mobilised explicitly to counter the capricious and less public world of conservative elites. Notions of independence, unhindered competition and mutual co-operation – never envisioned as being incompatible – were elevated under the watchful gaze of a vaguely defined, although 'enlightened' public. The language of 'independence', a beguiling incorporative rhetoric often directed at the upper strata of the working class, could also be utilised to challenge the artisan's traditional reliance on the omniscient patron. Its many complex associations, as this passage from the *Scotsman* reveals, included a robust and publicly oriented masculinity:

> The principle, which, with the view of inducing the labouring classes to secure independence, and provide against the accidents of life, by their own industry and foresight, renders it expedient or rather necessary to give them a *share in the management* of their own benefit societies; requires also that Artists should, by associating together, with equal duties and equal rights and privileges, obtain a full conviction of the benefits of co-operation ... This [the founding of the Scottish Academy] was now taking their right position with the public. It was manifesting a becoming reliance on their own powers, and on public feeling. It was the only way, in short, by which they could prove themselves MEN – intelligent, useful, and worthy members of society – as well as ARTISTS.[32]

The principle of public scrutiny is also invoked as a key regulatory mechanism governing the new relations of artistic production, mobilised to oppose systems that the artist, Patrick Gibson, described as 'directed more to private advantage, and the gratification of selfish feelings, and the attainment of selfish ends, than the accomplishment of those generous purposes, which ennoble human nature and shed lustre on society'.[33] During the 1820s the political implications of this discourse were inescapable, a fact emphasised by Gibson even in the course of their denial:

> I am no advocate for the monstrous doctrine of universal suffrage, nor for those theories of reform which would subvert the fabric of society; but it is clear, that, if ever the representative system was of any use, it was in a case like the present. Here was no risk of a political convulsion, no risk of raising the demon of democracy above the sphere in which, for the peace and wellbeing of society, he is destined to move; but the simple fact of a score of quiet, decent, sober-minded men of genius, demanding the right of having a say on matters solely their own.[34]

Gibson's description of an academy as a 'representative system' reminds us that the liberal principles underpinning these rationalisations were drastically breached in practice. The artists' longing for prestige and social domination meant that in 1826 the Scottish Academy was constituted on a model drawing directly from the Royal Academy in London: a closed and exclusive private association, superficially open to the operations of the public sphere, but in reality hedged in by exclusionary economic barriers (a twenty-five guinea membership fee), restrictive hierarchies (initially limited to fifteen academicians and ten associates) and intimidating

regulations and ritual (see the disciplinary code in the Academy's constitution). Despite Joseph's hopeful assertion, it was never intended that power should be 'equally possessed by all', and it was through these financial and status exclusions – as well as the gender barrier common to most organisations in the public sphere – that the members of the Scottish Academy chose to preserve what their first annual report described as 'the dignity of their profession'.[35]

Gibson's terse denial of the political ramifications of his struggle exposes the contradictions involved in a quietistic clique of artists making strategic use of discourses utilised by a powerful emergent political bloc in Edinburgh during the 1820s. (Although the Academy's protracted attempts to attain a Charter of Incorporation brought its members into direct conflict with the Lord Advocate and the networks of secrecy and patronage that structured political life in Scotland, there is no evidence that any Academician was involved in direct political protest.) The 1820s saw a transformation in levels of political activity in Edinburgh, with Whig elites attempting to harness the support of bourgeois opinion in order to convert their growing social authority into direct political power. At the beginning of the decade a series of large public meetings articulated the case for reform, providing members of the middling ranks with their first direct sense of their political potential as a united class. Leading Whigs such as Henry Cockburn, Francis Jeffrey and Thomas Dick Lauder roused the respectable, propertied, Edinburgh citizenry to political protest, urging them to counter the perceived indifference of the lower ranks and the venality of the higher. Described by contemporaries as the 'anti-Tories', the diverse constituency that made up this new body politic provided evidence of an 'organic crisis' threatening the authority of Britain's traditional ruling bloc. Cockburn, a staunch supporter of the Academy, proved to be the Scottish bourgeoisie's most tenacious defender, and along with Francis Jeffrey he was responsible for drafting the bill which enfranchised the £10 property holders in 1832.[36]

It was from this liberal 'central rank', as contemporaries described it (a political middle class in the making), that the Scottish Academy attempted to build its constituency, and from 1828 – shirking complaints of illiberal practice that had been levelled earlier at the Institution – it deliberately forged closer links with leading members of the commercial and professional bourgeoisie as well as reform-minded urban gentry.

Academy dinners, promenades and private openings were central to this emergent business culture, encouraging the circulation of artistic commodities and providing a congenial atmosphere within which academicians could foster ties of mutual obligation with urban patrons. Guest lists at the Academy's annual suppers were dominated by the names of Edinburgh's leading active citizenry (Cockburn and Jeffrey were regular guests), as well as representatives from a variety of middle-class associations, their presence bolstering institutional links and encouraging bourgeois solidarity. The Academy's 1829 annual supper included prominent figures from the legal, religious and educational establishments, as well as other

members from the mercantile and professional classes (bankers, booksellers, a printer, the city's leading seedsman and florist, a prominent surgeon, small-scale manufacturers of all kinds, a civil engineer and figures from local government). Whilst it would be wrong to define the attachments of the Academy's supporters solely in terms of their economic functions, or suggest that they formed a political bloc utterly distinct from that of the Royal Institution (their number included a handful of prominent Tories), it is clear from the list of guests invited, the structuring of the toasts and the tenor of the reported speeches, that the members of the Academy and their guests consciously defined themselves in opposition to the Royal Institution.[37] For this brief period in its history, caught up in a wider struggle for political hegemony, the Academy fostered the support of members of a distinctive class fraction, those whose economic interests and ideological commitments were on the whole more deeply embedded in the commercial operations of an urban economy.

The space given over to celebrating this and other similar suppers in the liberal press reveals the importance accorded to institutions like the Academy in the struggle for bourgeois hegemony. For the *Scotsman* in particular, arrogating the authority and prestige of the fine arts to the bourgeois public sphere was a vital element in its propaganda battle against Tory oligarchy, and it proved very effective at exposing the Royal Institution's corrupt and secret practices. However, the Academy's private suppers themselves were far from public occasions: the (all male) guests were admitted by invitation only (about 100 for the 1829 supper), and unlike the Institution's private promenades they were funded directly from the Academy's coffers. Despite the *Scotsman*'s eager criticisms of the Institution's private gatherings, it had little to say about the exclusions of their academic equivalent, exposing the limits of the liberal critical agenda. Indeed, beyond the ritual reviews of annual exhibitions, the public aspects of the Academy's programme were subject to very little press scrutiny.

The centrality of these private forms of association to the Academy's early existence can be seen in the formation in October 1829 of a less formal sister organisation, the St Luke Club of Scottish Artists. Essentially a private supper club modelled on the Royal Academy's Academy Club, it was instigated in the wake of the Hope-Cockburn Award to encourage 'friendly intercourse amongst the members and for the promotion and discussion of all matters connected with the fine arts'. Membership, decided by ballot and costing two shillings and sixpence a year, was open to 'Artists by profession, Amateurs or promoters of the Fine Arts', and the founding list was dominated by members of the Scottish Academy.[38] But in 1834, in a significant shift of emphasis, the St Luke Club began a series of widely advertised annual dinners costing twelve shillings and sixpence. Although structured on the format of the Academy's private dinners, these suppers were governed by different rules of access: entry was gained by purchasing a ticket, rather than private invitation, and was thus (in theory at least) more open.[39] According to press reports these were popular events,[40] and they represent an attempt by the Academy

to enlarge its business culture and extend its influence beyond a narrow corpus of supportive patrons.

With the Hope-Cockburn Award of 1829, the opening chapter of the Scottish Academy's 170-year history came to a close, and although over the next twenty years there were continued attempts by a small clique of connoisseurs associated with the Board of Manufactures to frustrate the Academy's commercial expansion, the Royal Institution was allowed by its directors to slip slowly into obsolescence. For a brief period between 1822 and 1830, the battle for academic legitimacy in Edinburgh became closely intertwined with a broader struggle for bourgeois political representation, a fact explained not only by the symbolic power of the fine arts, but also by the dearth of formal political institutions through which that struggle could be engaged. As a prominent, although vulnerable, urban association in an era before the beginnings of limited middle-class suffrage, the Scottish Academy eagerly associated itself with the Whig-led opposition, and its public and private faces provided important venues for the demonstration of bourgeois solidarity and the display of newly acquired professional capital.

To what extent other artists' organisations were significantly structured by this seismic shift in the shaping of the British body politic deserves further detailed investigation. Certainly in Edinburgh the rapid transformation in the balance of urban politics during the early 1830s – driven in part by the fear of Radical incursions – gave great impetus to the Scottish Academy's campaign for legitimation, and it was very quickly able to co-opt the majority of those who had once defended opposite ground. By 1833 the Academy's role as the central professional authority on the fine arts in Scotland was firmly established, the philosophical and economic power of a congealed aristocratic culture finally subordinated to its bourgeois equivalent.

Far less secure was the Academy's ability to foster a thriving commercial culture, and its finances remained in dangerous disarray, a situation the Academicians blamed on a variety of extra-artistic factors, including Edinburgh's deadly cholera outbreaks and the mood of disquiet generated by the political upheaval of the early 1830s.[41] However, these economic difficulties were substantially resolved in 1834 with the formation of the powerful Edinburgh art union, the Association for Promotion of the Fine Arts in Scotland, founded in part by the Academy's Secretary, D. O. Hill, and managed predominantly by Whig sympathisers from the city's legal elite. Its links with the Academy were extremely close, its lottery mechanism resoundingly popular. And despite the worst economic recession of the nineteenth century, the art union poured around £40,000 into the Academy's coffers over the next fifteen years, working to construct what the Academy itself could never achieve unaided: a large bourgeois public for the fine arts in Edinburgh. Not surprisingly, the power of the Scottish Academy and art union bloc generated considerable opposition, with counter-organisations emerging during the late 1830s challenging both its paternalist attitude to public patronage, as well as its protectionist stranglehold over the Edinburgh art market. But the challengers were

quickly disposed of, and by the mid-1840s, thanks largely to the institutional patronage of the art union, the Royal Scottish Academy celebrated its role as the august guardian of public taste in what its members proudly claimed was the second artistic city of the Empire.[42]

Notes

I would like to thank Colin Trodd and Terry Brotherstone for their help with this essay.

1 T. Fawcett, *The Rise of English Provincial Art: Artists, Patrons and Institutions Outside London, 1800-1830* (Oxford, 1974), and J. Seed, '"Commerce and the liberal arts": the political economy of art in Manchester, 1775–1860', in J. Wolff and J. Seed, eds, *The Culture of Capital: Art Power and the Nineteenth-Century Middle Class* (Manchester, 1988), pp. 45–81.

2 H. Cockburn, *Memorials of His Time* (Edinburgh and London, 1909), p. 254.

3 *Edinburgh Magazine*, April 1819, pp. 290 and 294.

4 See the *Scotsman*, 20 April 1822, p. 126.

5 *Scots Magazine*, June 1815, p. 413.

6 For a full account of these developments see D. Forbes, 'Artists, patrons and the power of association: the emergence of a bourgeois artistic field in Edinburgh, *c*. 1775–*c*. 1840' (unpublished Ph.D. dissertation, University of St. Andrews, 1996).

7 *Scots Magazine*, May 1815, p. 327.

8 *Ibid.*, September 1815, p. 75.

9 The archive of the Institution is held in the Scottish Record Office (hereafter SRO), Edinburgh, NG 3/1–7.

10 Cockburn, *Memorials of His Time*, p. 337.

11 The Board of Manufactures' papers are held in the SRO, NG 1/1–73.

12 SRO, NG 3/7/3, 'Circular to the nobility and gentry requesting them to support the Institution', 10 May 1820.

13 *Edinburgh Evening Courant*, 5 April 1819, p. 3.

14 *Scotsman*, 10 February 1827, p. 92.

15 'Roger Roundrobin' [Patrick Gibson], *A Letter to the Directors and Members of the Institution for the Encouragement of the Fine Arts in Scotland* (Edinburgh, 1826), pp. 13–14.

16 SRO, NG 3/4/4, 24 December 1822.

17 C. Trodd, 'The authority of art: cultural criticism and the idea of the Royal Academy in mid-Victorian Britain', *Art History*, 20, 1 (1997), pp. 3–22.

18 'Progress and present state of the fine arts in Scotland', *Edinburgh Annual Register, 1816* (Edinburgh, 1820), pp. 470–82.

19 'Remarks on the history of painting in Scotland', *Edinburgh Magazine*, November 1817, p. 327.

20 *Scotsman*, 21 February 1829, p. 119.

21 L. Paterson, *The Autonomy of Modern Scotland* (Edinburgh, 1994).

22 *Scotsman*, 11 March 1820, p. 87.

23 *Ibid.*, 26 February 1825, p. 134.

24 *Ibid.*, 15 February 1826, p. 97.

25 *Ibid.*, 25 March 1826, p. 191.

26 See Gibson's other anonymous pamphlet criticising the Institution, *Report of the Edinburgh Society of Cognoscenti on the Exhibition of the Scottish Institution for Encouraging the Fine Arts* (Edinburgh, 1822), pp. 37–8.

27 SRO, NG 3/1/1, document dated 18 January 1825.

28 Royal Scottish Academy, Edinburgh (hereafter RSA), uncatalogued letter, 11 January 1827.

29 For a full analysis see A. J. Dalgleish, 'Voluntary associations and the middle class in Edinburgh, 1780–1820' (unpublished Ph.D. thesis, University of Edinburgh, 1991).

30 G. Eley, 'Nations, publics, and political cultures: placing Habermas in the nineteenth century', in C. Calhoun, ed., *Habermas and the Public Sphere* (London, 1993), pp. 298 and 307.

31 SRO, NG 3/4/32, letter from Joseph to Francis Cameron, Assistant Secretary to the Institution, 15 February 1828.

32 *Scotsman*, 4 February 1829, p. 73.

33 P. Gibson, *A Letter to the Directors and Members of the Institution*, pp. 23–4.

34 *Ibid.*, pp. 26–7.

35 RSA, handwritten first annual report of the Scottish Academy, dated 1828.

36 I. G. C. Hutchison, *A Political History of Scotland 1832–1924: Parties, Elections and Issues* (Edinburgh, 1986).

37 See the report in the *Edinburgh Weekly Journal*, 29 April 1829, p. 133.

38 A copy of the St Luke Club's rules, followed by a list of founding members, can be found amongst Walter Scott's papers, National Library of Scotland, Edinburgh MS 3912, f. 3738.

39 *Scotsman*, 8 March 1834, p. 1.

40 *Edinburgh Evening Courant*, 24 March 1834, p. 3.

41 See the Academy's *Sixth Annual Report* dated 13 November 1833.

42 For a full analysis of Edinburgh's art unions see Forbes, 'Artists, patrons and the power of association'.

From graphic to academic

Caroline Arscott

Luke Fildes exhibited *Applicants for Admission to a Casual Ward* at the Royal Academy in 1874. It is a painting that has long been hailed as a key work in nineteenth-century British social realism. Herkomer, Fildes, Holl and Walker introduced rather grim and troubling scenes of poverty, deprivation, suffering and death into Royal Academy painting in the late 1860s, 1870s and subsequent decades. Walker's *The Vagrants* (1867, Tate Gallery) shows a group of women and children, understood to be gypsies, in the open, huddled round a smoking bonfire. Herkomer's *The Last Muster* (1875, Port Sunlight) shows a group of aged Chelsea pensioners at church, just at the moment when one of them has died. His *Eventide: A Scene in the Westminster Union* (1878, Walker Art Gallery) takes as its subject a room in the women's section of the workhouse, inhabited by aged and infirm residents. Holl's *Newgate: Committed for Trial* (1878, Royal Holloway College) shows women and children visiting their imprisoned menfolk. Fildes's picture is set outside a police station. A queue of homeless people is waiting to be issued with tickets for overnight accommodation at the workhouse. Vagrants were accommodated in a separate section of the workhouse from settled inmates, in what was known as the casual ward. These casuals had to apply to the nearest police station for tickets certifying that they were genuinely needy and eligible for shelter. In this article I will be considering what was at stake in electing to present this kind of scene in the context of the refined and elevated setting of the Royal Academy.

Fildes selected a theme that spoke distinctly of the contemporary city. The title of the work assured the viewer as to the purpose of the assembly. The theme itself suggested the concentration of population in big cities, and the associated concentration of impoverishment, and displaced, homeless or drifting people. Various signs in the work reinforce this sense of the modern urban setting. The infrastructural elements of the paved street, its curb and gutter, the size and solidity of the police building with its gaslit entrance, the complex layers of public announcements posted on the wall, and, above all, the scale and variety of the assembled destitute crowd indicate the modern city. I will consider how this dingy aspect of the modern city came to be selected for the glittering environment of the Royal

Academy exhibition, and how this particular work relates to the range of representations that tried to come to grips with the down-side of modern life.

In his essay 'The discontinuous city' John Tagg lays out five key characteristics of representational systems that seek to assimilate modernity: the separation of subject from object, the fixing of difference, the immediacy of experience, the transparency of representation and the instrumental mode.[1] Tagg bases his account on the institutions and knowledges that sprang up in the industrial era. He closely follows the analysis of the disciplinary order developed by Foucault. The schools, police forces, military institutions, hospitals, prisons and departments of public health are all seen as crucial components of modernity, producing intersecting discursive fields which categorise, oversee and discipline the urban inhabitant. As a photographic historian Tagg is interested in the fantasy structures of the bourgeois subject (a certain kind of photographer, or viewer of photographs), who acts as an investigator *vis-à-vis* the working-class object of investigation. This bourgeois onlooker has much in common with the viewer of the social themes of fine art, whether in the pages of middle-class journals or on the walls of the Royal Academy, though we should exercise caution in jumping from one format to another, acknowledging the specificity of the kind of archival photography under consideration. Tagg considers the libidinal curiosity which such a bourgeois investigator experiences. He suggests that a libidinal urge is fundamental, acting as a kind of psychic underpinning, but points out that it is accompanied and overlaid by a corresponding repressive impulse. A free play of the libido would allow for mobile, substitutive operations of perception or apprehension. On the other hand, the action of repression tends to arrest the substitutive movements of desire. This produces a fantasy of fixed categories and polarised difference. Tagg suggests that this produces particular forms of representation.

> In the fantasy of the subject of this knowledge, the other of this singular and overpowering encounter could be totally and immediately known; reduced to a difference the system of difference produced, pathologised, desired and controlled. The fixing of this difference constituted the questionable alibi and unstable power of social discipline. It worked – insofar as it did – by arresting the proliferation of frames of differentiation, by reducing difference to duality, and by holding in place a rigid and irreversible polarisation of the positions of subject and object. But it also needed to enforce the immediate presence of that object to the subject, and this was produced by imposing a transparency on experience and representation, as the instruments of an overwhelming truth.[2]

Particular, instrumental, forms of photography, he suggests, are developed in collusion with disciplinary institutions, and offer models of knowledge, pleasure and subjectivity that compete, in some ways, with the forms produced by portrait photography, high art photography, or, post-1880, with the burgeoning field of amateur photography. The key example is the photography of those in custody, carried out by police or prison authorities. Photographic practice, he stresses, is stratified.

In a Postmodern gesture he renounces any totalising ideological reading of the relationship between class interests and representation – indeed the very notion of society or social totality is refuted, as being an illusory and temporary phantom. The position that bourgeois society is only a product of the fantasy structure of disciplinary discourse is not one that I wish to align myself with. Nonetheless Tagg's move from Foucauldian categories to the territory of psychic positioning and modes of representation is suggestive in many ways. The notion of fixity of difference that he associates with instrumental photography, and the emphasis on the multiple subjectivities produced by the stratification of photographic practice could be helpful in establishing the characteristics of the Fildes work that is the subject of this essay.

Fildes's painting *Applicants for Admission to the Casual Ward* (1874, Royal Holloway College; figure 15) has, as its subject, the working of the Poor Law which was a central disciplinary institution in Victorian Britain. Moreover, as a subject for art, it relates, very deliberately, to the image-making processes of social investigation and reportage. Mid-nineteenth-century realism had a knowing relationship to social and 'scientific' investigation. This was an issue for a wide range of images. In the context of Orientalism the relationship between fantasy and the ostentatious display of archaeological, geological and social knowledge has been extensively analysed in the work of Said and others.[3] In literature as well as the visual arts there was a constant interchange between fiction and fact; there was the recycling of fictive images in the context of reportage and the insertion of documentary elements in fictional settings. One example to consider would be the inclusion of portraits of well-known police detectives in the figures making an arrest in a painting by Frith. Frith's *The Railway Station* (1862, Royal Holloway College) is a humorous, fictional scene showing representative types assembled in a crowd at Paddington Station. Among the generic types particular historic personages appear, but, rather than rupturing the illusion, these portrait elements appear to have bolstered the audience's conviction of the overall truth of the image. Clearly there was two-way traffic between invention and investigation. It was not just that Dickens and Reade used Blue Books and newspaper reports as material for their novels, but that Dickens is regularly cited in the context of investigative journalism, or in purportedly factual guidebooks.[4] Tagg differentiates between fine art photography and instrumental photography, but any effort to differentiate between strata is complicated by the existence of forms of representation that stray from one area into another. We might think about Fildes's painting as occupying a position of overlap between strata, or invoking one stratum from another. It is an example of a fine-art image that participates in some of the operations of surveillance identified by Tagg. I propose that those instances of representation that trespass on the borderline between reportage and high art be considered in terms of categories of separation, transparency and fixity, within the libidinal framework of curiosity and repression. However, my argument does not lead me to the resounding conclusion that these works of realism can be bundled together as manifestations of the panoptic gaze.

15 Luke Fildes, *Applicants for Admission to the Casual Ward*, 1874, oil on canvas, 137.1 × 243.7 cm.

Vagrants, or casuals, were subject to different regulations from the regular inmates of the Victorian workhouse. The provisions of the Poor Law were dictated by the prevailing anxiety that state assistance would sap the will to work, and produce a costly, dependent population of sponging paupers. Workhouses were set up throughout Britain as punitive institutions closely allied to prisons.[5] The theory was that food and shelter could only be dispensed to those who came under the roof and the rules of the institution, and the rules were designed to be so strict and austere that scroungers would be deterred. The indigent would be separated from the general population and could be taught valuable lessons of discipline, application and time-keeping within the sealed environment of the workhouse. This separation of paupers from the general population was considered desirable, as the moral failings leading to poverty (idleness, improvidence, drunkenness) could, at least, be prevented from communicating themselves to other sections of the workforce. Pauper children were allowed out to attend school, and in some areas the aged were allowed out at intervals, but, by and large, paupers were incarcerated so long as they received assistance. They were also intended only to receive assistance in their parish, or union, of residence, and powers existed under the New Poor Law to ship paupers back to their home parish. This system was designed to spread the cost of this form of benefit, so that taxpayers in large towns did not end up paying for the poor of the entire region or, indeed for those immigrants from other regions who became incapacitated or fell out of employment.

 The casual wards of the workhouses were very different from the other sections of these institutions. Casuals were notionally in transit, on the move in search of work. For the time being their keep was not chargeable to the home union, but to that through which they passed. The aim was to keep them on the move, so there

were regulations to stop casuals using the accommodation in any one workhouse for more than one night.[6] This section of the pauper population could not be cordoned off from the general urban mass in the way that regular inmates could be. Not working and not institutionalised, not geographically fixed, they were the social residue that escaped categorisation and were the focus of great anxiety. How were thieves and prostitutes to be distinguished from the deserving cases? How could unions be sure that free accommodation was not being abused by scroungers? In large cities these anxieties were felt most acutely, as a large, floating, indigent population existed that might periodically be driven to apply for this kind of aid. The Buller Memorandum of 1848 instructed all unions to tighten up the admission of casuals.[7] It recommended that the police be used to issue tickets to applicants, because, it was argued, the police would be familiar with criminals and could more effectively screen out the undeserving. It was feared that the virtuous would be polluted by the vicious in the casual wards, though the distinction between deserving and undeserving was a precarious one, given a context in which thrift and energy were thought to be the key to prosperity. In 1868 a circular was issued recommending that casuals be accommodated in separate cells rather than in dormitories, though this system was never uniformly applied.[8] Vagrants would be treated more like prisoners. This coincided with a phase of increased vigilance on the part of the authorities regarding applicants for relief; a campaign was launched to cut down the continuing provision of out-relief and to enforce strictly the use of deterrent labour tasks for able-bodied paupers.[9]

Contamination could take place outside the workhouse too. It was feared that the routes and refuges of those tramping for work could serve as conduits and reservoirs for a mobile criminal element, carrying contagion through society. Such medical and sanitary metaphors were in common use in the discussion of vagrancy, and, more generally, in the troubled commentary that grew up in response to the modern city.[10] The wandering poor, in the guise of Mayhew's costermongers, or the lodging house inhabitants of an 1835 publication called *The Dens of London Exposed*, or the vagrants who were the concern of the Buller Memorandum were seen as the source of sickness and malfunction. They were seen as the cause of sickness in the economic circulation of the body of the nation, carrying poisonous discontent. In the same physiological framework the danger could be posed in terms of blockage or thrombosis threatening the economy, conceived of as a digestive or arterial system. They were compared to foul and offensive excrement that conveyed disease miasmatically in the circulating air or as polluting particles in running water. In this sanitary framework, too, the threat could equally be considered in terms of blockage where the paupers were like accumulating piles of dirt blocking routeways or choking pipes. The imagery is ubiquitous and extremely complex. The interchangeability of frameworks is striking; social categories could stand in for economic considerations, the city for the nation, the body, the street or the sewer for the social order. In this convoluted representational nexus any term could stand metaphorically for any other. One point I wish to draw out in relation to

tramps or casuals is that the imagery of flux and stasis produced a double-bind. They were dangerous as a mobile poison in the system and as a static blockage. Consequently there were contradictory impulses at work, on the one hand to contain or arrest, and on the other, to expel and move on. These impulses applied equally to deserving and undeserving. Any intermingled criminals or fakers could certainly be picked out as the most potent source of danger, but the very constituency of the general group, homeless, shifting, shiftless, was an anomaly in the bourgeois world-view. Casuals tested the disciplinary workings of the state. Mobile and recurrently invisible, the vagrants of London and other big cities presented a major problem for the regulatory mechanisms of authority. Foucault's writings propose *stasis* and *visibility* as key underpinnings of the panoptic regime.[11] In other words the ability to fix and oversee was vital to the efficient domination of the state's subjects in this era. Fildes's painting shows the crowd at the police station where the vagrants are sifted and assessed and tickets are issued. This is an investigatory juncture; the moment when the wanderers are stopped and scrutinised. We might expect this to be a thoroughgoing celebration of the ability of the authorities to exercise vision and exert control. Yet if we also acknowledge the impulse to flush away the casuals from the containing institution of the workhouse we are prepared for this to be also, in part, an anti-disciplinary motif.

I have suggested that there was an intricate relationship in various forms of Victorian realism between imagination and investigation. In the case of 1870s social realism the relationship was further complicated by the fact that many of the social subjects in fine art were first developed, by the artists concerned, in the context of graphic journalism. This is the case with Fildes's painting. The subject was first drawn by him for a full-page woodcut illustration in the newly launched illustrated publication the *Graphic* as 'Houseless and Hungry' (figure 16). It appeared with a fairly lengthy text in December 1869. The *Graphic* had just been launched by William Luson Thomas.[12] Thomas had broken away from the *Illustrated London News*, to set up this rival publication, conceiving of a paper which would have similar coverage of current events and contemporary issues but would use more self-consciously 'artistic' illustration. The *Illustrated London News* had a wood engraving method that amounted to a quick, serviceable imitation of steel engraving. By and large the images were even in tone, delineating well-lit objects with neat outlines and orderly hatching. The new paper aimed to produce more expressive images making a greater use of rhythmic linear patterning and contrasts of light and shade. Artists were encouraged to select their own subjects and the text was written to accompany their work. These artistic offerings fell half-way along a spectrum of visual imagery in the *Graphic*: at one extreme were the reproductions of exhibition pictures and, at the other extreme, the work that was commissioned as reportage to accompany news stories. In all cases the images were supported by explanatory text (occasionally poems rather than factual or descriptive passages), and the interaction between text and image was a crucial aspect of the functioning of the whole array of work.

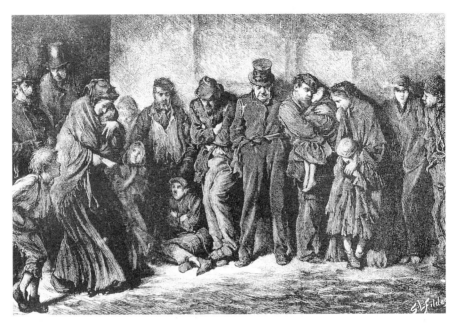

16 Luke Fildes, '*Houseless and Hungry*', wood engraving, 29.2 × 40.7 cm, from the *Graphic*, 1:1
(4 December 1869).

 Looking at the article accompanying Fildes's picture we find that the scene of
vagrants is framed in terms of the legislative provision under the Poor Law and its
amendments. The text mentions the Homeless Poor Act of Mr Charles Villiers.
The Villiers Memorandum of 1863 had urged Poor Law Unions to help the truly
destitute; and the rise in the number of casual beds available in London in the
1860s, and the number of admission orders issued by the Metropolitan Police in
the period, reflects a new policy, particularly in London. The numbers of vagrants
passing through the casual wards appears to have increased dramatically. The
number of casual beds available in London doubled between 1863 and 1866. By
1869 the annual numbers of tickets issued by the Metropolitan Police had risen to
443,974 from a figure nearer two thousand in 1864.[13] The Act rearranged funding
arrangements to spread the cost of this provision and removed financial disincen-
tives which had been preventing the provision of accommodation by individual
workhouses. Economic conditions and unemployment rates played an appreciable
part in boosting the numbers requiring to be housed in this way, but the take-up of
state provision was also very sensitive to changes in workhouse regulations and
policy. By the end of the 1860s numbers had risen so much that, in line with the
late 1860s turn against the 'undeserving', the institutions introduced new deter-
rent measures for vagrants. A deterrent work task was already included; stone-
breaking for the right to stay overnight, but in 1871 the Pauper Inmates Discharge
Act was introduced to punish those who returned to a ward twice in one month.[14]

They were locked in for three days and the work task was increased from 3cwt of stones to 5–10 cwt of stones. The references in the *Graphic* text to the Villiers Act indicate, reassuringly, that state provision is generous and adequate to the need.

> Mr Charles Villiers, when President of the Poor Law Board, brought forward the measure known as the Houseless Poor Act. It is by virtue of that Act that the group before us will obtain food and shelter tonight. Before it became law, they would have slept on the strip of pavement by the workhouse of St. Martin-in-the-fields, or burrowed beneath the dark arches of the Adelphi, or looked out separately for some door-step with a covered porch.[15]

The reader is told that all the individuals assembled in the scene were admitted into 'one of our great workhouses a few minutes after this sketch was taken'. At this juncture, in the swing away from mid-1860s liberalisation of provision towards late 1860s retrenchment, it is not surprising to discern a niggling suspicion of the provision being over-generous; the article ends on a note of anxiety as it suggests that some will genuinely go on to seek work the next day, while others will go on 'to spend another idle shiftless day in the streets or parks, and to present themselves next night at another metropolitan police office, to be examined and certificated and subsequently bathed, sheltered and fed'. Indeed, the reassurance offered by the article is constantly set against warnings that there are some who are less worthy than others to receive state aid. All will be helped, but all are not equally worthy. The bulk of the article gives little character sketches and histories of the figures assembled. In the doorway on the left, we are told, is a country man who has come to town to help his erring son and has been left penniless, and, in the foreground, a woman with her children, whose dock labourer husband has been imprisoned for assaulting her. To her right are two kinds of impostors, one who feigns willingness to work, another who exaggerates his shivering destitution. In the centre stands a loud-mouthed drunk, with seditious political opinions. Next to him is a mechanic out of work, tenderly nursing his sleeping child. We are told of his illness, a spell in hospital, the loss of his job to a more skilled and younger man and his dogged search for work. His gaunt wife and beautiful daughter stand beside him. On the right are two boys; one on the far right of a criminal type, the other reduced from better circumstances and staring with hopeless vacancy.

Almost every figure in the composition is accounted for. The individual circumstances leading to destitution and the moral characters of the vagrants are itemised. Reading these mini-narratives and looking at the engraving we enact the procedure assigned to the police. The text equips us to sort out the crowd and implicitly suggests the option of refusing authorisation to the ne'er-do-wells: the two impostors, the drunk and the villainous boy. It leaves the reader feeling somewhat ambivalent about the blind generosity with which the law is apparently being applied. The reader is furnished with a stern attitude and is set up to view the image from a disciplinary position of power and knowledge.

We need to ask whether this is carried through in the organisation of the visual image; whether the visual image positions the viewer similarly to the way the text positions the reader. The woodcut itself brings all the figures together in a uniform arc. The group is also rendered fairly homogenous by the overall dark tonality and the linking shadows. Surface pattering and the expressive purpose of the sweeping lines also ties together the group. The expressive curve of the bent body of the boy, the swirls of the windswept, rough cloth of the woman's dress, on the left of the picture, and the scrunched-up corduroy at the knee of the shivering man's trousers, as he rests one frozen foot on the other to try and keep off the cold pavement, produce linear pulses within the composition. These repeated emphases link the separate motifs. The unity is not just an aesthetic harmonisation but also summons up a community of misery. The viewer is brought extremely close to the figures, both by means of the journal's portable character and through the shallow pictorial space of the composition. It is a closeness that could have produced discomfort for a middle-class viewer, who might have been threatened by the evocation of filthy, possibly diseased and verminous bodies. The evident distress of the figures would have been an additional source of discomfort in a composition which did not allow the viewer the buffer of intervening space or the opportunity to look away.

The viewer is spared nothing in terms of exposure to the composite degradation or the collective suffering. Access does not follow on from this proximity, however. For all our closeness to these figures we are offered neither portrait-like individuation nor the distinctive features of caricature. The polarised lighting scheme has a tendency to produce shadowed eyes and blanked-out flesh. The theme of weary, miserable waiting is conveyed by a rank of rigid expressions, lips pinched shut and set in a resigned line, or drawn half-open, snarl-like, in anxiety. Armed with the text the viewer can assign identities and moral rankings to the figures; without it the judgements would be less secure. The flabby and bleary visage of the drunk is easy to read, and the resolute grip of the tender father, but the shades of difference between the old man in the doorway and the shivering man next to the drunk are less apparent. The key point to draw out is that the intensity of the experience of looking does not, in itself, amount to the capability to mount surveillance. The middle-class viewer experiences the view of the destitute as an alien spectacle. The proletarian and lumpen bodies are perhaps uncomfortably close but they are indisputably other, *objects* to the viewer/*subject*. So far, the polarised differences indicated by Tagg, in the case of instrumental photography, appear to be in place. If we look for an accompanying transparency and fixity, however, the image seems to evade the disciplinary categorisation that is said to characterise bourgeois investigation. Opacity and mobility might be more readily offered as characteristics of this dark and pulsating image.

When Fildes reworked the subject in oil paint, as a contribution to the Royal Academy exhibition of 1874, the resultant scene was very different.[16] For one thing the picture was large: 8 feet in width. We see the rearrangement of the

figures, the introduction of colour, the deepening of pictorial space, the use of
gentler lighting from the police station light and a greater finish of individual
faces. All these things tend to break up and distance the group of figures. In the
Royal Academy context there was no accompanying article to mitigate the shock
of the image and to facilitate an anecdotal reading. The audience could not rely on
a text to anchor the meaning of the visual image. In the place of such a commen-
tary the artist resorted to internal means of sorting the crowd into groups so that
the viewer could experience variable emotional responses to the figures. This is,
effectively, the narrativisation of the subject. The Royal Academy Catalogue did
include a short text:

> Dumb, wet, silent horrors! Sphinxes set up against that dead wall, and none likely to
> be at the pains of solving them until the *general overthrow*:
> Charles Dickens, extract from a letter in the third volume of Forster's *Life of Dickens*

This text, like the article in the *Graphic*, acts as a supplement to the possibilities of
the visual image. However, it can be said to work in the opposite way. Rather than
compensating for the fearful opacity and mobility of the image, and suggesting the
discrimination and fixing that a disciplinary knowledge of the working-class
demands, it undoes some of the visual sorting out. The text alludes to Forster's
biography of Dickens and the sentences were taken from one of Dickens's letters to
John Forster. From the surviving account, it appears that he intended its inclusion
to demonstrate a kinship between his view of the subject and Dickens's. We are told
of Forster telling Fildes about Dickens's letter, and Fildes exclaiming on the simi-
larity between Dickens's impression and his own, and asking permission to use the
extract in the Royal Academy catalogue. 'Why ... those words absolutely represent
my subject. May I quote them?'[17] Of course in the Royal Academy catalogue it is
cut loose from the account, that appears in Forster's *Life*, of Dickens, on one of his
night walks, passing by Whitechapel Workhouse. This was not published until later
in the year, but we can envisage Fildes having access to Forster's manuscript. In the
published account we hear of Dickens wandering into the East End. He sees seven
heaps of rags against the workhouse wall on this wintry, rainy night. They prove to
be seven homeless women, and, enquiring within, he finds that the workhouse is
full to capacity so that these seven young women are excluded. All he can do is give
each a shilling, watched in silence by a small crowd of local people. These are nearly
as poor as the destitute women, but we are told that none asks for aid. The women
take off, they too are silent, giving not a word of thanks. Only one is reported as
speaking: '"Look at me," she said, as she clutched the shilling, and without thanks
shuffled off.'[18] This anecdote, which so struck Fildes, is extraordinary because of
the way the young woman's remark comes up against a resounding silence. What
she means by it is obscure and, anyway, beside the point, whether 'look at my desti-
tution' or 'look at me furnished with a shilling'. It is a remark marooned in the
wordlessness of all involved. We have the silence of withheld appeals and withheld
thanks. It is the silence of witness, on the part of the little crowd and on Dickens's

part. With the words 'look at me' the balance between telling and watching is deci-
sively shifted. Interpretation and even charitable intervention take second place to
the chilling experience of seeing with one's own eyes. At this moment the reader is
not party to the cautious watching of disciplinary surveillance, nor its variant in the
concerned supervision of the philanthropic gaze. Watching is emptied out. It is not
given meaning by the imperatives and impulses of bourgeois involvement. The
exhortation to look comes from the object of the gaze, but the failure of speech is
quite general.

The full resonance of that anecdote was not available to the audience at the 1874
Royal Academy exhibition, though they would have been familiar with the earlier
volumes of the *Life* that had already been issued. All that is given in the catalogue
are the isolated descriptive phrases. They are evocative but so condensed that the
implications need to be puzzled out. If the figures are dumb and silent it is because
they cannot, or will not, speak of their individual plights. That stoic silence is
equally a resistance to interpretation, a thwarting of individual judgements on the
part of the viewer. If these inscrutable figures are sphinxes it is because they offer a
message although they appear obdurately incommunicative: a message in riddle
form. Motionless as statues, they are nonetheless monstrous like the chimeral
sphinx whose very appearance is a horror and a riddle. The Egyptian motif,
together with the phrase 'that dead wall', suggests a civilisation devoted to death
and one that is defunct, long vanished. Dickens's implication is that the appearance
of the figures outside the workhouse is testimony to the morbidity of the modern
social order and gives warning of the violent dissolution of the social order.
Revolutionary upheaval is presaged by the shivering group, and such a social con-
vulsion will be both the impetus to solve the riddle and the riddle's solution. It will
finally demonstrate the untenability of a regime that fails to offer care and shelter to
the desperately poor. Readers of the catalogue would have grasped the idea that
what was being alluded to was a threat of the disintegration of the social fabric.
Furthermore they would have understood that the figures were being described as
indecipherable, resistant to interpretation.

Contemporary reviewers of the painting nonetheless cheerfully proceeded to
decipher and interpret. The implications of the catalogue quotation tended to pull
the picture away from anecdotal narrative into ominous silence, but the visual
prompts provided by the canvas were more than enough to tie it down again. The
Athenaeum ran through the cast of characters: 'the under-grown and half-starved
London urchin, bigger and more ungainly than a lad should be, the mournful
widow, the man of failing age, the sot'.[19] Most significantly the review noticed how
the composition was divided into groups. 'Here, some in the shadow of the arch,
some near the door of the adjoining "casual" ward, is a numerous group, or rather a
series of groups of men, women, children, of all ages and states of health, but all
wretched and forlorn.' The horror of the scene is said to be mitigated by the way
that each character is differentiated and true to life; the range and diversity of char-
acters is indicated.

From the burly, kindly-looking policemen, who do their office like gentlemen among
the woeful crowd, to the most completely lost wretch who stands on the pavement or
leans against the grimy walls, there is not a figure that is not genuine in design or
faithful and true in sentiment, for Mr. Fildes has not given us anything sentimental
here. Woeful and sorrow moving as the design is, there is no clap-trap in it: it is not a
pleasant work, but far from being a repulsive one. On the contrary, its genuineness is
proved by its simplicity.[20]

The Academy too based its assessment of the picture on the way its art merits miti-
gated the painful associations of the scene. The reviewer (F. T. Palgrave) here too
was wary of over-emotional 'sentimentalism' and of improper wallowing in the dis-
tressful, but found that the picture could be broken down into component parts.
First, the range of characterisation was noted: 'we have here a truth and variety of
character'. Second, the beauty of line and colour was asserted, and it is interesting
to see this demonstrated by the imaginary isolation of one character group.
'Abstract the mother and the two children in the centre (the group where the older
child is lovingly guarding the little one) from the rest, divest them of raggedness
and hunger, and the lines are lovely with almost the finest loveliness.'[21] These
reviewers, in their defence of Fildes's project, are responding to the features of the
picture that distinguish it from Fildes's woodcut image. The differentiation of the
figures within the picture is achieved by casting a soft light on to that particular
group of mother and two children, along with the father cradling a third, sick child.
The light accentuates the delicate pinks and blues of their clothing and the softness
of the children's golden hair. It pulls the family group together, suggesting an emo-
tional bond and cuts them off from the less attractive figures alongside them. They
seem to radiate love and, within their own circle, can balance stoical strength
against despairing frailty. Elsewhere the scene is murky and the figures are almost
monochrome. The soldier on the far right offers another area of bright colour. The
warmer tone again corresponds to a suggestion of moral worth as we see that he is
crippled and so unable to work.

The other family group that is isolated by the composition is the mother and
baby, with a child in tow, moving away from the police station, the mother
holding her ticket of admission. This is not such a reassuring motif. From the
clothing of mother and child we identify her as a widow, the *Athenaeum's*
'mournful widow', and take it that she has been left without means of support.[22]
We are not inclined to see her as undeserving, but these figures have none of the
pretty softness of the other group. The dark fabric and harsh light on the figure
of the woman makes a ragged silhouette of her, the shape of her clothing is hard
to comprehend. We get stark definition on her face and hands and register
unkempt hair, hook nose, puffy eyes and strained grasping fingers. The child is
pasty-faced and blubbering. Narrative impulses and the ethical framework
demanded that the visual experience be broken up into units that could be
assessed and compared: the faulty and the virtuous, the ugly and the beautiful.
While the other figures could be sorted according to these criteria, the figure of

the widow is slightly discomfiting because there is no indication of grace and warmth to reassure the viewer of her virtue.

The reviews of Fildes's painting were by no means unanimous as to its success. The *Art Journal* considered the question of aestheticising the subject.

> He has made no attempt to make his picture pretty: he has in truth, deliberately left it horrible and weird, but so much of artistic taste as there was room for he has bestowed upon the work. The arrangement of the different figures is as artistic as the subject permitted, the colour is quiet and in harmony.[23]

The reviewer simply did not think that these aestheticising moves were sufficient to make the subject acceptable. Despite the evidence of artistic taste the picture is still 'horrible and weird', the assembled vagrants are perceived collectively as 'deformed and wretched creatures'. The *Saturday Review* was most damning and, again, it is the collective identity of the group that is registered rather than the heart-warming stories of individuals.

> Mr. Fildes is another artist who makes a protest against the popular principle that a picture ought to be agreeable. Assuredly for once he goes too far in the opposite direction when he depicts with revolting reality the squalor, the dirt, and the rags of a herd of miserable 'Applicants for admission to a Casual Ward'.[24]

For this reviewer the picture consists of indeterminate, scarcely human detritus. A herd of animals, an accumulation of rags constitute a subject that resists interpretation. It may produce emotion and shock, Fildes is said to be 'lost in emotion',[25] but it is a shock that produces aphasia, depriving the viewer of words.

In the context of the Royal Academy exhibition, where an image could not be anchored by an extensive accompanying text, Fildes chose to modify and narrativise the composition that he had developed for the *Graphic*. The terms of the reviews indicate that he acted prudently because he gave the critics the option of adopting a disciplinary viewpoint and fixing the positions of this dangerously mobile constituency, and some were ready to take up this option. Others were not prepared to do so, and the inability of many of the critics to read the picture in a categorising manner shows that the picture also pulled in another direction.[26] Part of my argument is that the motif of vagrants occasioned a double response, since social policy was caught between the wish to arrest and the wish to move on. In visual terms the picture equivocates between the anecdotal and the illegible. The surface of the picture does not tally with the idea of a compartmentalised fixed other for a bourgeois observer. If we return to the features set out by Tagg in his account of bourgeois systems for representing the city, we can pick out his allusion to the transparency of representation. Transparency, in a literal sense, is just what is missing in Fildes's picture with its rough, flecked paintwork. The whole scene is viewed through a textural fog that seems to be made up of fragments of cloth, mud, smoke and snow. The overwhelming impression is of the dissolution of form, as particles swirl in the field of vision. Clothing gives way to rags, rags disintegrate

into the miasmatic atmosphere, and rend to reveal portions of bodies: toes, shins, knees. Ultimately flesh itself is seen to fly into fragments as the starving dog strips a bone. There is little chance of securing reassuring fixity when the vision seems to be premised on the interchangeability of matter. In the essay I have been citing, Tagg invokes the disciplinary gaze and he presents it in terms of a fetishistic fixing of the mobility of desire. My emphasis is as much on the unfixing as on the achieved disciplinary categorisation. My argument has been that this picture of the modern city, which highlights the issue of surveillance and discrimination, does in fact problematise the exercise of power through vision. Perhaps it might be said to reintroduce the possibilities of desire, albeit in a formal rather than thematic sense. In the context of the Royal Academy the complementary functions of graphic image and journalistic text somehow had to be worked together in the medium of paint on canvas. In part this resulted in an aestheticised and narrativised image. However, there were other aspects to the picture, elements which tended to reduce vision to the stark operation of sight, stripping away the support of speech. The bourgeois audience at the Academy was faced with the equivalent of the bundles of rags seen by Dickens outside the workhouse, and was left with the unadorned injunction, 'Look at me'.

Notes

1 J. Tagg, 'The discontinuous city', in J .Tagg, *Grounds of Dispute, Art History, Cultural Politics and the Discursive Field* (Basingstoke, 1992), pp. 141–2.

2 *Ibid.*, p. 141.

3 E. Said, *Orientalism* (London, 1978); L. Nochlin, 'The imaginary Orient', *Art In America* (May 1983), pp. 119–91.

4 S. M. Smith, *The Other Nation: The Poor in English Novels of the 1840s and 1850s*, (Oxford, 1980).

5 See K. Williams, *From Pauperism to Poverty* (London, 1981) and P. Wood, *Poverty and the Workhouse in Victorian Britain* (Stroud, 1991).

6 L. Rose, *Rogues and Vagabonds: Vagrant Underworld in Britain 1815–1985* (London and New York, 1988).

7 *Ibid.*, p. 80.

8 *Poor Law Board Circular* (1868), cited by Rose, *Rogues and Vagabonds*, p. 84.

9 M. J. Wiener, *Reconstructing the Criminal: Culture Law and Policy in England, 1830–1914* (Cambridge, 1990), p. 109.

10 See C. Gallagher, 'The body versus the social body in the works of Thomas Malthus and Henry Mayhew', in C. Gallagher and T. Laqueur, *The Making of the Modern Body: Sexuality and Society in the Nineteenth Century* (Berkeley, Los Angeles and London, 1987), pp. 83–106 and M. Poovey, *Making a Social Body: British Cultural Formation 1830–1864* (Chicago and London, 1995).

11 M. Foucault, *Discipline and Punish: The Birth of the Prison*, trans. A Sheridan (Harmondsworth, 1977; 1st pub. 1975).

12 See J. Treuherz, ed., *Hard Times: Social Realism in Victorian Art* (London, 1987), chs 7 and 10.

13 Figures cited by Rose, *Rogues and Vagabonds*, p. 80. Felix Driver gives figures, taken
 from the Register of Authorised Workhouse Expenditure, for authorised construction
 of new Poor Law buildings 1835-83. Casual wards are listed as follows: 1835–50, 21;
 1851–66, 24; 1867–83, 175. This shows the vastly increased scale of the vagrant housing
 operation in the latter part of the period: F. Driver, 'The historical geography of the
 workhouse system in England and Wales, 1834–1883', *Journal of Historical Geography*,
 15 (1989), p. 279.
14 Rose, *Rogues and Vagabonds*, p. 83.
15 *Graphic* (4 Dec. 1869), p. 9.
16 There is a detailed account of the painting in J. Chapel, *Victorian Taste: The complete
 Catalogue of Paintings at the Royal Holloway College* (London, 1982), pp. 83–7.
17 *Magazine of Art* (1880), p. 51.
18 J. Forster, *The Life of Charles Dickens*, 3 vols (London, 1969; 1st pub. 1872–74), vol. 2,
 p. 131.
19 *Athenaeum* (2 May 1874), p. 602.
20 *Ibid.*
21 *Academy* (1874), p. 585.
22 This is a change from the identification of the figure as a battered wife whose husband
 has been imprisoned, which had been proposed in the *Graphic*'s explanation.
23 *Art Journal* (1874), p. 201.
24 *Saturday Review* (2 May 1874), p. 562.
25 *Ibid.*, p. 654.
26 Jeannie Chapel points out that the *Athenaeum*, having welcomed the grouping of the
 picture in the first instance, complained of an excessive proliferation of characters in a
 subsequent review: Chapel, *Victorian Taste*, p. 86.

Auditing the RA: official discourse and the nineteenth-century Royal Academy

Gordon Fyfe

The faces of upper-class institutions lend credence to the thesis that British modernisation was sabotaged by tradition. An industrial bourgeoisie, so the argument goes, emerged as the motor-force of modernisation in the first half of the century and was set to accelerate into the future. Then, seduced by the charms of an aristocratic lifestyle, it surrendered its 'radical' powers. However, the evidence for a hegemonic culture of traditionalism, most systematically stated by Martin Wiener, has long seemed fragile. The validity of the thesis has been thrown into doubt by an accumulating body of data and by the reinterpretation of existing evidence about property, culture and modernity.[1]

One challenge comes from Mike Savage and his associates who argue that the terms of the debate have been drawn too narrowly. Inspired by Bourdieu, they emphasise the role of cultural assets in the struggle for power and privilege, suggesting that the debate about class and British modernisation has been preoccupied with divisions within the propertied class. They show how the professional class had a long historical association with the British state. Opposing those who stress aristocratic survival as the key to British institutions, they demonstrate the evolution of a relatively cohesive, male metropolitan professional class as an essential element in modern state formation. They argue that the protagonists in the traditionalism debate have failed to detect the complex networks of upper-class power that progressively characterised domination in the nineteenth century. Modernisation was linked to a spurt in professionalisation as growing numbers of specialists serviced the particular requirements of power yet traded on the universalism of expertise. A credentialist attack on patronage was a means by which the state, after 1848, sought to fireproof itself against revolution by purging 'Old Corruption'. In addressing these material processes of professionalisation, Savage and his associates provide a more complete picture of upper-class structuration as the interweaving of economic, political *and* cultural processes.

I am less concerned at this point in the argument with the authorship of social change. My suggestion is that, irrespective of who might be said to apprehend and

direct modernisation, the Wiener thesis elides the *reflexive* character of tradition under modernity. Reflexivity refers to modernisation as it institutionalises knowledge which flows from a continual examination of social practices; what is distinctive in modernity is, as Giddens states, its 'presumption of a wholesale reflexivity'.[2] Giddens argues that modern people are engaged in a constant review of their social practices, and that such recursive actions are characteristically modern in their subversion of certainty. For example, the 'traditions' of the British state are not traditional in the sense of being reproductions of earlier social, cultural and political forms. The authority of tradition lies in its capacity to reinvent itself, thus to form new connections in the modern world. Bagehot's assessment of monarchical power in an age of bureaucratic efficiency is entirely to the point in its critical assessment of the role played by royal custom in re-enchanting the machinery of government.[3]

One aspect of reflexivity concerns the internal relationships between knowledge, the professional classes and the state. A partnership between reformed professions and the state accentuated the modernity of the latter through new modes of occupational regulation in which professions, such as law, medicine, civil service and fine arts were deeply implicated. The hallmark of these occupations was that they articulated an ideology of public service. The making of the modern state involved, amongst other things, a professionalisation of knowledge about society. The development of governmental systems of information-gathering (in the form of commissions, reports and inquiries serviced by 'experts') is one expression of the Victorian state's reflexivity. As reflexiveness is one of the keys to the subtle association between professional autonomy and the power of the modern British state, I shall demonstrate this relationship by examining a significant nineteenth-century moment in the reproduction of the power of the *Royal* Academy of Arts.

The Royal Academy

One locus of professionalisation was the Royal Academy (hereafter RA), an exhibiting and teaching body, which was instituted in 1768.[4] The establishment of the RA was an outcome of competitive struggles between cultural factions, groups and associations. The formation of the RA entailed a fight for access to cultural power, governmental and royal patronage and institutional self-determination. The RA quickly established itself as the dominant institution in the mediation between visual culture and cultural markets in the capital.[5] By the middle of the century Academicians were a privileged corps of celebrated living painters.

There were forty full Academicians who, with the exception of the first generation, were elected from amongst a subordinate body of Associates (a maximum of twenty). Associates were elected from amongst exhibitors at the Summer Exhibition to which all artists were invited to submit their work. The RA's association with the monarchy was crucial; George III provided accommodation at Somerset House and gave financial aid in its early years. Though not without its

dangers, this connection allowed the RA, especially from the 1830s, to escape direct control by the agencies of the bourgeois state. Indeed, Martin Shee's response to those parliamentary radicals for whom the RA was a sign of 'Old Corruption' was both terse and pointed: 'The Royal Academicians, my Lord [John Russell] owe much to their sovereign, but nothing to their country'.[6]

Along with galleries, museums, industrial expositions and other artists' societies, the RA formed an exhibitionary complex of official and semi-official spaces.[7] This configuration was part of a network of administrative agencies which included the Crown, Parliament and government departments. The RA worked in and through the social and discursive spaces of the state, generating itself through complex social and institutional relationships. Correspondingly, other parts of the state found cultural expression through their transactions with the RA. The story of how the RA moved from Somerset House to Trafalgar Square demonstrates the relationship between governmental rule and royal culture within the nation-state. [8] The RA's first proper home at Somerset House resulted from the parliamentary deal that was struck over Crown lands and the income for George III's political and household expenses. It was from this arrangement that a government obligation to find premises for the RA arose. The relationship to monarchy was personal, labyrinthine and subtle; it required detailed explanation from Lord Farnborough that the post was not in his gift when, in 1830, George IV was all set to install his own noble President. One Academic position, that of Treasurer, was made by the monarch, who, in addition to approving all other appointments, was referred to for consent in all important management matters.[9]

The exhibitionary complex was subject to competing principles of professionalisation. One was a bureaucratic mode, exemplified in South Kensington, where cultural power was rooted in a centralising departmental officialdom with salaried officials and teachers. South Kensington had emerged out of the radical bourgeois impulse of Select Committee proposals of 1835 and was funded by the profits from the Great Exhibition of 1851. The other mode, exemplified by the RA, conformed to an Anglo-American pattern in which the professions serviced the state as semi-independent corporations of experts in a strategy of trustmaking. This relationship of the cultural state to professional autonomy was expressed in the pragmatic, piecemeal building of institutions; in the emergence of a partly private, partly public, corporate identity; in the production of a cultural space that conflated the national and the local as a sign of the English school of art.

Mapping the RA

By the 1850s RA power ran deep into the developing cultural state. Academic authority was part of a distinctive British pattern of class and state formation where professionals, including artists, found legitimation through collaboration with state agencies. Along with other institutions, such as the aristocratic British Institution and the Old Watercolour Society, the RA was located within a web, or

field of interdependencies, conflicts and institutional associations that composed the art world.

A field is, as Bourdieu writes, a relatively autonomous social space whose structure 'is a state of the power relations among the agents or institutions engaged in the struggle [to define and monopolise authority]'.[10] A field of art is the space of relations and positions in which artists, critics and other cultural agents determine legitimate art. Bourdieu argues that modernisation entails a 'division of labour of domination'.[11] With this formulation he dissents from the conventional sociological view that dominant cultural categories are imposed on subordinate classes by the economically powerful. Rather, he maps dominant institutions as emergent properties of a field, or figuration of power, which is shaped by struggles over the priority of different assets; effective domination flows from success in simultaneously managing domination in diverse fields of action.[12]

The nineteenth-century field of art was configured and reconfigured through the medium of struggles for the prize of the monopoly of the power to define the categories of art and artist. The prize was consecration as the English school of art, and it was this identity that the Academicians, who were primarily oil painters, sought to monopolise through the privileges of royal association, fashionable social intercourse and the command of the growing middle-class art market. As the century progressed there were some doubts and uncertainties concerning academic privileges and especially so in relation to the management of the Summer Exhibition. Other groups, such as watercolourists, asserted that their capacity to embody a tradition of 'national' art was ignored by the RA.[13] It is clearly the case that the RA wanted to 'speak' a national discourse *as* it looked to the monarchy for its privileges. National academies were concentrations of cultural power which triumphed within the field of art and through transactions with the field of power. The RA regulated the relationship between these different fields in order to generate, authenticate and monopolise cultural capital; but it was caught between the congealed traditions of aristocratic culture and the fluidity of commercial society. A hybrid institution, the RA looked in two directions: towards a field of power whose orderings permitted a residual estate habitus, where artistic identity was forged in the bonds of face-to-face relationships to patrons; and towards the heterogeneity of a marketised art-world, where artistic identities proliferated in the impersonal spaces of free competition between individual economic agents. The early nineteenth-century RA resolved these tensions through the authority of its annual Exhibition.

Official discourse of art

The growth of an art profession and the related expansion of the market placed strains on a centralised, congested and successful RA Summer Exhibition, which was controlled by a privileged elite of Academician officers. Given that the RA had been born out of tensions between tradition and modernity, the friction associated

with the Exhibition is not surprising. From the 1830s these tensions were exacerbated by industrialisation which widened fissures within the field of power and created a new balance of power which tended to fragment the elite. This was linked to a parliamentarisation of cultural power[14] and to the institution of official inquiries which empowered those who had been marginalised by the RA (for example engravers and watercolourists) to speak as 'cultural critics' of the Old Order.

From the 1830s the RA was wholly or partly the subject of official inquiries and of public interventions by reforming radicals. These include the *Select Committee on Arts and Manufactures* (1835–36); the *Report from the Select Committee on National Monuments and Works of* Art (1841); *Select Committee on the National Gallery* (1850); *Select Committee on the National* Gallery (1853); *The National Gallery Site Commission* (1857); the *Royal Commission Report on the Present Condition of the RA* (1863); and Edward Edwards's *The Administrative Economy of the Fine Arts in England* (1840). Edwards's proposed reforms that would have amputated the exhibitionary function from academic teaching, professionalising the RA as a central school with the support of public funds coupled to official inspection, and developing expertise in areas such as copyright.[15] Amongst the many dissidents who drew upon the Edwardsian paradigm one forgotten figure is Thomas Skaife, a Liverpool miniaturist who appears to have exhibited at the Summer Exhibition between 1846 and 1852 (figure 17). Skaife, who lampooned the Academy's sensitivities to public inquiry in his anti-RA pamphlet of 1854, found common cause with parliamentary radicals. Angry at the RA's rejection of his miniatures, he challenged the RA's occupancy of the National Gallery (hereafter NG) in Trafalgar Square, queried the RA's charge for access to its Summer Exhibition in a public building, and drew heavily on the evidence given in Parliament.[16]

The 1863 Royal Commission

Among the key divisions of the Victorian social order was the contested division between civic value and private need and it was this that made the Trafalgar Square location of the RA its Achilles' heel. The NG Select Committee of 1853 heard evidence that the trusteeship of Sir Charles Eastlake, who was also the President of the RA, gave him a conflict of interests. There were legitimate reasons for the RA sharing premises with the NG. However, in the 1850s and early 1860s, the placing of the RA at the NG was a privilege that required detailed explanation. The NG needed additional space. Might one or both institutions be transferred to South Kensington, or to Burlington House in Piccadilly? There was official recognition of an obligation to house the RA somewhere, but why was this the case? Such uncertainty attracted a second wave of criticism and resulted in the Royal Commission of 1863.

As early as 1850, the government, determined that the RA must be found new premises, suggested a move to Piccadilly. Short-lived and fragile administrations

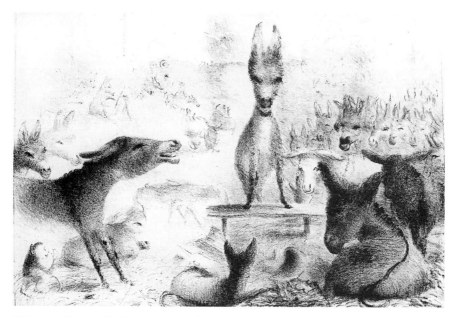

17 Thomas Skaife, '*A Chief's amang you takin' notes*', 1854, lithograph.

left the matter unresolved. The Derby administration accepted an obligation that, should the RA be required to move, then new premises would be found at public expense. In 1859 it was proposed that a sum of £20,000 would be raised for the RA, this to contribute to building costs on its removal from the NG.[17] This was the context in which the 1863 Royal Commission sat down to:

> inquire into the present position of the RA in relation to the Fine Arts, and into the circumstances and conditions under which it occupies a portion of the NG, and to suggest some measures as may be required to render it more useful in promoting art and in improving and developing public taste.[18]

Seven Commissioners took evidence from over forty witnesses during five months of 1863 and reported in July with a volume running to 557 pages. The RA had repulsed the attacks of radical bourgeois critics of the 1830s and 1840s.[19] This was the point of departure for the Report which cited plaudits by Robert Peel and Lord John Russell as evidence of the RA's public standing.[20] The aristocratic and gentlemanly composition of the Commission should not, however, be read as aristocratic survival but as contested modernisation that identified professional models of occupational control and training. The Commissioners took evidence from Delebare Roberton Blaine (barrister and copyright expert) and J. Storrar MD (a member of the Medical Council) as to practices in other professions, and were informed of the failure of the Medical Act of 1858 to secure lay recruitment to the Medical Council. From Richard Redgrave RA (Inspector-General of art schools at South Kensington) came an account of his institution's mode of training. The

Commission probed the possibility of an integrated programme with South Kensington feeding the Royal Academy Schools.

The investigation penetrated deep into the RA: into its constitution; into its association with the monarchy; into its composition (both categories and numbers of members); into the question of lay membership; into its government and finances; into relations with other exhibiting societies; into copyright and professional ethics; into the Summer Exhibition; into its teaching; and into its charities. Its documentary evidence included revenue, expenditure and exhibition statistics, a petition about the Exhibition from nearly eighty discontented outsider artists, official correspondence pertaining to the NG situation and other items. The subject of the building was paramount, for this pertained to politics and political patronage. What was the RA doing in a public building? Did the exhibition space permit a proper assessment of national art? To whom did the Summer Exhibition belong: to the Academicians or to the wider constituency of exhibitors, most of whom would never become members?

The prevailing opinion of the Academicians, when pressed by the Commissioners, was that the RA was a private body exercising a public function. The rhetorics of public and private were important because they formed one of the conceptual spaces in which the value of the institution was measured. As Charles Eastlake explained to the Commissioners, the RA was a public or national institution only in the sense that its objects were national. Commissioner Seymour clarified Eastlake's meaning: 'you only meant … that it was instituted for the public good'.[21] The Academicians' evidence must have confirmed the Commissioners' sense of the need to clarify the RA's relationship with government. David Roberts stressed the difficulty of reconciling public status with 'taking shillings at the door'. The institution was, he claimed, more private than public.[22] Edwin Landseer opined that indifferent rooms were all that the RA received in return for public service: well, then, let the government have a go at doing things better.[23] For Daniel Maclise the RA was 'a private institution doing … a great public work'.[24] Richard Westmacott was disarmingly frank: 'when we wish not to be interfered with we are private, when we want anything of the public we are public'.[25]

Among non-Academicians, H. W. Phillips (portraitist, son of an RA and Honorary Secretary to the Artists' General Benevolent Institution) thought the Academy should be made into a properly public institution. Sir Coutts Lindsay detected conflicts of interest resulting from its constitution, whilst Lord Taunton saw dangers in bringing the RA under government. J. C. Robinson, an officer at South Kensington, thought the existing arrangement worked well for it had created 'a professional aristocracy'.[26] These matters were taken up by the Commissioners who probed the legal status of the Instrument of Foundation, which was the governing declaration made by George III in 1768. Monarchy was the key to the RA's ambiguity; the institution had no direct relationship with government. It could disappear into the aura of the throne at will; any attempt to make it a public body had to be sanctioned by the monarch. The Instrument of

Foundation was, it transpired, a trust that was unobjectionable and enforceable in law. However, the Commissioners proposed the need for a charter: this would give the RA a 'clear and definite public character instead of the anomalous and ambiguous position' that allowed it to determine the moments at which it was public or private.[27]

The Commissioners obtained information about the Exhibition. Most exhibitors were not Academicians and the majority of works submitted were rejected. The Commissioners judged that the RA was conducted honestly, but concluded that the demands of English art had outstripped its ability to meet them under its present constitution. Arrangements for display at the Summer Exhibition were generally sound, but the RA lacked the physical capacity to delineate the true range of contemporary English art. The facts of submission, acceptance and rejection at the Exhibition raised issues concerning its management and selection practices, as well as the RA's capacity to act as a truly 'national-public' institution.[28] The arrangements and membership categories of the 1760s were inadequate for the 1860s, whilst Academicians retained unwarranted exhibiting privileges. On the subject of teaching, the Commissioners recommended the institution of a School Committee to deal with matters pertaining to the management, content and delivery of formal lectures. In addition, it was suggested that a salaried General Director (not necessarily an Academician) should act as Superintendent, in order to overlook the production and reproduction of pedagogic regimes within the RA schools.

The Commissioners noted the hostility of artists to lay members, but recommended they be adopted drawing on the model of the General Medical Council (Commissioner Lord Elcho had been associated with the Medical Act of 1858). Academicians were unhappy about a proposal for a new membership category of artist-craftsman. This was a response to evidence provided by A. J. Beresford Hope, the High Tory MP, writer on ecclesiastical and architectural matters, and collector of early Italian and Flemish painting.[29] The Commissioners proposed that distinguished craftsmen in metal, stone or wood might receive honours from the RA. The RA response was the measured one that, if any benefit accrued, it could establish closer links with South Kensington on this matter.[30]

The Commission sought to determine how the profession of the artist should be constituted in a world where the received categories of public and private were characterised by anomie. How might professional boundaries be determined when public and private were so confused? Training, lay control and public service were germane to professional autonomy and to professional boundaries, but the crucial matter was the state's relationship to the creative powers of the artist. For a few years, in the 1850s and early 1860s, the RA was uncertainly subtended by two paradigms of professionalism: the RA might secure its independence at Burlington House or, alternatively, it might be sucked into South Kensington. How it avoided the latter fate and how it retained its integrity testifies to the subtlety of the profession-state relationship as it was worked out for and by Academicians in the 1850s and 1860s.

Memory and record

Although official discourse provides access to a wealth of historical data, it is not a transparent medium through which the truths of witnesses' experiences are articulated or remembered. Official discourse, materialising relations of power, permits some identities to flourish and others to wither. Official inquiry into art is an initiative for determining the relationship between the field of power and the field of art; it is a moment at which the state, or some sector of the state, recognises and seeks to organise, control or calibrate the human capacities through which the processes of modernisation are enacted.

In such situations, recording and regulating official memory is a process of generating, constituting and ordering information for the purpose of the final Report. It was customary for witnesses to be allowed to edit their evidence; this may account for differences between contemporary recollections of the 1835–36 and 1853 Select Committees. At a sitting of the Select Committee of 1853, Lord Elcho pressured a witness to soften his attack on Eastlake's performance as NG Keeper.[32] Elcho's case was that Eastlake was being unnecessarily humiliated in a scandal about improper cleaning of pictures and that it would be gentlemanly to spare him. It was this event, no doubt, which encouraged Skaife to demonstrate the discrepancy between the minutes of evidence and the Report, and to argue that there was a conspiracy to keep scandalous events at the NG out of public view.[33]

In 1863 an admission by Landseer revealed that the RAs had just recently discovered that they had no law against the admission of female students to the Schools. The revelation had emerged from the *cause célèbre* of a woman who submitted a qualifying drawing with her first name given as an initial. The drawing, explained Landseer, with no hint of irony, had therefore been favourably 'judged entirely on its own merits'.[34] That this matter was not pursued by the Commissioners is unsurprising, although witnesses Blaine and Robinson were among those who proposed a limited female access to membership of the RA. That it was not the only instance of Academicians' ignorance about their laws raises the issue of amnesia and the implicit rules of institutional action. Another example arises from the Commission's attempt to clarify the rules of election of Associates to the RA, the regulations of which required that candidates resign from other metropolitan societies before offering themselves for election. The RA consolidated its power partly by means of strategies that marginalised artists other than the majority of successful oil painters, sculptors and architects. A rule insisting that candidates for membership of the RA withdraw from other societies was a means of controlling their access to the business of patronage. By mid-century the fact that watercolours were promoted as a distinctive feature of the national tradition presented a challenge to the Academicians' exclusive claim to represent the English school.[35]

The Commissioners explored the rule which compelled successful artists to resign their membership of the major watercolour societies before seeking election

to the RA. The issue was important for it might be evidence that the RA did not represent the multiplicity of styles, genres and mediums that comprised 'national art'. Eastlake informed the Commission that watercolourists might be elected as Associates of the RA. Why, then, Eastlake was asked, did last year's Exhibition Catalogue publish the rule? When pressed on the matter Eastlake's reaction was to report that the rule concerning resignation was not applied; in an oversight they had forgotten to revise the law. Later, Eastlake converted an act of discrimination into one of benevolence, claiming that it was retained to please other societies. [36]

David Roberts reported that, in practice, watercolourists were ineligible for election unless they turned to oils.[37] Henry Warren, President of the New Society of Watercolourists, neither knew that the RA was open to watercolourists nor found it credible that the rule was a favour to other societies. The President of the Old Watercolour Society, Frederick Tayler, unaware that watercolourists were not constitutionally excluded from the RA, took the rule as a sign of its repressive nature. He went on to add that this indicated the RA's failure to recognise individual talent in its blind commitment to policing the divisions and hierarchies of art production: 'instead of recognizing the talent of the individual they [the Academicians] confine honours to his particular mode of painting'.[38]

Tayler's observations, along with the confusions about the status of water-colourists, are indicators of the altered priorities that attended the autonomisation of the field of art from the field of power. The early nineteenth-century RA had managed this process to its own advantage by developing exhibitionary practices that linked it with a range of aristocratic codes, systems and rituals. Tayler's evidence is important, for its assertion of autonomy is made in the name of an 'inferior' medium rather than the absolute authority of a particular institution. Professional freedom, then, is associated with the creativity of a vast multiplicity of artists; it is not generated by the regulations and systems of academic culture. This division between oil painters and watercolourists demonstrates that aesthetic divisions and conflicts within the Victorian art world were articulated through differentiated and unequal access to the field of power, which, in turn, determined forms of patronage, and the process of professionalisation.

Conclusion

Paradoxically the RA's engagement with the forces of modernity favoured close identification with a monarchy that was also in flux. However, its trajectory through the field of the state gave rise to discursive tensions. The divisions of art, divisions between Academicians, Associate Academicians, aspirant outsiders, other societies and institutions were articulated as four discourses of accountability. These divisionary articulations, projecting a vision of what the RA should be or become, presented different images of its contradictory location within the force field of the British state. These discourses were: a fading radical bourgeois vision, a centralising vision, a chartist vision, and a royal vision.

The radical bourgeois vision had been associated with earlier figures like Joseph Hume and William Ewart who fought a parliamentary campaign for free popular admission to the RA Exhibition and submission of the RA to parliamentary inspection. The radicals were sympathetic to artist-dissidents and other malcontents who challenged the management of the Summer Exhibition. Their strategy was to connect professional discontent with a natural rights discourse, thus to draw a distinction between the 'Toryism' of the RA and the liberalisation processes associated with the modern industrial state. However, as we have seen, the Commissioners marginalised this discourse.

Among the centralisers A. J. Beresford-Hope is a notable figure. Before the Commission he proposed the introduction of an artistic department of state under a cabinet minister who would be held in check by a central but independent body. The proposed body would be an enlarged and strengthened RA, which would be located at the centre of an official arts administration and thus clearly placed within the public sphere.

The chartist vision, considered by the Royal Commission and recommended in its Report, sought to reform the RA through the introduction of a charter, which would act as a substitute for the Instrument of Foundation. The intention was to specify the rights and duties of the RA, drawing its private business into the public realm. This was the key reformist element of the Report which recommended, amongst other things, widening the membership of the RA, broadening participation, reforming teaching and increasing the space: '[t]here is no subject ... on which the representations made to us have been more unanimous, or ... more justly founded, than the complaints of want of adequate space'.[39] The RAs did not demur; what separated them from others was the answer to the question: whose space is it?

The Royal vision was much favoured by the Academicians, which is not surprising as they guarded their direct relationship to the Queen. The position was stated in the RA's response to the Report.[40] The RAs conceded the virtues of some proposals but resisted others, retaining the aura of association with the monarchy and securing the RA as a place beyond the rationalization associated with the state, which was seen as a centralising agency.[41] The Academicians went to the Commission with the resignation of those who felt that they had been over-audited and that auditors could have nothing new to learn. There was some anxiety that they might be put on 'a foreign footing'. Early in 1863 the Queen observed that she was not prepared to appoint the Royal Commission until the proposed list of Commissioners had the approval of Eastlake. She reported that, if the inquiry led to constitutional change, then Eastlake and the principal members of the RA would leave.[42]

Some witnesses protested that official inquiry had become part of the normal politics of the RA. Landseer observed: '[e]very generation of 20 years there is an inquiry of this sort'. Maclise objected to a 'wretched suspicion in regard to the Academy' and to a constant repetition of questions by new generations of inquisitors. Maclise went on: 'during the whole of my career there has been a series of

inquisitions as to its proceedings, which appear rather extraordinary to me, and the same thing happens over and over again. Even the questions that were answered 15 or 20 years ago crop up again.'[43]

Landseer and Maclise may or may not have been encouraged by Lord Elcho's suggestion that settling public disquiet might lead to a cessation of inquiries.[44] However, official inquiry was the price that the RA had to pay for its autonomy and for its professionalising trajectory through the field of state power. Inquiry (and thus knowledge) was at one with the broader impulse of a modernising state whose panoptic gaze was turned on to parts of itself. This was the price of professional autonomy. What is special about the RA is that its link to the state was refracted through the monarchy; its only answerable link to the state was beyond the reach of Parliament. The RA avoided integration into the bureaucratic bourgeois state by disappearing into the aura of monarchy. Despite its traditional faces, English upper-class power accommodated processes of modernisation in which different categories of art were renegotiated throughout the nineteenth century.

The RA adroitly positioned itself as a private agency embodying civic characteristics and exercising public duties. The institution was more engaged with modernity than is indicated by traditional stereotypes of academies. Institutions such as the British Institution (1806), the Burlington Society (1857), and the Grosvenor Gallery (1877) were, of course, aristocratic interventions as the old order sought to recover itself on the terrains of the state and the art market; but in no sense did they amount to a rule of taste. The aristocracy was not free to rule in a world where the RA had consolidated its claim to be a National Academy, and in which radical bourgeois elements sought to subordinate it and the NG to parliamentary power. Tradition did not sabotage modernity; modernity meant that at every turn tradition needed to think again.

Notes

I am grateful to Colin Trodd for his comments and suggestions on an earlier version of this paper.

 1 The relevant literature includes D. Cannadine, *Aspects of Aristocracy* (Harmondsworth, 1994); W. D. Rubinstein, *Capitalism, Culture and Decline in Britain 1750–1990* (London, 1993); T. Johnson, 'The state and the professions: peculiarities of the British', in A. Giddens and G. Mackenzie (eds), *Social Class and the Division of Labour* (Cambridge, 1982); M. Savage, J. Barlow, P. Dicken, and T. Fielding, *Property, Bureaucracy and Culture: Middle Class Formation in Contemporary Britain* (London, 1992); M. J. Wiener, *English Culture and the Decline of the Industrial Spirit 1850–1980* (Harmondsworth, 1985); J. Wolff and J. Seed, eds, *The Culture of Capital: Art, Power and the Nineteenth-Century Middle Class* (Manchester, 1988).
 2 A. Giddens, *The Consequences of Modernity* (Oxford, 1990), pp. 36–45.
 3 W. Bagehot, *The English Constitution* (London, 1963; 1st pub. 1867).
 4 S. C. Hutchison, *The History of the Royal Academy* (London, 1968), pp. 42–50.

5 C. Trodd, 'The authority of art: cultural criticism and the idea of the Royal Academy in mid-Victorian Britain', *Art History*, 20, 1 (1997), pp. 3–22.

6 M. A. Shee, *A Letter to Lord John Russell (her Majesty's Principal Secretary of State for the Home Department) on the Alleged Claim of the Public to be Admitted Gratis to the Exhibition of the Royal Academy* (London, 1837), p. 13. Shee was RA President 1830–50. An indication of convergence between monarchy and RA is royal attendance at the institution's Dinner: '[b]efore May 3, 1851, the Crown had not been represented at the Royal Academy dinner. It has seldom been unrepresented since': T. H. S. Escott, *Social Transformations of the Victorian Age* (London, 1897), p. 350.

7 T. Bennett, *The Birth of the Museum* (London, 1995), pp. 59–88.

8 L. Colley, *Britons: Forging the Nation 1707–1837* (London, 1996), pp. 208–50. Also *Royal Academy, position in relation to Fine Arts, Royal Commission*, Report, Minutes of Evidence, Earl Stanhope (1863) [3205] xxxv, iii, Minutes. Appendix no. 17.

9 W. T. Whitley, *Artists and Their Friends in England 1700–1799* (New York, 1968; 1st pub. 1928), vol. 1, p. 250; idem, *Art in England 1821–1837* (Cambridge, 1930), pp. 186–7. From 1874 the Treasurer was elected.

10 P. Bourdieu, *Sociology in Question* (London, 1993), p. 73.

11 L. J. D. Wacquant, 'From ruling class to field of power: an interview with Pierre Bourdieu on La Nobless d'Etat', *Theory, Culture and Society*, 10:3 (1993), pp. 19–44.

12 *Ibid.*, p. 25.

13 J. L. Roget, *A History of the Old Water-Colour Society* 2 vols; 1st pub. 1891 (Clopton, 1972), vol. 2, pp. 125–31.

14 The term 'parliamentarisation of power' comes from N. Elias and E. Dunning, *Quest for Excitement* (Oxford, 1986), pp. 19–62.

15 E. Edwards, *The Administrative Economy of the Fine Arts in England* (London, 1840), p. 177.

16 T. Skaife, *Exposé of the Royal Academy of Arts* (London, 1854). A T. Skaife with a Liverpool location is listed as RA exhibitor in the years 1846–52: A. Graves, *A Dictionary of Artists who have Exhibited Works in the Principal London Exhibitions from 1760–1893* (3rd ed., Bath, 1970), p. 256. Joseph Sharples of the Walker Gallery Liverpool kindly informs me that an F. Skaife is listed as exhibitor at the Liverpool Academy for 1847 and that an A. Skaife showed there in 1860.

17 Hutchison, *History of the Royal Academy*, p. 122. Also *Royal Commission*, Minutes, qq. 760–92.

18 *Royal Commission*, iii. On the 1863 Commission see D. Robertson, *Sir Charles Eastlake and the Victorian Art World* (Princeton, 1978), pp. 351–3.

19 H. C. Morgan, 'The lost opportunity of the Royal Academy: an assessment of its position in the nineteenth century', *Journal of the Warburg and Courtauld Institute*, 23 (1969), pp. 410–20.

20 *Royal Commission*, Report, iii–iv.

21 *Royal Commission*, Minutes, q. 802.

22 *Ibid.*, qq. 1194–6.

23 *Ibid.*, qq. 1318–20.

24 *Ibid.*, q. 1411.

25 *Ibid.*, q. 1909.

26 *Ibid.*, q. 4511.

27 *Royal Commission*, Report, vii.

28 *Royal Commission*, Minutes, qq.192–4.

29 *Ibid.*, qq. 4244–7.

30 *Royal Commission*, 'Observations of the Members of the Royal Academy', 7.

31 Q. Bell, 'Haydon versus Shee', *Journal of the Warburg and Courtauld Institutes*, 22 (1959), pp. 347–58. In 1863 Holman Hunt was permitted to revise his evidence with a footnote, *Royal Commission*, q. 3042.

32 Skaife, *Exposé*, pp. 83–4.

33 *Ibid.*, pp. 44–7.

34 *Royal Commission*, qq. 1006–7.

35 An indication of this is the display of English watercolours at the Paris Exposition Universal of 1855: Roget, *History of the Old Water-Colour Society*, 89–90.

36 *Royal Commission*, Minutes, q. 889.

37 *Ibid.*, q. 1149.

38 *Ibid.*, q. 3735.

39 *Royal Commission*, Report, xiv.

40 Hutchison, *History of the Royal Academy*, pp. 120–1 and 132.

41 'Observations of the Members of the Royal Academy.' On the charter the RAs responded unambiguously: 'we are not prepared to ... surrender our present Deed of Establishment', p. 2.

42 Charles Eastlake Smith, ed., *Journals and Correspondence of Lady Eastlake* (London, 1895), vol. 2, p. 167.

43 *Royal Commission*, Minutes, q. 1342.

44 *Ibid.*, q. 1414.

PART III

ACADEMIC TRADITIONS AND
CRITICAL KNOWLEDGES

The lure of Rome: the academic copy and the *Académie de France* in the nineteenth century

Paul Duro

Adressez-vous donc aux maîtres, parlez-leur, ils vous répondront, car ils sont encore vivants. (J. A. D. Ingres)

By the mid-nineteenth century, the French state's principal pedagogical invest-ment in Italian art, the *Académie de France*, had been in existence for some two hun-dred years. Founded in 1666, the Academy was the embodiment of French aesthetic ambitions, serving as meeting place, cultural embassy, workshop and art school.[1] Its principal function was to receive each year a small number of accom-plished artists – all laureates of the *Prix de Rome* – who would stay for periods of up to five years, working at a programme that included, along with the study of painting, sculpture and architecture, courses in mathematics, geometry, perspec-tive and anatomy. Underlying all these studies would be imitation of the Antique, and emulation of the masters of the Roman High Renaissance.

This essay will seek to answer, through consideration of the role assigned to the copy in the nineteenth-century Academy, a deceptively simple question. In repro-ducing the work of the Old Masters, what did the students believe they were doing? On first inspection, the answer may appear to be self-evident. By copying, these young artists were availing themselves of the opportunity to study at first hand the art of the past and to round out the studies they had undertaken in France with a more practical understanding of the pictorial processes of those artists – such as Raphael – their teachers had long argued represented as the pinnacle of artistic achievement.[2] Of equal importance, several years spent in Rome studying the finest examples of Antiquity and the Renaissance accorded these young artists a cachet of learning and distinction neither the venerability of the Academy, nor its status as the pre-eminent finishing school for French artists, would do anything to diminish.[3]

But there are in these explanations – which all students of the time would recognise and most would agree with – worrying ambiguities of both principle

and procedure. Although it is clear that the rationale of devoting much of the curriculum at the Academy to copying was designed, on the one hand, to lead students through imitation to invention, was making copies the best way to achieve this aim? If, on the other hand, the goal was to perpetuate the reputation of a select band of artists through replication, and by these means to associate themselves, as latecomers, with a tradition then under threat from a nascent modernism, how did this translate into producing an art free of servile imitation? Most worrying of all, was not the relationship that these young students entered into with the art of the past itself problematic, not least in the sense that copies undertaken with the aim of procuring the secrets of the masters of past art frequently became confused in the minds of both students and teachers with appropriation – the belief that to reproduce the original was in some way to possess it, thereby making the imitation not a simple reproduction of appearances, but an evocation of the essence of another?[4] The answers to these questions are certainly not self-evident, but we might reasonably suggest one conclusion at the outset: neither the students nor their teachers could offer a viable counter-argument to the criticism that a near-exclusive emphasis on the art of the past would ultimately deny to the present-day artist the means to envisage a future beyond imitation.

We will need to examine these questions in more detail, but first it would be useful to establish a framework for how the theory of imitation is inscribed into the nineteenth century's own understanding of the past. This is important, for one thing is certain, without reference to its theoretical underpinnings, our understanding of the practice of copying will be reduced to seeing it as a mechanical and servile act of repetition, emptied of all pedagogical or aesthetic significance. And for all its shortcomings, it was – for its detractors as well as its advocates – very much more than that.

Imaging the past

The nineteenth century was the century of historicism. By historicism – a term which, unhappily for our peace of mind, boasts two, almost diametrically opposing, meanings – I mean that process by which the present informs itself of the past. Hayden White, among the most astute of contemporary historiographers of the nineteenth century, evokes the term 'imagination' to account for this process of reconstituting a past out of the debris left to the present. Significantly for the present study, the nineteenth century's resurrection of the past was at once rigorous, objective and scientific, while being framed through the sentimentalising narratives of anecdotal history.[5] For today's Post-Structuralist historians the adjectives 'rigorous, objective and scientific' strike a chill into the soul. From our post-Heideggerian, post-Foucauldian perspective, any history which purports to see in its analysis of the past a reality that is both objective and immutable is accused of ignoring the very process of history itself. For us the meta-narratives of the philosophers of history, such as Hegel and Marx, and the equally expansive

canvases of historians like Michelet, ignore the imperative to reconfigure the past through the concerns of an ever-advancing present.

These points were taken up by Friedrich Nietzsche in his essay 'On the uses and disadvantages of history for life' of 1874. In it he offers a familiar lament:

> We moderns have nothing whatever of our own; only by replenishing and cramming ourselves with the ages, customs, arts, philosophies, religions, discoveries of others do we become anything worthy of notice, that is to say, walking encyclopaedias.[6]

As an insight into the nineteenth century's theory of imitation this could hardly be clearer, and the task remaining for an age burdened by the achievements of past is to find enough courage to assimilate its lessons without allowing them to swamp the creative impulses of the present. 'Imagine,' Nietzsche asks us:

> the extremest possible example of a man who did not possess the power of forgetting at all and was thus condemned to see everywhere a state of becoming: such a man would no longer believe in his own being, would no longer believe in himself, would see everything flowing asunder in moving points and would lose himself in a stream of becoming: like a true pupil of Heraclitus, he would in the end hardly dare raise his finger.[7]

'Hardly dare raise a finger.' Nietzsche's remark may strike us as acceptable poetic licence, a figure of speech to suggest that exaggerated respect for the past felt by those who pretend to continue a great tradition. But this stance was, for many young, and not so young, nineteenth-century artists, not poetic licence at all, but the literal truth. Here is an account of the reaction of Charles Gleyre, the teacher of the Impressionists, to his encounter with the Old Masters:

> There awoke, or rather there developed in his soul, through the comparison he made between his own weakness and the power of the great artists of the Renaissance, a timidity and lack of confidence in himself that he would never overcome. It is no doubt from this moment which dates that fatal doctrine he all too often professed ... that the Old Masters had said everything there was to say and that there was nothing left to be done.[8]

To be clear on this point, I am not suggesting that Nietzsche's view has in some way conditioned the responses of artists like Gleyre – that response, we might well argue, Gleyre had constructed for himself without any philosophical prompting – only that Nietzsche's argument illuminates the experience of many nineteenth-century artists, and thanks to the pedagogical programme of the *Académie de France*, the working practice of the laureates of the *Prix de Rome* most of all. Let us then first consider: why Rome?

The lure of Rome

The mantle of learning an extended stay in Rome conferred on an artist had found institutional expression in a letter Colbert sent in 1664 to Nicolas Poussin, then the

most important French expatriate painter in Rome, offering him the directorship of the new Academy:

> Because it still seems necessary for young people of your profession to spend some time in Rome in order to form their taste and style from the originals and examples of the greatest masters of Antiquity and the last centuries … His Majesty has resolved to send each year [to Rome] a certain number [of students] … under the tutelage of an excellent master who can direct them in their studies and give them the good taste and the style of the ancients, and who will point out to them, in the works they will copy, those beauties, secret and almost inimitable, that escape the attention of the majority.[9]

Poussin refused the offer, and while in part this was no doubt due to his advanced age – he died the following year – it is reasonable to assume his decision was influenced by a belief that institutionalising the study of the Old Masters was not the best way to train artists in the spirited emulation of the art of the past. Equally problematically for the success of the Academy as a teaching institution, Colbert's letter also contains the seeds of an ambiguity that would have been present no matter which 'excellent master' had been approached. The copies the students were to make would be both replicas and studies; that is, they were tribute owed to the French state for the expense of maintaining an Academy in Rome, while also being a pedagogical exercise designed to reveal the mysteries of the art of the past to young artists. Given the need to furnish the vast new galleries of Louis XIV's Versailles, as well as provide suitably imposing models for the Gobelins tapestry factory, it is unsurprising that the first objective initially took precedence over the students' aesthetic education. Colbert's first thought was to respond to his master's dynastic ambitions by attempting to plunder Rome of its collections by purchasing them complete from the Italian nobility, but soon a papal decree forbade the export of artworks without permission – a measure aimed largely at the rapacious French who were seen to be despoiling Italy of its treasures.[10] If France could not have the originals, then it would have their copies. In a move designed to kill two birds with one stone – reproduction and pedagogy – Colbert instigated a programme of wholesale reproduction. The director in Rome was instructed to have the student painters copy 'all the beautiful paintings in Rome', while the sculptors would reproduce statues and the architects draw up plans of churches and palaces.[11]

Once established, Colbert pursued his policy with his customary vigour. In a letter of 1672 he wrote to the Academy's foundation director in Rome, Charles Errard, repeating that the students should be made to copy everything of beauty in Rome; then, if possible, be made to do it again.[12] And in a letter of the following year to Errard's replacement, Noel Coypel, the message remains the same:

> You also must work continually, and arrange it so that I may have, from you and your students each year, the fruits of your labours which may then demonstrate … those benefits His Majesty expects.[13]

In the following decades the call for ever-greater reproductive efforts was to become the administration's anthem. Faced with the restoration of several royal palaces in 1724, the director of royal buildings Louis-Antoine d'Antin wrote to Charles-François Poerson, then director in Rome: 'I ask you to employ your students in making copies of all you have that is most beautiful in Rome.'[14]

With such firmness of purpose it is unsurprising that work in the Academy in Rome soon settled into a regular pattern of annual shipments of artworks – both originals and copies – to Paris. But this official requirement fitted ill with the importance, recognised by both students and teachers, of the value of copying as a means of instruction. Students can only have been aware that while they were filling the galleries of Versailles with reproductions of all that was famous in Rome, their own studies were languishing. As early as the mid-1670s Coypel wrote to Colbert that the students were 'sick of copying', and proposed a modification of the programme to reduce the importance placed on imitation.[15] Later directors likewise attempted to moderate the state's perception that the purpose of the Academy was to provide reproductions for the royal palaces but with the same result. In 1702 the superintendent of buildings, Jules Hardouin-Mansard, wrote to René-Antoine Houasse, under whose directorship the number of copies had declined: 'I consider that the students should apply themselves to copying rather than working from their inspiration', an indication that nothing much had changed in the three decades since the Academy had opened.[16] But implementation of Mansart's wishes proved difficult, and another letter from Houasse the following year gives a clue why: 'The students only work at copying very reluctantly ... saying their teachers in Paris warned them ... not to [waste their time] making copies.'[17]

While other directors were more conciliatory than Houasse towards the practice of imitation, they nevertheless sought to steer the student's practice of copying away from the making of replicas towards a more specifically pedagogical purpose. Antoine Wleughels, director between 1725 and 1737, showed his understanding of the theoretical justification of imitation of the art of the past in noting:

> It is not to turn them into copyists that they have been sent here, but to make them into great men who will replace, in their turn, other able artists. It is imperative that they should copy only the best paintings, then go on to do something of their own.[18]

Here, then, the copy is not an end in itself but is situated in a role preparatory to the making of an original work. As will be shown later, the copy was to find its pedagogical justification in a programme of studies where, at least in theory, imitation would assume the guise of a creative process, the preparation necessary to composition, and therefore proper to invention.

With the gradual return of the copy to its original purpose in art instruction the 'tribute' copy metamorphosed into a pedagogical exercise – without anyone quite knowing how. Since unthinking adherence to tradition had become a hallmark of the *Académie de France*, this in itself might not have been a cause for concern. More worryingly, however, for a flexible and forward-looking theory of

imitation, the criterion for evaluation did not change either. Down the long years of industry report after report from the parent institution in Paris continued to offer praise when these copies were faithful to the appearance of the original – and censure when it was not. Here is the report on Eugène-Jean Damery's copy of Raphael's *School of Athens* in 1848: 'Excellent in every respect, the copy reproduces the character of the model, and is so faithful that it could be taken for the original.'[19] Leaving aside the problem faced by a theory of imitation which supposes perfection is to be found in exact reproduction, the difficulty here lies in separating the nineteenth century's notion of exactitude from its aesthetic beliefs regarding the art of the past. From this perspective, the Academy was necessarily more aware of the faults of omission than commission. The hapless Auguste Lebouy's copy of Raphael's *Heliodorus* of 1846 was castigated as having: 'So many deficiencies that we refrain from naming them, as they are unhappily all too obvious.'[20] The result was that the most praised copy was that which exhibited fewest defects – not the most qualities. This had the effect of inhibiting experimentation and intimidating the students into a servile and self-defeating copy practice that exaggerated respect for the model and engendered a slavish veneration of the past. Charles Thévenin, director in 1818, understood that it was not just a question of students fulfilling a requirement of the curriculum, but that the work should have a meaningful purpose:

> I admit that it may appear painful to artists who, having studied for four years the masterpieces of great artists and are burning to make something of their own, are then obliged to confine themselves to an exact copy of a complete painting.[21]

This reasonable objection notwithstanding, the evidence suggests that requiring a student to undertake a copy while all along arguing that the purpose was to engender originality was surely over-optimistic. And it is here that Nietzsche, once again, informs on the poverty of the practice when he argues that if knowledge of culture precedes a knowledge of life then the student can only mediate experience through the tired clichés of the past:

> It is exactly the same crazy method which leads our young painters into picture galleries ... As if one could appropriate the arts and sciences of past times, the actual yield of life's experience, by taking a fleeting stroll through the gallery of history![22]

Yet this was precisely what the *Académie de France* tried to do. The programme of study required its students to produce a copy in the penultimate year of the five-year *Prix de Rome* scholarship, immediately preceding the task of the final year – the making of an original composition on a historical or biblical theme.[23]

Following on closely from the copy, the work of the final year would retain the influence of the model copied the previous year. As a preliminary to embarking on an original creation, such preparation became for many artists second nature. Paul Baudry, who won the *Prix de Rome* in 1850 with *Zenobia Found by the Shepherds* (figure 18) at the age of only 22, had returned from Rome an enthusiast for the Old

Masters. His rise through the academic hierarchy was rapid and was to culminate in membership of the *Institut de France* and the commission to decorate the new *Opéra* designed by his friend Charles Garnier. Yet his first reaction on gaining the prestigious commission was to embark on a two-year sabbatical in Rome to copy, 'like a schoolboy learning his lessons' as he himself noted, the frescoes of Michelangelo in the Sistine Chapel. The months of work, described by Baudry as a silent dialogue with the greatest artists of the past resulted, perhaps inevitably, in the walls of the *Opéra* being covered in pastiches of paintings of the Roman High Renaissance (figure 19).

Of course, up to a point Baudry had acted like the history painter he considered himself to be. His practice followed that of artists as diverse as David and Rubens, both of whom had studied in Italy. The difference was that, as Delacroix remarked in admiration of the Flemish master, Rubens went to Italy and returned more himself than ever.[24] By this Delacroix did not mean that Rubens had learned nothing in Italy, but that he remained in control of his individual stylistic vocabulary in spite of examples of monstrously celebrated artists on all sides.[25] With his freedom to

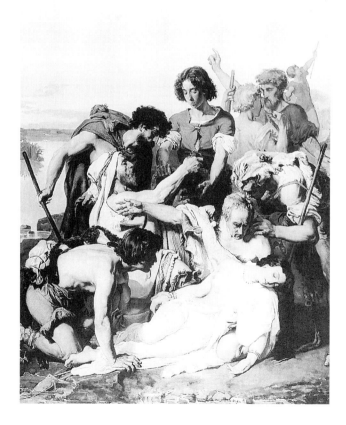

18 Paul Baudry, *Zenobia
Found by the Shepherds*,
oil on canvas, 1850,
146×115 cm.

choose and to reject, Rubens's study of the Old Masters matches Nietzsche's injunction to embrace the past the better to create a future of one's own making. Examination of Rubens's practice of imitation bears this out. In his study after Polidoro da Caravaggio's decoration of the Palazzo Milesi, what has been taken from the earlier artist is the arresting composition and striking perspective lending horse and man a monumentality appropriate to the subject – the heroic origins of Rome (figure 20). But there the 'influence' stops. There is no repetition of the model's technique or handling. On the contrary, the drawing – in brush, pen and ink – looks more like a Rubens than the work of any other artist: the bold use of light and shade, the massed form, the energetic treatment of outline, all leave us with the certainty that no other artist would, or could, have approached the model.[26] Rubens has not lost his sense of self.

Unlike the 'strong' Rubens, Baudry's approach is 'weak,' or in the terminology of Nietzsche, 'life-denying'.[27] In Baudry's preparatory study for the decoration of the *Opéra*, the influence of Michelangelo is everywhere apparent. The pose is that of the prophet Isaiah from the Sistine Chapel ceiling, while the treatment is a kind

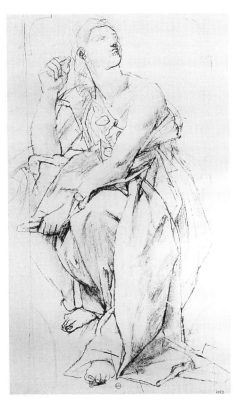

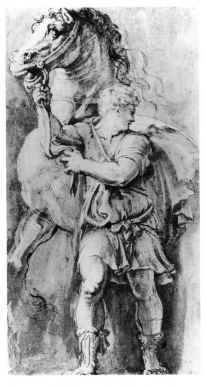

19 Paul Baudry, *The Muse Calliope*, pencil, 49 × 29.5 cm.

20 Peter Paul Rubens, *Youth Leading a Horse, after Polidoro da Caravaggio,* ink and body colour on paper, 1605–08.

of reverse development, working back from Michelangelo's finished painting towards an imaginative reconstruction of Michelangelo's own preparatory studies. This is not the first time Baudry had allowed his imagination to intervene in the process of historical appropriation – indeed, such preparation was for Baudry no more than his usual procedure before painting an 'original' work. For example, when he assembled studies for his celebrated *Charlotte Corday* of 1860, he copied not only David's iconic *Death of Marat* – a painting which itself has an undetermined relationship with the actual event – but also a supposed portrait of Corday which he duly 'historicised' with a fake inscription. Neither work was in itself necessary to the finished canvas; rather for Baudry this procedure added legitimacy to the end result.[28]

We might wonder at Baudry's lack of self-confidence. What we are witnessing here is the amalgam of the documentary and the imaginative in which the means to represent the one becomes indistinguishable from the object of the other. In Baudry, the needs of the present – his present – have been ransomed for a share of a putatively timeless past blocking off all possibility of progress. Baudry uses Michelangelo's painting to legitimise his own. It was an approach that saw in the example of the past an immutable and eternal truth which the present had only to reach back to recover. Against this form of historical picturing there was for Nietzsche the life-affirming kind of emulation such as that practised by Rubens, which saw in history an endless source of options that allowed the artist the freedom to recompose the past into a genuinely original future.[29]

It is perhaps from this perspective that Ingres, during his directorship (1835–40) of the *Académie de France*, suggested that the obligatory copy be moved from the fourth to the first year. This would have the effect of establishing the maximum delay between the execution of the copy and the creation of an original history painting in the student's final year. Ingres's intention was to minimise the impact of technical procedures, while a secondary effect would be that compositional practice would be emphasised early on in the student's stay in Rome. If, as he claimed, the value of studying older art was to teach the student observation, then his proposal is logical as it coincides with the development of the student's knowledge of the forms of older art. The proposal would also avoid an interruption in the progressive emancipation of the student from servile copy to original creation. However, opposition to change remained implacable, and the Academy rejected Ingres's suggestion.[30]

Nature and the Antique

Fundamental to an understanding of the academic copy is the dispute between those who professed a theory of imitation based upon close observance of nature and those who advocated an emulation of the Antique. The distinction had been drawn as early as the seventeenth century when a mechanical and therefore anti-intellectual form of representation, such as Dutch genre painting might be held to employ, was

considered no longer in keeping with painters' pretensions. The work of art was seen to embody the artist's personality, and as such became the unique creation of a personality in which resided a psychology of vision which separated the artist from those whose work was merely a copy of nature.[31] The consequences for a theory of imitation were far-reaching. Emphasis on the individuality of the artist led to a parallel requirement being applied to the work of art – that it should be original. The problem was that, once originality became important as a criterion for evaluating a work of art, then all forms of imitation could be equated with plagiarism, and the copy, far from rivalling its model, characterised as a pastiche. However, the *Académie des Beaux-Arts* sought to reconcile the contradiction by making a subtle distinction between real and false originality. For the Academy, the copy, through the exemplary procedure of recreating the pictorial construction of the model imitated, constituted the re-enactment of a prior pictorially articulated intellectual development. In this way the student was held to develop true originality through a temporary subservience to the model, without ever falling into base imitation.

Furthermore, it is important to note that, for the *Académie des Beaux-Arts*, true originality – the originality resulting from profound and extended study of the art of the past – should not be confused with the merely bizarre. The first was an essential component of beauty, while the latter was a false quality based upon novelty, such as the gestural handling of paint or an emphasis on colour might provide (hence the Academy's disapproval of Rubens, and to a lesser extent Michelangelo). The real danger lay in the fact that a highly personalised technique was not open to the same standards of judgement as one based on study of the Old Masters. Technically, this required the painter to eradicate any visible signs of handling which might re-establish the plastic presence of the picture at the expense of the idea depicted.[32] Ingres, who understood better than most the parameters within which academic painting functioned, warned against this threat. For Ingres the visible brushstroke was an abuse of execution characteristic of false talent. It should not be apparent, otherwise it would destroy the illusion and – a significant choice of vocabulary – immobilise the representation.[33]

Thus imitation of those artists of the past whose technique accorded with Ingres's view was the essential prerequisite, on the one hand of good composition, and on the other of sound practice. Gleyre, although never a member of the Academy and hardly sympathetic to Ingres's doctrinaire approach, likewise warned against a mannered preoccupation with execution. His pupil Paul Milliet records that for his teacher the value of copying rested on the repetition of the executive stage of picture making, and that Gleyre criticised the reproductions in the *Musée des copies* for ignoring the way the original painters had made their pictures: 'The copyists appear not to have bothered with procedure at all, they have contented themselves with an approximation which renders neither the impression nor the handling.'[34] Clearly Gleyre saw no value in copying the surface appearance of the model but only in reproducing procedure. This belief that the visible application of paint interfered with the illusion necessary for the academic

painter is important in understanding the means by which the nineteenth century overcame the temporal span between the copy's production and the models it emulated. In adopting a procedure that hid the material aspects of painting under a patina of illusionism, the academic artist was better able to identify his production with that of his models. These views were not held by Ingres and Gleyre alone, but were likewise professed in the *Académie des Beaux-Arts*:

> It is only recently that, through a return to a truer conception of art, the exact imitation of the work of a master for the purposes of study has been undertaken, and it is from this point of view that copies present a real importance for the education of the artist.[35]

In fact the Academy sought at every level as close an identification as possible with the model, not its interrogation, and cautioned against a transient fame gained at the expense of further study: 'The brilliant success gained by some artists independently of an orthodox education has allowed others to dream of a new art, of a more rapid, or easier, path to success and fortune.'[36] This advice was repeated endlessly: avoid the seduction of rapid success won through the deployment of facile techniques and instead find professionalism through application and duty. Defending at the same time its own philosophy of art and the value of five years of study at the *Académie de France*, the Academy in this mid-century stance reveals concern with the impact of pictorial techniques that challenged its authority to arbitrate the question. The classical studies demanded by the Academy excluded any route to artistic excellence that avoided diligent application and an extended period of apprenticeship. The highly finished copy was respected for its evident degree of exactitude arrived at through a faithful reproduction of the working methods of the author of the work copied.

Unsurprisingly the results of this procedure became second nature to students trained in faithful imitation: Garnotelle, the Goncourts' academically minded student, is given the *Prix de Rome*, not for his talent or future promise, but for his application, his assiduity, for the sound working practices of the diligent copyist of the masters:

> [He] epitomised the case of the artist born without talent but blessed with will-power, thankless persistence, courage in the face of his mediocrity, and patience. Through application and perseverance he had become an almost competent draughtsman, the best in his studio. His drawing was no better than exact – a dry line, a copied contour, all servile and strained, where nothing breathed that air of freedom characteristic of the great interpreters of form. ... For this artist colour did not exist. His compositions were mediocre, drawing on a second-hand imagination borrowed from a dozen well-known paintings. Garnotelle was, in a word, a man of negative qualities, a student without the vice of originality.[37]

The case is fictional, but the circumstance is not. In order to give further dimension to these observations, let us now turn to an analysis of the circumstances

surrounding the copy Henri Regnault, *Prix de Rome* winner in 1866, made while a
student at the *Académie de France*.

Emulation at the limit

Like all students, Regnault – whose dazzling debut in the Salon was ended by an
early death in the Siege of Paris in 1871 – was constrained within certain limits,
including the necessity of selecting a model to copy from among the artworks of
Rome. But profiting from the liberalisation of the programme following the 1863
teaching reforms and the directorship of the liberal Ernest Hébert, Regnault trav-
elled to Spain and there fell under the spell of Velasquez: 'I have never seen a
painter to compare. What colour, what charm, what sureness of touch, all that is
new and original! This is young and vigorous painting, good from every aspect,
created without effort, without pain, without fatigue.'[38] Had Regnault's enthu-
siasm been less ardent and his judgement cooler he might have realised he had
listed the very qualities the Academy habitually warned against – colour, charm,
touch, novelty and originality – while praising a procedure 'created without effort,

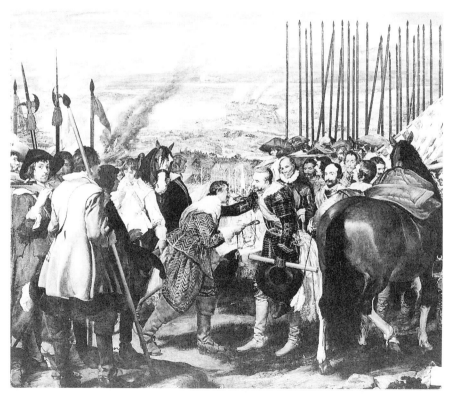

21 Diego Velasquez, *Surrender of Breda*, 1634–35, oil on canvas, 307 × 367 cm.

without pain, without fatigue', anathema to academic thinking. But the young artist, distant from the guidance of the Academy, went ahead with his choice of copy: the *Surrender of Breda* (figure 21), exhibited, then as now, in the Prado Museum.

At first Regnault made good progress and his letters home are full of enthusiasm for the undertaking, although a note of anxiety soon creeps in when he notes, 'the handling is not exactly easy to reproduce, but it's fascinating'.[39] All too soon Regnault's ardour turns to disillusionment. While the early stages of laying-in had presented few problems, his difficulties increase when he tries to reproduce what Velasquez had accomplished last, and with so little effort:

> I have made the error of selecting the wrong painting, or at the very least, of failing to choose one with more carefully finished passages. … I have undertaken a task which will be long and painful, because nothing is more difficult to copy than that which seems to be easily done, and executed with such marvellous assurance.[40]

A spirited emulation might work so long as the copyist was prepared to renounce reproducing the appearance of the model in favour of evoking its painterly qualities

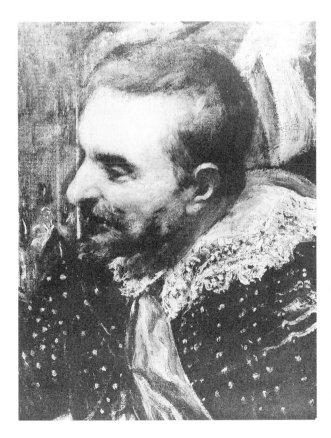

22 Diego Velasquez, *Surrender of Breda* (detail).

through the use of a complementary technique. But the gestural expressiveness of the paint mocked Regnault's efforts. Consideration of the head of the victorious general Spinola explains Regnault's dilemma (figure 22). Spinola's lace ruff is painted with Hals-like freedom, the studs on his jerkin mere dabs of paint. To all intents and purposes, especially the purposes of the Academy, the picture is unreproducible.

By ignoring the pedagogical purpose of the copy and following his preferences, Regnault had allowed himself to be drawn into a situation where his skills were necessarily unequal to the task. And by selecting a model in which the painterly passages that had come so easily to Velasquez could not be reproduced, the best Regnault could achieve was an approximation – exactly the kind of superficial effect Gleyre had warned against, and precisely what the Academy argued was of no pedagogical value. In committing the double fault of ignoring the Academy's advice on the choice of model and failing to meet the fundamental criterion of the academic copy – that it should be faithful to the original – Regnault sinned twice. It is significant that Regnault's confession was made to Hébert who, we might note, had done nothing to dissuade Regnault in his choice. But even if the director had acted more decisively it is unlikely his student would have listened, as Regnault voiced what had become universal opinion in a letter that accompanied his already degraded reproduction: 'A copy is not so important that one is disgraced for having made it a little too dark.' Leaving the copy unfinished to be completed by an unnamed painter friend, he commented airily that, while his copy was bad in this respect, 'I've followed the rules, or at least tradition', and concluded that the Academy 'would understand his difficulties and good intentions'.[41] It is difficult not to believe that he did not much care whether they did or did not.

Conclusion

What have these examples told us about how the Academy approached the art of the past? First of all, that to speak of only one kind of imitation of art is clearly wrong. Here I have confined myself to the example of the academic copy executed in fulfilment of part of the Academy's *Prix de Rome* programme. Yet the ubiquity of the practice does not prove a guarantee against its misapplication, or help to explain why the copy formed a cornerstone of the academic edifice. Rarely can painters have been less lucid about what they were doing, or the Academy more self-contradictory over the value of an artistic practice. For the student, the copy, its nature disguised under the rubric of 'pedagogy', constituted an everyday artistic event, the banality of which militated against questioning its role as a necessary stage on the road to originality. Of course, what we have been examining here is not a self-aware practice at all, but a discursive construct based on the meeting of pedagogy and tradition. Only from this perspective can we understand how a system designed to favour a tiny number of artists at the expense of the

many came to dominate institutional art practice in the nineteenth century. For it is clear that for the artists I have discussed, and many hundreds more throughout the century, the practice of making copies for study purposes was seen as a necessary prerequisite to the making of significant work of their own invention. This is not to conclude that they were happy prisoners of their fate, but it is for this reason alone – that the copy seemed necessary – that we may begin to see in the these works of imitation not the unthinking expression of conservative values but an essential component in a system of training that enabled many artists to climb into the realm of history painting and identify themselves, however tenuously, with the Old Masters.

Notes

1 The Academy's statutes were signed by Colbert on 11 February 1666 and allowed for 12 students – 6 painters, 4 sculptors and 2 architects – who should be French, Catholic, male, and single; see Henri Lapauze, *Histoire de l'Académie de France … Rome*, 2 vols (Paris, 1924), vol. 1, pp. 1–7.

2 For the influence of Raphael on French art, see *Raphael et l'art français*, exhibition catalogue, Grand Palais (Paris, 1983).

3 Countless biographies and autobiographies published in the nineteenth century attest to the transformative effects of a period of study at the *Académie de France* in Rome. By way of example see Eugène-Emmanuel Amaury-Duval, *Atelier d'Ingres* (Paris, 1878); Auguste Barbier, *Souvenirs personnels* (Paris, 1883); Charles Ephrussi, *Paul Baudry: sa vie et son oeuvre* (Paris, 1887).

4 This form of appropriation is discussed by Sir James Frazer in *The Golden Bough: A Study in Magic and Religion*, 3 vols (London, 1900); see also Michael Taussig, *Mimesis and Alterity: A Particular History of the Senses* (New York, 1993), esp. pp. 44–58; also Albert Boime, *The Academy and French Painting in the Nineteenth Century* (London, 1971), pp. 123–4.

5 Hayden White, 'Interpretation in history', in idem, *Tropics of Discourse: Essays in Cultural Criticism* (Baltimore, 1978), p. 51.

6 Friedrich Nietzsche, 'On the uses and disadvantages of history for life', in Daniel Breazeale, ed., *Untimely Meditations*, trans. by R. J. Holingdale (Cambridge, 1997), pp. 59–123, esp. p. 79.

7 *Ibid.*, p. 62.

8 Charles Clément, *Charles Gleyre* (Paris, 1877), p. 52.

9 Anatole de Montaiglon, ed., *Correspondance des Directeurs de l'Académie de France … Rome*, 18 vols (Paris, 1887–1912), vol. 1, p. 1.

10 The decree dates from 1686: *ibid.*, vol. 1, p. 153.

11 Lapauze, *Histoire*, vol. 1, p. 8.

12 Montaiglon, *Correspondance*, vol. 1, p. 36.

13 Lapauze, *Histoire*, vol. 1, p. 41.

14 Montaiglon, *Correspondance*, vol. 3, p. 53.

15 *Ibid.*, vol. 1, p. 48.

16 Lapauze, *Histoire*, vol. 1, p. 139.

17 Letter dated 26 June 1703; see Montaiglon, *Correspondance*, vol. 3, p. 103.

18 Letter to Louis-Antoine, duc d'Antin, dated 8 August 1724, in *ibid.*, vol. 7, p. 65.
19 *Rapport sur les ouvrages envoyés de Rome par les pensionnaires de l'Académie Nationale de France pour les années 1848 et 1849*, Archives nationales, Paris, AJ52 201, AJ52 453; and Ecole nationale supérieure des beaux-arts, Paris, Inventaire général 19.
20 *Rapport sur les ouvrages envoys, de Rome par les pensionnaires de l'Académie royale de France pour l'année 1846* (Paris: Institut de France, 1846); see also 'Etats des envois de Rome', Archives nationales, Paris AJ52 201, 'Académie de France … Rome: copies exe-cutées par les pensionnaires', AJ52 453; also Ecole nationale supérieure des beaux-arts, Paris, Inventaire général 17.
21 Lapauze, *Histoire*, vol. 2, p. 131.
22 Nietzsche, 'On the uses', p. 118.
23 By the nineteenth century the programme of study in Rome had been fixed at five years. For 1821 the programme was as follows: Year One: A life-size nude figure painted from life; Year Two: Four nude figures drawn from nature, and two drawings from the Antique; Year Three: A sketch of the student's composition, drawn or painted; Year Four: A copy of a painting by an Old Master; Year Five: A history painting composed of several life-size figures. The programme was to remain unchanged until 1863 when reform reduced the scholarship to three (later four) years. See *Statuts et Reglements de l'Académie de France … Rome*, Archives de l'Institut de France (Beaux-Arts) 5 E 12. For a study of the 1863 teaching reforms see Albert Boime, 'The teaching reforms of 1863 and the origins of modernism in France', *Art Quarterly*, 1 (1977), pp. 1–39.
24 See Delacroix's notes towards a Dictionary of Fine Arts in his Journal (this reference dated 1 March 1859), in Hubert Wellington, ed., *The Journal of Eugène Delacroix*, trans. Lucy Norton (London, 1995), p. 413.
25 For a study of Delacroix's own copies of older art see *Copier Créer: de Turner … Picasso – 300 oeuvres inspirées par les maîtres du Louvre*, exhibition catalogue, Musée du Louvre (Paris, 1993), pp. 234–49.
26 For a discussion of Rubens's copy see Michael Jaff, *Rubens and Italy* (Ithaca, 1977), p. 48.
27 I have borrowed the terms 'strong' and 'weak' from Harold Bloom, *The Anxiety of Influence: A Theory of Poetry* (Oxford, 1973), esp. pp. 5–16.
28 See Paul Duro, 'Marat, Charlotte Corday and the assassination of history', *Australian Journal of Art*, 8 (1989/90), pp. 122–32.
29 Hayden White, *Metahistory: The Historical Imagination in Nineteenth-Century Europe* (Baltimore, 1973), p. 332.
30 Lapauze, *Histoire*, vol. 2, p. 247.
31 For a study which associates the 'mechanical' or executive aspects of artmaking with craft see Donald Posner, 'Concerning the mechanical parts of painting and the artistic culture of seventeenth-century France', *Art Bulletin*, 75, 4 (1993), pp. 583–98; see also Martin Kemp, *The Science of Art: Optical Themes in Art from Brunelleschi to Seurat* (New Haven and London, 1990).
32 This is, of course, the polar opposite of Greenberg's characterisation of Modernist painting: see Clement Greenberg, 'Modernist painting' (1965), reprinted in Francis Frascina and Charles Harrison, eds, *Modern Art and Modernism: A Critical Anthology* (London, 1986), pp. 5–10.
33 By 'immobility' Ingres meant the stasis which might beset a painting which fails to mediate correctly between the idea and its manifestation. Success was achieved when the painting, as material object, lost its substance and transmitted the concept without

its physical presence impinging on the spectator's perception: see Henri Delaborde, *Ingres, sa vie, ses travaux, sa doctrine* (Paris, 1870), p. 150.

34 Paul Milliet, *Une famille de Républicains Fouriéristes*, 2 vols (Paris, 1915), vol. 1, p. 249.

35 'Copie,' *Dictionnaire de l'Académie des beaux-arts* (Paris, 1858–87).

36 *Rapport sur les ouvrages envoyés de Rome par les pensionnaires de l'Académie royale de France pour l'année 1838* (Paris, 1838).

37 Edmond and Jules de Goncourt, *Manette Salomon* (Paris, 1979).

38 Arthur Duparc, *Correspondance de Henri Regnault* (Paris, 1872), pp. 185–7.

39 *Ibid.*, p. 194.

40 Josephin Aimé Péladan, *Ernest Hébert: son oeuvre et son temps* (Paris, 1910), pp. 162–4.

41 Lapauze, *Histoire*, vol. 2, p. 399.

Cultivation and control: the 'Masterclass' and the Düsseldorf Academy in the nineteenth century

William Vaughan

The Masterclass

In his classic survey of the history of academies of art in Europe since the Renaissance Pevsner refers to the establishment of *Meisterclassen* (Masterclasses) as 'the most important innovation in the history of academies during the nineteenth century'.[1] Innovated by members of the celebrated German medieval revivalist group, the Nazarenes, this practice aimed to counter the impersonal character of academic tuition with a more individual and engaged style of instruction based on an idealised notion of the apprenticeship system that pertained in artists' workshops during the Middle Ages. In essence it involved the grouping of advanced students of promise around a principal teacher, or 'master'. Each of these students would have a studio of their own close to that of the master, who would visit and provide sustained individual instruction. Such careful treatment, it was held, would enable the advanced student to absorb the most intimate secrets of the craft and to be encouraged to develop in directions most suitable to his (it was almost always his) personality and inclinations. Introduced first at the Academy in Düsseldorf in the 1820s the practice slowly spread until it had become the norm in German academies by the middle of the century, as well as being widely imitated in other countries, particularly in northern Europe.

Yet while allowing that this innovation gave a new emphasis to the personal requirements of the student in academic training, one can question the nature of its effect. Pevsner himself, despite expressing admiration for the concept, admitted that it did not in the end lead to dramatic innovation either in artistic practice or education. He saw this as the result of a failure by the reformers to press their changes far enough; the Nazarenes, and the Romantics in general, had declared war on the old academies. The victory was theirs – as complete as could be. One after another they had entered the strongholds of the enemy. And then when they could

have established a new regime, the spirit of Colbert, if it may be called that, proved stronger than theirs. How can this be explained?[2] Pevsner answered his question broadly in terms of the then dominant modernist association of the artistic avant-garde with political radicalism. It was the move back to conservatism after the Napoleonic wars that prevented 'reform' being able to succeed beyond a certain point. He was looking at the matter from the perspective of one who had seen the progressive practices of the Bauhaus in the 1920s extinguished by a totalitarian regime. Writing in the later 1930s he had every reason to support the progressive spirit at a time when Europe was being blighted once again by the forces of reaction and repression.

Looking at the issue from the perspective of the 1990s, however, we may regard things rather differently. Without wishing to challenge the observation that the Masterclass system – despite the immense prestige it enjoyed in the period in which it was practised – had a limited outcome, we can see it less as a failed Romantic dream and more as a carefully constructed process for extending the control of professional practice at the time. The period following the Napoleonic wars was one of growing professionalisation in the German states. This was the time when reforms were introduced into the universities to enable them to regulate more clearly their research practices, student intake and provision of qualified practitioners in such areas as law, medicine and the church. The pressure behind this was as much related to social control[3] as it was to any altruistic pursuit of pure knowledge, although the ideal of the latter was vociferously promoted and increasing scorn was poured on the *Brotstudent*, the 'bread student' who simply learned what he needed for purposes of a earning a living.[4] Closely controlled by powerful legally-trained government bureaucrats the system was intended to counter the subversive tendencies that had emerged in the wake of the French Revolution and had been inflamed by democratically-minded 'demagogues' during the period of the War of Liberation (1809–14). A well-regulated system of higher education was seen as a critical means of constructing a well-ordered professional class who would exert a beneficial effect on society at large. While considered as belonging to the same Stand – or social rank – as the professionals, fine artists were not seen as partaking in social control in quite the same way as these. On the other hand, it was clear that they had a symbolic function to perform and that personal fulfilment and ordered activity could be shown to be as compatible here as else-where. The *Masterclass* was an exemplification of this principle. It mirrored the simultaneous growth of idealism and control that was to be found in the universities. A key change in the universities of the day was the growing emphasis on a linking between original research and structured instruction. The university professor was no longer simply required to transmit pre-existent knowledge. He was expected to be involved in the creative development of his subject and to communicate the benefits of this to his students. The Masterclass performed a similar function. For the advanced student now became involved in the actual pictorial practice of the master. An important corollary of the development of the Masterclass was

the initiation of large-scale public (and usually state funded) mural schemes. Peter Cornelius – the Nazarene who first proposed the introduction of the Masterclass system – was engaged in the planning and production of the vast mural schemes commissioned by Ludwig I of Bavaria to turn Munich into an 'art city'.[5] The members of Cornelius's Masterclass in fact had little opportunity for personal expression. They were in practice his assistants, trained to carry out his designs on the walls of the churches and public buildings he had been commissioned to decorate much in the way that a research student in a university might be expected at that time to help in conducting the research of his professor.[6]

Not all Masterclasses were as rigid as that run by Cornelius. But they all contained within them the notion of a paternalistic surveillance of the student's development and activities. This had the effect of regulating development and change in Germany, channelling these to become part of a relatively harmonious 'dialectic' rather than precipitating iconoclastic challenges by an avant-garde, as became the norm for the 'Modernist' development in art in Paris in the nineteenth century. It is certainly striking that in contrast to France – and even to Britain, where the Pre-Raphaelites staged their protest – there were no artistic revolts in Germany in the mid-nineteenth century. The place where such a revolt was most likely to have taken place was Düsseldorf – the academy in the heart of the industrialised Rhineland area that saw the early activities of Karl Marx leading up to the Revolution of 1848.[7] Yet while there were some skirmishes amongst its members, these never led to a total secession or rupture.

The Nazarene project

Yet the kernel of the idea of the Masterclass had come from a moment of rebellion. When the Brotherhood of St Luke was established in Vienna in 1808 by a group of disgruntled academy students, it was intended to promote an alternative and more individualistic mode of study. The idea of rebelling against the academy was not new. The cult of original genius in the later eighteenth century had brought with it the almost inevitable conclusion that art could not be taught, and that academies must necessarily promote mediocrity born of what the Nazarene leader Franz Pforr called 'slavish studies'.[8] The French Revolution had further provided the prototype for 'fraternal' rebellion which had already led to the breakaway Barbu group in David's studio in Paris. Ironically David had himself caused a rupture with academy practice, using the political power that he gained as a supporter of the Jacobins to have the French academy of the *ancien régime* abolished and instigating himself a form of Masterclass in his own studio. David was rebelled against in his turn because the paternalistic system he set up came to be seen as a new kind of authoritarian imposition.[9] The pattern of recurrent rebellion set up here was to persist and become a feature of Parisian artistic practice. The difference in the German Masterclass system ultimately was that this cycle did not occur. The new generation did not feel the need, in their turn, to stage an open rebellion.

The members of the Brotherhood of St Luke were not in themselves political radicals. Yet they were promoting an anti-authoritarian view of art. They sought to replace hierarchy with a communal structure. Although they designated the two most powerful personalities in the group – Friedrich Overbeck and Franz Pforr – as their guiding spirits, this did not lead to any formal system of command. They worked as a close group – particularly after leading members had travelled to Rome in 1810 and set up a communal existence in the deserted monastery of St Isidoro on the Pincio. Even before that time, in Vienna, they had preferred shared drawing sessions without 'instruction' to attendance at academy classes. For they saw pictorial 'truth' as being something discoverable via their own perceptions rather than through the 'imposition' of an academic prototype. At one level this belief related to the Romantic notion of self-discovery and individual genius. Each person must develop their own perception by their own path. At another it promoted the ideal of 'community', the *Gemeinschaftsideale* in which authoritarianism was replaced by group practice. The father figure had been rejected and the brothers proceeded on terms of sharing and equality.

An image of this sharing can be seen in the many 'friendship' portraits produced by the Nazarenes and their associates. That produced by Wilhelm Schadow – a member of the Brotherhood who was later to become director of the Düsseldorf Academy – shows the artist together with two sculptors: his brother Rudolph and the famous Danish Neoclassicist Bertel Thorwaldsen (figure 23). The brothers face each other, the tools of the trade laid out on the ledge between them, as if in challenge. But they are clasping hands. Rudolph – the more masculine in appearance – holds his mallet at the alert, but in the shadows. Thorwaldsen, despite sharing Rudolph's trade, is dressed in a soft costume closer to that of the painter. He puts his hand on the painter's shoulder as though to show that there is no conflict between such people and sculptors. Furthermore, while he is the most distinguished member of the group he is not imposing authority, rather inviting communality.

While not immediately evident, there was an inherent contradiction between the 'communal' image of the artist and the notion of individual genius. As with so many artistic brotherhoods in the nineteenth century, this instability precipitated the dissolution of the Brotherhood within a few years. Yet, in the period in which it might be said to have functioned as a real alternative community, it did produce an art and an identity that seemed to offer an exciting challenge to more normative forms of practice. Perhaps this can be seen most intensely in the study drawings and portraits produced at this time. For in these there was both an uncovering of self – the revealing of personal identity through direct exploration – and the sense of a shared ideal. By contrast, the historical and religious paintings have a more formulaic appearance and tend to be more closely dependent upon models from the past. The portraits and drawings convey a sense of the intensity of relationship that existed between the members and which was expressed most fully in the very close friendship between Overbeck and Pforr. This was broken by Pforr's death in 1812, and from that time on the Brotherhood gradually began to loosen its ties and fall apart.

23 Wilhelm von Schadow, *Self Portrait with the Artist's Brother and the Sculptor Bertel Thorwaldsen*, *c*. 1815/16, oil on canvas, 91.5 × 117 cm.

It was perhaps a sign of this growing dissolution of the more intimate and personal group that the brothers should have undertaken a public venture, the decoration of the ante-room of the Prussian consul Salomon Bartholdi in Rome in 1815.[10] It was this series of frescoes that brought the Brotherhood international fame and at the same time underlined a change of direction. Overbeck became more withdrawn from the others, remaining committed to the monk-like dedication of the Brotherhood and continuing his career in Rome as a leading painter of the religious revival. Peter Cornelius – a latecomer to the Brotherhood who effectively assumed the dominant role formerly occupied by Pforr – made the move back to Germany where he used the Nazarene ideal as the basis for building a national didactic art. Cornelius's role can in many ways be seen as an act of usurpation. During his early years in Germany he had become fired by the nationalist movement to re-establish a national artistic identity. When he came to study in Rome he saw the Nazarene group as providing a congenial basis for this. He already perceived the painting of the frescoes for Consul Bartholdi as a national project and used its success to negotiate both his leading role painting murals for Ludwig of Bavaria and his role as Director of the 'reformed' Academy at Düsseldorf.

Almost inevitably, the close bonding of the Nazarenes leads to questions of the homo-social nature of the group. Even allowing for changes in social habits, the

intense personal nature of the relationships seems to move beyond those of a professional organisation, or even of the bonds of the familiar student groups, the *Burschenschaften* of the period. Whatever the full nature of these relationships, it is clear that such associations did in some degree undermine the credentials of the Brotherhood as the source of a national art. Overbeck's passive, monk-like demeanour was particularly criticised for its femininity. Cornelius, on the other hand, exhibited from the start a more masculine vigour. The break between the two can, in a sense, be seen as a form of divorce. More importantly, it showed Cornelius separating the active role of the independent genius from the communal image of the artist. He was now to become the man of action who would reform both the teaching of art in Germany and its public role.

Cornelius and the national context

It is revealing that, as part of this process of separation, Cornelius should reconceptualise the practice of communal study that had been at the centre of the Nazarenes' activities in the Convent of St Isidoro. In this reconceptualisation – as the name 'Masterclass' itself implies – he introduced a critical figure who had not been there for the Nazarenes, namely the Master. Now communal study is no longer about self-discovery as a shared experience. It is about being 'guided' by the master to self-fulfilment as the agent of a public project. Cornelius would hardly have succeeded in his aim had it not fallen in with the pattern of practice being sought by the rulers and administrators of the new order. 1815 – the year in which the Bartholdi frescoes were executed – is also the year in which the post-Napoleonic order was established in the German countries, with critical moves being taken to reassert authoritarian control. Even the visual arts were brought in to this new order, particular in Prussia where the state bureaucracy was gearing itself for an even more thorough administration of the affairs of its citizens. The actual number of citizens had been increased massively by the territorial gains that Prussia had made at the Congress of Vienna. Amongst the new citizens was Cornelius himself, as a native of Düsseldorf.

Cornelius had had close contact with a number of Prussian state officials around 1815, in particular the historian Baron von Niebuhr. Through these he absorbed thoroughly the Hegelian belief that the Prussian state represented the synthesis of former political systems and was poised to lead towards the perfection of mankind. Unlike so many denizens of the Rhineland, Cornelius appears to have had no qualms about the annexation of his homeland to the Prussian state. An ardent nationalist, he saw the state machine as providing him with the means of establishing German painting as the art of the future with a major aesthetic and didactic role. Already as early as 1814 – the year in which the *Befreiungskrieg* had been successfully concluded with the expulsion of the French from German territory – Cornelius had written to the Prussian minister Joseph Görres expressing his hopes for the establishment of a national didactic art.[11] It was with this mission

in mind that he accepted the position as Director of the revived Düsseldorf Academy in 1819.

The Düsseldorf Academy had been established in 1773 by the Kurfurst von Pfalz, the then ruler of this part of the Rhineland, as part of a move to enhance the cultural status of his capital. At that time Düsseldorf possessed a famous gallery of Renaissance and Baroque paintings (including a magnificent set of paintings by Rubens, Van Dyck and other Flemish masters). Ambitions changed after the Kurfurst Karl Theodor inherited the Kurfurstendom of Bavaria and moved to Munich. When, in 1806 his successor Maximilian was elevated to the title of King of Bavaria, the new monarch commandeered the Düsseldorf Gallery on the grounds that it was a personal possession of his family. These paintings now form a major part of the Alte Pinakothek in Munich. At the same time as the gallery was moved to Munich, the academy at Düsseldorf was closed. Most of its staff (including its director Peter van Langer) also moved to Munich. At that time it seemed that the hopes of establishing Düsseldorf as an 'Art City' had foundered for ever.[12]

The memory of former cultural glory was a significant factor in the decision to re-establish the Academy under the Prussian administration in 1819, in the old Academy building (figure 24). It could be seen as a move to return some of the cultural prestige that had been removed from the city by the self-seeking and irresponsible behaviour of its former ruler. The Prussian administration, it was implied, would behave in a more public-spirited manner, demonstrating that disinterested manner of government that made it so suitable as a model for future developments. Support was even given for the attempts by the burghers of Düsseldorf to have their collection returned to them. This campaign was not abandoned until 1870, when the right of the Bavarian monarchs to the collection was confirmed as part of a state agreement between Prussia and Bavaria. During the period covered by this article, however, the hope of having the collection returned remained alive and this stimulated the interest in developing the city's cultural profile.

Cornelius's interest in becoming director of the re-established Düsseldorf Academy was doubtless also influenced by personal considerations. Born in Düsseldorf in 1783, he was the son of the former inspector of the Academy and had received his early instruction there. Already highly critical of the classical style and instruction techniques there, he undoubtedly felt the appeal of returning to paternal territory and reforming it. The re-established Academy provided him with a tabula rasa on which to perform these acts.

As has been mentioned above, Cornelius used the Masterclass in practice more to provide apprentices to help him carry out his Munich murals than as a form of engaged teaching. His commitment to Düsseldorf also turned out to be limited. In 1825 he accepted a call from Ludwig of Bavaria to move to the academy of Munich, and took almost all his students with him. His old friend and colleague Mosler was left to carry on a caretaker administration until other arrangements could be made.

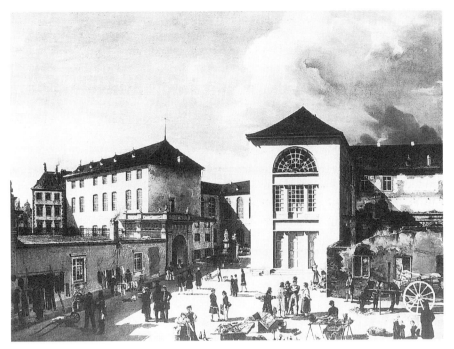

24 Andreas Achenbach, *The Old Academy in Düsseldorf*, 1831, oil on canvas, 64×81 cm.

Schadow and the Masterclass

It had been Cornelius's intention that a fellow Nazarene and fresco painter, Julius Schnorr von Carolsfeld, should follow him as director of the Düsseldorf Academy. Like Cornelius, Schnorr was engaged in painting murals in Munich – the *Niebelungen* cycle in the Residenz – and his presence at Düsseldorf would have continued the subservience of the academy there to the needs of Munich murals. Perhaps it was for this reason that the Prussian authorities decided instead to appoint a somewhat less distinguished member of the Nazarene circle, Wilhelm von Schadow. Schadow was from Berlin – son of the celebrated sculptor Gottfried Schadow – and while he had been amongst those painters to produce a mural in the Casa Bartholdi in Rome, he had subsequently become better known for his oil painting and in particular his skills as a portraitist. Unlike Cornelius he had no particular agenda for the renewal of Christian and national art in Germany. He fitted more into the Prussian model of the paternalistic but dedicated official. While favouring a rigorous style himself, he did not impose this on the members of his Masterclass, but allowed them greater licence to follow their own inclinations. A sense of his more liberal approach to teaching can be found in his publication *Gedanken über die folgerichtige Ausbildung der Maler* (*Thoughts on the Consistent Education of the Painter*) of 1828. In contrast to Nazarene teaching, Schadow lay

great stress on the study of nature as a basis for artistic education: 'The most exact conception of the object possible and the most naturalistic representation of the same is the tendency and method of the Düsseldorf school.'[13] He made oil, rather than fresco, the basis of study and insisted that all students should become proficient in portraiture to give them a sense of the specific. Yet while Schadow gave a different stress to that of Cornelius, he nevertheless conducted a course of impressive rigour. As before, the Masterclass was arrived at only after many years of intensive study of form and colour. The elementary class lasted two years and concentrated solely on drawing, taught largely by copying engravings and simple geometric forms. After that came the preparatory class, in which first drawing from the antique was done and then from the living model. Following the mastery of form that was held to have been achieved through this means, the student was introduced to oil painting. At first this was limited to the copying of portraits – which were held to be the best introduction to the use of colour. After this came oil painting of the model, in which colour and form were held to become united. At the same time as this 'practical' painting was being taught students were gaining mastery in anatomy, perspective and theory of proportion. Only after these had been mastered were they allowed to essay their own compositions. At this point the student was expected to demonstrate a mastery of all the details that would go to make up a successful historical composition. It was from those who showed most success at this that the students were chosen to make up the envied Masterclass.

 This daunting programme shows that the Masterclass system was hardly one that fostered untrammelled individuality. And while it did certainly give more scope for naturalistic study and the development of painterly skills than Cornelius's regime had, it was still seen by many who went through it to be a stultifying experience. This was not just because of the regimentation, it was because the 'shared' experience of the Masterclass seemed to deny the possibility of any individuality being developed. One teacher, Heinrich Christophe Kolbe, complained that the communal experience – in which students and teachers would often paint sections on each others' works – led to a bland uniformity and interfered with individual development: 'Every stroke, first in the cartoon and then in the picture itself, is repeatedly corrected or overpainted until the master is satisfied with it.'[14] Kolbe further complained that students had little or no experience of works by other masters – either living or dead – so that the whole of Düsseldorf painting was in danger of becoming a self-perpetuating manner out of touch with developments elsewhere.

 Perhaps not surprisingly, Kolbe was dismissed for his complaints against the methods of the Masterclass. It should be recalled, too, that this meticulous, paternalistic method of educational surveillance was no more than a mirror of the broader system of education within Prussian schools and universitites. As in the case of those institutions, furthermore, the Director of the Academy hardly had a free hand. He was himself closely overseen by a higher official in the administration, one of those

people whom Karl Marx characterised as the 'Grand inquisitors with which the Prussian Regime pesters the official centres of scholarship'.[15]

Rebellion and reconciliation

Despite this regulative system, the Düsseldorf school received strong local support from both journalists and the increasingly wealthy bourgeoisie. The writer Friedrich von Uechtritz produced a book *Blicken in das Düsseldorf Kunst und Kunstleben* (1839/40) which helped to spread the notion of Düsseldorf as an art city. Equally important were the activities of the local 'Art Union', the *Kunstverein für die Rheinlande und Westfalen*. Founded in 1829, it prospered with the industrial bourgeoisie who supported it to become one of the most powerful art unions in Germany. It not only distributed works amongst its members but it also became an important patron of other institutions, buying and donating historical and religious works to museums and churches.

Undoubtedly it was the taste for naturalism supported both by this institution and the critics that provided encouragement for those artists who challenged the Academy. Schadow, while himself favouring idealist art, was enough of a politician to know when to trim his sails. Many of his own students – notably Friedrich Lessing – produced pictures overtly critical of the regime, notably the famous 'Hussite Sermon'.[16] Another sign of opposition was the complaint that Schadow was favouring those students he had brought with him from Berlin. As a result of this a number of Rhineland students at the Academy left in 1836. Most of these went on to study in Munich but one, Alfred Rethel, left to study in Frankfurt under Philipp Veit, another Nazarene, but one who had kept the less authoritarian ideals of his youth.

It could be argued that Rethel was only able to discover his own individual and powerful voice by leaving Düsseldorf. In the end he expressed this both in his major cycle on the life of Charlemagne for the town hall at Aachen and more famously through his wood engraving series *Auch ein Totentanz*, which became famous throughout Europe as a commentary on the revolutions of 1848.[17] Ironically Rethel himself came to re-establish the workshop ideal through the wood engraving workshop he set up towards the end of his career, which constituted a clear move back to a 'craft' system free of the Academy.

Rethel was the most successful 'rebel' from Düsseldorf; but the one most radical in his beliefs was Hasenclever. Hasenclever had first entered the Düsseldorf Academy in 1827 (at the age of seventeen), but had been forced into a period of autodidacticism by the disapproval of Schadow. It was at this time that he began to paint portraits and small genre pictures. When resuming his studies at Düsseldorf he resumed too his critical stance. This is shown clearly in his satirical depiction of a scene in one of the Academy's studios (figure 25). Hasenclever shows himself with a group of his fellow students making a mockery of the teaching practices. One is mimicking the pose of an antique statue. He is holding out a bottle to another

who plays the role of a debauchee. Around them lie the props of academic training – the lay figures, classical statues and paraphernalia of romantic history painting. It is a deliberately 'anarchic' composition from painters who feel themselves to be outcasts – hence the reference to 'Siberia' in the book at the feet of the one who is sketching, the genre painter Otto Grashof. This was an 'original composition' that would certainly not gain its author a place in the 'Masterclass'. Yet, interestingly enough, it was one of the pictures purchased by the *Kunstverein für die Rheinlande und Westfalen* and delivered to a member, Professor Klütz in Neustrelitz.[18] There was, it appears, a bourgeois following for such tomfoolery. But there was more than playfulness in Hasenclever's opposition. He was also a supporter of radical politics. During the uprising of 1848 he painted a major history painting showing a worker's delegation confronting the Düsseldorf town council, a work that earned him the praise of Karl Marx.[19]

Another artist who counted amongst the 'rebels' at Düsseldorf was the American painter Emanuel Gottlieb Leutze. Leutze came to Düsseldorf in 1841 and studied under the academy teacher Carl Friedrich Lessing, though in a private capacity. He never underwent, therefore, the full rigours of the Masterclass system. Yet he undoubtedly profited in his own country from association with the rigour of the German academic system. During this period, in fact, the Düsseldorf school

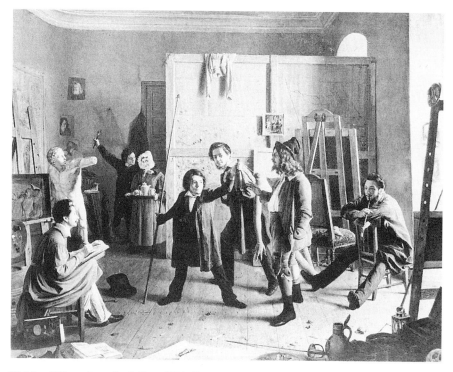

25 Johan P. Hasenclever, *Studio Scene*, 1836, oil on canvas, 72 × 88 cm.

was strongly promoted in America. Partly to get the pictures out of the way during the revolutionary period, the Prussian Consul in New York, John G. Boker, organized an exhibition of Düsseldorf paintings in New York and these were eventually sold. They had an immense impact. They reinforced in Americans the great advantage of the rigorous method that the Düsseldorf Academy seemed to impose.[20]

Leutze had been active in the struggle in 1848 and his picture of America's own leader of revolution, George Washington, taking the irreversible step of crossing the Delaware to begin his heroic task became a sensation when it appeared in triumph in New York in September 1851, and rapidly moved on to become a national icon. Yet Leutze's own revolutionary days were over by then. Like Hasenclever and Rethel, he moved away from revolutionary and confrontational subjects in the latter part of his career.

One of the signs of a general change in mood amongst the 'rebels' in Düsseldorf was the establishment of the *Malkasten* (Paintbox), an artists' club with a broad membership. Leutze was active in the Malkasten, producing the idyllic image of the painter's life in his Summer illustration (figure 26). This was one of the illustrations to the highly popular series of *Düsselfdorfer Künstleralben* (Düsseldorf Artists' Albums) that began in 1851 and ran through to 1866. So popular were these outside as well as inside Germany that they appeared in an English edition as well from

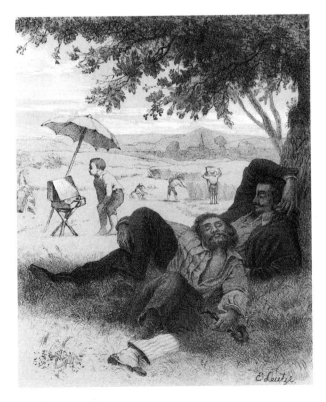

26 Emmanuel Leutze, *August*, 1851, illustration to *Düsseldorfer Künsteralben*, 1851.

1854. It is a humorous and playful send-up of the artist's life expressed in full idyl-licism and excusable because it is, after all, August, the holiday month, in which they can be seen relaxing. The peasant boy who looks with puzzlement at the pic-ture while the drowsy artists smoke and relax provided the comic peasant for the burghers. It is clear, too, that not much hard work is being done with the harvest.

The easefulness present in this picture was like that promoted by the *Malkasten* itself. The artist members were likened to the individual paints in a paintbox – each different and equal, and operating in harmony with each other. It was a sign of this accord that the membership consisted of both non-Academy artists – such as Leutze and Hasenclever – and Academy officials such as Hildebrandt. In fact this seeming reconciliation of official and non-official had a more sinister side. For the Prussian state actually encouraged Academy membership of the *Malkasten*, so as to keep control of it. As the Düsseldorf Regierungspresident wrote in 1853 to Minister von Raumer: 'The continuation of the director and members of staff as members of the *Malkasten* even after the events of 1848 seems to us to be particu-larly appropriate as this provides the means whereby precautions can be taken against many political and social extravagances'.[21] In effect this continued the prin-ciple of the Masterclass out into social life. Potentially subversive painters such as Hasenclever and Leutze were thus brought into the sphere of academic influence and continued to produce works in which the artist was not the critic of society, but represented some pleasant ideal, living in harmless ease and casting an ironic but not unfriendly eye on the practices of his fellows. If this did not quite fit the heroic role that Cornelius had envisaged for the German artist as propagandist of the state, at least it maintained the function of social control.

Notes

1 N. Pevsner, *Academies of Art, Past and Present* (Cambridge, 1940), p. 213.
2 *Ibid.*, p. 228.
3 The concept of social control is one habitually used by sociologists to describe the kind of control that institutions exert by setting up predefined patterns of conduct. This con-trolling character is seen as being inherent in the process of institutionalisation. To say that a segment of human activity has been institutionalised is already to say that it has been subsumed under social control. The regularisation of the activities of universities in post-Napoleonic Germany represents the kind of institutionalisation that suggests the presence of such a process of social control: see Peter L. Berger and Thomas Luckman, *The Social Construction of Reality* (Harmondsworth, 1971), pp. 72–3.
4 C. E. McClelland, *The German Experience of Professionalization* (Cambridge, 1991), pp. 31–4.
5 For an English-language account of this process see W. Vaughan, *German Romantic Painting* (New Haven and London, 1980), pp. 216–23.
6 W. Hütt, *Die Düsseldorfer Malerschule, 1819–1869* (Leipzig, 1995), pp. 9–11.
7 K. Marx, *The Revolutions of 1848: Political Writings*, vol. 1, ed. and intro. David Fernbach (Harmondsworth, 1973), pp. 9–13.

8 F. H. Lehr, *Franz Pforr* (Marburg, 1924), p. 64.

9 G. Levitine, *The Dawn of Bohemianism* (University Park, Pa., and London, 1978), pp. 111–13.

10 These frescoes are now preserved in the Nationalgalerie, Berlin. For an introductory account of this scheme in English see Keith Andrews, *The Nazarenes: A Brotherhood of German Painters in Rome* (Oxford, 1964), pp. 33–7.

11 Ernst Förster, *Peter von Cornelius*, 2 vols (Berlin, 1874), vol. 1, pp. 155ff.

12 Hütt, *Die Düsseldorfer Malerschule*, p. 8.

13 'Die möglichst angemessene Auffassung des Gegenstandes, die naturgetreue Darstellung desselben ist die Tendenz und Methode der Düsseldorfer Schule': quoted in *ibid.*, p. 15.

14 'Jeder Strich, erst im Karton, dann im Bilde selbst, wird solange korrigierte oder übermalt, bis der Meister damit zufrieden ist. Daß auf diese Weise die Arbeit dem Anschein nach nicht gerade schlecht werden kann, ist leicht einzusehen': letter from Kolbe to Geheimrat Schulze in Berlin, Geheime Staatsarchiv Preußischer Kulturbesitz Berlin-Dahlem, Rep 76 V e. sekt. 18 abt 1, 1, vol. X. Quoted in *ibid.*, p. 16.

15 'Groß-inquisitoren, mit denen die preußische Regierung die offiziellen Zentrum der Wissenschaft plagt': K. Marx, 'Preußen und die Hohenzollern (1858/59), in Marx and Engels, *Werke*, Bd. VIII (Berlin, 1960), p. 639.

16 Carl Friedrich Lessing, *Hussite Sermon*, 1836, oil, 230 x 290, Kunstmuseum, Düsseldorf, cat. no. 228.

17 Vaughan, *German Romantic Painting*, pp. 233–9.

18 Irene Markowitz, *Die Düsseldorfer Malerschule* (Düsseldorf, 1969), p. 116.

19 Hütt, *Die Düsseldorfer Malerschule*, p. 193.

20 As the *Art-Union Bulletin* put it when reviewing the Düsseldorf Gallery in New York: 'It is full of evidence of that indefatigable and minute study of Form which characterizes the German schools.' While admitting that the rigour of the Academy was such that 'newly-arrived students are almost reduced to despair', the article continues with a robust defence of such practice: 'the firmness and accuracy of touch … give a completeness and unity to the expression of thought on canvas, which a half-educated artist, however great his genius, can never obtain by his uncertain and tentative experiments.' See Donelson F. Hoopes, exhibition catalogue *The Düsseldorf Academy and the Americans* (Atlanta, G., 1972), p. 23.

21 'Das Verbleiben des Direktors und der Lehrer im Malkasten auch nach dem Jahre 1848 erschien uns um so angemessener, als dadurch manchen politischen und gesellschaftlichen Extravaganzen vorgebäugt worden …': Hütt, *Die Düsseldorfer Malerschule*, p. 196.

Academic othodoxy versus Pre-Raphaelite heresy: debating religious painting at the Royal Academy, 1840–50

Michaela Giebelhausen

This essay examines the transformation that religious painting underwent during the 1840s, disclosing the underlying values generated and contested in academic discourse and cultural criticism, as well as addressing the issues and problems associated with the production and reception of religious painting in the context of the emergence of the Pre-Raphaelite Brotherhood (hereafter PRB). The essay concludes with a detailed account of Millais's *Christ in the House of his Parents*, and argues that this painting created the conditions for the realignment of the cultural and academic forces that had tended to drift apart in the early 1840s. As such, this essay explores the complex relations between art writing, aesthetics and artistic practice, thus demonstrating the nature of the value system which supported and sustained the Royal Academy (hereafter RA) during this critical period.

Socialising art

During the 1840s, debates in the artistic field were overshadowed by the Westminster Cartoon Competitions held to decorate the new Houses of Parliament.[1] The aspirations of the Fine Arts Commission, which was established in 1841 to manage the decoration scheme, were aptly summarised by its secretary Charles Lock Eastlake. In an article written for Knight's *Penny Cyclopaedia*, Eastlake invested art with a strong social role: 'The tendency of the Arts ... to purify enjoyment, to humanise and regulate the affections, constitutes their noblest use.'[2] Similarly high hopes for the social purpose of art were expressed by other writers. In an unsigned article on the progress of British art, which appeared in the *Art Union* in 1848, the writer enthused about 'High Art, for National purposes, – as a means of Education; as the annalist of our History; as the inculcator of Moral Truths; as the promoter of Commerce; the agent towards Social Refinement'.[3] The hopes for the social function of high art were fuelled by the

Westminster Cartoon Competitions, which – although in themselves frustrating and indecisive – exerted a noticeable influence on the works shown at the RA Summer Exhibition. Both *The Times* and the *Athenaeum* were happy to report the beneficial effect the competitions were having on the work displayed at the RA.[4]

The first Westminster Cartoon Competition of 1843 invited entries devoted to subjects from national history and literature, specifically from the works of Spenser, Shakespeare and Milton. Religious themes could only be entered via such sources as Milton's *Paradise Lost*. Although some of the subjects favoured by the competition can be traced to the earlier patriotic-commercial ventures of Boydell and Macklin, the programmatic nature of this state-sanctioned event tended to conflate the national and the spiritual, so as to create a new interest in the dynamics and identity of religious and historical expression.

Until the 1840s, the academic paradigm consolidated by Reynolds in the *Discourses on Art* remained dominant, despite perceptive attacks from critics like William Hazlitt.[5] Reynolds followed academic orthodoxy in his presentation of history painting as the purest form of artistic expression because it involved the artist in processes of abstraction and selection from nature in order to generate compositional unity and pictorial coherence. His theory of central form, however, was not as conventionally Aristotelian or Platonic as would be expected of a writer-artist in the academic tradition. Again, unlike Le Brun, Reynolds had little to say about religious painting as such, but he did acknowledge its place within the realm of history painting.

During the 1840s, both history painting in general and religious subjects in particular were beginning to become at once more empirical and genre-like. Although a full explanation for this transformation lies beyond the nature of this enquiry, we should note the important role played by the cultural press of this period. However, whilst many of the commentators were arguing for a stronger sense of authenticity in the representation of scriptural subjects, Henry Howard – the RA's Professor of Painting from 1833 to 1847 – promoted a traditional Neoclassical aesthetic in his treatment of history painting. Adopting the anti-pictorialist rhetoric of Lessing, he tried to protect history painting from two threats: genrefication, and the belief that pictorial representation was inherently textual or illustrative.[6] He conceded that 'the historical painter should make himself acquainted with the civil, military, and religious costumes of different nations, at different periods, as it must occasionally be requisite to introduce various objects, dresses, and implements, for the sake of historical truth.'[7] Although Howard's combination of Neoclassical art theory and anti-pictorialism demonstrates the complexity of academic writing in the early Victorian period, he worked within a modified Reynoldsian framework, even if he gave more space to examining religious subjects than did the first President of the RA.

Howard's defence of academic art, was, predictably, a defence of the RA, its history, character and institutional identity. Although the RA's Summer Exhibition was the most important showcase for art in Britain, it also attracted its

share of criticism, most of which dealt in some way with its perceived commercialism. It was common to find reviews that discovered in the RA confirmation that commercial society tends to reduce most forms of cultural expression to marketised objects, things or processes.[8] Hazlitt's critique of the RA culture of display, which entailed a subtle reading of the interdependence between academicism and commercialism, worked on this level. He highlighted the doubled discourse of value operating at the RA, whose respective metaphorical sites – the temple and the marketplace – collided in the spectacular nature of the RA Summer Exhibition.[9] While the RA was supposed to associate high art with the production of history painting, the Summer Exhibition provided the prime marketplace for paintings as commodities, where in an inverted version of the hierarchy of genres, commissioned portraits and genre paintings prevailed. This fundamental contradiction in the RA's ideology, in which the laws of the market threatened to desecrate the temple, provided contemporary art criticism with a powerful moral stance.[10] If the voices of the press were fragmented, ritualised, and anonymous, some assumed a policing role, guarding the transcendent value of art in the face of the material transactions of the marketplace.

In policing the progress of contemporary art, the critics pronounced value-judgements on individual works, with the help of a specific set of ideas and phrases derived from academic theory and philosophical criticism, creating a common art-speak shared by writers and readers.[11] The satirical magazine *Punch* commented on this highly ritualised shared vocabulary and pointed out its chief function: '[the] language of pictorial criticism, like its subject, should be mysterious and unintelligible to the vulgar.'[12] *Punch* drew attention not only to the limited vocabulary, but also to its ritualistic use, remarking that the terminology is 'indispensable, and may be used pretty much at random'. However, the tone of art criticism generally implied that it aspired to a responsible social role. The ritualised and limited format of the RA reviews did not simply reflect cultural values existing in some wider context, as Helene Roberts has suggested, but the reviews themselves were sites for the construction, policing and reinforcement of such values.[13] In the next section, I concentrate on a number of questions voiced in the periodical press concerning the production, function and reception of religious painting.

Values of religious art

Certain elements of the periodical press not only attacked the RA for its double standards but also called into question the academic values it promoted. Some attacks questioned the Neoclassical and Reynoldsian notion that history painting was the highest form of art. Critics argued that traditional academic history painting, with its obscure subject-matter derived from classical literature and mythology, held little significance for contemporary middle-class audiences. Of the traditional high art subject-matter only religious painting was exempted. In 1840 the *Art Union* proclaimed:

Let us remember that Michel Angelo, Raffaelle, and Titian ... selected those [subjects] chiefly from Holy Writ, which, according with the feeling of the time, appealed to general sympathies. Their works are still the admired of all who have hearts to feel; while those artists of a more modern school, who have ransacked the Greek and Roman historians and poets, have shown ... how utterly impotent they are to excite any lasting impression, or to advance the cause they desire to support.[14]

The value of religious painting was its ability to appeal to 'feeling' and 'general sympathies'. The *Art Union*, whose editor S. C. Hall was committed to educating the public, was an important voice in the association of religious painting with the ethic-moral role traditionally linked to the entire range of high art subjects. The production of religious painting was regarded as an instrument to elevate the tastes and moral faculties of painters and audiences alike. The *Art Union*, in promoting the production of religious painting for private consumption as the most suitable antidote to the overtly materialist values of the marketplace, at once acknowledged the commercial nature of art and checked its most extreme manifestations.[15] The *Art Union* regarded Eastlake's *Christ Lamenting over Jerusalem* (figure 27), which was exhibited at the RA in 1841, as a form of religious art that was at once elevating and popular.[16] Elsewhere, the *Athenaeum* was full of praise for the picture's melancholy and meditative subject matter.[17]

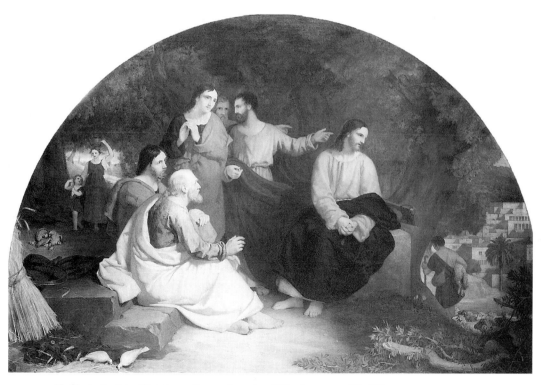

27 Charles Eastlake, *Christ Lamenting over Jerusalem*, 1841, oil on canvas, 99 × 150 cm.

According to the reviewers, Eastlake had successfully continued the academic methodology of Reynolds, at the same time as incorporating the virtues of pre-Renaissance painting: sincerity and earnestness.[18] When the Vernon version was donated to the nation in 1847, the *Art Union* stated that 'this picture will be a triumphant addition to the National Gallery – a work well qualified to hang side by side with those of the greatest men of any age'.[19] Eastlake was praised for being 'the first of our school who has truly succeeded in popularising high-class art'. In the face of recurrent criticism of the damaging effect of the art market, Eastlake's work was valued as a sensible adaptation of the high art ideal. In 1846 the *Art Union* commented on the positive entanglement of the economics of the marketplace and the progress of art by claiming that private patronage was discerning enough to support works of quality: 'the middle class in England – the class in which there is large wealth to expend upon luxuries – has learned to appreciate the practical utility as well as the true enjoyment to be derived from Art'.[20] Here Eastlake is made to represent the civilising values and legitimate cultural interests of a commercial middle-class public.

The enthusiasm for religious painting displayed by the *Art Union* was not entirely shared by other periodicals. In 1843 the *Athenaeum* described some of the complex difficulties pertaining to the contemporary practice of religious painting. It commented on the noticeable increase in religious subjects. In contrast to the *Art Union*, however, it criticised the strong pictorial tradition which exerted a stranglehold on current painting: 'it is as if the remembrance of the Old Masters had paralysed hands no longer guided by the same devout spirit'.[21] At the same time, the *Athenaeum* also acknowledged the emotional appeal of scriptural subjects, which the *Art Union* had promoted as the key characteristic of religious painting. Such discussions indicate the problems regarding aesthetic identity which the critical discourses of religious art faced and effaced in the 1840s.

The newly acquired status of religious painting as a prime didactic tool, which had been initiated by the periodical press, might have influenced the significant change that occurred in the themes selected for the RA's biannual gold medal competition.[22] During the 1840s two of the five subjects were taken from the Old Testament, and in the 1850s scriptural subjects outnumbered the other subjects for the first time in the competition's history. A noticeable change also occurred in the numbers of religious paintings that were exhibited at the RA Summer Exhibition, which increased steadily from 1835 to 1850. Despite this marked increase and the growing numbers of scriptural subjects set for the RA gold medal competition, religious painting commanded a tiny market share, ranging from 1.5 per cent in 1830 to 4.5 per cent in 1850; the average lay at about 2.5 per cent.[23] When considering strictly scriptural subjects, the numbers are even smaller.[24] Although religious painting constituted a minute field of artistic production, the periodical press invested it with a disproportionate amount of symbolic capital. Despite the significant increase in religious pictures exhibited at the RA and the thematic changes that occurred in the gold medal competitions, there is no indication that the RA

was engaging in a redefinition of the role of religious painting. This impression is also corroborated by the lectures of C. R. Leslie, who succeeded Howard as Professor of Painting in 1848.

Leslie, academic tradition and the value of genre

Leslie's lectures, which concerned themselves with the recognition and transmission of cultural value, addressed the nature of academic discourse, method and training. His lectures, which rejected Howard's strict Neoclassical aesthetic, adapted Reynolds to argue that genre divisions were not value dividers. Where Howard had borrowed from Lessing to generate an anti-pictorialist reading of the nature of painting, Leslie, more interested in demonstrating how certain images registered expression and character, examined different contexts and traditions in which universal truths appeared. Thus Leslie's reading, which looked across genres to discover essential values in the transmission of sympathy and sentiment, locked together Raphael and Hogarth, because both combined the particular and the general in their articulation of beauty and humanity. Leslie's lectures not only took account of contemporary art historical scholarship, which was reconsidering the qualities of pre-Renaissance art, but also reviewed some of the fundamental tenets of the anti-academic position developed by Hazlitt, who was a great supporter of the Hogarthian tradition of expressive naturalism.[25] Although Leslie was careful not to upset the canon – 'for I ever recur to Michael Angelo and Raphael as the greatest of all painters', he no longer maintained a strict hierarchy of genres, but argued for an appreciation of art that recognised value in a multiplicity of pictorial styles, subjects and narratives.[26] This resembled Hazlitt's view. In his praise of Hogarth's art, which combined historical circumstance with moral purpose, Leslie promoted a re-evaluation of history painting started by Hazlitt, who had argued that the quotidian was a crucial aspect of modern art.[27] However, Leslie had little to say about traditional forms of history painting, or ways in which his re-evaluation of Hogarth might revivify or transform them.[28] If Leslie, speaking as the RA's Professor of Painting, by necessity lacked Hazlitt's bold, anti-academic rhetoric, he strove for a gradual modification of the academic paradigm by incorporating some of Hazlitt's ideas about the value of materialism in art. At the same time, he continued to work within a Reynoldsian framework, particularly when he compared the liberalism of the RA with the authoritarianism of continental academies.

It is not surprising to find that some voices in the periodical press were promoting the genrefication of religious painting. In 1844 the *Art Union* claimed that '[we] have long contended for Oriental character as a propriety in Scriptural art'. Consequently, it praised the oriental atmosphere of Dyce's *Joash Shooting the Arrow of Deliverance* (figure 28) as 'showing research after authorities for costume; without which an artist can never accomplish truth'.[29] The painting was noted for its originality, a quality generally felt lacking in scriptural painting. Moreover, it was applauded for the successful combination of the conflicting demands that were

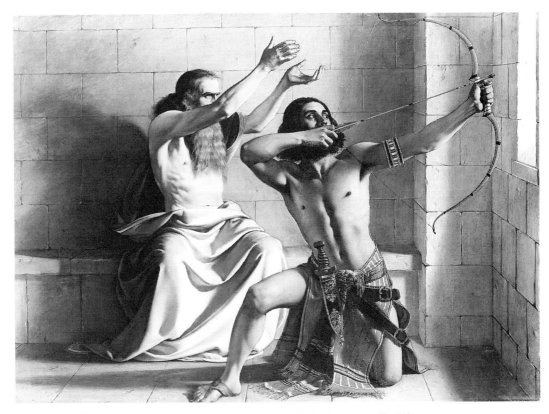

28 William Dyce, *Joash Shooting the Arrow of Deliverance*, 1844, oil on canvas., 77 × 110 cm.

increasingly being made of a contemporary practice of religious painting. According to the reviewer, Dyce had not only fulfilled the demand for antiquarian realism, which signified the gradual tendency towards genrefication, but had also displayed disciplined self-control in drawing, a sign of the moderate influence of contemporary German art. In addition, he had retained the flamboyant colour-relations traditionally associated with English painting. This signalled a general shift in the criteria that were being applied to contemporary art, placing stronger emphasis on outline and drawing, which led to a change in the critical reception of Eastlake's work. Hailed as the successful populariser of high art in 1841, Eastlake's style had failed to convince many critics by the end of the decade. Eastlake's moderate eclecticism no longer satisfied those commentators who advocated a style that increased the genre-like elements of scriptural painting by insisting on the 'localising detail' associated with Hazlittean criticism rather than the 'general characteristics' of Reynoldsian academic theory.

This transformation occurred in the reviews of the 1850 RA Summer Exhibition where both Dyce and Eastlake showed religious paintings. While Eastlake's *Good Samaritan* failed to attract positive reviews, *The Times*'s critic

praised Dyce's *The Meeting of Jacob and Rachel* as 'by far the most perfect and successful' example of scriptural painting shown at the RA of 1850.[30] The painting was seen to satisfy both the Hazlittean-Lesliean demand for naturalism and sentiment, and the religious discourse which associated aesthetic authenticity with spiritual purity and historical specificity. The introduction of a genre-like love theme found particular favour with the *Athenaeum* critic who commented on '[the] charms of the modest maiden'.[31] The painting, celebrated for its pictorial severity, brilliant colouring, oriental atmosphere and moderate sentiment, was hailed as 'a most masterly production, in all respects honourable to the British School of Art'.[32]

Rewriting religious art

An important influence the critics noted repeatedly, especially in connection with the production of religious painting, was that of pre-Renaissance art. Over a number of decades, the art-historical research of Ottley, Rumohr, Rio, Kugler and others had initiated a fundamental reappraisal of early Italian art.[33] Their ideas became known mainly through assimilation by writers such as Lord Lindsay, Anna Jameson and John Ruskin. Jameson's *Memoirs of Early Italian Painters* of 1845 – based on articles first published in the *Penny Magazine* – popularised research into Early Art, turning Giotto, Cimabue and Gozzoli into household names.[34] On the whole, the reappraisal of Early Art broadened the aesthetic horizons of the age without threatening the academic hierarchy, because its key values – earnestness and simplicity – were assimilated into academic discourse. The re-evaluation of the relative merits of Early Art was reflected in the lectures of some of the RA's most senior Academicians. Thomas Phillips, Professor of Painting from 1825 to 1832, praised 'the perfection of feeling and understanding that mingled with the imperfections to be found in the works of the early painters'.[35]

Although Leslie dealt sensitively with the characteristics of Early Art, he was also mindful of his position as Professor of Painting. Consequently, he criticised value-judgements which placed the achievements of Early Art over those of the academic heroes Raphael and Michelangelo. Kugler's *A Hand-Book of the History of Painting* – published in an English translation in 1842 – represented one such famous threat to the validity of the established canon. Leslie took issue with Kugler's view that Raphael's Vatican frescoes and the Cartoons were inferior to his early work, because 'they had more of earth and less of heaven in them'.[36] Instead he claimed that Raphael had acquired his deep knowledge of human nature, which informed his work and made it the perfect academic role model, because he 'went out of the church and into the world'.[37] Leslie rejected a reversal of values that placed the 'purity of feeling' displayed in the work of medieval artists above the representation of character, passion and sentiment.

Leslie claimed that some contemporary painters regarded early artists no longer simply as precursors to the art of the High Renaissance, but as suitable models for current practice.[38] The otherwise moderate tone of Leslie's lectures

was abandoned in the defence of academic conventions and replaced by a high-pitched note of moral indignation. The 'bigoted admiration of any one school or any one master ... to the exclusion of all the rest', Leslie regarded as 'sectarianism in Art'.[39] He equated an artistic practice that deviated from the *via media* of academic synthesis with 'fanaticism'.[40] Confronted by a rival value-system, Leslie argued for the validity of a modified academic paradigm, one which transcended aesthetic and religious sectarianism.

This position was challenged by the works of the PRB, which did not conform to the conventions of the academic system associated with Reynolds, Howard, Leslie and Eastlake. The disruptive nature of Pre-Raphaelite painting was primarily due to its style, which was based on close observation of nature and so favoured the particular over the general. The PRB not only appropriated certain characteristics from the two available anti-academic positions – the writings of Hazlitt and Ruskin on the one hand, and the rediscovery of early Italian art on the other, but also drew on contemporary scientific observations in the fields of physiognomy and physiology.[41] Hard-edged Pre-Raphaelitism represented a break with the established orthodoxy.

The investment of religious painting with symbolic capital made it a small, but significant field of cultural production. This proved extremely attractive to the Pre-Raphaelite newcomers to the artistic field who assumed a position reminiscent of Bourdieu's aesthetic asceticism that seeks to transgress 'the boundary between the sacred and the profane'.[42] Their contribution to religious painting represented a fundamental challenge to this symbolically charged practice, forcing a verbose defence of the academic paradigm. Bourdieu has remarked on the reticence of the dominant position to declare itself:

> The dominant are drawn towards silence, discretion and secrecy, and their orthodox discourse, which is only ever wrung from them by the need to rectify the heresies of the newcomers, is never more than the explicit affirmation of self-evident principles which go without saying and would go better unsaid.[43]

Revealing academic values

The revealing clash between the established orthodoxy and the so-called Pre-Raphaelite heresy occurred at the hostile reception of Millais's *Christ in the House of His Parents* (figure 29). Although the Pre-Raphaelite position had been located outside the established paradigm from the very beginning, the critical reception of their work only changed when their chosen *nom de guerre*, Pre-Raphaelite Brotherhood, became known in 1850. This was seen to signify opposition to academic theory, which venerated Raphael. Consequently the idiosyncrasies of the Pre-Raphaelite style could no longer be judged according to the values of the established paradigm, but had to be regarded as a deliberate refusal to work within its boundaries.

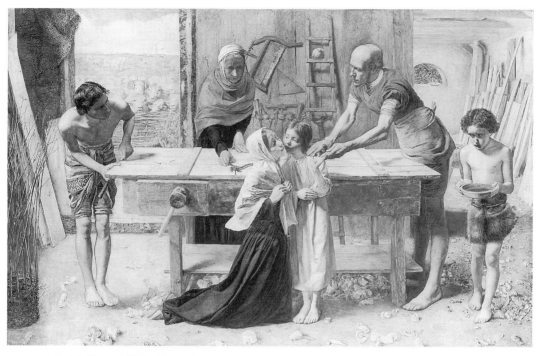

29 John Everett Millais, *Christ in the House of his Parents*, 1849–50, oil on canvas 86.4 × 139.7 cm.

Millais's *Christ in the House of his Parents* received the most hostile reviews not only because it was the most radically Pre-Raphaelite work that the Brotherhood exhibited that year, but also because of its sensitive subject matter. Its unusual treatment of the Holy Family represented a challenging intervention in the symbolically charged field of religious painting. With its hieratic arrangement of figures, suspended narrative, elaborate symbolism, and detailed realism, Millais's picture rejected established academic conventions concerning compositional unity and pictorial coherence. The strategies of defence deployed by *The Times,* the *Athenaeum* and the *Art Journal* were strikingly similar. All three agreed that Millais possessed great talent. It was the sheer quality of his work that made it impossible for the critics to ascribe its peculiarities to lack of training, immaturity or simply youth. But they lamented the fact that he wilfully misapplied his talent, wasting it on the representation of wood shavings and the production of a deformed or grotesque pictorial economy. With such strategies, the *Athenaeum* critic concluded, the PRB was playing for notoriety rather than for lasting fame: 'Their trick is, to defy the principles of beauty and the recognised axioms of taste.'[44] The writer recognised the PRB's stance of defiance, which he perceived to be directed against academic theory and more loosely defined notions of taste.[45] At the same time, he was bewildered by the paradigmatic shift, when he wrote: 'It is difficult in the present day of improved taste and information to apprehend any large worship for an

Art-idol set up with visible deformity as its attribute.' Here superior knowledge, cultural refinement, progress and modernity were juxtaposed with worship and idolism, which implied retrogression and iconomania. The critic's mock-religious language, with its borrowings from traditional anti-Catholic rhetoric, enabled a clever juxtaposition of the established orthodoxy with the artistic practices of the Pre-Raphaelites. This was also apparent in the evaluation of *Christ in the House of his Parents*:

> Mr. Millais … has been most successful in the least dignified features of his present-ment, – and in giving to the higher forms, characters and meanings a circumstantial Art-Language from which we recoil with loathing and disgust. There are many to whom his work will seem a pictorial blasphemy.

The charge of 'pictorial blasphemy' was founded on the deliberate mismatch of style and subject matter, which violated a fundamental academic premise. This highly emotive language studded with religious terms sought to reaffirm the moral powers of the established orthodoxy. As Bourdieu has suggested, its clandestine strategies were only made explicit by 'the need to rectify the heresies of the new-comers'.[46]

The Times adopted a similar stance when evaluating the works of the Pre-Raphaelites in general and Millais's *Christ in the House of his Parents* in particular: 'Mr. Millais … has sunk into extravagance bordering in one instance on irrever-ence … till nothing remains of chiaroscuro, perspective, nature, and truth.'[47] The Pre-Raphaelite style was denied the status of authentic high art. In the true fashion of classic axiology which represented the established paradigm as natural and truthful, more fundamental insinuations were opened up, which implied the Pre-Raphaelite aesthetic as other: sectarian, unnatural and untruthful.[48] The *Art Journal*, which had so persistently promoted religious painting, couched its review of Millais's painting in fairly traditional anti-Catholic rhetoric.[49] In the aftermath of the heated religious controversies of the 1840s, which included Newman's seces-sion to Rome, the dispute over the Maynooth grant and repeated no-popery riots, anti-Catholic rhetoric furnished the debate over the PRB with a high-pitched and morally charged language.[50] This topical and polemical rhetoric not only served to discredit the work of the PRB, it also implied a parallel between Catholicism and the Pre-Raphaelites, which was motivated by the Brotherhood's predilection for pre-Reformation art. Despite such wider implications, which the critics hoped to foster, the use of that rhetoric remained tied to the analysis of strictly academic and pictorial offences. The anti-academic stance of the secret Brotherhood signified a dangerous conspiracy at the centre of the RA which not only challenged the estab-lished paradigm but also threatened the claims that had been made for religious painting.

That the use of Early Art as a role model for contemporary art production engendered a fear of cultural retrogression and social regression can be seen in the remarks made by the *Athenaeum*: 'The quaintness and formal-looking character of

Art in the schools of Siena, Pisa, or Florence were the results of a primitive condition of society.'[51] If the Pre-Raphaelite harnessing of Early Art was part of a critical project that questioned the cultural norms, value-systems and institutional practices of the RA, the fear of cultural retrogression was most vehemently expressed in Charles Dickens's satirical essay 'Old lamps for new ones', which contained the notorious attack on *Christ in the House of his Parents*.[52] Dickens understood the painting as a sign of a widespread cultural phenomenon, which he termed 'the great retrogressive principle'. He described the ways in which the threat of retrogression was going to permeate not only the fine arts, but all walks of life. On the model of the PRB similar formations would be founded, so Dickens claimed, such as the Pre-Perspective Brotherhood, the Pre-Newtonian Brotherhood or the Pre-Galileo Brotherhood. Perspective and gravity were listed as natural and scientific laws: the established orthodoxy – represented in the conventions of academic art – was defended through references to nature and science.

The other deep-rooted contemporary fear concerned the conflicting images of the RA. This was connected with the realisation that religious painting of the kind Millais had produced with *Christ in the House of his Parents* was unable to fulfil the task of negotiating between the temple and the marketplace. In a frenzied *tour de force*, Dickens brought together all the metaphors of pathology which we have encountered in the reviews. He introduced the Pre-Raphaelites with a series of clever moves: the recourse to the definition of the transcendent value of academic painting, the equation of the RA with the temple and the resulting visitor response to the holy site of art:

> you come, in this place, to the contemplation of a Holy Family. You will have the goodness to discharge from your minds all Post-Raphael ideas, all religious aspirations, all elevating thoughts; all tender, awful, sorrowful, ennobling, sacred, graceful, or beautiful associations; and to prepare yourselves, as befits such a subject – Pre-Raphaelly considered – for the lowest depths of what is mean, odious, repulsive, and revolting.[53]

The temple had been desecrated. To demonstrate the desecration of the temple, Dickens gave his well-known description of the picture, comparing the Virgin Mary to a specimen in a freak show, who would 'stand out from the rest of the company as a Monster, in the vilest cabaret in France'. The alternative aesthetic of the Pre-Raphaelites was seen as challenging not only the established orthodoxy but also its consecrated institutions. Precariously poised between the rituals of the temple and the rules of the market, the RA's image as an institution that facilitated the production and consumption of serious art needed to be preserved.

The social role of religious painting was inextricably linked with academic forms of representation. Any violation therefore of its pictorial conventions also called the social functions of art into doubt. Millais's painting was regarded with suspicion, because its refusal to conform to academic conventions also seemed to imply a deliberate violation of the social role of religious painting. The painting's stylistic

'nonconformity' was recognised as fundamentally different: the antithesis of academic art. This challenge to the established orthodoxy mobilised a defensive strategy that relied on the key values of academic theory – nature and beauty. They provided strong moral categories when turned into their opposites: unnatural and ugly. Both terms possessed great potential for metaphorisation through which the periodical press pathologised the Pre-Raphaelite project. In the morally charged language deployed to defend the established orthodoxy, the alternative aesthetic of the Pre-Raphaelites was conceptualised as heresy.

Notes

1 See T. S. R. Boase, 'The decoration of the new palace of Westminster', *Journal of the Warburg and Courtauld Institutes*, 17 (1954), pp. 319–58. For a useful contemporary account, see *A Description of the New Palace of Westminster* (London, 1848).

2 C. L. Eastlake, *Contributions to the Literature of the Fine Arts* (London, 1848), p. 3.

3 'The progress of British art', *Art Union*, 1848, p. 3.

4 See, for example, *Art Union*, 1846, p. 171; *Art Union*, 1847, p. 185; *The Times*, 29 April 1848, p. 3; *Athenaeum*, 1848, p. 463.

5 See P. P. Howe, ed., *The Complete Works of William Hazlitt* (London and Toronto, 1930–34), vol. 18, pp. 62–84 and 122–45.

6 H. Howard, *A Course of Lectures on Painting, delivered at the Royal Academy of Fine Arts* (London, 1848), pp. 51ff.

7 *Ibid.*, p. 248.

8 For a recent evaluation of nineteenth-century readings of the RA, see C. Trodd, 'The authority of art: cultural criticism and the idea of the Royal Academy in mid-Victorian Britain', *Art History*, 20:1 (1997), pp. 3–22.

9 Howe, *Hazlitt*, vol. 16, pp. 181–211. On the notion of value, see Barbara Herrnstein Smith, *Contingencies of Value: Alternative Perspectives for Critical Theory* (Cambridge, 1988), pp. 126ff.

10 J. Chandler L'Enfant, 'Truth in art: William Michael Rossetti and nineteenth-century realist criticism' (unpublished Ph.D. thesis, University of Minnesota, 1996), p. 2. For a detailed account of RA reviews, see E. Prettejohn, 'Aesthetic value and the professionalization of Victorian art criticism 1837–1878', *Journal of Victorian Culture*, 2:1 (1997), pp. 71–94; and also H. E. Roberts, 'Art reviewing in early nineteenth-century art periodicals', *Victorian Periodicals Newsletter*, 19:1 (1973), pp. 9–20.

11 L'Enfant, 'Truth in art', pp. 16ff.

12 'Articles on art', *Punch*, 8 (1845), p. 247.

13 H. E. Roberts, 'Exhibition and review: the periodical press and the Victorian art exhibition system', in J. Shattock and M. Wolff, eds, *The Victorian Periodical Press: Samplings and Soundings* (Leicester and Toronto, 1982), pp. 79–107.

14 'Reflections arising out of the late "exhibition"', *Art Union*, 1840, p. 127.

15 'Historical painting in England', part I, *Art Union*, 1840, p. 65.

16 *Art Union*, 1841, p. 76.

17 *Athenaeum*, 1841, pp. 376ff.

18 *The Times*, 4 May 1841, p. 5.

19 *Art Union*, 1847, pp. 386ff; likewise the following quotation. On the different versions of the picture, see D. Robertson, *Sir Charles Eastlake and the Victorian Art World* (Princeton, 1978), pp. 268–72. For a listing of the engravings, see R. Treble, ed., *Great Victorian Paintings: Their Paths to Fame* (London, 1978), p. 31.

20 *Art Union*, 1846, p. 171.

21 *Art Union*, 1843, p. 511.

22 For a full list of subjects, see J. E. Hodgson and F. A. Eaton, *The Royal Academy and its Members* (London, 1905), pp. 384ff.

23 These numbers comprise all categories of paintings with religious connotations, such as scenes from the Old and New Testaments, historical scenes, domestic genre and allegory. For a detailed analysis, see M. Giebelhausen, 'Representation, belief and the Pre-Raphaelite project, 1840–1860' (unpublished D.Phil. dissertation, Oxford University, 1998), appendix A, pp. 306–11.

24 New Testament subjects varied between 0.16 and 1.37 per cent, i.e. between two and twenty pictures. Old Testament subjects varied between 0.08 and 1.12 per cent, i.e. between one and seventeen pictures. To my knowledge there exists no comparable analysis for other European countries; but Foucart's study of nineteenth-century French religious painting contains several appendices listing paintings commissioned by the French government for display in churches both in Paris and the provinces. These outnumber by far the RA average: B. Foucart, *Le Renouveau de la peinture religieuse en France 1800–1860* (Paris, 1987), appendices A–D, pp. 358–416.

25 See note 9.

26 C. R. Leslie, 'Professor Leslie's lectures on painting', lecture II, *Athenaeum*, 1848, p. 220.

27 *Ibid.*, p. 222.

28 S. West, 'Tom Taylor, William Powell Frith and the British school of art', *Victorian Studies*, 33:2 (1990), p. 311.

29 *Art Union*, 1844, p. 158.

30 *The Times*, 4 May 1850, p. 5.

31 *Athenaeum*, 1850, p. 509.

32 *Art Journal*, 1850, p. 167.

33 F. Haskell, *Rediscoveries in Art: Some Aspects of Taste, Fashion and Collecting in England and France* (London, 1980), pp. 85–106; W. Lottes, *Wie ein goldener Traum: die Rezeption des Mittelalters in der Kunst der Präraffaeliten* (Munich, 1984), pp. 20–38; W. Vaughan, *German Romanticism and English Art* (New Haven and London, 1979), pp. 80–97.

34 A. M. Holcomb, 'Anna Jameson: the first professional English art historian', *Art History*, 6:2 (1983), pp.171–87; Judith Jameson, 'Invading the house of Titian, the colonisation of Italian art: Anna Jameson, John Ruskin and the *Penny Magazine*', *Victorian Periodicals Review*, 27:2 (1994), pp. 127–43.

35 T. Phillips, *Lectures on the History and Principles of Painting* (London, 1833), p. xi.

36 Leslie, 'Professor Leslie's lectures on painting', *Athenaeum*, 1848, lecture II, p. 221.

37 *Ibid.*, pp. 221ff.

38 *Ibid.*, lecture I, p. 192.

39 *Ibid.*, p. 193.

40 *Ibid.*, p.191.

41 J. F. Codell, 'Expression over beauty: facial expression, body language and circumstantiality in the paintings of the Pre-Raphaelite Brotherhood', *Victorian Studies*, 29:4 (1986),

pp. 255–90; S. Grilli, 'Pre-Raphaelitism and phrenology', in L. Parris, ed., *Pre-Raphaelite Papers* (London, 1984), pp. 44–60.

42 P. Bourdieu, *The Field of Cultural Production: Essays on Art and Literature* (Cambridge, 1993), ed. and intro. Randal Johnson, p. 102.

43 *Ibid.*, p. 83.

44 *Athenaeum*, 1850, pp. 590ff.

45 For an analysis of notions of taste and decorum in relation to the reception of Pre-Raphaelite work, see S. P. Casteras, 'Pre-Raphaelite challenges to Victorian canons of beauty', in M. Warner *et al.*, *Pre-Raphaelites in Context* (San Marino, 1992), pp. 13–35.

46 Bourdieu, *The Field*, p. 83.

47 *The Times*, 5 May 1850, p. 5.

48 I follow the notion of classic axiology developed by B. H. Smith; see note 9 above.

49 *Art Journal*, 1850, p. 175. On the prevalent strategies of anti-Catholic rhetoric, see O. Chadwick, *The Victorian Church* (London, 1966), vol. 1. pp. 167–231, 271–309.

50 For a succinct discussion of the controversies, see W. Ralls, 'The papal aggression of 1850: a study in Victorian anti-Catholicism', in Gerald Parsons, ed., *Religion in Britain, volume IV: Interpretations* (Manchester and New York, 1988), pp. 115–34.

51 *Athenaeum*, 1850, p. 590.

52 C. Dickens, 'Old lamps for new ones', *Household Words*, 15 June 1850, pp. 265–7. For a useful analysis of Dickens's interest in Millais's painting, see J. B. Bullen, 'John Everett Millais and Charles Dickens: new light on old lamps', *English Literature in Transition, 1880–1920*, special series, 4 (1990), pp. 125–44.

53 Dickens, 'Old lamps for new ones', pp. 265ff.

Academic cultures: the Royal Academy and the commerce of discourse in Victorian London

Colin Trodd

In this essay I want to consider some of the practices, meanings and customs associated with the Royal Academy (RA) in the second half of the nineteenth century. By dealing with a range of ideas concerning the nature, function and significance of academic culture in this critical period, I intend to address a number of issues: projections of English school discourses; promotions of academic value in relation to continental models of academicism; readings of the interplay between modern art and the technologies of exhibition and display; justifications of entrepreneurial culture, the refashioning of academic authority and the concomitant reordering of the RA's identity. As such, this piece forms part of a more substantial work on the connections between Victorian art, critical discourses and cultural institutions; but, in order to establish some form of critical focus for what follows, I shall explore these subjects in relation to Charles Eastlake and Hubert Herkomer, two of the most significant figures in the history of the RA during the second half of the nineteenth century.[1]

Many of the readings of the RA between 1850 and 1900 address the institution by scrutinising its role with regard to the formation and development of national art. This entangling of academic power with the idea of a national school is particularly noticeable in the *Art Journal*, the RA's greatest ally amongst Victorian periodicals. Throughout the period it claims that the qualities of the RA ensure a spirited individualism or an expressive independence that circumvents the generalising attributes of continental academies. The RA, it asserts in 1865, 'displayed' the 'English school' in an exhibition as 'remarkable for its variety as for its vigour'. Such virtues, emerging from 'nature' and 'freedom', create a unique academic culture; however, 'in countries where the State and the Church have been tyrants over life, property and thought, the arts have been marked by uniformity, even monotony'.

> Yet in England, where each person has the privilege of thinking as he likes, the artist will naturally paint as he pleases. Hence the endless variety seen upon the walls of our Academy. The contrariety of creeds in religion, the opposition of opinions in politics,

even the conflict of theories in the metaphysics of mind or in the philosophy of out-
ward nature, all tend to that truly Catholic and universal Art which is tolerant as it is
extended. ... The liberty our national arts enjoy has grown up year by year by the side
of that freedom which is fittingly called constitutional, because part of the very life
and blood of the body politic. And thus it is that the arts of England beat with the
pulses of the people, and the cries of the multitude are echoed within the walls of our
exhibitions.[2]

This belief, that the uniformity propagated by the theory-based academicism of
foreign systems is transcended by the liberal empiricism of native art was a
common trope of English school narratives, many of which articulated the RA as an
organic space emerging from the localising character of a national culture that cele-
brates variation and differentiation in custom, convention, genre and style. More
specifically, the capaciousness of this art could be contrasted with a 'foreign' or
'totalising' aesthetic: English notions of beauty, it might be claimed, conjoining the
value of observation and the discipline of study, enable the RA to generate a cul-
tural climate where painters 'produce Nature rather than reproduce other works of
art, however great and glorious they may be'.[3] The Redgraves, in reviewing the his-
tory of national art, find an 'English school constituted on the system of individual
independence', which, unlike the '*atelier* system of the Continent', is derived from
a flexible academic culture; and if we find in the English Academy 'artists of varied
originality', this is because they are 'untrammelled by rules and systems'.[4]
Elsewhere, C. R. Leslie celebrated the RA for its ability to distinguish between the
laws of nature and the 'rules' of art which disfigure Continental academies.[5]

Exhibiting: academic vision and signs of the English school

In a series of detailed and carefully composed discourses presented to students
between 1852 and 1864, Charles Eastlake epitomises this sceptical attitude to theory,
self-consciously working within an experiential framework established by
Reynolds's aesthetics. In place of abstract models of art, Eastlake proposes a learning
system based on principles apparently derived from the visualising process itself.
Sight, the most perfect and delightful of senses, is also the most sensible and
rewarding form of experience and knowledge; and thus the values and customs of
teaching at the RA are entwined with the pleasures encountered by the specular sub-
ject: both are obliged to acknowledge legitimating or governing truths, but both are
essentially self-fashioning. Therefore, the RA, it is possible to assert, transcends
Continental models of academicism by dint of its capacity to confirm the indepen-
dence of the artist, thus making him realise that the destiny of painting is the genera-
tion of 'imitative representation'. Consequently, he should not believe that the
science of his art is reducible to his capacity to produce rhetorical compositions
whose narratives compel us to emulate certain acts; instead, he must come to recog-
nise that the purpose of art is to create 'representations professing to be as intelligible
as possible'.[6] The art of painting, bound up with perception and representation of

the idea of beauty as the intelligence of nature, is, for Eastlake, something more than the manipulation of a series of conventions and devices that elicit sympathy, compassion and engagement. The act of painting, the perpetual struggle to overcome the self-enclosing nature of academicism through the realisation of the authenticating knowledge of the characteristics and the signatures of the phenomenal world, is therefore locked into, and validated by, the endless interplay between classical aesthetics and modern empiricism. Moving between rule and observation, Eastlake wants his student-artists to see the historical nature of art through its visual features: it is teachable, and forms a pedagogic culture, because its primary values are sensual rather than textual. This capacity to acknowledge the critical powers of pictorial representation encourages 'immunity from circumscribed dogma and from the danger of routine', and 'is to be found in the variety of styles which has hitherto been so remarkable in the English School'. Thus 'the influence of the same freedom is apparent in recent, as well as earlier examples; for I think I might safely quote the honoured time of Wilkie and Turner as affording sufficient evidence that this Academy has not sought to impose conventional systems for the truth of Nature … nor had the effect of checking Nature'.[7]

In addition to this emphasis on the historical nature of academic style, and the characterisation of English art as a contribution to its continued validity and importance, Eastlake refers to the common principles which inform representation; and as these principles are identified with the nature of seeing itself, they confirm that painting establishes its organic identity by realising both the individual and social nature of experience. Art communicates by connecting individual sensory experience with a universal visual language, or by announcing that such experience was always the confirmation of the universal nature of human character. With regard to the practice of painting, this means that the language of the universal must avoid restitution of the generalising tendency of academicism. Eastlake claims that as 'distinctness of representation' is the 'first object of Art which addresses the eye', authenticity of expression is secured against the 'repetition', 'uniformity' and 'monotony' of much post-Renaissance history painting. 'Distinctness' is not the copying of nature, but the correct arrangement of forms within pictorial space, the proper definition of colour relations, and the appropriate judgement of the internal economies of compositional order. As the translation of perceptual material into the visual design of the image as a painterly form, 'distinctness' is 'not attained by a dry exhibition of minute markings in shadow, but rather by the quality of transparency – a quality which while it supposes an intervening medium and an appearance beyond the surfaces, cannot, for the same reasons, be compatible with literal distinctness'.[8] 'Distinctness', searching for 'the real' through the generation of a model that acknowledges its endless elusiveness, resists any simple equivalence between physical object and painterly motif. However, in building up the fugitive solidity of the surface of the image, the art of painting reveals its status as the perpetual regeneration of its own conceptual processes.

In order to secure the intelligibility of representation the artist must combine the technical mastery of the medium and the sensibility of character and expression drawn from personal experience. Successful practice, then, is the constant revivification of art by the fusion of the traditional and the contemporary, the universal and the familiar; by the generation of a representational logic that functions as a sensible accommodation of the truths of aesthetics and psychology:

> If Art were not thus to keep pace with experience, or if the principle of selecting the most normal appearances only were rigidly adhered to, we should have every figure a type of its class, every object would be required to be free from accidents, and the sphere of imitation would be circumscribed accordingly. ... The characteristics of Art are ... modified by the character of the individual; but if labour cannot be transformed into seeming freedom, it must, at all events be concealed; and if the conditions of any technical process be such as to render the evidence of toil unavoidable, that process cannot be of much value.[9]

Eastlake makes two observations here. First, the standard academic point that signs of labour must be submerged by the governing agencies of judgement and taste, in order to preserve the status of painting as a legitimate intellectual practice. Second, by emphasising the interplay between experience and knowledge, and by recognising the importance of the relationships between character and expression and perception and representation, he suggests the 'intimacy' between academic practice and individual action. Students at the RA schools, he writes, are encouraged to 'discriminate between the judicious application, and the blind adoption, of what are called "academic rules"'.[10] Like Reynolds, Eastlake defines the value of the RA in terms of the identification and encouragement of 'principles which relate to the effectual practice of ... Art ... as a visible language'.[11]

Eastlake's characterisation of the English school in terms of its rigorous yet relaxed openness to the relationship between perceptual vision and pictorial construction, an attitude that suggests the generation of an informed yet informal response to the idea of academic authority, is not always repeated by reviewers of the RA's Summer Exhibition. Clearly, Eastlake's deliberate policy is to split the empirical-academic tradition of modern English art from foreign 'academicism', with its self-legitimating epistemology. Where he marks out a space for English art in terms of its synthesis of sight and design, and the concomitant balancing of material object and pictorial sign, many critics address a subject that seems to negate this symmetry: the development of an exhibitory culture that generates the 'gallery picture', an object which is characterised through the appearance of pictorial devices and mechanisms that speak all too directly to the eye.[12] And, ironically, such criticisms could be associated with judgements concerning the suppression or sequestration of the characteristic qualities of the English school itself. William Michael Rossetti, for instance, claims that the coming into being of an authentic English school, one which would transcend the 'abnormal thoroughness' of Pre-Raphaelitism, is blocked by the visual culture of 'the sketch', the dominating

motif-mechanism of public exhibitions. The modern painter, reduced to a position of aesthetic thraldom, generates technologies of manufacture and display. In this concatenation of pictorial inscriptions:

> One perceives that many artists can now do a great deal, if they choose; but the more sound one sees the attempts of the painter himself to be, the less one is disposed to accept with implicit faith the rather cheap outcome of those attainments. Sketches, may be excellent things, and they testify to the ready availability of the artist's gifts: but sketches magnified into pictures cloy upon one. They betray ... a self-complacent unconcern for higher efforts.[13]

Other accounts find in the Summer Exhibition an artificial space in which the performative logic of 'commerce' generates an atmosphere redolent of a 'sale-room or bazaar' where paintings are 'wares' and lack anything but the most rudimentary of aesthetic values.[14] In this anti-commercial rhetoric, one which is sceptical of the fluidity of the visual character Eastlake identifies as a sign of the authenticity of English painting, the RA is the site in which the reduction (or return) of art to 'trade' is sanctioned. The Exhibition, collapsing the pleasure of art into the search for 'tricks' and 'manipulations', is an 'engine for debasing and vulgarising public taste'.[15] Exhibitory culture, so this discourse goes, reconstructs the home of art: public display becomes individual publicity; style becomes advertising; pictorial character becomes visual sensationalism.[16]

In this discourse, the Exhibition is seen as something inextricably locked into material forces, which, emanating from beyond the realm of authentic culture, destroy the legitimate public that would sustain true English art. Here are J. B. Atkinson's comments on the RA Exhibition of 1869:

> In fact, one of the uses of an Academy is to sustain academic dignity and decorum; and we trust that the time may come when the unwashed democracy of art will be disinherited, and that which is truly regal and noble be established and endowed. It is certainly an evil that in this country the patronage of art has passed from an aristocracy of birth to an aristocracy not even of talent and education, but of vulgar wealth; and there is hardly an exhibition which does not afford melancholy proof that artists paint down to the market.[17]

For this anti-commercial discourse, common in most periodicals other than the *Art Journal*, the 'levelling democracy' of the RA Exhibition transforms the institution into a 'Showroom' full of 'tradesmen' and 'travellers': a place where art becomes 'speculative' and painting 'a mere facility of representation'.[18] Painting, blending with the decor, is part of the atmosphere of the gallery, rather than the dominating value within a vivid, genuine and authentic cultural space; and therefore the character of the English school is superseded by a set of pictorial devices and gestures:

> there is the white key, the yellow key, the black key; the dry manner, the glutinous manner, the hard manner, and the fuzzy manner: no centrality anywhere, no

concentration of force towards any one point, by which alone supreme excellence can be achieved, no aim in fact, at any speciality, but simply that each may excel the others in any possible variety of evil, as if every one strove to outrival his neighbour's faults.[19]

How was it possible, after the 1860s and 1870s, for supporters of the RA to find in it signs of something resembling 'the English school' or authentic national art? How could the anti-commercial discourse be blocked, resisted or negated from within the RA itself? What practices could be used to legitimate the RA's investment in the commercialisation of culture in late Victorian London? How were these practices inscribed into cultural discourse?

At home with Herkomer

In the latter part of the nineteenth century the RA becomes involved in processes of internal reconstruction, seeking to secure its distinct position within the art world by responding to the changing dynamics of artistic production and consumption. As social relations between artists and patrons are restructured by the further absorption of art within a market economy, artists become increasingly associated with systems of reproduction, advertising and business, thus creating a sort of entrepreneurial culture that seems to offer the prospect of the reconciliation of art and commerce.[20] As such forces are factored into the general economies of institutional practice, it is worth considering the social composition of the membership of the RA at this important moment in its history. On the one hand, it continues to recruit its members from those who had been students at the institution, such as G. F. Watts, whom I shall have reason to examine later in this essay; and, on the other hand, a number of the most prominent Academicians, such as Herkomer, Fildes and Gilbert, begin to enter the realm of art through the less elevated opportunities afforded by the commercial world of design, illustration and advertising.

For most of the nineteenth century there was a rigorous division between the RA and the 'commercial' arts. Engravers were not admitted to full membership until 1853, and this and other forms of graphic production were seen as useful but subordinate transmitters of high art.[21] If reproductive technologies had been marginalised by the authority of academic discourse, there was a tradition within which the specialised skills of engraving could be appreciated. At the beginning of the nineteenth century, Landseer and Blake had articulated a politico-cultural rhetoric that asserted the centrality of engraving in the formation of a national school of art.[22] It is this discourse, with its celebration of the heroic, fertile artist-producer-businessmen, that J. Walter Thornbury alludes to when he asserts: 'What did the more good to English art than twenty pretentious and unjust academies was a King's patronage of West, the spread of engraving and the rise of middle-class purchasers, who rendered it no longer necessary for artists to depend on the caprice and folly of idle rich patrons.'[23]

As we shall see, it is Herkomer, whose status as an artist is bound up with his apparent capacity to reconstruct the relationship between academic authority and the commercialism of the modern art world, who seems to offer some writers the prospect for a new kind of alignment between the market, the public and forms of cultural association and affiliation. Indeed, with a background in 'design' and 'graphics', and with his hostility to the academic system he had experienced in his youth, Herkomer's success as an Academician warrants detailed examination.[24]

Herkomer, who claims to have 'violated all academic principles', becomes one of the key Academicians of the 1880s and 1890s, generating work across a range of media (figures 30 and 31).[25] The structure of his career could be written about in terms of the tension between two discourses: that which asserts the significance of the RA lies in the formation and preservation of the English school; that which asserts the centrality of individual artist-creators working through commercial mediums to address the interests of the *national* class, the middle class. In the former account the RA encourages and preserves national character by dint of its capacity to recognise artistic genius; in the latter account a commercial art finds a commercial class and establishes the symbolic nation in the symbiosis of production and consumption. Of course, Herkomer's significance can be characterised in other ways. His capacity to map out an artistic path beyond the classical formalism of Leighton, the neo-Velasquezism of Millais and the aestheticism of Whistler, could be charted in terms of the acquisition of operational, multivalent skills combining business competence, cultural invention and disciplinary efficiency. A. L. Baldry, for instance, claims that Herkomer is 'dominated by the love of production', and that 'by working one characteristic against another the relative proportions of them all have been adjusted and the whole machinery of his mind has been induced to run smoothly without any of those sudden breaks in continuity which would be almost certain to put it out of gear'.[26] Saxon Mills, another of his biographers, dwells on his mastery of different forms of work and production, seeing in his invention of the 'Herkomergravure' evidence of 'a large infusion of mechanical talent in his comprehensive genius'.[27] This allows him to present Herkomer as a composite figure: in his movement between genres, media and patrons he exhibits the energy and insight of a successful businessman; in his rigorous dedication to labour, craft and technique, the sterling qualities of the dedicated professional. With Herkomer, executive skills become the organisational capacities of the creator-technician, as the inventive explorer works into being his cultural identity. If Herkomer provides evidence that innovation, independence and common-sense generate an informal originality of thought and practice, this discourse sees the RA as a liberal society of individual practitioners rather than a national school of Academicians.

Identified with the pre-eminence of productive practices that rationalise and organise work-time, thus systematising artistic labour across a range of activities, Herkomer becomes a precision instrument reconciling art, commerce and trade within a new economy of manufacture, science and culture: 'His study has been a

process of building up in which every experiment was made with reference to what had gone before. ... Through it all has been the systematic planning of the engineer who perfects every bit of his machine before he puts it together and tries to make it do the work for which it has been designed.'[28] His career offers the possibility of a modernised Academy run by active, versatile and independent artists who realise their professional status through the importation of techniques associated with business culture. The artist becomes, as Herkomer himself acknowledges in a semi-ironic aside, the visible point of a 'Company'.[29] His own success as an artist is conterminous with his capacity to function as a self-commissioning agent: both producer and consumer of his work, he internalises public need into the fabric of his productions. In a sense, he incorporates 'advertising' into the very being of his creations: art production becomes a process of auto-promotion or self-authoring publicity, because he markets his labour-power as he exhibits or makes visible his art in different genres, media and commercial networks.

Attitudes to art-labour present us with valuable information about how artistic value is historically calibrated and articulated. The prospect of seeing art as a

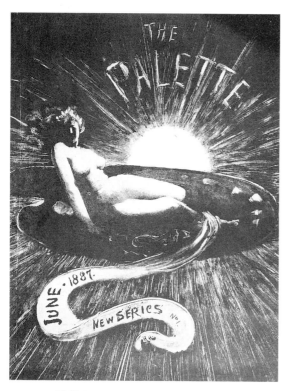

30 Hubert Herkomer, Title-page to *The Palette*, June 1887.

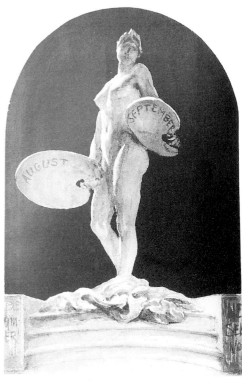

31 Hubert Herkomer, Title-page to *The Palette*, August–September, 1888.

network of commercial powers in which invention, innovation and mastery of different media become signs of entrepreneurial flair, established an important framework for thinking about the nature of artistic identity in late nineteenth-century London.[30] In the *Magazine of Art* we find representations of the artist authoring himself through his engagement with a panoply of reproductive technologies. Moreover, in offering the possibility of disentangling professional and artistic success from traditional and conventional narratives of the English school, Herkomer's achievements could be celebrated by commentators looking for new ways to write about the progress of national art. Here is a career that is made to teach not the value of learning – Herkomer's non-artistic education amounted to six months' study at a Southampton day-school – but the value of confidence, competence and careful deployment of physical and mental resources. In Herkomer, then, artistic identity is seen to emerge from the networks of work and discipline.[31]

Within the popular art press Herkomerian culture is championed for its capacity to co-ordinate complex systems of production and marketing by fully recognising and exploiting the shape of the modern art world. For Spielmann, editor of the *Magazine of Art*, modern Academicians are successful to the extent they recognise the symbiosis of art and commerce, painting and advertising.[32] Culture, needing the same publicity as any object in a market, is made to speak directly to customers through the alliance of artists and journalists; and both paintings and artists exhibit and advertise themselves in newspapers and journals in order to perform public duties. This approach, emphasising the commercial nature of art within modern society, locates artistic value in a realm that separates art from the pedagogical regimes of individual pleasure and social improvement with which it is associated in both academic and aestheticist discourses. And in Herkomer, this model finds an artist-merchant providing his customers with their 'needs' as he contributes to national culture. The perfect conflation of convention and innovation, or tradition and experimentation, Herkomer's art is taken to speak to an open community of consumers ranging from statesmen, members of the aristocracy, intellectuals, bishops, professionals, industrialists and the urban middle class.[33] He is the artist as businessman-gentleman: he serves 'society' and makes himself in the market; he works for money, but only in order to secure an income that enables him to experiment in new techniques, processes and forms of art. Herkomerian labour becomes a form of investment whose value is reproduced through the reproductive circuits in which it is displayed: in advertising, engraving, illustrations and other forms of popular visibility.

It is possible, of course, to see in Herkomer a rather different set of forces, impulses and powers. His comedic conflation of ceremonial and popular culture is, in many ways, the purest articulation of the cultural complex within which registrations of academic life are forged in late Victorian England. This social and cultural 'eclecticism' is written across a multiplicity of events, practices and career moves: in his sketches of Bavarian life and leisure; in his quasi-wild landscapes of

ancient 'tribal' Britain; in his shift from graphics to easel painting under the sign of 'social realism'; in his absorption into the world of civic, plutocratic and aristocratic portraiture; in his 'autocratic' directorship of his own 'liberal' art school that preached 'self-expression' over formal doctrine; in his observations about pater-nalism, folk-culture and the customs of medieval Germany; in the construction of the military-pomp bombast of his mansion in Bushey; in his devotion to his American exercise machine and his Swedish health experts or 'manual manipula-tors' who maximised his productivity during his portrait-painting binges; in his entrepreneurial activity and mechanical inventions; in his devotion to motorised transport; in his fascination with 'electro-biology' and mesmerism; in his interest in new technologies of representation and new broadcasting systems. Everywhere we look in this career we find signs of a personality with a dual investment in tradi-tion and modernity.[34] Herkomer embraces the technological world, but he will mourn the passing of the traditions, conventions and ceremonies of village life in Bushey. He will align himself with progress, but only if the past is preserved as a set of nostalgic or picturesque representations.

Bushey, at once home, school and place of work, registers this oscillation between tradition and modernity within Herkomer's artistic and social life. An environment forged in the impossible desire to assimilate the family history of artisan culture into his own vision of himself as a technomath, the nature of this landscape, marking the place of the Herkomerian mythos, is worth noting. In the early 1880s, as a result of his success in genre and portrait painting, Herkomer transforms his Bushey residence into what Saxon Mills calls a vast 'construction camp'.[35] Still living in a double-sized labourer's cottage, by 1883 the surrounding land had been turned into an industrial complex, the function of which was to rationalise his labour-time and increase his productivity. In addition to his studio, he also owned a number of other buildings: a gigantic wooden shed festooned with the latest examples of American technology in the form of gas-engines, turning lathes, circular saws and other contraptions associated with the building trade; a blacksmith's forge and smithy; printing rooms for the production of his etchings and engravings; a laboratory, aiding his artistic and technical experiments; work-shops, design-sheds and other buildings associated with the production and man-ufacture of artefacts. This technological empire had been constructed to enable Herkomer, his father and uncle to become the builders, designers, carvers and craft-makers of Lululaund, the mansion they would create here.[36]

Herkomer's celebration of work, force, progress, action and ceaseless physical expansion, point him in the direction of Rhodes (whom he painted in 1894–95) rather than the Reynoldsian tradition continued by Eastlake. Art, as labour-power, is the heroic mastery of recalcitrant matter that must be subjugated; the artist, needing to conquer new techniques, generates new territories of experience.[37] This media-enriched identity can be compared with that of another Academician with whom he was strangely friendly: G. F. Watts, who certainly contributes to the tradition of academic formalism of Reynolds and Eastlake. In the late

nineteenth-century literature in which he appears, Watts emerges as an unhomely holy relic: he bodies-forth an idea of art and value that seems to be slipping away in the modern world; he embodies an ideal of academic life that has yet to be realised in English culture; he locates a realm of genius that is both unique to him and sanctioned by tradition; he generates an art that is both individual and universal; he presents a personality that is extraordinarily private at the moment he creates a truly public art. A common trope of the literature on the artist is that his is a career that labours to reconcile the intimate and the heroic, the sensual and the spiritual, the physical and the numinous.[38] If Herkomer works in a space between a modernised history painting directing itself toward a national mythos, and a form of modified subject painting, Watts's identification with the modern is somewhat more attenuated, oblique and elliptical. Where Herkomer draws upon the reproductive arts in order reach his customers, Watts seems to regard engraving in terms of the imposition of a barrier between the artist and the public. Commerce, then, stands between the artist and his identity, which is forged in his creation of a public art and through direct intercourse with a Public Spirit. The commercialisation of art is a burden art should not be expected to bear, and it is difficult to imagine that he would have any interest or investment in the idea that the RA could 'modernise' itself by encouraging its membership to experiment in the reproductive technologies of the commercial arts.[39]

Where Herkomer employs a quasi-entrepreneurial discourse to link the artist with a business ethos that both embraces and transcends the division of labour by working through and mastering different technologies of art, Watts seeks to overcome the negativity of divided labour by exploring the chemistry of painting. Watts, resisting the obvious advantages associated with the commercial production of art materials, wishes to recover a moment before the advent of colourmen as figures blocking the artist's authentic knowledge of his media. Ironically, perhaps, he wants to return to a time before the advent of the modern Academy and its specialisation of function; he wants to return to an organic 'craft' or guild culture in which artists have direct knowledge of the technologies and processes involved in the material production of pigments.[40] These two artists represent two of the most interesting positions within the cultural network that is the late Victorian RA: the experimental 'art-worker', who, eschewing theoretical knowledge and classical aesthetics, makes, generates and proliferates his identity through a complex of media production; the 'modern master' who clothes himself in tradition and seeks the conflation of theoretical and practical knowledge in a prelapsarian moment before the institutionalisation and systemisation of art by academies.

This reading suggests that the division between 'naturalistic' and 'classical' forms of late Victorian academic painting is more complex than we tend to think. Nor is it possible to reduce the subject of the 'English school' to a set of examinations about pictorial conventions, principles or characteristics. The concept of the 'English school', and that of the academic itself, are imprisoned within the histories which have written them; but unlike the Academy, which was a real physical

structure with a material history, the 'English school' fascinated cultural commen-
tators because it was locked into an institutional culture in which it was always
about to surface as a coherent aesthetic value. If Herkomer and Watts attracted
commentators writing in this tradition, they also confirm that this discourse is less
predictable than has been realised. In both cases we note the focus on physical
processes, work cultures and bodily power; the elaboration of labour becomes a
marker of enterprise, a token of value, and the discharge of energy acts as a surro-
gate for artistic coherence. The artist is a network of signs of creative action that
might come to embody the unity of a school. We are left with the irony that
although Herkomer and Watts stood for the process of generative power neither of
them left anything that could be called a 'school' in the sense in which Reynolds
and Eastlake used the term.

Notes

1 I am currently working on a manuscript with Paul Barlow entitled *Carlylean Prospects:
 Art and Art Criticism after the Pre-Raphaelites*, which develops some of the themes
 addressed in this essay. Eastlake, who had been knighted in 1851, was President of the
 RA from 1850 to 1865 and Director of the National Gallery from 1853 to 1865.
 Herkomer, the Professor of Painting at the RA between 1899 and 1900, was knighted in
 1907.
2 *Art Journal*, June 1865, p. 161.
3 *Burlington House*, 1878, p. 137.
4 R. and S. Redgrave, *A Century of British Painters* (London , 1866), pp. 264–5.
5 C. R. Leslie, *A Hand-Book for Young Painters* (London, 1855), pp. 41–2.
6 C. Eastlake, *Contributions to the Literature of the Fine Arts* (London, 1848; 2nd ed.
 1870), pp. 302–4.
7 C. Eastlake, *Discourses*, 1853 (London, 1852–64), pp. 5–6.
8 *Ibid.*, 1855, p. 6.
9 *Ibid.*, 1858, pp. 6, 13.
10 *Ibid.*, 1853, p. 6. He develops the point again in a later address. See the 1864 discourse,
 pp. 12–13.
11 *Ibid.*, 1854, p. 32; J. Reynolds, *Discourses on Art*, ed. R. Wark (New Haven and London,
 1959), pp. 15–18.
12 Of course, this dread that the modern exhibition generates a gallery culture of com-
 mercial pictures devoid of artistic merit, goes back to Hazlitt and beyond. In Hazlitt's
 opinion, the very possibility of a national school in art is blocked by the fatal error of
 British painting, which exhibits 'a desire to produce a popular effect by the cheapest
 and most obvious means, and at the expense of everything else; – to lose all the delicacy
 and variety of nature in one undistinguished bloom of florid health; and all precision,
 truth, and refinement of character, in the same harmless mould of smiling, self-com-
 placent insipidity': W. Hazlitt, 'An inquiry whether the fine arts are promoted by acad-
 emies and public institutions', *Annals of the Fine Arts*, 5 (1820), pp. 285–6. A related
 point is made by Reynolds, but he approaches the problem from the perspective of the
 painter. He warns young artists to be selective in their imitations and in those whom

they 'endeavour to please', because vulgarity of style and corruption of taste befall all artists who seek the attention of the popular and common mind. He goes on to say, 'I mention this because our Exhibitions, while they produce such admirable effects by nourishing emulation and calling out genius, have also a mischievous tendency, by seducing the Painter to an ambition of pleasing indiscriminately the mixed multitude of people who resort to them:' Reynolds, *Discourses*, pp. 89–90.

13 W. M. Rossetti, *Notes on the Royal Academy Exhibition* (London, 1868), p. 2.

14 S. Colvin, 'The Grosvenor Gallery', *Fortnightly Review*, 1877, p. 820.

15 H. H. Statham, 'Reflections at the Royal Academy', *Fortnightly Review*, 1876, p. 60.

16 These and related issues are tackled in my 'The authority of art: cultural criticism and the idea of the Royal Academy in mid-Victorian Britain', *Art History*, 20:1 (1997), pp. 3–22; and in P. Barlow and C. Trodd, eds, *Governing Cultures: Institutions of Art in Victorian London* (Aldershot, 1999).

17 J. B. Atkinson, 'The London art season', *Blackwood's Edinburgh Magazine*, 1869, p. 222.

18 W. Davies, 'The State of English painting', *The Quarterly Review*, 1873, pp. 300–1; p. 290.

19 *Ibid.*, p. 295.

20 Trodd, 'The authority of art', pp. 3–7.

21 S. C. Hutchison, *The History of the Royal Academy 1768–1986* (London, 1986), p. 99.

22 J. Landseer, *Lectures on the Art of Engraving, delivered at the Royal Institute of Great Britain*, (London, 1807); W. Blake, *The Complete Poetry and Prose of William Blake*, ed. D. V. Erdman (Berkeley and Los Angeles, 1988).

23 J. Walter Thornbury, *Haunted London* (London, 1865), p. 80. C. R. Leslie makes a similar point, but links this commercial discourse to a commercial patron: 'had there been no such art as engraving, there would have been no such patronage as Boydell's, which gave birth to some of the greatest works of the British school; and to this same art of engraving it is scarcely too much to say we owe the very existence of Hogarth': see Leslie, *Autobiographical Recollections* (London, 1860), p. 214.

24 Some critics identified Herkomer's significance in terms of a double skill: the attempt to reunite arts and crafts, through the organisation of his work-time within his studio-workshop at Bushey; the generation of a popular pictorial style that steers 'a way between a false idealism and a crude realism': see W. L. Courtney, 'Hubert Herkomer, the story of his life', *The Art Annual* (December 1892), p. 17.

25 J. Saxon Mills, *Life and Letters of Sir Hubert von Herkomer* (London, 1923), p. 88.

26 A. L. Baldry, *Hubert von Herkomer: A Study and a Biography* (London, 1904), p. 6. An earlier article, celebrating Herkomer and modern British portrait painters, had claimed that they 'load canvases with massive material as an engineer raises earthwork': see *Blackwood's Edinburgh Magazine*, July 1885, p. 17.

27 Saxon Mills, *Life*, p. 196.

28 Baldry, *Hubert von Herkomer*, p. 50.

29 Saxon Mills, *Life*, p. 136.

30 It should be noted, however, that in the aestheticist turn of the anti-commercial discourse Herkomer again looms large, this time as a proto-mechanised figure. Here is George Moore: 'it has become patent to everyone that the Academy is conducted on as purely commercial principles as any shop on the Tottenham Court Road. ... Mr Leader's landscapes are like tea-trays ... Mr. Dicksee's figures are like bon-bon boxes,

and ... Mr. Herkomer's portraits are like German cigars ... Mr. Herkomer reminds me of the Tyrolean carvers who come over here in vans. I do not know if he uses photography, but the mechanical manner in which the characteristics of the figure are seized, suggest photography': *Fortnightly Review*, 1892, pp. 829–30.

31 Saxon Mills and Herkomer himself plot his success in terms of his capacity to evade the influence of Fred Walker, who stands as a template for a putative school of classical naturalism running across the conventions of landscape painting as propagated by the RA: see Saxon Mills, *Life*, pp. 46–8; H. Herkomer, *My School and Gospel* (London, 1908), pp. 22–9.

32 Spielmann's identification of art and advertising displays some interesting characteristics. In acknowledging the authority of the businessman-owner to transform a painting into an advertising image for his commodities or services, he is forced to recognise that modern commerce does not enable the artist to control the production and marketing of his work: see Spielmann, 'Art and advertising', *Magazine of Art*, 1889, pp. 423–7, a critical response to Frith's less sanguine essay 'Artistic advertising', pp. 421–3.

33 In 1892 the *Art Journal* states that Herkomer is the favourite portrait painter of 'the learned, the prominently political, the triumphant in business': p. 222.

34 Sources here include: Saxon Mills, *Life*, pp. 159–60, 113, 89–90, 98, 130, 138–40; Herkomer, *My School*, pp. 1–5, 9–13; Herkomer, *The Herkomers* (London, 1911), vol. 2, pp. 187–231.

35 Saxon Mills, *Life*, pp. 138–9.

36 An intriguing theme in Saxon Mills's book is that not only was Herkomer's mansion a monumentalisation of the craftsmanship associated with the traditions and customs of his family, but that it represented an attempt to resist the commodification of art, culture and craft once they had been restructured or transformed by the processes of capitalisation. Of his father and uncle, he writes: 'These men carry forward the tradition of the workers who built the cathedrals, dwelling-houses and civic buildings of the medieval German towns. In those days an able craftsman was honoured by his native town ... as a wealthy capitalist ... is honoured in our own. The factory system, the organisation of wage-labour in masses, the competitive struggle for wealth and social position, the Smilesian philosophy of getting on, and up in life – such influences as these, if they have not fixed an actual stigma on handicraft, however honest and independent, have robbed it ... of much of its old pride and prestige': *Life*, p. 14.

37 Herkomer thought that Reynoldsian 'quasi-subject portraiture' was a joke: see Herkomer, *The Herkomers*, vol. 2, p. 119. If there is nothing Reynoldsian about his art or his critical ideas, Herkomer has little to say about Hogarth, who tended to be the hero of the commerce-genre tradition celebrated by Cunningham, Leslie, Frith and Spielmann.

38 See my 'Turning back the Grotesque: G. F. Watts, the matter of painting and the oblivion of art ', in C. Trodd, P. Barlow and D. Amigoni, eds, *Victorian Culture and the Idea of the Grotesque* (Aldershot, 1999).

39 If we restrict ourselves to Watts's writings on art, then it is the case that he perpetuates an anti-commercial discourse which we tend to find in the writings of those hostile to the RA, such as Blake; or those, such as Shee, who patrol the RA in order to ensure that the laws of art and manufacture, or the principles of taste and trade, are not entwined: see M. Watts, ed., *G. F. Watts, Annals of an Artist's Life*, 3 vols (London, 1912); Blake, *The Complete Poetry and Prose*; M. A. Shee, *Rhymes on Art* (2nd ed., London, 1805).

40 This anxiety about the belatedness of Victorian art, or the alienation of the modern artist from traditional practical knowledge of painters' materials through the rise of specialised manufactories of oil paints, is also addressed by Holman Hunt. In Hunt's account of the history of technique, it is the professionalisation of art, with its division between theoretical and practical knowledge, that confirms the separation of the modern artist from the skills and experiences of the Old Masters: see W. Holman Hunt, 'The present system of obtaining materials in use by artist painters', *Journal of the Society of Arts*, 23 (1880), pp. 487–93.

Select bibliography

This bibliography does not contain historical articles, notices, exhibition reviews or other related materials, all of which can be found in the notes of the relevant chapters.

Académie des beaux-arts, *Dictionnaire de l'Académie des beaux-arts*, Paris, 1858–87.

Ackerman, G. A., *The Life and Work of Jean-Leon Gérôme*, London and New York, 1986.

—— 'The Neo-Grècs: a chink in the wall of Neoclassicism', in J. Hargrove, ed., *The French Academy: Classicism and its Antagonists*, London and Toronto, 1990.

Ades, D., *Art in Latin America: The Modern Era, 1820 to the Present*, New Haven and London, 1989.

Adorno, T., *In Search of Wagner*, trans. R. Livingstone, London, 1981.

Allen, B., ed., *Towards a Modern Art World*, New Haven and London, 1996.

Altick, R. D., *The Shows of London*, Cambridge, 1978.

Andrews, K., *The Nazarenes: A Brotherhood of German Painters in Rome*, Oxford, 1964.

Atkinson, J. B., *et al.*, *English Painters of the Present Day*, London, 1871.

Bagehot, W., *The English Constitution*, London, 1963 (1st pub. 1863).

Baldry, A. L., *Hubert von Herkomer: A Study and a Biography*, London, 1904.

Bann, S., *Paul Delaroche, History Painted*, London, 1997.

Barlow, P and Trodd, C., eds, *Governing Cultures: Institutions of Art in Victorian London*, Aldershot, 1999.

Barrell, J., *The Political Theory of Painting from Reynolds to Hazlitt*, New Haven and London, 1986.

—— 'Sir Joshua Reynolds and the Englishness of English Art', in H. K. Bhabha, ed., *Nation and Narration*, London and New York, 1990.

Barringer, T. and Prettejohn, E., eds, *Frederic Leighton: Antiquity, Renaissance, Modernity*, New Haven and London, 1999.

Barrington, Mrs R., *The Life, Letters and Work of Frederic Leighton*, London, 1906.

Baudelaire, C., *Curiosités esthétiques, l'Art romantique et autres oeuvres critiques*, Paris, 1962.

Bell, C., *Art*, Oxford, 1914.

Belluzzo, A. M., *The Voyager's Brazil*, 3 vols, São Paulo, 1995.

Bennett, T., *The Birth of the Museum*, London, 1995.

Berger, P. L. and Luckman, T., *The Social Construction of Reality*, Harmondsworth, 1971.

Bhabha, H. K., *The Location of Culture*, London, 1994.

Blake, W., *The Complete Poetry and Prose*, ed. D. V. Erdman, Berkeley and Los Angeles, 1988.

Blaugrund, A., ed., *Paris 1889: American Artists at the Universal Exposition*, Philadelphia, 1989.

Boase, T. S. R., 'The decoration of the new palace of Westminster', *Journal of the Warburg and Courtauld Institutes*, 17, 1954.

Boime, A., *The Academy and French Painting in the Nineteenth Century*, London, 1971.

—— *Thomas Couture and the Eclectic Vision*, New Haven and London, 1980.

—— 'Ford Madox Brown, Thomas Carlyle and Karl Marx: meaning and mystification of work in the nineteenth century, *Arts Magazine*, 56, 1981.

—— *The Art of Exclusion: Representing Blacks in the Nineteenth Century*, London, 1990.

Boschloo, A. W. A., ed., *Academies of Art between the Renaissance and Romanticism*, The Hague, 1989.

Bosi, A., *Dialética da Colonização*, São Paulo, 1992.

Bourdieu, P., *Distinction*, London, 1984.

—— *The Field of Cultural Production: Essays on Art and Literature*, Cambridge, 1993.

—— *The State Nobility*, Oxford, 1996.

Bowie, A., *Aesthetics and Subjectivity: From Kant to Nietzsche*, Manchester, 1993.

Brewer, J., *The Pleasures of the Imagination*, London, 1997.

Bryson, N., *Word and Image, French Painting and the Ancien Régime*, Cambridge, 1981.

—— *Tradition and Desire, from David to Delacroix*, Cambridge, 1984.

Bullen, J. B., 'John Everett Millais and Charles Dickens: new lights on old lamps', *English Literature in Transition, 1880–1920*, special series, 4, 1990.

Bürger, P., *Theory of the Avant-garde*, trans. M. Shaw, Manchester, 1984.

Cannadine, D., *Aspects of Aristocracy*, Harmondsworth, 1994.

Carline, R., *Draw They Must: A History of the Teaching and Examining of Art*, London, 1968.

Carr, J. Comyns, *Papers on Art*, London, 1885.

—— *Some Eminent Victorians*, London, 1908.

Casteras, S. P. and Denny, C., eds, *The Grosvenor Gallery*, New Haven and London, 1996.

Chadwick, O., *The Victorian Church*, 2 vols, London, 1966.

Chandler L'Enfant, J., 'Truth in art: William Michael Rossetti and nineteenth-century Realist criticism', unpublished Ph.D. thesis, University of Minnesota, 1996.

Chapel, J., *Victorian Taste: The Complete Catalogue of Paintings at the Royal Holloway College*, London, 1982.

Chu, P. D. and Weisberg, G. P., eds, *The Popularization of Images: Visual Culture under the July Monarchy*, Princeton, 1994.

Clark, K., *The Nude: A Study of Ideal Art*, Harmondsworth, 1985 (1st pub. 1956).

Clark, T. J., *The Absolute Bourgeois: Artists and Politics in France, 1848–1851*, London, 1973.

—— *Image of the People: Gustave Courbet and the 1848 Revolution*, London, 1973.

—— *The Painting of Modern Life: Paris in the Art of Manet and his Followers*, London, 1984.

—— 'Clement Greenberg's theory of art', in F. Frascina, ed., *Pollock and After: The Critical Debate*, London, 1985.

Codell, J. F., 'Expression over beauty: facial expression, body language, and circumstantiality in the paintings of the Pre-Raphaelite Brotherhood', *Victorian Studies*, 29: 4, 1986.

—— 'Ford Madox Brown, Carlyle, Macaulay, Bakhtin: the pratfalls and penultimates of history', *Art History*, 21:3, 1998.

Colvin, S., *A Selection from Occasional Writings on Fine Art*, London, 1873.

Colley, L., *Britons: Forging the Nation 1707–1837*, London, 1996.

Cook, E. T. and Wedderburn, A., eds, *The Works of John Ruskin*, 39 vols, Sunnyside, 1903–12.

Corkran, A., *Frederic Leighton*, London, 1904.

Corrigan P. and Sayer, D., *The Great Arch: English State Formation as Cultural Revolution*, Oxford, 1985.

Dalgleish, A. J., 'Voluntary associations and the middle class in Edinburgh, 1780–1820', unpublished Ph.D. thesis, University of Edinburgh, 1991.

Dawtrey, L. and Jackson T., eds, *Investigating Modern Art*, New Haven and London, 1996.

Debret, J. B., *Voyage pittoresque et historique au Brésil, ou séjour d'un artiste français au Brésil, depuis 1816 jusqu'en 1831*, 3 vols, Paris, 1834–39.

Delaborde, H., *Ingres, sa vie ses trauvaux, sa doctrine*, Paris, 1870.

Délécluze, H. C., *David, son école et son temps*, Paris, 1855.

Denis, R. C., 'The educated eye and the industrial hand: art and design instruction for the working classes in mid-Victorian Britain', unpublished Ph.D. dissertation, University of London, 1995.

—— 'A preliminary survey of drawing manuals in mid-Victorian Britain, *c.*1825–1875', *Journal of Art and Design Education*, 15:3, 1996.

Driver, F., 'The historical geography of the workhouse system in England and Wales, 1834–1883', *Journal of Historical Geography*, 15, 1989 .

Duro, P., 'Art institutions: academies, exhibitions, art training and museums', in S. West, ed., *Guide to Art*, London, 1996.

Eagleton, T., *The Ideology of the Aesthetic*, London, 1990.

Eastlake, C., *Discourses*, London, 1852–64.

—— *Contributions to the Literature of the Fine Arts*, London, 1848 (2nd ed. 1870).

Edwards, E., *The Administrative Economy of the Fine Arts*, London, 1840.

Efland, A. D., *A History of Art Education: Intellectual and Social Currents in Teaching the Visual Arts*, New York, 1990.

Eisenmann, S. F., *et al.*, *Nineteenth Century Art: A Critical History*, London, 1994.

Eitner, L., *An Outline of European Painting from David through Cézanne*, London, 1987.

Elias, N., 'The retreat of sociologists into the present', *Theory, Culture and Society*, 4, 1987.

Faunce, S. and Nochlin, L., *Courbet Reconsidered*, New Haven and London, 1988.

Fawcett, T., *The Rise of English Provincial Art: Artists, Patrons and Institutions Outside London, 1800–1830*, Oxford, 1974.

Ferreira, F., *Bellas Artes: Estudos e Apreciações*, Rio de Janeiro, 1885.

Flaxman, J., *Lectures on Sculpture as delivered before the President and Members of the Royal Academy*, 2nd ed., London, 1838.

Flint, K., 'Moral judgements and the language of English art criticism 1870–1910', *Oxford Art Journal*, 6:2, 1983.

Forbes, D., 'Artists, patrons and the power of association: the emergence of a bourgeois artistic field in Edinburgh, *c.*1775–*c.*1840', unpublished Ph.D. dissertation, University of St Andrews, 1996.

Förster, E., *Peter von Cornelius*, 2 vols, Berlin, 1874.

Forster, J., *The Life of Charles Dickens*, 3 vols, London, 1969 (1st pub. 1872–74).

Foucart, B., *Le Renouveau de la peinture religieuse en France 1800–1860*, Paris, 1987.

Foucault, M., *Discipline and Punish: The Birth of the Prison*, trans. A. Sheridan, Harmondsworth, 1977.

Frascina, F. and Harrison, C., eds, *Modern Art and Modernism: A Critical Anthology*, London, 1982.

—— and Harris, J., eds, *Art in Modern Culture: An Anthology of Critical Texts*, London, 1992.

—— et al., *Modernity and Modernism: French Painting in the Nineteenth Century*, New Haven and London, 1993.

Fried, M., *Absorption and Theatricality: Painting and the Beholder in the Age of Diderot*, Berkeley, 1980.

—— *Realism, Writing, Disfiguration*, Chicago, 1987.

—— *Manet's Modernism*, Chicago, 1995.

Fry, R., ed., *Discourses by Reynolds*, London, 1905 .

—— *Last Lectures*, Cambridge, 1939.

Fuseli, H., *Lectures on Painting*, 2 vols, London, 1801.

Fyfe, G., 'The Chantry episode: art classification, museums and the state, *c.*1870–1920', in S. Pearce, ed., *Art in Museums*, London, 1995.

Gaehtgens, T. W. and Ickstadt, H., eds, *American Icons: Transatlantic Perspectives on Eighteenth- and Nineteenth-Century American Art*, Los Angeles, 1992.

Gallagher, C. and Laqueur, T., *The Making of the Modern Body: Sexuality and Society in the Nineteenth Century*, Berkeley, Los Angeles and London, 1987.

Galvão, A., *Subsídios para a História da Academia Imperial e da Escola Nacional de Belas Artes*, Rio de Janeiro, 1954.

—— 'Resumo histórico do ensino das artes plásticas durante o Império', in Instituto Histórico e Geográfico Brasileiro, *Anais do Congresso de História do Segundo Reinado, Comissão de História Artística*, vol. 1, Rio de Janeiro, 1984.

Giebelhausen, M., 'Representation, belief and the Pre-Raphaelite project, 1840–1860', unpublished D.Phil. dissertation, University of Oxford, 1998.

Giddens, A., *The Consequences of Modernity*, Oxford, 1990.

Goldstein, C., *Teaching Art: Academies and Schools from Vasari to Albers*, Cambridge, 1996.

Gomes Pereira, S., ed., *180 anos da Escola de Belas Artes: Anais do Seminário EBA180*, Rio de Janeiro, 1997.

Gonzaga-Duque, L., *A Arte Brasileira*, Campinas, 1995 (1st pub. 1888).

Gotlieb, M., *The Plight of Emulation*, Princeton, 1996.

Graña, C., *Modernity and its Discontents*, New York, 1967.

Graves, A., *A Dictionary of Artists who have Exhibited Works in the Principal London Exhibitions from 1760–1893*, Bath, 1970 (1st pub. 1901).

Green, N., 'Circuits of production, circuits of consumption: the case of mid-nineteenth-century art dealing', *Art Journal*, 48:1, 1989.

Greenberg. C., *Collected Essays and Criticism*, 4 vols, London and Chicago, 1986–94.

Gruetzner Robins, A., 'Leighton and British Impressionism: the academician and the avant-garde', *Apollo*, 2, 1996.

Hadjinicolau, N., 'Sur l'ideologie de l'avant-gardisme', *Histoire et Critique des Arts*, 6, 1978.

Hallé, C. E., *Notes from a Painter's Life*, London, 1909.

Harford, J. S., *The Life of Michael Angelo Buonarroti*, 2 vols, London, 1857.

Hargrove, J., ed., *The French Academy: Classicism and its Antagonists*, London and Toronto, 1990.

Harrison, C., *Modernism*, London, 1997.

—— and Wood, P., *Art in Theory, 1815–1900: An Anthology of Changing Ideas*, Oxford, 1998.

Hartley, K., *et al.*, eds, *The Romantic Spirit in German Art 1790–1990*, Edinburgh and London, 1994.

Haskell, F., *Rediscoveries in Art: Some Aspects of Taste, Fashion and Collecting in England and France*, London, 1980.
—— *Past and Present in Art and Taste*, New Haven, 1987.
Heidegger, M., *Basic Writings*, ed. D. F. Krell, London, 1993 (revised ed.).
Herkomer, H., *Etching and Mezzotint Engraving*, London, 1892.
—— *Catalogue of a Collection of Examples of New Black-and-White Art*, London, 1896.
—— *A Certain Phase of Lithography*, London, 1910.
—— *The Herkomers*, 2 vols, London, 1911.
Herrnstein Smith, B., *Contingencies of Value: Alternative Perspectives for Critical Theory*, London, 1988.
Hilles, F. W., *The Literary Career of Sir Joshua Reynolds*, Cambridge, 1936.
Hobsbawn, E. and Ranger, T., eds, *The Invention of Tradition*, Cambridge, 1984.
Hodgson, J. E. and Eaton, F. A., *The Royal Academy and its Members*, London, 1905.
Holcomb, A. M., 'Anna Jameson: the first professional English art historian', *Art History*, 6:2, 1983.
Howard, H., *A Course of Lectures on Painting, delivered at the Royal Academy of Fine Arts*, London, 1848.
Howe, P. P., ed., *The Complete Works of William Hazlitt*, 21 vols, London and Toronto, 1930–34.
Hutchison, S. C., *The History of the Royal Academy 1768–1986*, London, 1968.
Hütt, W., *Die Düsseldorfer Malerschule, 1819–1869*, Leipzig, 1995.
Iungham, G., *Capitalism Divided?*, London, 1984.
Johnston, J., 'Invading the house of Titian: the colonisation of Italian Art: Anna Jameson, John Ruskin and the Penny Magazine', *Victorian Periodicals Review*, 27:2, 1994.
Jones, S., 'Leighton's debt to Michelangelo: the evidence of the drawings', *Apollo*, 143, 1996.
Kant, I., *Critique of Judgement*, trans. J. H. Bernard, London, 1914 (2nd ed. revised).
—— *Critique of Judgement*, trans. J. C. Meredith, Oxford, 1952 (1st pub. 1911).
Kemp, M., *The Science of Art: Optical Themes in Western Art from Brunelleschi to Seurat*, New Haven and London, 1990.
Krauss, R., *The Originality of the Avant-Garde and Other Modernist Myths*, Cambridge, Mass., 1985.
Landseer, J., *Lectures on the Art of Engraving, delivered at the Royal Institute of Great Britain*, London, 1807.
Lapauze, H., *Histoire de l'Académie de France, Rome*, 2 vols, Paris, 1924.
Lehr, F. H., *Franz Pforr*, Marburg, 1924.
Leighton, F., *Addresses Delivered to the Students of the Royal Academy*, London, 1896.
Leslie, C. R., *A Hand-Book for Young Painters*, London, 1855.
—— *Autiobiographical Recollections*, London, 1860.
—— *Memoirs of John Constable*, Oxford, 1880.
Leslie, G. D., *The Inner Life of the Royal Academy*, London, 1914.
Lessing, G. E., *Laocoon: An Essay on the Limits of Painting and Poetry*, trans. E. Frothington, London, 1874.
Levitine, G., *The Dawn of Bohemianism*, University Park, Pa., and London, 1978.
Lottes, W., *Wie ein goldener Traum: die Rezeption des Mittelalters in der Kunst der Präraffaeliten*, Munich, 1984.
McClelland, C. E., *The German Experience of Professionalisation*, Cambridge, 1991.

Macdonald, S., *The History and Philosophy of Art Education*, London, 1970.

McWilliam, N., 'Limited revisions: academic art history confronts academic art', *Oxford Art Journal*, 12:2, 1989.

—— *Dreams of Happiness: Social Art and the French Left, 1830–1850*, Princeton, 1993.

Mainardi, P., *Art and Politics of the Second Empire: The Universal Expositions of 1855 and 1867*, New Haven and London, 1987.

—— *The End of the Salon: Art and the State in the Early Third Republic*, Cambridge, 1993.

Manthorne, K. E., *Tropical Renaissance: North American Artists Exploring Latin America, 1839–1879*, Washington, DC, 1989.

Marrinan, M., 'Historical vision and the writing of history at Louis-Philippe's Versailles', in P. D. Chu and G. P. Weisberg, eds, *The Popularization of Images: Visual Culture Under the July Monarchy*, Princeton, 1994.

Marsden, G., ed., *Victorian Values: Personalities and Perspectives in Nineteenth Century Society*, London and New York, 1990.

Marx, K., *The Revolutions of 1848; Politcal Writings*, vol. 1, ed. and intro. D. Fernbach, Harmondsworth, 1973.

Mello Júnior, D., *Pedro Américo de Figueiredo e Melo, 1843–1905*, Rio de Janeiro, 1983.

—— 'As exposições gerais na Academia de Belas Artes no Segundo Reinado', in Instituto Histórico e Geográfico Brasileiro, *Anais do Congresso de História do Segundo Reinado, Comissão de História Artística*, vol. 1, Rio de Janeiro, 1984.

Meynell, W., ed., *Some Modern Artists and their Work*, London, 1883.

Milner, J., *The Studios of Paris: The Capital of Art in the Late Nineteenth Century*, New Haven and London, 1988.

Montagu, J., *The Expression of the Passions: The Origin and Influence of Charles Le Brun's 'Conférence sur l'expression générale et particulière'*, London, 1994.

Montaiglon, A. de, ed., *Correspondance des Directeurs de l'Académie de France, Rome*, 18 vols, Paris, 1887–1912.

Moore, G., *Impressions and Opinions*, London, 1891.

—— *Modern Painting*, London, 1898.

Morales de los Rios Filho, A., 'O ensino artístico: subsídio para a sua história', in Instituto Histórico e Geográfico Brasileiro, *Anais do Terceiro Congresso de História Nacional*, vol. 8, Rio de Janeiro, 1942.

Morgan, H. C., 'The lost opportunity of the Royal Academy: an assessment of its position in the nineteenth century', *Journal of the Warburg and Courtauld Institutes*, 23, 1969.

National Gallery, *Select Committee, Report, and Minutes of Evidence*, London, 1852–53.

Nead, L., 'The Magdalen in modern times: the mythology of the fallen woman in Pre-Raphaelite painting', *The Oxford Art Journal*, 7, 1985.

Newall, C., *The Art of Lord Leighton*, Oxford, 1990.

Nochlin, L., *Politics and Vision: Essays on Nineteenth-Century Art and Society*, London, 1991.

Olds, C., 'Jan Gossaert's *St Luke Painting the Virgin*: a Renaissance artist's cultural literacy', *Journal of Aesthetic Education*, 24, 1990.

Ormond, L. and Ormond R., *Lord Leighton*, New Haven and London, 1975.

Orwicz M. R., ed., *Art Criticism and its Institutions in Nineteenth-century France*, Manchester, 1994.

Palgrave, F. T., *Essays on Art*, London, 1866.

Parris, L., ed., *Pre-Raphaelite Papers*, London, 1984.

Parsons, G., ed., *Religion in Britain. Vol. 4: Interpretations*, Manchester and New York, 1988.

Pater, W., *The Renaissance: Studies in Art and Poetry*, ed. Donald L. Hill, Berkeley, 1980.

Paterson, L., *The Autonomy of Modern Scotland*, Edinburgh, 1994.

Pattison, E. F .S., 'Sir Frederick Leighton, P.R.A.', in F. G. Dumas, ed., *Illustrated Biographies of Modern Artists*, London and Paris, 1882.

Pears, I., *The Discovery of Painting: The Growth of Interest in the Arts in England*, New Haven, 1988.

Perkin, H., *The Rise of Professional Society Since 1800*, London, 1989.

Pevsner, N., *Academies of Art, Past and Present*, Cambridge, 1940.

Philadelphia Museum of Art, *The Second Empire: Art in France under Napoleon III*, Philadelphia, 1978.

Phillips, T., *Lectures on the History and Principles of Painting*, London, 1833.

Pinacoteca do Estado, *O Desejo na Academia 1847–1916*, São Paulo, 1991.

Podro, M., *The Critical Historians of Art*, New Haven and London, 1982.

Poggioli, R., *The Theory of the Avant-garde*, Cambridge, 1968.

Pointon, M., ed., *Art Apart: Art Institutions and Ideology across England and North America*, Manchester, 1994.

Pollock, G., *Vision and Difference: Femininity, Feminism and the Histories of Art*, London and New York, 1988.

Poovy, M., *Making a Social Body: British Cultural Formation 1830–1864*, Chicago and London, 1995.

Potts, A., *Flesh and Ideal: Winckelmann and the Origins of Art History*, New Haven, 1994.

Poynter, E. J., *Discourses Delivered to the Students of the Royal Academy*, London, 1897–1905.

Prettejohn, E., 'Morality versus aesthetics in critical interpretations of Frederic Leighton, 1855–1875, *Burlington Magazine*, 138, 1996.

—— 'Painting indoors: Leighton and his studio', *Apollo*, 143, 1996.

—— 'Aesthetic value and the professionalisation of Victorian art criticism', *Journal of Victorian Culture*, 2:1, 1997.

—— 'Art and "materialism": English critical responses to Alma-Tadma 1865–1913', in *Sir Lawrence Alma-Tadema*, exhibition catalogue, Zwolle, 1996.

Redgrave, R. and Redgrave, S., *A Century of British Painters*, London, 1866.

—— *A Century of Painters of the English School*, London, 1890 (2nd abridged ed.).

Rewald. J., 'Foreword', *Pissarro 1830–1903*, London, 1980.

Reynolds, J., *Discourses on Art*, ed. R. Wark, New Haven and London, 1959.

Roberts, H. E., 'Art reviewing in the early nineteenth-century art periodicals', *Victorian Periodicals Newsletter*, 19, 1973.

—— 'Exhibition and review: the periodical press and the Victorian art exhibition system', in J. Shattock and M. Wolff, eds, *The Victorian Periodical Press: Samplings and Soundings*, Leicester and Toronto, 1982.

Robertson, D., *Sir Charles Eastlake and the Victorian Art World*, Princeton, 1978.

Robinson, R. W., *Members and Associates of the Royal Academy of Arts*, London, 1891.

Roget, J. L., *A History of the Old Water-Colour Society*, 2 vols, Clopton, 1972 (1st pub. 1891).

Rose, L., *Rogues and Vagabonds: Vagrant Underground in Britain 1815–1985*, London and New York, 1988.

Rosen, C. and Zerner, H., *Romanticism and Realism: The Mythology of Nineteenth-Century Art*, New York, 1984.

Rossetti, W. M., *Notes on the Royal Academy Exhibition*, London, 1868.

Royal Academy of Arts, *Frederic Leighton, 1830–1896*, London, 1996.

Royal Commission, *Royal Academy in Relation to Fine Art*, London, 1863.

Rubinstein, W. D., *Capitalism, Culture and Decline in Britain 1750–1990*, London, 1993.

Said, E., *Orientalism*, London, 1978.

—— *Culture and Imperialism*, New York, 1993.

Savage, M., Barlow, J., Dicken, P. and Fielding, T., *Property, Bureaucracy and Culture: Middle Class Formation in Contemporary Britain*, London, 1992.

Saxon Mills, J., *Life and Letters of Sir Hubert Herkomer*, London, 1923.

Schiller, F., *On the Aesthetic Education of Man: in a Series of Letters*, trans. E. M. Wilkinson and L. A. Willoughby, Oxford, 1967.

Shee, M. A., *Rhymes on Art*, London, 1805.

—— *A Letter to Lord John Russell ... on the Alleged Claim of the Public to be Admitted Gratis to the Exhibition of the Royal Academy*, London, 1837.

Shiff, R., *Cezanne and the End of Impressionism*, Chicago, 1984.

Silverman, D. L., *Art Nouveau in Fin-de-siècle France: Politics, Psychology and Style*, Berkeley, 1989.

Skaife, T., *Exposé of the Royal Academy*, London, 1854.

Smith, S. M., *The Other Nation: The poor in English Novels of the 1840s and 1850s*, Oxford, 1980.

Spencer, R., 'Whistler's "The White Girl": painting, poetry and meaning', *Burlington Magazine*, 140, 1998.

Stebbins, Jr, T. E. *et al.*, *A New World: Masterpieces of American Painting 1760–1910*, Boston, 1983.

Stephens, F. G., 'Introductory essay', in E. Rhys, *Sir Frederic Leighton Bart, P.R.A: An Illustrated Chronicle*, London, 1895.

Tagg, J., *Grounds of Dispute: Art History, Cultural Politics and the Discursive Field*, Basingstoke, 1992.

Taine, H., *Philosophie de l'art*, Paris, 1872 (2nd ed.).

Taunay, A. d'E., *A Missão Artística de 1816*, Brasilia, 1983 (1st pub. 1911).

Taussig, M., *Mimesis and Alterity: A Particular History of the Senses*, London and New York, 1993.

Thistlewood, D., ed., *Histories of Art and Design Education: Cole to Coldstream*, London, 1992.

Thompson, E. P., *The Poverty of Theory and Other Essays*, London, 1978.

Thornbury, J. W., *Haunted London*, London, 1865.

Traill, H. D., ed., *The Works of Thomas Carlyle*, London, 1896–99.

Treble, R., *Great Victorian Paintings: Their Paths to Fame*, London, 1978.

Treuherz, J., ed., *Hard Times: Social Realism in Victorian Art*, London, 1987.

Trodd, C., 'The authority of art: cultural criticism and the idea of the Royal Academy in mid-Victorian Britain', *Art History*, 20:1, 1997.

—— Barlow, P. and Amigoni, D., eds., *Victorian Culture and the Idea of the Grotesque*, Aldershot, 1999.

Varnedo, K., 'Revision, re-vision, re:vision", *Arts Magazine*, 49, 1974.

Vaughan, W., *Romantic Art*, London, 1978.

—— *German Romanticism and English Art*, New Haven and London, 1979.

—— *German Romantic Painting*, New Haven and London, 1980.

Viollet-le-Duc, E., *Esthétique appliquée à l'histoire de l'art*, Paris, 1994 (1st pub. 1864).

Wagner, A. M., *Jean-Baptiste Carpeaux: Sculptor of the Second Empire*, New Haven and London, 1986.

Warner, M., *et al.*, *Pre-Raphaelites in Context*, San Marino, 1992.

Watts, M., *G. F. Watts, Annals of an Artist's Life*, 3 vols, London, 1912.

Weisberg, G., 'Jules Breton, Jules Bastien-Lepage and Camille Pissarro in the context of nineteenth-century peasant painting and the Salon', *Arts Magazine*, 56, 1982.

Wellington, H., ed., *The Journal of Eugène Delacroix*, London, 1995.

West, S., 'Tom Taylor, William Powell Frith and the British school of art', *Victorian Studies*, 33:2, 1990.

White, H. and White C., *Canvases and Careers: Institutional Change in the French Painting World*, New York, 1965.

—— *Metahistory: The Historical Imagination in Nineteenth-Century Europe*, Baltimore, 1973.

—— *Tropics of Discourse: Essays in Cultural Criticism*, Baltimore, 1978.

Whitley, W. T., *Art in England 1821–1837*, Cambridge, 1930.

Wiener, M. J., *English Culture and the Decline of the Industrial Spirit 1850–1980*, Cambridge, 1981.

—— *Reconstructing the Criminal: Culture, Law and Policy in England, 1830–1914*, Cambridge, 1990.

Williams, K., *From Pauperism to Poverty*, London, 1981.

Williams, R., *Culture and Society, 1780–1950*, Harmondsworth, 1958.

Wilson, C. H., *The Life and Works of Michelangelo*, London, 1876.

Wilson, J. M., *The Painting of the Passions in Theory, Practice and Criticism in Later Eighteenth-Century France*, New Haven, 1981.

Winckelmann, J., *The History of Ancient Art*, trans. G. Henry Lodge, Boston, 1856.

Wolff, J. and Seed, J., eds, *The Culture of Capital: Art, Power and the Nineteenth-Century Middle Class*, Manchester, 1988.

Wood, P., *Poverty and the Workhouse in Victorian Britain*, Stroud, 1991.

Wornum, R. N., ed., *Lectures on Painting by the Royal Academicians Barry, Opie and Fuseli*, London, 1848.

Index

Note: page references in *italics* refer to an illustration; 'n.' after a page reference indicates a note number on that page.